WHO OWNS AMERICA'S PAST?

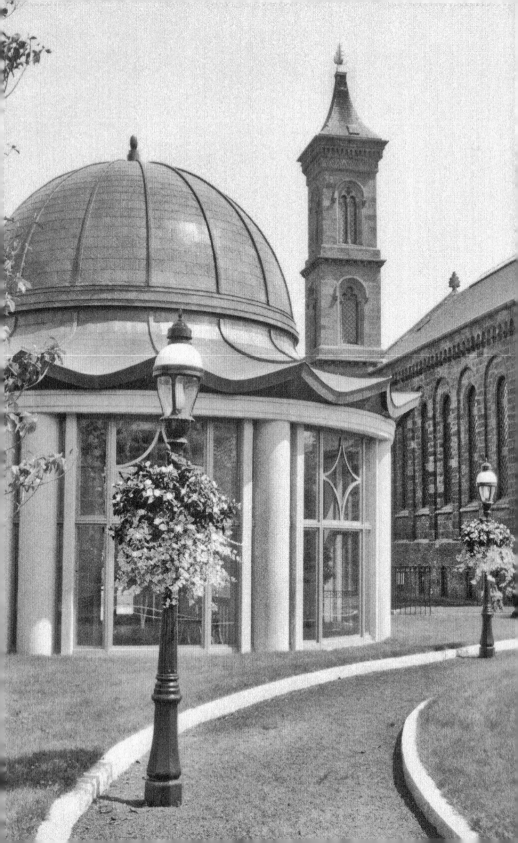

WHO OWNS AMERICA'S PAST?

The Smithsonian and the Problem of History

ROBERT C. POST

JOHNS HOPKINS UNIVERSITY PRESS *Baltimore*

Johns Hopkins Paperback edition, 2017
9 8 7 6 5 4 3 2

Johns Hopkins University Press
2715 North Charles Street
Baltimore, Maryland 21218-4363
www.press.jhu.edu

The Library of Congress has cataloged the hardcover edition of this book as follows:
Post, Robert C.
Who owns America's past? : the Smithsonian and the problem
of history / Robert C. Post.
 pages cm
Includes bibliographical references and index.
ISBN-13: 978-1-4214-1100-2 (hardcover : alk. paper)
ISBN-10: 1-4214-1100-8 (hardcover : alk. paper)
ISBN-13: 978-1-4214-1101-9 (electronic)
ISBN-10: 1-4214-1101-6 (electronic)
 1. Smithsonian Institution—History. 2. Public history—United States.
3. Museums—Social aspects—United States. 4. Museums—Political
aspects—United States. I. Title.
Q11.S8P67 2013
069.09753—dc23 2013004825

A catalog record for this book is available from the British Library.

ISBN-13: 978-1-4214-2258-9
ISBN-10: 1-4214-2258-1

Frontispiece: Faces of the Smithsonian new and old: the entrance to the subterranean S. Dillon Ripley Center, the quadrangle kiosk, completed in the 1980s, and, beyond, the Castle, completed in the 1850s. (Smithsonian Institution Archives, Image No. 96-1386)

Special discounts are available for bulk purchases of this book.
For more information, please contact Special Sales at 410-516-6936
or specialsales@press.jhu.edu.

Johns Hopkins University Press uses environmentally friendly book
materials, including recycled text paper that is composed of at least
30 percent post-consumer waste, whenever possible.

FOR DIAN

CONTENTS

*What do people say casually when they hear
you work in a museum? "Oh, you work at the
Smithsonian? How interesting . . . "*

—S. DILLON RIPLEY, *The Sacred Grove*, 1969

PREFACE

A while back, I was doing research in the Smithsonian Institution
Archives when an exhibit called *America's Smithsonian* returned
to Washington after a coast-to-coast tour. Its closing venue was the
S. Dillon Ripley Center, named for the ornithologist who led the Smithsonian as its secretary for twenty years, from 1964 to 1984, longer and more
eventfully than any other secretary except the first, Joseph Henry, who
held office from 1846 to 1878. The Ripley Center is a subterranean world
entered through a kiosk on the Mall, which leads you to a long escalator
ride down. I had read reviews of *America's Smithsonian*—panned in New
York, a hit in Los Angeles—but I had not seen it myself. So one afternoon,
I signed out of the archives, then in the old Arts and Industries Building,
walked over to the kiosk next to the Castle, the institution's red sandstone
signature, and descended.[1]

Even though funds had run short and the sixty-horse carousel seen on
the tour was now missing, I could believe the publicity about this being
"the largest collection of national treasures ever exhibited outside the

Smithsonian."[2] But I was an old hand at the Smithsonian, and jaded, and so I hurried through. I paused at Alan Shepherd's *Freedom 7* spacecraft and the red, white, and blue Pontiac in which Richard Petty was said to have won his two-hundredth NASCAR race, the Firecracker 400 at Daytona. What captured most of my attention, however, was an adventuresome infomercial for Trans World Airlines (TWA) on a video that commanded the entrance to the gallery. In one final flight of corporate optimism (it declared bankruptcy for the third and last time soon afterward), TWA had helped finance the Smithsonian's 150th anniversary celebration as a $10 million donor to its Corporate Partner Program, created "to assist the Institution in its marketing objectives." As dubbed by a critic in California, *America's Smithsonian* was the "gonzo" centerpiece of that celebration.

Then I headed for the escalator, which surfaces near a different escalator just across Jefferson Drive, this one connecting with the Smithsonian Metrorail station. As I reached the top, a man headed the other way with his family called over, "Is there anything down there?"

"A big exhibit," I answered.

"Of what?" he asked.

All I could say was "All sorts of things." I knew this would be of no help to anyone trying to apportion time late in the day among a dozen attractions along the Mall. I had noticed Frank Lloyd Wright furnishings from the Imperial Hotel in Tokyo, Jacqueline Kennedy's inaugural gown, the gloves laced on Muhammad Ali before he fought George Foreman in Zaire, and several jackets: one worn by Chuck Yeager when he broke the speed of sound, another worn by Harrison Ford in the Indiana Jones movies, another by Cesar Chavez amid California lettuce fields. There was art by Richard Estes and Andy Warhol, and there were specimens from the natural history collections—mastodon teeth, dinosaur skulls, and exotic minerals, including one called Smithsonite. But most prominent were objects from the diverse technological realms that had always comprised the Smithsonian's richest collections. Some were prominent simply because they were large—*Freedom 7* and the Apollo 14 command module *Kitty Hawk*, a lunar rover, an Apollo 15 space suit, a Tucker "car of the future," and the NASCAR Pontiac—some not large but prominent anyway: a compass from the Lewis and Clark expedition, an Altair microcomputer,

and a Jarvik heart, as well as even smaller items labeled "Morse Telegraph Key," "Bell 'Box' Telephone," and "Edison Light Bulb." There was also a Star Trek phaser, Judy Garland's ruby slippers, and Kermit the Frog.

So many different *kinds* of things, some unique like *Freedom 7*, many not at all—not even the ruby slippers, a mild embarrassment when another pair turned up in a Christie's auction—and I really had no answer to "what's down there?" except for an unhelpful "you'll have to see for yourself."

■

THIS IS A BOOK ABOUT THE CHANGING WAYS in which the Smithsonian Institution has put historical artifacts on display. In the 1850s, when John Wesley Powell was first shown ethnological specimens arrayed in the Great Hall of the Castle, he called what he saw "interesting flotsam and jetsam." There were things that caught his eye, of course, but little or no attempt to explain their meaning or relate them one to another. In *America's Smithsonian*, only the TWA video seemed purposeful (Fly TWA to Faraway Places!); the artifacts, though artfully posed and illuminated, were displayed in much the same mode as what Powell had seen long ago. The assumption was that people would find them "interesting," as Powell did. By the time Secretary Ripley mentioned that word, *interesting*, when he wrote *The Sacred Grove*, he knew that an artifact became "a national treasure," *any* artifact, solely by virtue of being "in the Smithsonian." This had long been true for the technological devices that dominated *America's Smithsonian*, all of them perceived as engines of human progress. It was now true even for props from television shows, like the phaser, because of their "instant connection with people."[3]

In the 1950s, with the emergence of professional designers, and especially with the move into the spacious new Museum of History and Technology (MHT) in the early 1960s, there were efforts to incorporate artifacts into historical narratives by means of "scripts" with silk-screened "labels" that not only identified objects but might also address their meaning. Hence, along with a Railroad Hall in MHT, there was a synoptic exhibit called *Growth of the United States* that incorporated a venerable locomotive, the *John Bull*, meant to illustrate a storyline about growing corporate hege-

mony, and there was even a plan to bring a "slum dwelling" into the exhibit to illustrate a script telling about the plight of newly arrived immigrants.

The plan to exhibit a slum dwelling was abandoned, and the tenor of Smithsonian exhibits remained upbeat through the 1970s and on into the 1980s. But this episode indicated a countercurrent pushing toward stories about the "dark side" of urbanization and industrial capitalism and even toward mankind's "tendency to use knowledge to do evil." This was an expression used by Philip Ritterbush, the scholar in charge of Ripley's Office of Academic Programs, and Ripley's closest advisor, Assistant Secretary for History and Art Charles Blitzer, spoke disdainfully of exhibits that treated "gleaming machines" as objects of reverence.[4]

Ritterbush and Blitzer were both gone by the time Ripley retired in 1984. But their dark-side apprehensions were revitalized when Robert McCormick Adams, from the University of Chicago, succeeded him as secretary. Adams was working on a book titled *Paths of Fire: An Anthropologist's Inquiry into Western Technology*, and he believed that technology's consequences had been "overwhelmingly positive."[5] He also believed in the educational power of exhibits featuring technological devices, but with a twist: "progress" with scare quotes. He wanted exhibits to have a critical edge and to "make people feel uncomfortable." It soon became clear that this was deeply offensive to certain outsiders who got termed "stakeholders," and there followed a confrontation that made the news for weeks and months on end. By the time *America's Smithsonian* went on the road in 1996, Adams had returned to academe and anybody left at the institution would have thought twice about proposing an exhibit that more than glanced at the dark side. A renewed effort to imply—actually, to insist on—a link between technology and human progress was evident in all the heroic "spacefaring" technology featured in *America's Smithsonian*, as well as the Jarvik, the Altair, even the Pontiac.

At the heart of the confrontation was the National Air and Space Museum (NASM), a museum born from a rib of the Museum of History and Technology and endowed with an expansive building of its own in 1976, as a celebration of both the Apollo 11 mission and the Bicentennial. NASM's first director was the astronaut who had piloted the Apollo 11 command module to the moon, Michael Collins. Then, in 1987, the director's job

went to Martin Harwit, a Cornell University astrophysicist who had been present in the 1940s when "nuclear devices" were detonated at Bikini Atoll. In league with Adams, Harwit began planning for an exhibit to mark the fiftieth anniversary of the end of World War II. *The Last Act*, it would be called. The centerpiece was to be the forward fuselage of the *Enola Gay*, the Boeing B-29 that the commander of the wartime Army Air Forces, General H. H. "Hap" Arnold, had donated after VJ Day.

The cost of developing the B-29 Superfortress exceeded that of the Manhattan Project, and nearly four thousand of them were manufactured, an astounding accomplishment for such a complex and, dare one say, magnificent device. But rather than just celebrating a triumph of American technological prowess (and military victory), Harwit and Adams agreed on deploying the *Enola Gay* along with a revisit to the strategy of targeting civilian populations with air power in order "to break a nation's will." After the incineration of more than sixty Japanese cities, "strategic bombing" reached a nadir with Hiroshima and Nagasaki in August 1945. The *Enola Gay* was not just any B-29, of course. It was the plane selected to carry out the atomic bombing of Hiroshima, and even Senator Barry Goldwater, NASM's most powerful political ally, had remarked that it was not "appropriate" for display. During hearings in the early 1970s, Goldwater said, "What we are interested in here are the truly historic artifacts. I wouldn't consider the one that dropped the bomb on Japan as in that category." But Harwit's plan was to include not only the forward fuselage and bomb bay but also a close-up look at Ground Zero—melted lunchboxes, charred timepieces, ghastly photos of the dead and dying—as well as scripting that cast doubt on the decision to drop the bomb. For some people, there could be a no more disturbing reminder of technology's "tendency to use knowledge to do evil." For others, what was planned at NASM was only a disrespectful exercise in "historical revisionism."[6]

There was confusion about what *revisionism* actually meant. But one thing was for sure: never had word about a Smithsonian exhibit so inflamed popular passions. The commander of the Hiroshima mission, General Paul Tibbets, called it "a package of insults." This led to emasculation of the script. Then, for attempting to purvey a "countercultural morality pageant" at a museum that was expected to celebrate technological ingenuity and

human derring-do, Harwit lost his job, and the curators who had worked on the exhibit were humiliated. Said Representative Newt Gingrich, "Americans are sick and tired of being told by some cultural elite that they ought to be ashamed of their country." The most common public perception was that NASM had shamed the Smithsonian by embracing "the worst elements of America's academic culture."

Whatever had happened, it would happen no more. To this day, exhibits at the National Air and Space Museum, or anywhere under Smithsonian aegis, rarely lack a celebratory tenor. *America's Smithsonian* was one example among many. "Imagination, resourcefulness, and daring"—this is what Vice President Cheney saw in 2003 when he delivered the keynote at the opening of NASM's soaring annex near Dulles Airport, the Steven F. Udvar-Hazy Center, where eighty airplanes were on display. Cheney could just as well have been referring to trains, trucks, and automobiles in a new exhibit at the National Museum of American History (NMAH—the Museum of History and Technology had been renamed), largely funded by General Motors and called *America on the Move*. Or his reference could have been to fighting men and machines in *The Price of Freedom: Americans at War*, an exhibit funded by Kenneth Behring, a man who, by his own account, "climbed aboard the American dream and rode it to the top."[7] Behring had promised to donate $80 million to NMAH if it would dispense with academically faddish "multiculture" exhibits and "really do an *American* history museum."

Behring also wanted his own name added to the museum's name—"The Kenneth E. Behring Center" is now chiseled on the façade—and his aims for the museum as a whole seemed well on the way to fulfillment when it reopened in 2008 after a two-year makeover. The centerpiece was an exhibit called *For Which It Stands*, featuring the Star-Spangled Banner, but more dramatic and more prominent was the "abstract architectural representation" of a waving flag created from 960 reflective tiles. The drama was thanks to the New York design firm of Chermayeff & Geismar, with more than half the $20 million cost of the whole exhibit contributed by a different kind of design firm, Polo Ralph Lauren. President George W. Bush was there, urging every American to come visit this "fantastic place

of learning." It was as if penance had been paid for that "package of insults" in the 1990s.

True, a handful of Smithsonian exhibits did not fit the pattern. One was *Between a Rock and a Hard Place: A History of American Sweatshops*, which had a brief run despite being labeled a "smear" by the American Apparel Manufacturing Association. Another was *Captive Passage*, whose narrative dealt with the transatlantic slave trade, 12 million men and women all told. *Captive Passage* was staged nowhere near the Mall, however, but rather at the institution's Anacostia Museum in southeast Washington, a part of the city most tourists never visited.

Whether or not they hinted at anything less than upbeat, there was a shift in the latter decades of the twentieth century away from exhibits that were "collections-driven," with artifacts sparsely labeled and deployed in taxonomic groupings or even randomly—*America's Smithsonian* and NASM's Udvar-Hazy Center could both be called collections-driven or, better, neo-traditionalist. The shift was toward "story-driven" exhibits in which artifacts served to sustain narratives and were deployed like illustrations; *The Last Act* would have been a prime example. And, when funding was available, exhibits were starting to appear in which artifacts, props, and stage sets—sound and light and diverse forms of interactive and "immersive" media—were richly blended to create an "experience." In exhibits like *For Which It Stands* and *America on the Move*, the authentic artifacts sometimes seemed secondary, and the flavor was distinctly postmodern.

∎

COLLECTIONS-DRIVEN/NEO-TRADITIONALIST, story-driven, postmodern/immersive—all three approaches could cover a lot of ground, and to try and put these modes of exhibitry into working context I looked into correspondence and internal memos held by the Smithsonian Institution Archives, located in the distinctive Romanesque building next door to the Norman Castle. It was called the United States National Museum when it opened in 1881, but since 1910 it had been known as Arts and Industries (A&I). By the end of the twentieth century, it mostly housed

offices—among others, offices for the archivists and for the scholars editing the papers of Joseph Henry. There were still a few exhibits, but A&I's last hurrah as a major gallery had been an extravaganza called *1876*, installed at the time of the Bicentennial and emulating the ambience of the Centennial Exposition staged in Philadelphia a century before. Bunting, banners, greenery, and gilt signage had adorned the hall, with its display of totem poles, a spectacular lighthouse lens and steam hammer, an even-more-spectacular orchestration—a mechanical contrivance that could emulate the sounds of an entire band—and all sorts of manufactured goods and machines, many of the machines painted in gaudy colors and gold-leafed, as they had been at the Centennial.[8]

The designer of *1876* was Bill Miner, a protégé of Charles and Ray Eames, who succeeded in creating something unique in the history of the Smithsonian: an exhibit that was collections-driven, story-driven, and immersive, all at once—a look into another world, a time machine. This was an exhibit I worked on myself, and even discussed over coffee with an unsung freelance named Lynne Cheney. I had to agree when she applauded its "Victorian wonders" and "unabashed pride."[9] And I shared in the disappointment when the artifacts got dispersed, beginning in the 1980s. Some of them went to the National Museum of Natural History directly across the Mall. Many more went to the National Museum of American History, to the west of Natural History. Big machines like the 20-foot steam hammer were loaned to an affiliated industrial museum, but nothing was new enough to have gone to the Air and Space Museum, near the eastern end of the Mall, almost under the Capitol dome.

For the Smithsonian, the Capitol is both an imminent physical presence and the symbol of a fateful power relationship. When the planned *Enola Gay* exhibit was canceled, it was in the face of a threat to "zero out" the funding upon which the institution depended for 70 percent of its annual budget, several hundred million dollars. Not long before, the Smithsonian's National Museum of American Art had been pummeled for *The West as America*, an exhibit depicting the classic work of Frederick Remington and Charles M. Russell as "carefully staged fictions."[10] The institution had found itself in the thick of the culture wars, specifically in the contention over "ownership" of the past that was inflaming public discourse about the

National History Standards and funding practices of the National Endowment for the Arts. And, as the pitch for TWA in *America's Smithsonian* or Kenneth Behring's remark about "real" history and his peculiar notion of what was "beneficial for America" suggested, there were dilemmas involving blurred lines between commercialism and public enlightenment, between education and celebration and unalloyed prejudice.

To elaborate on how this had happened is one purpose of my book. That purpose gained urgency as the man who became Smithsonian Secretary for seven years, Lawrence Small, showed no compunctions about accepting donations like Behring's that came with dubious stipulations attached—apparently it was at Behring's insistence that *The Price of Freedom* depicted the Mexican War, like all the nation's wars, as "a benign and inevitable outgrowth of American democracy."[11] Unlike exhibits with dark-side themes or inflected with political correctness, scornful to the cultural right (veneration of "pop-culture ephemera" was another bugbear), Small's "warped priorities" and "Don Perignon lifestyle" offended critics of all hues. This disaster (there is no better word for it) gets a chapter near the end of this book.

Controversies persisted in the regime of Small's successor, G. Wayne Clough, about exhibits, about funding, about a "branding" campaign with a tagline that strikes many people as silly, though not about the man himself, an honorable and distinguished former university president (Georgia Institute of Technology), in the tradition of Ripley's predecessor, Leonard Carmichael (Tufts), who served between 1953 and 1964. In Carmichael's day and before, the Smithsonian was seldom in the public eye. Its sleepy nickname, The Nation's Attic, seemed entirely appropriate. Now, rarely does a week go by when something about the Smithsonian, good or bad, does not make the news. But, good or bad, there is nothing really new except the publicity, and a second purpose of my book is to show that problematic entanglements, a collision of noble ideals with barely restrained commercialism or popular passions or political muscle, have been inevitable ever since the National Museum was established in the 1880s; indeed, they reflect concerns Joseph Henry had expressed during the Smithsonian's formative years before the Civil War.

WHEN I FIRST VISITED WASHINGTON, D.C., in the fall of 1958, ground had just been broken for MHT, and I saw only a raw construction site. In Arts and Industries, I saw the *John Bull, Spirit of St. Louis,* and Star-Spangled Banner (then awkwardly folded and only partly visible) as any other tourist would. When I returned a decade later, my relationship was different, for the new MHT was hosting an annual meeting of the Society for the History of Technology (SHOT), with which it had a symbiotic bond, and I was beginning to form a personal bond that would grow into a lifetime allegiance. But I still was not *directly* involved. That changed in 1971 when I came to the museum on a graduate fellowship, thanks to a program initiated by Secretary Ripley and administered by his assistant secretary, Philip Ritterbush. As I was completing a doctoral dissertation about the inventor Charles Grafton Page, which touched on the Smithsonian's early days, I landed a job with the senior curator in the Division of Mechanical and Civil Engineering, Robert Vogel. In 1974, I moved over to the director's office as special assistant to Brooke Hindle for four years, and after that I took on a diversity of assignments throughout the museum and elsewhere in the institution until I took leave in 1996.

In the course of that quarter-century, I spent fifteen years editing SHOT's quarterly, *Technology and Culture,* a challenging and rewarding task initially blessed by Ripley and then affirmed and reaffirmed by a museum director, Roger Kennedy, who agreed with Ripley that it was important for the staff to reach out to the world of academic scholarship and also to pursue strong research and publication agendas of their own. Sometimes these agendas seemed peculiar; the author of a monograph on tea-drinking customs in colonial America received an "Order of the Golden Fleece," Senator William Proxmire's way of publicizing what he regarded as boondoggles by civil servants. Peculiar, yes, but not unimportant; the senator was wrong. Frank Taylor, the indispensable man in the founding of the new museum, argued that through publications, "we can join other historians . . . in making continuing contributions to the body of historical knowledge and interpretation."[12] The museum provided both the impetus and an outlet for first-rate scholarship in the realm of material culture, especially in the

history of technology and science, scholarship that could not have been sustained in any other institutional setting.

During my Smithsonian tenure, I also spent time as an editor of books aimed at the "general reader" (another Ripley initiative), books on invention, on the environment, on the American presidency, all with sales well into six figures. I led a "task force" that was partly or largely responsible for several major exhibits—selecting artifacts from the collections, writing scripts, and then seeking accommodation with designers, men and women whose allegiance might be less to education than to engendering excitement among the tens of millions of people these exhibits would reach. After serving my time as a subordinate to the curators of the engineering collections, I had direct responsibility for the collections in maritime history. Because *word from the Smithsonian* was then perceived as unimpeachable (the institution being a sanctuary where "knowledge was secure," in historian Neil Harris's words), my duties included a response to public inquiries about matters ranging from the identity of antique tools and timepieces to the manifest of the *Mayflower* and the fate of the *Titanic*.[13] (My counterpart Jeffrey Post, a mineralogist at the Museum of Natural History next door, would get inquiries about the Hope Diamond, its 44.5 carats outweighed in popular imagination by tales of a curse.)

Over a period of two decades, I worked alongside three directors, very different men, but each of them admirable. Brooke Hindle and Roger Kennedy I have mentioned (for Hindle I was "clerk of the works"; Kennedy called me his "fireman"). The third, whose shorter tenure in the late 1970s was bracketed by Hindle's and Kennedy's, was Otto Mayr, with whom I collaborated on a book and climbed mountains in Colorado, who later served ten years as director of the Deutsches Museum in his native Munich, the museum upon which the Smithsonian's Museum of History and Technology was initially patterned. My colleagues included some of the most creative, committed, and courageous men and women I have ever known, and a few knaves, fools, and martinets. All in all, however, it was a splendid experience, working for the Smithsonian—actually, a dream of mine ever since I discovered a place near my boyhood home called Parker Lyon's Pony Express Museum, which had attracted the attention of Man Ray because displays ranged from a glorious narrow-gauge locomotive

from the 1880s to a great wooden crate containing the butts of thousands of cigars said to have been smoked by Ulysses S. Grant—probably my introduction to a sense that history museums may often walk a line between straightforward description and pure whimsy. This has been reinforced more recently by the Museum of Jurassic Technology in the Palms district of Los Angeles, not far from the site of the Pony Express, where the exhibits include a beautiful scale model of Noah's Ark.[14] I imagine that this model might be as memorable to some youngster today as that crate full of cigar butts was to me years ago.

ACKNOWLEDGMENTS

Because I saw some of what follows at first hand, my narrative will slip into the first person, as it has done already. Quotations lacking attribution usually are remarks I heard with my own ears. But my guiding precept in all that follows is Dennis Hopper's line in *Search and Destroy*: "Just because it happened to you doesn't make it interesting." I suspect that Dillon Ripley was hinting at the same thing when he noted that people would say "how interesting" when he told them where he worked. Still, there is a facet of full disclosure that I cannot omit, acknowledging those to whom I owe thanks. Above all, my wife and muse, Dian, for her thoughtful attention to my prose, for her unfailing encouragement, for her enduring love, indeed for everything. Thanks, too, to Bob Brugger at the Johns Hopkins University Press for all his good advice, and to Glenn Perkins for his meticulous editing. For criticism and support, I also owe thanks to friends and colleagues whose special interest is technology in history: Bob Casey, Joe Corn, Ruth Schwartz Cowan, Steve Cutcliffe, Deborah Douglas, Robert Friedel, Russell Douglass Jones, Miriam Levin,

Alex Roland, Matt Roth, Joe Schultz, Bruce Seely, Bruce Sinclair, John M. Staudenmaier SJ, Steve Thompson, Rudi Volti, Rosalind Williams, and Julie Wosk. And, even though he died as I was just beginning to glimpse the dimensions of this inquiry, I cannot fail to mention Melvin Kranzberg, for many years a major force in Smithsonian affairs and entirely deserving of designation by Sinclair as "the mother of all fathers."

Two early forays took place while I was a resident fellow at the Dibner Institute for the History of Science and Technology when it was still located in Cambridge, Massachusetts, and I must express appreciation to Evelyn Simha, the executive director, as well as the directors during each of my terms, Jed Buchwald (1995–96) and George Smith (2001–2). Special thanks is due to the director of the Lemelson Center for the Study of Invention and Innovation, Art Molella, my oldest Smithsonian friend. Along with Ron Becker, another old friend who for many years was the adept and observant associate director for administration at the National Museum of American History (NMAH), Art helped me think through many of the issues addressed here—to inspect kitchens, as we took to calling it. Some of those issues were addressed first by Marilyn Sara Cohen in her 1980 George Washington University (GWU) doctoral dissertation, "American Civilization in Three Dimensions: The Evolution of the Museum of History and Technology of the Smithsonian Institution," and I cannot thank Marilyn too much for her pathbreaking scholarship. In the Smithsonian Institution Archives, Bruce Kirby, LaNina Clayton, Courtney Esposito Bellizzi, and Jim Steed became genial collaborators, as did Alison Oswald in the Archives Center, National Museum of American History, which holds the Kranzberg Papers. Joanne Gernstein London, an Air and Space Museum curator who was at work on her GWU dissertation, "A Modest Show of Arms: Exhibiting the Armed Forces at the Smithsonian Institution, 1948–1965," flagged archival information she knew would interest me. Among all the über-officials in the Castle and "bureau directors" in the museums, I owe something special to Charles Blitzer, even though he may not have liked gleaming machines (as I did, sometimes), for he went out of his way to persuade me not to burn bridges at "my" museum when tempted away by an offer from elsewhere in the institution.

As to my museum, History and Technology, later American History,

I owe thanks to almost everybody with whom I associated at one time or another. It is not easy to single out individuals, but I'll try to mention those whom I remember best: Silvio Bedini, Peggy Bruton, Susan Fay Cannon, Tom Crouch, Pete Daniel, Barney Finn, John Fleckner, Anne Golovin, Susan Hamilton, Rob Harding, Elizabeth Harris, Bill Harvey, Josiah Hatch, Jeff Howard, Peggy Kidwell, Claudine Klose, Gary Kulik, Nancy Long, Karen Loveland, Nadya Makovenyi, Joan Mentzer, Bill Miner, Robert Multhauf, Susan Myers, Bill Pretzer, Carl Scheele, Bob Selim, Elliot Sivowitch, Hal Skramstad, Carlene Stephens, Jeffrey Stine, Debby Warner, Jack White, Bill Worthington, and Helena Wright. And, of course, Brooke Hindle, Otto Mayr, and Roger Kennedy, to whom I answered directly, one after the other. Time and again, John Stine showed what Paul Reistrup, the president of Amtrak, meant when he told me, "The sergeants will do the job if they trust you." Responding to queries about the way things were fifty and sixty years ago, Ben Lawless provided me with a sheaf of email that always brings a smile, and here he has also honored me with two original drawings that are evocative as only Ben's can be. And a last word of appreciation for Peter Marzio, my coach as an exhibit rookie, and David Shayt, whose wit and creative passion never failed to brighten my days at the museum. Both of them died much too young.

ABBREVIATIONS

A&I	Arts and Industries
ACS	American Chemical Society
AFA	Air Force Association
AHA	American Historical Association
AHR	*American Historical Review*
ANON	*A Nation of Nations*
ASEE	American Society for Engineering Education
ASME	American Society of Mechanical Engineering
CFA	Commission on Fine Arts
CRC	Conservation and Research Center
GOUS	*Growth of the United States*
HABS	Historic American Building Survey
HAMMS	Historic American Merchant Marine Survey
HOK	Hellmuth, Obata, and Kassabaum
HUAC	House Un-American Activities Committee
MHT	Museum of History and Technology

MNA	Museo Nacional de Antropología
NAFMAB	National Armed Forces Museum Advisory Board
NASA	National Aeronautics and Space Administration
NASM	National Air and Space Museum
NCFA	National Collection of Fine Arts
NMAA	National Museum of American Art
NMAAHC	National Museum of African American History and Culture
NMAH	National Museum of American History
NMAI	National Museum of the American Indian
NMHT	National Museum of History and Technology
NPS	National Park Service
OAH	Organization of American Historians
OMB	Office of Management and Budget
REDE	Research and Design Institute
SAL	*Science in American Life*
SBV	Smithsonian Business Ventures
SHA	Society for Historical Archaeology
SHOT	Society for the History of Technology
SIA	Society for Industrial Archeology
UNITE	Union of Needletrades, Industrial and Textile Employees
T&C	*Technology and Culture*
USAF	United States Air Force
WSJ	*Wall Street Journal*

WHO OWNS AMERICA'S PAST?

*The most remarkable trend of modern thought,
notwithstanding the effervescent boastfulness of the
nineteenth century, is an appreciation of the work
done by those who have gone before.*

—J. ELFRETH WATKINS, Smithsonian Curator of
Mechanical Technology, 1891

CHAPTER 1 ※ A Chain of Events Linking Past to Present

Today's Smithsonian Institution includes scientific bureaus stretching from Cambridge, Massachusetts, to Chesapeake Bay to Panama to Kitt Peak, Arizona, and in Washington, D.C., one can find dozens of botanists, zoologists, and geologists at work on the upper floors of the National Museum of Natural History, some with a view of the Mall, others looking out at the Department of Justice just across Constitution Avenue. All told, the Smithsonian boasts nine "international research centers," one of which, the Conservation Biology Institute in Front Royal, Virginia, is allied with the National Zoological Park on Connecticut Avenue and serves as the focus "for the Smithsonian's global effort to conserve species and train future generations of conservationists." Important though their efforts may be, these research centers are seldom in the public eye.[1] With much of the Smithsonian, however, visibility is essential.

The Smithsonian publishes monthly magazines, *Smithsonian* and *Air and Space / Smithsonian*, and a wealth of historical monographs, many on the marvels of human flight and space exploration—no historical topic that

concerns the institution engenders so much popular enthusiasm. It runs an affiliations program, through which it shares its 136 million artifacts with other museums, from the National Museum of Industrial History in Bethlehem, Pennsylvania, to the Buffalo Bill Historical Center in Cody, Wyoming (maybe Lyon's Pony Express Museum would be an affiliate, were it still around). It sponsors the Smithsonian Channel, a joint venture with Showtime, which "explores the history of our planet, life, and culture with 100 percent family-friendly programming." It produces blockbuster traveling exhibits such as *America's Smithsonian* and smaller ones such as *Earth from Space* and *Beyond Baseball: The Life of Roberto Clemente*. It generates a sprawling Internet presence, including "the first major museum to open on the Web before completing a physical structure," the National Museum of African American History and Culture, planned for a site just beyond the western end of the Mall, in the shadow of the Washington Monument. But the Smithsonian is best known for museums that actually line both sides of the Mall, stretching nearly a mile from the foot of Capitol Hill and spread beyond, even to New York City.

Some of these are art museums—the Hirshhorn, the Freer, and African Art and the Sackler in the Ripley Center—hushed places where decorum reigns. Some are hybrids of history and art, most notably the National Portrait Gallery, which shares the old Patent Office building on Judiciary Square with the American Art Museum, but also the Renwick, across Pennsylvania Avenue from the White House, and the Cooper-Hewitt National Design Museum, on 91st Street in Manhattan. Exhibits at the National Museum of the American Indian are utterly and purposefully unconventional, as is its building, clad in yellow sandstone as distinctive as the Castle's red sandstone. Then there are the National Museum of American History, the National Air and Space Museum, and the National Museum of Natural History, the latter best described as a hybrid of history and science.[2] These are the most popular museums, each with several million visitors annually. In none of them do hush and decorum reign, not in tourist season, anyway. They can be congested, noisy, even rowdy. Here it is that enthusiastic crowds come face to face with marvels of nature such as the Hope Diamond and with icons of immense evocative power: the oldest locomotive in America and the first airplane in the world; the *Spirit*

of St. Louis and the Star-Spangled Banner and Dorothy's ruby slippers from *The Wizard of Oz*; items associated with men and women who reside in the pantheon of history, technology, and pop culture. Crowds and noise notwithstanding, visitors are here to pay homage, just as they would do at Mount Vernon, Menlo Park, or even Universal Studios.

When Air and Space opened in 1976, it immediately captured the title of "world's most popular museum": on just one day, 87,000 people came through its doors, 9.6 million the first year. That has remained the norm since then, compared to about 6 million at Natural History and 4 or 5 million at American History, and visitation rarely fell significantly, not until September 11, 2001.

Other sites in the capital city were visited by millions, of course, but one thing that made the Smithsonian different was that its history museums could and did publicize ventures that, one way or another, stood to benefit. Surely if a present-day exhibit called *America on the Move* is even more prominently signposted as "The General Motors Hall of Transportation," some sort of benefit is likely to accrue to General Motors. Yet there was nothing new here, for exhibits of conveyances had never been free of commercial entanglements. The curator who accessioned the first steam-powered "road vehicle" (or one of the first, for such claims were often disputed) was also president of a Philadelphia firm organized to make such vehicles, the Moto-Cycle Manufacturing Co. And when the Museum of History and Technology opened in 1964, whole new realms of self-aggrandizement opened with it. In the new museum's petroleum exhibit, for instance, one could find a fifty-seven-foot mural painted by Delbert Jackson, staff artist for the Pan American Petroleum Company, with roughnecks wearing the faces of executives who financed the exhibit such as Jacob Blaustein, the founder of Amoco. (This was much like a Texas mural commemorating the Alamo, which "substituted the faces of Hollywood actors for those of the original heroes"—hence, Davy Crockett looked exactly like John Wayne.)[3] And speaking of petroleum, the Pontiac in the 150th-anniversary exhibit, *America's Smithsonian*, was more than Richard Petty's race car, it was a bold advertisement for STP, an "oil treatment" that had twice caught the attention of the Federal Trade Commission and precipitated fines for false advertising.

■

IF COMMERCIAL AMBIGUITIES WERE ALWAYS EVIDENT, so were complications broadly termed *political*. Both the Museum of History and Technology and the National Air Museum (Air and Space after 1966), evolved in the overarching context of the Cold War and were the product of a deeply felt need not just to celebrate American technological prowess and progress but to flaunt it. In the Smithsonian's early years, however, there had been no consensus that a museum was a good idea *at all*, in part because of concerns that a museum might be freighted with political dangers, well-founded concerns as it turned out. To begin, the government took a long time to decide what its English benefactor, a man who had never been to America, could actually have had in mind when he penned a bequest "unique in the annals of testaments."[4] He named a nephew as his primary legatee, but in the event of said nephew's death without an heir (as happened), James Smithson willed the equivalent of a half-million dollars "to the United States of America, to found at Washington, under the name of the Smithsonian Institution, an establishment for the increase and diffusion of knowledge among men." A lot of men had designs on this money (which amounted to a substantial fraction of the entire federal budget), and "the Smithsonian problem" was debated for years after President Andrew Jackson's special agent, Richard Rush, delivered the bequest, in the form of gold coin, to the United States Mint in Philadelphia.[5]

Finally, after more than a decade of debate and indecision, Congress passed a bill that provided for an institution comprising a laboratory, a library, and a repository for "all objects of art and of foreign and curious research, and all objects of natural history, plants, and geological and mineralogical specimens belonging or hereafter to belong to the United States." This institution would be located on the "Grand Avenue" envisioned by Pierre Charles L'Enfant that was being developed as "The Mall" by landscape architect Andrew Jackson Downing and in a building that emulated (incongruously, it seemed) a twelfth-century Norman castle. There would be a Board of Regents headed by the vice president of the United States, with the chief justice of the Supreme Court as an ex-officio member and also serving as "Chancellor of the Smithsonian Institution,"

three members of the Senate, three of the House of Representatives, and "nine citizens." The regents would choose and oversee a secretary, a title that implied the status of a cabinet officer, perhaps minister of culture.

Joseph Henry, the man they chose, had no interest in establishing a museum, not without funding from the public purse that would be kept separate from interest on the Smithson bequest, which he planned to shepherd carefully, especially after realizing how readily it could be frittered away. A professor at the College of New Jersey (Princeton), Henry was an accomplished natural philosopher (we would call him a physicist) whose understanding of electricity and magnetism was said to be on a par with that of the great Michael Faraday in England, and Henry sought to build a *scientific* institution of international stature.[6] The increase of knowledge through original research was far more central to his purposes than its diffusion, though that, too, would be taken care of through a vigorous publication program. But the Castle had a roomy look, and forces pushing him toward taking on a museum proved irresistible. In 1858, the commissioner of patents, pressed for space, managed to transfer custody of the "National Cabinet of Curiosities," including a cache of specimens collected by Charles Wilkes during his round-the-world expedition of 1838–42. For that, Congress appropriated $3,650 for the "National Museum of the United States," to be disbursed through the Department of the Interior. And therein lay the seeds of troublous times when the federal appropriation would become a weapon in the culture wars. To the end of his days, Henry warned that "the functions of the Institution and the Museum are entirely different," and he sought to keep the museum subordinate, perceiving that it might eventually define the Smithsonian more so than its scientific research and that the museum was "liable to be brought under direct political influence."[7]

Henry was to be proven entirely correct, though at first the museum was only, as he put it, an "elephant's foot." Henry's resistance to a museum diminished somewhat as Congress increased its appropriation (and he became more attuned to possibilities for acquiring valuable private collections), and he had his assistant Spencer F. Baird find space in the Castle for displaying specimens of botany, geology, and ethnology. Flotsam and jetsam this might be, but it would "both enlighten and amuse the public,

though not always in that order of priority."[8] The collections continued to grow as a result of Smithsonian-sponsored expeditions in the American West, notably John Wesley Powell's explorations of the Colorado River Plateau. Technological devices that accumulated were mostly instruments used in getting a measure of the land, along with Native American paraphernalia that adventurous men like Powell picked up, by one means or another, in the course of their fieldwork. Anomalous but significant was a large electromagnet dating to 1831 that Henry himself had devised while he was an instructor at the Albany Academy in New York, but a prized collection of scientific apparatus was lost in an 1865 fire, along with virtually all of James Smithson's papers and personal effects.

Henry never believed that the presence of the National Museum in the Castle marked an "eternal marriage." "He hoped, even assumed, that the arrangement was only temporary," that somehow there would be a separation enabling the Smithsonian "to do what it did best in nineteenth-century America, support scientific research." But that hope, that assumption, was "doomed by circumstance."[9] In 1876, the Smithsonian was designated as the final repository for artifacts exhibited by government departments and agencies at the Centennial Exposition in Philadelphia's Fairmount Park, among them the Interior Department, War Department, Navy Department, Coast Survey, Light House Board, Patent Office, and Fish Commission. The Smithsonian mounted its own half-acre exhibit. Then, when the exposition closed as scheduled, after six months, many states and territories donated what they had brought to display, as did more than thirty foreign nations, and in late 1876 a trainload of artifacts was left on a siding near the Washington City Canal, designated for the Castle.[10]

Actually, there were two trainloads, each of twenty-one cars. The first contained everything that had been sent up from Washington for government exhibits; the second, what had been left behind from other exhibits. The railroad cars were smaller than conventional merchandise cars, but they nevertheless held an enormous accumulation of stuff (remember the phrase "all objects of art and of foreign and curious research"), and it was "far beyond the storage capacity of the Smithsonian Building," said Baird, who would succeed Henry as secretary in May 1878.[11] Indeed, Baird had long foreseen the Centennial Exposition not only as "an opportunity to

illustrate the importance of the Smithsonian's activities to the American people and to Congress" but also as a chance "to formulate an argument that could persuade Congress to provide the Smithsonian with a new building to be used as a national museum."[12] And so it was that Congress voted funding to erect a new building on a site adjacent to the Castle, this in keeping with a tradition dating back to the South Kensington Museum (the forerunner of London's Science Museum) being founded with core collections from the Crystal Palace of 1851.

The Smithsonian's new building was in the form of a square, 327 feet to a side, and had neither a basement nor (ironically, in light of its later nickname) an attic, part of the reason for its stunningly low cost of $250,000. The architect, Adolph Cluss, provided a space for sculptural groupings over each of the four entrances, but only one was ever executed, above the north entrance, the one most used. It was named, prophetically, "Columbia Protecting Science and Industry." The National Museum's first event was President James Garfield's inauguration ball in 1881.[13] Its doors were opened to the public the next day, under the direction of George Brown Goode, a thirty-year-old protégé of Baird's who had set up the government displays at the Centennial. Although he was trained as an ichthyologist, like Baird, when it came to museology Goode thought beyond the stock and trade of the natural scientist: taxidermy, skeletal remains, fossils, plaster casts, pressed flora. In their full range, he regarded the newly arrived collections as a sterling opportunity for imparting information about the role of technology in society and culture. Indeed, Goode had a plan for establishing technology at the heart of a new Department of Arts and Industries and ultimately reorganizing the entire museum around "the requirements or luxuries of man."

Collections were initially classified under the headings of textile industries, graphic arts, naval architecture, foods, fisheries, animal products, materia medica, and "historical relics," with ceramics and steam transportation soon added. Goode proposed a new mode of displaying these collections. Rather than just taxonomy in the manner of natural history displays—arrangement on the basis of shared characteristics—they would be dispersed throughout exhibits that were (permitting an anachronism) contextual. The naturalist Ernest Ingersoll caught the flavor in the January 1885 issue

of *Century Magazine* when he remarked that "it is not too much to say that the Museum is to be a vast systematic collection of labels illustrated by specimens." To fill out the stories he had in mind, Goode believed that the collections should be much richer, that he needed everything from "archery apparatus" and "base ball bats" to "velocipedes" and "wall paper." So he sent out two men he called special agents to find "objects which it is desirable ... to obtain provided that no restrictions be made by the donors as to the manner of arrangement or their grouping in collective exhibits."[14]

The ideal of starting first with a story was out of step with the tenets of a new historical discipline that was in the thrall of Germanic inductivism: for any edifice, *first the bricks and then the structure*. Nor was it the way things would be done at the Smithsonian, either, for when Goode died at age forty-five, in 1896, so did his concept of contextual or "thematic" exhibits. Not until *Growth of the United States* and *A Nation of Nations* in the 1960s and 1970s would exhibits be organized as narratives, with artifacts used as "corroborative evidence" rather than the "primary focus."[15] Martin Harwit's plan for exhibiting the *Enola Gay* in the 1990s was, after all, not "about" the airplane at all but largely a story of military strategy, with the airplane a very dominating illustration.

After Goode's death, his Arts and Industries Department became an adjunct of the Department of Anthropology, or really just a "cumbersome stepchild." For years to come, the Smithsonian's historical exhibits would be driven by the content of collections assumed to be intrinsically interesting and by the assumption that artifacts "spoke for themselves" in the same way as archaeological finds (or great art); they required only dating and identification, not "context." This mode would wax and wane but never completely go away, even in our own time, as anyone can see who visits the Air and Space Museum's neo-traditional Steven F. Udvar-Hazy Center today, with its airplanes grouped by type but otherwise not contextualized.

■

UNTIL WORLD WAR I, the development of technological collections and exhibits fell to a handful of men called curators—five, usually—who had backgrounds as technical practitioners. Among the more noteworthy

was John Elfreth Watkins, a civil engineering graduate of Lafayette College in Pennsylvania who had lost his left leg in a construction accident. In a remarkable personnel action, he was "detailed" to the Smithsonian by his employer, the Pennsylvania Railroad, the world's largest business enterprise. The railroad then lobbied Congress to appropriate money to pay Watkins to perpetuate "the history of the birth and development of steam transportation . . . in America." Watkins kept close ties with the railroad, and it was through him that the Smithsonian acquired the *John Bull*, arguably its truest piece of the True Cross, or at least on a par with the Star-Spangled Banner. The *John Bull* had been imported from England in 1831—in wooden crates and needing assembly, like a kit—at the very dawn of the railway age, and it was still operable when Watkins put it on display in A&I sixty years later, before taking it to Chicago for the World's Columbian Exposition.[16]

Watkins was a taxonomist par excellence. As curator of mechanical technology, he sought to implement a plan for organizing technological devices into parallel rows—pumps, valve gear, governors, and so on—each representing an evolutionary sequence, primitive to modern, and exemplifying a march away from empiricism and toward an adherence to scientific principles. In the manner of the scientific history then being transplanted from German to American universities such as the Johns Hopkins University, Watkins would say he was establishing a factual record in appreciation of "work done by those who have gone before." With chronology usually the sole organizing principle, he hoped "to secure a series of objects to illustrate the birth and development" of much more than steam transportation. His concern was "the mechanic arts, with special reference to the evolution of epoch-making inventions."[17]

Exhibits depicting an incremental evolutionary sequence were, of course, an anthropological mainstay with stone implements and pottery. Such a sequence could also be illustrated with complex mechanisms—with the models submitted along with patent applications, say, of which the Smithsonian had acquired thousands dating from the establishment of the Patent Office in the 1830s until the requirement was dropped in 1880.[18] It might later seem obvious that any such display was freighted with ideology by whoever was rendering judgments about primitive and modern,

empirical and scientific, about *progress*. After the Museum of History and Technology and, especially, Air and Space opened, this would become a standard complaint among academic historians who viewed collections-driven exhibits as failing to convey meaning, or rather, in historian Matt Roth's sly phrase, "the right meaning."[19] If artifacts are lined up from left to right, particularly if they get bigger and more complex (or, sometimes, smaller and less complex), or if rough edges give way to smooth or they get more "gleam"—there are any number of possible signals—there is "meaning." When a new generation of curators began trying to get in step with academic concerns about meaning, it quickly became evident that there were profound disagreements about the right meaning, about the relationship of exhibits and the way they were designed to the idea of progress and to political and patriotic narratives.

■

WATKINS ENJOYED AN AMIABLE RELATIONSHIP with his colleague Otis T. Mason, a Spencerian ethnologist whose specialty was the evolution of technical practice in primitive cultures. "All Nature is clay in the hands of the potter," Mason wrote. "Men were placed on earth to dress and keep it, to possess and subdue it. Through this wonderful faculty of invention the race has fulfilled itself."[20] With Watkins and Mason sharing a fascination for *homo faber*, the interests of engineer and natural scientist proved complementary. But Watkins died in 1903, just when "the gap between ancient and modern technics widened into an unbridgeable chasm."[21] The automobile, the electric streetcar and subway, wireless communication, motion pictures, subaqueous tunnels, long-span suspension bridges, skyscrapers, and airplanes all seemed to mark a watershed separating modern and primitive, and Watkins's most influential successor, George Maynard, insisted on distinguishing his studies of "man the mechanic" from anthropological studies of "man the handicrafter."[22] There was some logic to this. Early in the twenty-first century, people had a sense that technological change was more rapid and pervasive than ever before in history, but this was not so. "Change came faster in the old days," as a *New York Times* essay

was headlined, and indeed change was never so rapid, in so many diverse realms, as it was early in the *twentieth* century.

Maynard had joined the Smithsonian as "Custodian of Electrical Collections." He had worked for the Bell Telephone Company installing the D.C. phone system and, before that, served as chief operator for Western Union in Washington and as a member of the military telegraph corps during the Civil War. As with Watkins, his connections enabled him to acquire significant technological artifacts, in this case phonograph devices from Emile Berliner and the experimental telephone prototypes of Alexander Graham Bell. Unlike Watkins and his steam-powered conveyances, however, Maynard did not get the Bell apparatus with no strings attached, and Bell's descendants continued to exert an influence on Smithsonian affairs, notably in the 1960s, after the Museum of History and Technology had opened, when they objected to the storyline for an exhibit on telephony— which, they thought, allotted Bell insufficient eminence—and threatened to take their objections "to the public and to Congress."[23]

This was the first episode to entail a serious threat of political reprisal (the full story follows in chapter 4). But it was far from the first such controversy in which the Smithsonian had become involved, nor was it the first involving the Bell family or the first in which disputes over interpretation appeared to have self-serving aspects. There were disagreements involving the telegraph and the airplane, as well as the telephone, the most "American" of inventions (in contrast to the railway or the automobile, whose overseas origins were rarely in dispute). In all three cases, the problem involved "credit where credit was due." While schoolbook history assigned credit for the telegraph solely to Samuel F. B. Morse, for example, several others deserved a share. One was Joseph Henry, whose science was electricity and magnetism. Another was Charles Grafton Page, who, like Morse, was a recipient of research-and-development funds from the public purse, in his case for "electromagnetism as a motive power." Yet another was Alfred Vail, a New Jersey iron manufacturer who built many of Morse's instruments and financed the model Morse used to demonstrate his invention when he filed for a patent in 1837. In early times, the telegraph was known as the Morse-Vail telegraph.[24] But in 1913, when Vail's younger

son James visited the Smithsonian, it appeared to him that "the National Museum was making a conscious effort to remove Alfred Vail from the artifactual record." This seems overwrought, for the exhibit was clearly labeled "Instruments Designed by Morse and Vail." Still, a portrait of Morse dominated the exhibit case; there was no portrait of Alfred Vail, and none of James Vail's several points of criticism were answered to his satisfaction by Maynard, least of all his contention that the way the exhibit was staged amounted to an interpretation and not a representation of fact.[25]

Something similar was true in the notorious controversy involving "the unofficial chief scientist of the United States," Samuel P. Langley, and his so-called aerodrome.[26] Langley had succeeded Baird as secretary of the Smithsonian from 1887 to 1906, and when his own successor, Charles D. Walcott, put the aerodrome on display, he labeled it as "the first man-made aeroplane in the history of the world capable of sustained free flight." This was patently untrue—the aerodrome had failed to take wing even after the War Department endowed Langley with an immense sum, $50,000, for research and development. The display so incensed the surviving Wright brother, Orville, that in 1926 he sent the Wright *Flyer* overseas to the Science Museum in London, where it remained until after World War II, when the Smithsonian officialdom revised its story. Yes, Langley had flown models, but he could not get the aerodrome to take wing; his pilot was lucky to have survived. What Walcott had done was privilege Langley's abstract design, his models, over the Wright brothers' tangible accomplishment, carrying a man into the air.[27] In the eyes of Orville Wright, this was unforgivable.

At issue was not so much the staging of the exhibit, as in the case of the telegraph, but the "power of the artifact's label." And labels were typically most powerful to people who read them in isolation and believed that they presented not just an identification but also an interpretation. To return to the *Enola Gay*, its great silvery fuselage was an immensely powerful artifact and might cast any disquisition that happened to be silk-screened nearby into a figurative, if not literal, shadow. But it was not powerful at all when represented only by a words-on-paper narrative, a text, a script that curators proposed using to construct its meaning.[28]

IN 1910, THREE YEARS AFTER WALCOTT BECAME SECRETARY, the building next door to the Castle was officially renamed Arts and Industries (A&I) after a new $3.5 million building was completed on the other side of the Mall; this facility initially was called the New National Museum but soon became just the Natural History Building or Museum of Natural History. Transferred to the building, and out from under A&I's sometimes leaky roof, were specimens in zoology, geology, paleontology, and ethnography, all the taxonomic sciences whose pursuit had been the Smithsonian's top priority ever since Joseph Henry first charted its course. In A&I, curators made space for elaborating both the technological and "historical" collections. (Evolutionary pretensions about the nature of invention notwithstanding, there was no indication to the public that *all* the collections might be considered historical—a mistake not to be rectified until the Museum of History *and* Technology was renamed in 1980.) But the "Old National Museum" was again getting congested by the time Maynard died in 1918.

Maynard's successor, Carl W. Mitman, had a BA in mining engineering from Lehigh University and a Princeton master's degree. Originally from Newberg, Pennsylvania, deep in anthracite country, he first came to work for the Smithsonian in the summer of 1911, helping with a survey of natural resources. Four years later, Walcott appointed him, at age twenty-five, as curator of mineral technology. In 1919, he became curator of mechanical technology as well, and soon he was head of a new Department of Mechanical and Mineral Technology.[29] Mitman was extraordinarily industrious. He wrote easily and published often. He had a flair for persuading curators in other departments that some part of their collections ought to be moved into his department—the anthropological holdings of fishing and whaling gear, for example, included harpoons galore. He also collected more and more "oversize" artifacts that could not possibly fit into exhibit cases. There was mining machinery, of course, but also automobiles and fire engines, even a French tank and a German howitzer from the World War. And airplanes, which seemed to fascinate visitors more than anything else, especially when they were suspended overhead from A&I's exposed beams and could be seen from unusual angles. Lacking the room to display all his

collections, Mitman was able to gain access to a metal building behind the Castle, erected in 1917 for testing Liberty aircraft engines. That purpose was temporary, but the building was not. Afterward, it was sometimes known as the Aircraft Building, more often as the "Tin Shed." It relieved the space crunch only briefly and soon was filled with planes and other War Department surplus.[30]

So, in 1920, here was a decidedly youngish curator appealing to Secretary Walcott and the Board of Regents to establish a museum of engineering on the order of the South Kensington Museum, the Conservatoire des Artes et Metiers in Paris, and particularly the Deutsches Museum in Munich, by consensus the finest technical museum anywhere. Mitman's plea would be repeated, sometimes in his exact words, by others for many years to come:

The commanding place in the world which the United States has reached in the short space of seventy-five years is due largely to the full development and utilization of mechanical power in the exploitation of her natural resources. It is this that has made it possible for the people of the United States to enjoy a standard of living far and above that under which the peoples of the rest of the world exist and still no sign of appreciation either national or otherwise is to be found anywhere. What more suitable monument could there be, therefore, than a Museum of Engineering, and where could there be found a more logical place for it than as part of the great National Museum?[31]

After it was broadcast more widely, Mitman's appeal was enthusiastically received by leaders of the engineering community, particularly by a New Yorker named Holbrook Fitz-John Porter, who proceeded to commission an architect and launch a fundraising campaign with claims that seemed overdone: "Germany's pre-war industrial supremacy was, in large part, due to the influence of her museums in fostering, inspiring inventive talent and offering vocational guidance to her youth and adult population."[32]

In a 1925 memo to the Smithsonian staff that Porter likely drafted, Secretary Walcott wrote that the success of a $10 million fundraising campaign would rest mainly on large corporate contributions, in particular "corporations for which the Smithsonian has performed some service or with which it has had other contact or which should on general grounds

support the things for which the Smithsonian stands." On a list of forty-some "organizations that have received assistance from the institution" (presumably by way of exhibits favorable to their image), several mining companies ranked high, highest being Consolidation Coal of Baltimore, whose $20,000 was matched only by General Motors. Among "individuals who should be given an opportunity to make subscriptions" were Samuel Vauclain of the Baldwin Locomotive Works; Washington, D.C., land developer Harry Wardman; and Glenn Curtiss and Donald Douglas, both of whom had donated airplanes, as had Billy Mitchell, commander of the U.S. Army's air combat units in France during the World War. Just as each of these men had provided support for "the things for which the Smithsonian stands," they would know that their Smithsonian connection provided support, intangible but significant, for their own interests.[33]

Porter proved to be a loose cannon, distressing and finally alienating Mitman while actually raising very little money, and soon he was rendered persona non grata. For the rest of his career, Mitman would seek effective, trustworthy allies in fulfilling his dream of an American version of the Deutsches Museum. Occasionally he may have felt optimistic, as when Charles G. Abbot succeeded Walcott as secretary in 1928. Here was a Massachusetts Institute of Technology graduate and a technological enthusiast who was keenly interested in devices for measuring solar radiation and had helped Robert Goddard with his rocket experiments during the war. Surely he would be an enthusiast for a new museum. Abbot indeed urged the necessity of "providing a commodious building suitable to include exhibits of transportation, engineering and industry adequate to present the historical and present development of these arts in the United States," but the institution suffered severe budget cuts during the 1930s, and any "commodious building" was out of the question.

Yet Mitman never gave up. He got his department renamed Engineering and Industries to help ease the way toward the museum he had in mind, and in June 1941 he prepared notes for an appeal to Congress by Secretary Abbot: "We speak and write books about our great American scientists, engineers, inventors, and industrialists and of their noble contributions . . . Such acknowledgment, however, is not enough. Our gratitude and appreciation ought to be expressed in a more permanent manner as can

be done through the medium of a live, dynamic museum of engineering and industry."³⁴ June 1941 was too late, of course; much of the world was at war, and there would be no more talk about a new museum. Indeed, funding would not be authorized by Congress until thirty-five years after Mitman first began pursuing this dream, and he died just before ground was broken for the Museum of History and Technology. Winning support in the 1950s was the direct consequence of political anxieties of a sort that would have been foreign to Mitman, anxieties arising in the shadows of the Cold War.

Mitman did leave a significant legacy, however, an unflagging dedication that fired the spirits of younger colleagues, including a dedication to published scholarship that was rarely present among his predecessors but more common in successors and eventually a cornerstone of curatorial job descriptions. Mitman wrote for magazines like *Popular Mechanics*, but most notably he wrote more than three hundred biographies of engineers and inventors for the *Dictionary of American Biography* (*DAB*), a publication project of Charles Scribner's Sons in the 1930s that is still a valuable reference today. (And one wishes for a biography of Mitman as thorough and detailed as those he wrote for the *DAB*.)

It was Mitman, too, who was assigned responsibility for the Air Museum in 1946, after Congress authorized it in response to a proposal by General H. H. "Hap" Arnold, who arranged to save examples of planes that had flown under his command. The authorization was not accompanied by an appropriation for a new building, however, so Mitman had to make do with a toehold in A&I and with the Tin Shed, refurbished considerably but never concealing its lineage as a building intended to be temporary. He acquired the *Flyer* after Orville Wright felt confident that the Smithsonian's story of flight would be rewritten, and he continued to build up the collections in anticipation of eventual funding (an assemblage known as "Rocket Row" came to dominate the open space beside A&I). But that would take many years to materialize. Indeed, it would require the leverage of a one-time Republican presidential candidate, Senator (and Major General) Barry Goldwater, in the wake of the Apollo moon landing, so inspirational to the public at large. "With this momentous event," said Goldwater, "the time is at hand when the American people want to have a

decent home for the national museum where their country's exciting story in air and space can be told." But it would take even more than Goldwater's speeches; it would take a national hero, astronaut Michael Collins, pilot of the Apollo 11 command module, signing on as director.

The Air Museum was renamed in 1966, and when it opened as Air and Space in a brand new building ten years later, the imprint it bore from Mitman was still evident. While gathering technological collections from elsewhere in the Smithsonian and building on the efforts of Watkins and Maynard, Mitman had linked the Smithsonian to a credo of technological progress, and nowhere were the exhibits aimed at affirming this credo more than at the National Air and Space Museum (NASM). The history of aeronautics and space flight was shot through with unanticipated consequences, with failure and calamity, but this was rarely, if ever, evident at NASM, where the sleek form and the polished-aluminum gleam of the newer artifacts bespoke the march of progress—indeed, the laws of progress. Unlike History and Technology, with its collections of "materia medica" and "mining products" along with the *John Bull*, George Washington's relics, and the Star-Spangled Banner—exhibits that mixed treasure and dross—the technological and historical significance of so much at Air and Space seemed obvious. What was exhibited there seemed so *exciting*, not least the opportunity to get right up close to flying machines that had made history (even to touch them, if a guard wasn't looking), much of it within human memory.

In an essay published in *Technology and Culture* a few years after the museum opened, historian Michal McMahon called NASM "largely a giant advertisement for air and space technology."[35] This was exactly true, but there was no denying the excitement. In establishing the Smithsonian's new technological museums, History and Technology in 1964 and then Air and Space in 1976, the men who set the course would rarely deviate from Mitman's progressivist ideology, particularly not at Air and Space (which McMahon referred to as the most exciting experience at "Smithsonian Park") because they could see no need for it. While an imperious scholar like Charles Blitzer might hate the idea of glorifying "gleaming machines," others responded to what was displayed at NASM as if to a devotional experience. Yet, as time passed, NASM curators were being influenced

by—and some were beginning to help shape—a new historiography more attentive to contingency, to the circumstances that contribute to the "messy complexity" of historical causation, and to the question that could always be asked about technological progress: *Progress for whom?* Not that it makes technology any less worthy of study—quite the opposite—but, almost always, as some gain, others lose.

It would not be long before accusations of "indoctrination and manipulation" were being levied, not because of NASM's conflation of excitement, romance, and progress (which was McMahon's complaint), but because of narratives in which aircraft were merely props, not objects of worship, and later because of "countercultural" scripting, attention to the dark side. That turnabout, with smoldering tinder bursting into the full flame of warfare over the ownership of history, is addressed later in this book. But there is one thing about Mitman that bears repeating here. Besides his appreciation for the "noble contributions" of engineers and inventors, his progressivist ideology, he also appreciated the demands of good scholarship, as a reading of any of his three hundred entries in the *DAB* will readily confirm. This too would become a legacy. That legacy would be imparted to a succeeding Smithsonian generation by Frank Taylor, a Washingtonian who became Mitman's protégé in the 1920s. Taylor was a man of strong ideals and earnest purpose who would be essential to securing authorization for the Museum of History and Technology in the 1950s and who would then—in concert with a strange bedfellow, an Iowan who was a University of California PhD in the history of medieval science—set it on a course in which historical scholarship would matter a great deal.

The exhibition work consisted pretty largely of putting an object on a shelf in the case and putting a label by it to tell what it was.

—FRANK TAYLOR, 1974

I could not believe I had spent a full year in a small town doing exhibits that were just a hundred, a thousand times, superior to the exhibits being done at the United States National Museum.

—BENJAMIN LAWLESS, 1977

CHAPTER 2 ▪ Modernization

Frank Taylor was born on Capitol Hill in 1903. His father, Augustus, was a pharmacist and his cousin Ernest made and sold "astronomical and geodetical instruments," specializing in heliostats, devices that enable illuminating and photographing objects through a microscope. This environment sparked young Frank's interest in technology, and his parents sent him to Washington's new McKinley Technical Manual School, which had opened the same year he was born, when the city's population was about 280,000. Frank took a fancy to chemistry, and after graduating he set up a photo-finishing shop in the basement of his father's drug store at Second Street and Maryland Avenue NE, perhaps counting on referrals from Ernest. But business was slow, and in the spring of 1922 Frank rode his bike down to Arts and Industries in response to Carl Mitman's want ad for a "lab apprentice." Mitman had begun conferring with Holbrook Fitz-John Porter in what Art Molella calls "a spirit of hopeful conspiracy,"

but he took time to interview young Frank and confirm that he had passed his civil service exam, and then he gave him a job.

Lab apprentice? Long after, Frank recalled that there wasn't much having to do with chemistry, but there was plenty to do "repairing artifacts." He could be kept busy just with patent models, many of which had been damaged when they were crated to move from the Patent Office before the Civil War. Frank took his lunch breaks in the company of the *John Bull* or the automobiles and airplanes Mitman had begun to collect or the "Patent Metalic Life-Car," which, according to legend, had been instrumental in rescuing two hundred men and women from the immigrant ship *Ayrshire* when it was driven aground off Squan Beach, New Jersey, on January 12, 1850. Frank quickly realized how hit-and-miss the technological collections still were, despite the forays of George Brown Goode's special agents and the best efforts of J. Elfreth Watkins and George Maynard before Mitman. Still, there was an appreciable number of smaller items, the kind that could be arrayed in glass cases: patent models, scientific instruments like heliostats, small arms, surgical tools and medical potions, cameras and photographic apparatus (there had been an entire building at the Centennial Exposition dedicated to photography). Among the first donations after the National Museum opened were lithographic stones, zinc plates, tools, and colorants, as well as prints from Boston's Prang & Co. as well as from other lithographic firms. And ship models! Fully rigged models and builders' half-hulls by the hundreds. One of Taylor's first assignments was to help a young student at the Webb Institute of Naval Architecture measure half-hulls; this was Howard Chapelle, who, years later, would gain repute as the Smithsonian's eminent maritime historian.[1]

Finally, there were the "historical relics," foremost being those associated with George Washington, ranging from armchairs to a sword to a zither—a substantial catalog had been published a few years before Taylor arrived.[2] Almost as highly prized as Washington's relics (though awkwardly displayed) was the flag that inspired the national anthem, the Star-Spangled Banner—acquired from a descendant of Fort McHenry's commanding officer. And there were the beginnings of what would become one of the Smithsonian's prime attractions, *Costumes of the Mistresses of the White House*. The first of these had been donated by First Lady Helen Taft

in the last year of her husband's presidency, 1912. Several more followed, including gowns worn at presidential inaugurals. Their display was attended by two volunteers, Rose Gouverneur Hoes, great-granddaughter of President James Monroe, and Cassie Mason Myers Julian-James, "a wealthy Washington dowager." The reason the gowns were popular "eluded many senior museum officials."[3]

Research was prized throughout the Smithsonian, so there was a decent library, Mitman's doing. But the displays seemed dowdy and confusing. Said Taylor, "It looked as though nobody had paid any attention to arrangement or organization or anything else."[4] Photos of A&I in the early twentieth century show Aleut canoes cheek-by-jowl with elegant models of North Atlantic liners, Civil War field artillery intermixed with Japanese figurines and arrayed around the towering plaster model of "Freedom," sculptor Thomas Crawford's statue placed atop the dome of the U.S. Capitol in 1863. Never well funded, the "Old National Museum" had fallen into even deeper financial woe following completion of the Natural History Building on the other side of the Mall just before the World War. Scientists "over there" had all they needed to pursue their work, it seemed, but for the Department of Mechanical and Mineral Technology "there was practically no budget, no money or equipment or supplies." Taylor recalled that "nobody had a very high regard for what we were doing because we weren't scientists and didn't have our graduate degrees." People around A&I would say to one another, "We're in business for ourselves," meaning that little was to be expected in the way of support from the scientists (whose numbers always included the secretary himself, the official in charge of everything), who focused on what they regarded as the institution's primary mission of collecting, studying, classifying, and publishing information on natural history and ethnographical specimens.

■

TO JUMP AHEAD FOR A MOMENT: in 1954, after Taylor had been at the Smithsonian for more than thirty years, and it looked like the new museum of engineering and industry was actually going to materialize, he hired a man with a rich and unique background. The new employee had a BS in chemi-

cal technology from Iowa State University and had worked as a chemical engineer for Hercules Powder and U.S. Rubber; he had served in the navy as a shipboard engineering officer from 1943 to 1946, then spent three years in the occupation army of Japan, helping rebuild the chemical industry; and he had earned graduate credentials in history, very good ones—an MA and a doctorate from the University of California. This was Robert P. Multhauf, who, at age thirty-five, was wise as well as industrious, and he moved up quickly. When he became director of the museum in the late 1960s, Multhauf observed that "people here are like people everywhere else and some of them get ten times as much done as others do, and the ones who get very little done can be predictably expected to talk about burdens of one kind or another."[5] This observation had wide, if not universal, applicability. Frank Taylor was definitely a "ten times as much" person.

While moving through the ranks in Mechanical and Mineral Technology in the 1920s and 1930s, under the guidance of Mitman, Taylor visited many other museums in the United States and abroad, earned a mechanical engineering degree from the Massachusetts Institute of Technology, and then obtained a Georgetown University law degree, specializing in patent law. The higher degrees gained him respect among the scientists, although these men were always fussy about formal credentials and with Taylor it was still "mister," not "doctor." The well-read Mitman taught him about the history of technology, about engineering and industry, and even passed along a few of his assignments for the *Dictionary of American Biography*. Later, Taylor published a 202-page *Catalog of the Mechanical Collections*, in which he said he tried to convey "a thematic sense of what the museum was collecting and studying"—that term, *thematic*, would very slowly work its way into discussions of collections and exhibits.[6]

Taylor learned every facet of the museum business, from model-making to writing "intelligible exhibition stories" in twenty-five- and fifty-word snippets, a skill for which he sought to make the rewards more commensurate with those for published articles. In league with Mitman and a handful of allies among the ethnologists in Natural History, he pushed the idea that the Smithsonian should pay more attention to material culture, to the tangible legacy of *homo faber*, and indeed that material culture was a more fruitful area of study than "simple natural history." But Taylor always was

beset by apprehensions that almost nobody in the institutional hierarchy "had an idea . . . of what a historical museum might be," nor did anyone believe that exhibit work should "count" very highly on a professional resume. This would remain an issue for most of the twentieth century, with the archived correspondence full of pleas for justly rewarding efforts in "communicating ideas with objects" as well as putting words on paper.

■

IN 1931, TAYLOR GOT A JOB OFFER from Catholic University, where he had been teaching night classes in engineering, and, at age twenty-eight, he had to make a career choice. He chose the Smithsonian. Much later he recalled that this was partly because the institution offered "the interesting opportunity to work towards the establishment of a national museum of engineering, with a good chance of seeing it materialize during my lifetime," perhaps forgetting how elusive this prospect had seemed for so long. The museum would not actually materialize until Taylor was in his sixties, essential leverage being provided by new postwar geopolitics, the Cold War, and by a secretary, Leonard Carmichael, a Harvard PhD in psychology, who not only shared in the dream but also was skilled at political maneuvers from his years as president of Tufts University. Still, it was the groundwork of three decades, the efforts of Taylor and Mitman, that afforded a necessary, if not sufficient, cause by turning the Smithsonian into a household word.

For seven years, Taylor and colleagues had built that familiarity through a weekly NBC radio program called *The World Is Yours*, a Works Progress Administration project that often dramatized episodes in the history of invention and engineering. Beginning in 1936, Taylor wrote scripts aimed at explaining how there was "never a single inventor, that each man builds on the experience of the people before him." This had not been a common perception among a generation schooled in the belief that Edison invented the light bulb and Bell the telephone, all by themselves. (Some even believed that Henry Ford had invented the automobile.) But *The World Is Yours* comported with new sensibilities among those who wrote and read popular history (this was the classic age of the "debunking" biography)

and, even more importantly, among the community of historians coming under the influence of the "relativistic" Charles Beard and Carl Becker, who took more account of social forces, of "ambience," than they did of great men and individual genius.

Taylor remarked that *The World Is Yours*, which aired on Sundays between 4:00 and 4:30 in the afternoon, "had a great deal to do with making the Smithsonian a target for tourism . . . for visits to Washington. People would start thinking about the institution by telling a joke . . . 'That's old enough to be in the Smithsonian.'" But despite the increased visibility afforded the history of invention and engineering, most of the institution's budget still went into projects being pursued in the Natural History Building. This immense structure, which stretched for hundreds of feet along the Mall and was only in small part open to the public, was the heart of the institution's program of collection and classification. Upstairs corridors were stacked high with storage units full of specimens awaiting study by the scientific staff, most of whom never had anything to do with "diffusing" knowledge in the exhibit halls (which rarely changed in any event). They would have balked if asked to do so.[7] In popular sensibility, however, the Smithsonian came to be associated less with fossils and feathers than with the technological devices in A&I, especially after Charles Lindbergh donated the *Spirit of St. Louis*. A crowd larger than ever before gathered in A&I on the day the famed airplane arrived, May 13, 1928, and from then on, said Taylor, "If you got into a cab and asked to be taken to the Smithsonian, you were taken to the A&I Building."

By the 1930s, airplanes had acquired a reputation as the institution's most attractive and exciting historic artifacts. The collection was built by Paul G. Garber, a man described by two of his heirs at the National Air and Space Museum as "a personable dynamo" who "collected and preserved America's priceless aeronautical treasures for future generations to enjoy." Garber had gone to work for Mitman two years before Taylor did, and he quickly proved himself in many ways, not least in building a model of Leonardo da Vinci's "ornithopter," a human-powered flying machine, which attracted the attention of Secretary Walcott himself.[8] The diminutive Garber often worked side by side with Taylor during the 1920s, and in 1931 Mitman put him in charge of a new Section of Aeronautics

that was separate from Taylor's Section of Mechanical Technology, soon to be renamed the Division of Engineering when Mitman became head curator of A&I. Garber loved airplanes. He was a passionate devotee of "the winged gospel" and was ultimately responsible for collecting more than half of the 350 planes in the Smithsonian's possession by the 1990s. Taylor collected too, but his driving ambitions lay elsewhere; he wanted to see his Division of Engineering become something much, much more than a "bootstrap operation." He wanted to make people understand that the taxonomic work done in Natural History was "like putting stamps in a stamp album," whereas his own cohort was involved in a significant enterprise in "synthetic history, looking at the effects of invention and technology on society."

In 1939, a new Department of Engineering and Industries emerged on the organizational chart as a result of efforts by Taylor and Mitman, but they were no closer to realizing their dreams for a new *museum* of engineering and industry. Indeed, the Smithsonian's annual report for 1940 included a confession that there were barely enough funds to meet the payroll. During the war, national treasures like the *Spirit of St. Louis* and the Washington relics were sent away for safekeeping in a stone building near the headquarters of Shenandoah National Park, fifty miles west of the city. Even with star attractions missing and only a shadowy budget, Mitman kept A&I open as "part of an effort to stimulate patriotism." Taylor saw service in the Philippines and was discharged as a major in 1945. When he returned to Washington, he was probably not surprised to see that A&I "looked a little more shabby" than it had before he went away. Yes, the collections were continuing to grow; "men of industry," especially if nearing retirement, always seemed to be turning up things "old enough to be in the Smithsonian." What was hard to come by was custom-made "furniture" of the sort essential to protecting things on display, usually behind glass, while also showing them to best advantage.

The Philadelphia Electric Company, for example, had donated a cross-sectional model of the Conowingo hydroelectric generating station on the Susquehanna River, the second most powerful in the country, topped only by Niagara Falls. Mitman and Taylor were pleased, naturally, but the model was too elaborate and fragile to leave within reach. What it required was

a display case almost as big as a house, which devoured a significant portion of a year's discretionary budget for the Department of Engineering and Industries.[9] Scientists begrudged the money for exhibitions because they competed with funds for fieldwork and their never-ending chores in taxonomy. So, even as technological collections were growing richer—indeed, *because* they were growing richer—A&I looked more and more disorderly; as the *Washington Star* put it, "splendid silver tureens" were crowded by "old black machinery." Or, in Hendrik Willem van Loon's phrase, A&I was becoming "the sort of museum where there was so much that one saw nothing at all."[10]

■

AFTER THE WAR, when Secretary Alexander Wetmore reassigned Mitman to the task of planning for the new National Air Museum, they both assumed (incorrectly) that General H. H. "Hap" Arnold could make sure that funding would follow authorization. Mitman told Garber to get as many planes as possible on display in the Tin Shed and A&I, but he needed to find temporary storage for dozens of others. Now in charge of A&I, Taylor had to confront a vicious circle. Exhibits looked disorderly because everything had to be crammed into limited space, like an attic. Items that were just being stored were often interspersed, seemingly at random, with exhibits intended for public viewing. Curators might understand "open storage" mixed with exhibits, but ordinary visitors didn't. Not only was more room needed elsewhere for storage, but the exhibits themselves desperately needed "modernizing," in an expression that soon became common currency.

But Secretary Wetmore was not enthusiastic about diverting funds from the institution's scientific mission, defined a hundred years past by Joseph Henry, and Taylor knew that getting any budget at all for modernizing would require evidence that he could spend it to good advantage. A few museums—notably New York's Metropolitan Museum of Art, in its American Wing—had been pursuing new forms of display, such as the "period room," which put treasured artifacts in ambient surroundings, a technique derived from the diorama, which came to define exhibitry in

natural history.[11] Taylor needed to foster confidence that his people had the imagination to think beyond the disarray of an attic.

In 1946 Taylor took his dilemma to a public forum, a daring move and very likely not appreciated in the Castle. (The internal workings of the institution had almost never been aired this way, though Taylor would live to see the day when they would get aired far too often.) The A&I collections, he explained in an article for the *Scientific Monthly*, covered "almost the entire scope of engineering, the physical sciences, agriculture, and industry." No other U.S. museum had collections anywhere near as comprehensive, and yet those collections were nowhere near being "adequately served by the present facilities." Taylor foresaw a new building with spacious exhibit halls, parallel "reference galleries," and adjacent workshops staffed by attendants who would "assist inquirers in the use of the collections."[12] These attendants, "when not otherwise employed," would repair damaged artifacts, precisely the job Taylor had first been assigned a quarter-century before.

The second phase of Taylor's strategy was to enlist support among administrators in the Castle and at least a few men across the Mall in Natural History, probably in the Division of Ethnology. He began by compiling evidence of how arduous it was to get even the most modest new technological exhibit—his example was a few typewriters—through budgeting, procurement, and production. Then he proposed a plan for streamlining procedures and upgrading certain exhibits, to show on a small scale what could be feasible on a grander scale if given the funds—that being, ultimately, a new building. Knowing that Wetmore was interested in reforming the institution's antique budgetary practices and had hired two administrative specialists, John Graf and John Keddy—the first men in the Smithsonian hierarchy who were not scientists—Taylor hoped these newcomers might be persuaded to pay attention to the exhibits.

When he called all his A&I staff together, Taylor was not impressed by their energy and brainpower, not that of the old-timers anyway, men whom Multhauf would characterize as "hacks" when he came on board. But Taylor needed grassroots advice about modernization, and there were four people on whom he came to rely. Two of them were young women: Grace Rogers, the twenty-five-year-old curator of textiles and textile machinery

(who ultimately would come up with the name, Museum of History and Technology), and Margaret Brown, twenty-seven, who had been hired during the war when she was fresh out of the University of Maryland and who never lost her amazement that "the old men" in the Division of Civil History "tossed" her "the most popular exhibit in the museum," the gowns of the presidents' wives.[13] Then, there were two men, both regarded as mavericks and both young also, though not quite as young as Rogers and Brown. Mendel Peterson, a Civil History colleague of Brown's with a master's degree in English from Vanderbilt University, began deep-sea diving while stationed in the Philippines as a navy paymaster and would ultimately earn the sobriquet of "father of underwater archaeology." Jacob Kainen, a painter who was among the founders of abstract expressionism, had been hired by the Smithsonian because of his skill with printmaking technologies such as drypoint and aquatint and was now in charge of the extensive collections in graphic arts. Of all the curators, Taylor said, Kainen was "the quickest man to produce something when asked."[14]

Taylor knew he had to look beyond his quartet of A&I allies, however, and he was well aware that Mitman had never managed to engender much sympathy in the Castle or in Natural History. Both men had persistence; Mitman had proved that when talking other curators into "consolidating" their artifacts with his own engineering collections. But Taylor had tact, dignity, and presence on top of persistence, and he was able to persuade Wetmore and his administrators, Keddy and Graf, to let him chair a formal study. Why was it that exhibits were on a "downward" trend throughout the institution—downward "if measured only by elementary standards of legibility and housekeeping" and "when measured against rapidly improving modern techniques in all manner of presentation . . . steeply downward and accelerating?" Why were the few exhibits that were "adequate" so obviously offset "by others that are pitiable?"[15] The plan was for Taylor to head a subcommittee with three allies he had enlisted from Natural History, their aim being to modernize exhibits "of the greatest public interest and educational effectiveness."

Serving as Taylor's deputy was John C. Ewers, a Plains Indian specialist, who, like many ethnologists, was "more interested in the public museum side than other members of the traditional natural history museum" (and

who, quite early, Taylor began to imagine had the right stuff to be director of a new museum). Taylor also enlisted Herbert Friedman, an ornithologist like Wetmore, who was concerned about developing "the public museum side," and Paul Gardner, who had previously been employed as a designer at the Corning Glass Works in New York and was now in charge of the National Collection of Fine Arts (NCFA), a Smithsonian appendage in the Natural History Building.[16] After conferring at length and visiting other museums, Taylor and his colleagues submitted a proposal for reinstalling or modernizing (the terms were taken as synonymous) several exhibits in Natural History and one in A&I, chosen on the advice of Rogers, Peterson, Kainen, and Brown. It would be Brown's display of gowns. By now, everyone was becoming aware that except for these gowns and a dollhouse meticulously furnished by a retired librarian from Chevy Chase, there was not much on display in A&I with any traditional appeal to women. You could spend days and never see a woman enthralled by ship models or steam engines or even the remarkable collection of historic sewing machines, about which Grace Rogers would later publish a classic of hardware history.[17]

At Corning, Paul Gardner had been a designer of chic Steuben art glass, but the Smithsonian had never had anyone called an "exhibit designer," a fledgling occupation whose practitioners found work largely as department-store window dressers and with trade shows. In the museum world, the assumption had been that the curators of collections would take care of exhibiting them, a task assumed to require no special expertise or imagination. But even as the world's fairs of the 1930s had enhanced popular appreciation of a dramatic new aesthetic, what was displayed in almost any technological or historical museum was increasingly stereotyped as dull except to peculiar sorts of "buffs." Philip Ritterbush wrote of "fossilizing" exhibits that resembled "sediments on the sea floor" and were "of concern to a few bottom-dwellers sifting through [them] for their private amusement."[18] Poor lighting, indistinct labeling, overcrowding, and a prevalent "dustiness" seemed to be the norm at the U.S. National Museum.

But the time was right for change, and Taylor was a man—said another who knew him well—whose "heart and soul and entire life were devoted to the Smithsonian . . . and to the U.S. National Museum in particular"

and who never failed to impress anyone who met him with his dedication and presence.[19] The temper of the early Cold War years made the idea of a new museum seem important to people with their hands on the levers of political power. "What is needed in America today is a new appreciation and understanding of our American heritage and its advantages over the ways of totalitarianism and dictatorship," proclaimed the first issue of *American Heritage*, a richly designed hardcover periodical published by the American Association of State and Local History.[20]

At the Smithsonian, even though visitation was growing steadily, with annual numbers by mid-century well past 3 million—more than half of whom went to A&I—it was clear even to Secretary Wetmore that there ought to be higher standards for exhibitions than in the nation's four thousand other museums. Many of these were like the Pony Express Museum in California, "homespun," to put it in kindly terms. One task of the modernization committee was to select the "worst exhibition" in each of the Smithsonian's departments; there were a great many that "pressed for the distinction." The worst in the Department of Engineering and Industries, reported Taylor, looked "as though it was installed by someone who was looking away and possibly carrying on a conversation while putting the objects on the shelves." After seeing this report, Wetmore promised Taylor $150,000 to begin modernization, *if* this could be accomplished without resort to "glaring colors" and *if* there could be no "large expansion [in the number] of regular employees." "Glaring colors" were a sore point because the Department of Ethnology's Clifford Evans and his wife, Betty Meggers, had redone part of the South American Indian exhibit and painted the inside of display cases red.[21] Wetmore was shocked. But Taylor did persuade the secretary that he needed more people on the payroll, at least in temporary appointments, and got him to agree to the establishment of a design office separate from the curatorial staff.

■

THERE ALREADY WERE MEN AT THE SMITHSONIAN called "exhibit workers," or "preparators," skilled in various arts and crafts such as model-making and taxidermy, but often they were illustrators. Outstanding among their

current ranks was John Anglim, who had studied at the Chicago Academy of Fine Arts, then was employed briefly at the Smithsonian's Bureau of American Ethnology before joining the Office of Strategic Services in 1943. After the war he freelanced for several years and worked for the Army Map Service before returning to the Smithsonian in 1949. He had been involved with Evans and Meggers, and now with Ewers in redoing the North American Indian exhibit.[22] Taylor devised a new job description for Anglim—exhibits specialist—and then he became chief exhibits specialist after hiring an assistant, a young man just old enough to have taken part in the allied invasion of Europe and who had then gone to school on the GI Bill and earned a nice credential, a Master of Fine Arts degree from the University of Illinois. Benjamin Lawless had been working at a newly established museum in Saginaw, Michigan, teaching art but also helping a director who was fond of staging exhibits, and not only of art. It was in Saginaw, Lawless recalled, he realized that "I liked exhibitry more than I liked to teach art." One day in 1952 he was visiting his mother and father, who had moved to Washington from Chicago in the 1940s, and he decided to see how things were being done at the Smithsonian. Before, he had mostly looked at airplanes in the Tin Shed. Now, he went to A&I. What he saw there, he later remarked, "seemed to me to be the worst exhibition of things I had ever seen in my life."[23]

Nobody who knows Ben Lawless would deny that he was ever shy about exaggerating a point for emphasis. (Disturbed about the rough treatment of artifacts at Suitland, the Smithsonian's storage facility in Maryland, for example, he told a story of how Mitman had once acquired the world's largest chunk of anthracite, but due to an accident involving a forklift, the institution's holdings now included the third, fourth, and fifth largest.) Still, his assessment of A&I was not far from that of Leonard Carmichael, a seasoned academician with appointments at Brown, Princeton, and Rochester before becoming president of Tufts. In 1952 Secretary Wetmore resigned, partly because he was nearly sixty-seven and had an unfinished research and publication agenda and partly because he could see a coming shift in the Smithsonian's priorities, a shift away from the mission Joseph Henry had defined, which he did not welcome but knew he could not deter. The regents had offered Carmichael the job, and he was considering

but came close to declining because—as Taylor put it—when he inspected the exhibits they "looked so bad." He did accept, though, and he arrived in Washington at the same time as Lawless was hired and told to report to Margaret Brown, whose *Gowns of the First Ladies* was to be A&I's flagship in the exhibits modernization program, a decision Carmichael affirmed as soon as he took office and got his bearings.

Not least of Lawless's virtues was his familiarly with the work of Charles Eames and others who had been featured in 1950 in the Museum of Modern Art's "Good Design" series. Because Lawless had been in Michigan, Taylor and Ewers knew he was familiar with Cranbrook, the academy of art and design Eliel Saarinen had brought to life near Detroit and where Eames had taught in the mid-1930s. That familiarity was to serve Lawless well when he went on to subsequent phases in the modernization program that were funded more generously—$469,500 in 1954, including $102,600 for redoing the display of power machinery in concert with Robert Multhauf—and then to planning exhibits by the dozens for the aborning Museum of History and Technology, where he and Multhauf would occupy key administrative positions.

Taylor hired Multhauf in 1954 as curator of engineering and then quickly made him chairman of the new Department of Science and Technology, with the responsibility for recruiting new curators; there would be nearly a dozen for the department in the next few years. Taylor gave similar levels of responsibility to Philip Bishop, a Yale PhD in economic history, appointing him chairman of the Department of Arts and Manufactures, and to Richard H. Howland, a Johns Hopkins PhD in classical archaeology, who took up the chairmanship of the Department of Civil History. With their advanced degrees (and Multhauf with his from Berkeley), these were men of a sort who had never been seen in Smithsonian precincts. There was one other chairman, old-timer Mendel Peterson, now with the new Department of Armed Forces History. Armed Forces History remained a small unit, but Multhauf, Bishop, and Howland all had hired substantial new curatorial contingents for their departments by the time the new museum opened in 1964.

Another whole tier of men and women, nearly all of them from outside as well, were taking new roles at the Smithsonian. They considered

themselves professionals just as the curators did, for they were "people who knew how to draw, who knew about color and design and lighting."[24] They thought of themselves not as specialists in material culture or the history of technology, certainly not as scholars, but as artists. *Design*, a term theretofore heard in conjunction with furniture (as with Eames), with architecture (as with Saarinen), with automobiles and interiors and show windows, would become a Smithsonian commonplace. In a bemused tone many years later, Taylor recalled a turn of events that "sort of surprised, and in some cases, shocked old-line curators": designers often regarded themselves as every bit as entitled to "a prestigious status in the Smithsonian." Lawless had a story of a new designer telling Taylor about a curator who brushed him off by saying, "working with you artistic types is not in my job description":

> Taylor jammed on his fedora (not a good sign) and walked over to this fellow's office, followed by Jack Anglim and myself. He asked to see his job description, looked it over, and then asked the curator why he wouldn't do the work. When he heard the same thing about it "not being in my job description," Taylor re-wrote the description on the spot, handed it back, and said, "Now it is." That got around.[25]

Multhauf believed that the Museum of History and Technology fostered no more important an innovation than its independent design staff, artists capable of distilling exhibits from a "wilderness of fact and ideology."[26] By the early 1960s, that staff, with its helpmate (and sometime apprentice program), exhibits production, was larger than the curatorial staff, much larger, even though there were now more than forty curators tucked into cubbyhole offices in A&I, where there had once been only a handful. (The design and production staff had an expansive fabrication shop—called a "laboratory," probably for the same reason that curatorial storerooms were called "reference areas"—on 24th Street in Georgetown, supervised by Lawless.)

With the professional designer came not only a new style of exhibitry but also a new internal dynamic. At its best, there was a creative tension between curator and designer that brought out the finest in both parties, there being no better example of this than Multhauf and Lawless.[27] Scholar

and artist, these two had great regard for one another, though Lawless loved to tell of an inauspicious beginning. "On his first day, Multhauf wandered into the design office ... and right up to my desk, where he managed to spill an entire bottle of India ink on my nearly finished drawing. 'That shouldn't be too hard to clean up,' he said without a blink." The story may not have been entirely true, but Multhauf liked it too much to deny it. At worst, the tension was not creative at all, and it sent many bravely conceived projects into a tailspin, some never to recover, or, if they did recover, only with a whole new cast and a great deal of lost time. Any MHT veteran could cite a pet example of this sort of turnabout.

To designers, curators often seemed terminally unimaginative. Curators saw designers as touchy, irreverent, and "given to gimmicks." The new style certainly was full of novelties. There were unusual materials, expansive silk-screens, "photo-murals" and "audio-visuals," and theatrical lighting. (Also from theatrical realms were "scripts.") Floor plans sometimes had restricted sight lines in order to focus visitors' attention; later, displays were arrayed in a set sequence with a beginning, middle, and end, according to Bauhaus conventions. Perhaps most importantly, there would be a selectivity with artifacts instead of simply filling cases willy-nilly with everything on hand. Modernized exhibit halls might look open and airy, with room to stand back and contemplate featured artifacts from some distance. (Later they would get as crowded as before, not with artifacts but rather with stagery intended to foster an "experience.") Narratives replaced taxonomies. What to include? What to consign to storage? "Once the arrangement was no longer taxonomic," writes historian Gary Kulik, "the form that exhibitions took became an issue in ways that it never had before."[28]

Although Taylor sometimes spoke of "themes," exhibits having well-defined storylines remained mostly an ideal until many years later, when the idea of calling exhibits "halls" became passe and often they had names like the titles of books, like *Suiting Everyone*, *Field to Factory*, or *America on the Move*. What was most readily attainable was *context*, because it might just mean creating a *set*, and exhibit designers quickly got good at that. For example, items in the *Costumes of the Mistresses of the White House* had originally been lined up on dressmakers' forms in rows of identical glass cases. Lawless staged them. They were on mannequins, all with faces

modeled after the sculpted head of King Lear's Cordelia but with different hair-dos and in the context of theatrical backdrops that typified places in the White House where someone might actually have worn these outfits: the Music Room, Blue Room, East Room. It happened that the White House had a surplus of furnishings after the renovation Bess and Harry Truman carried out, and Margaret Brown became the beneficiary. The new exhibit was configured in a U-shape with indirect lighting in the ceiling and theatrical lighting in the eight individual rooms. Here, in addition to context, there actually was a theme, subtle but unmistakable: "women as cultural symbols of beauty, graciousness, and service to men."[29] Old-fashioned symbolism, perhaps, but *modernizing* is what the program was called, and modern the exhibit looked, especially because of the contrast to monotonous glass cases in other exhibits nearby and because of the siting in A&I, an entirely "Victorian" building without a hint of anything else modern.

 Gowns of the First Ladies opened on May 24, 1955, with President Eisenhower and First Lady Mamie as guests of honor. The gown of Mamie's on exhibit was the one she had worn on July 1, 1916, when she and Dwight were married. What a story! Nothing more newsy had happened at the Smithsonian in many years, and the media was out in force. It happened again across the Mall a few months later with the opening of modernized halls by the Department of Ethnology, *Native Peoples of Latin America and Southwestern United States*. Neighboring exhibits betrayed the ancient ways of the Nation's Attic; the new ones provided evidence that the institution would know what to do when provided with a spacious new venue. It was not clear at the time that modernization and the rapid ascendance of "design" marked a turning point and not only with regard to public notice for the Smithsonian. As soon as rigorous selectivity became the norm for many, if not all, new exhibits, that selectivity would be at least partly, and sometimes largely, the responsibility of designers with strongly held aesthetic precepts. It was not the actual gowns in their period-room settings that first caught the eye as one looked into the First Ladies exhibit; it was the cultural symbolism that was enhanced by the lighting, the colors, the architecture, and the floor covering, the drama of modernity with just a touch of Beaux Arts, all the things with which an artist like Lawless was

so adept. In the future, curators would still make "object lists" and write scripts, but designers would be more and more responsible for what people *actually saw* when they walked into an exhibit.

■

IN 1956, ONE YEAR AFTER HIS VISIT TO A&I, President Eisenhower signed Public Law 573, which provided $33.7 million for the first major construction project on the Mall since the National Gallery of Art in the 1930s: a new museum on a site fronting Constitution Avenue between Twelfth and Fourteenth Streets. After considering several alternatives, including the Museum of Man and His Works, the Museum of American Civilization, and even the Museum of American History, Carmichael and Taylor decided to call it the Museum of History and Technology.[30] *History and Technology.* Among those who took special notice was a professor of history at Case Institute in Cleveland, Melvin Kranzberg. Mel Kranzberg was in the process of inventing a new academic discipline, *history of technology*, and beginning to arrange for publication of a periodical called *Technology and Culture*, probably to debut in 1960, the same year targeted for the opening of the new museum. Ike's people imagined that he would still be in office and could bask in the glory of a national showcase for American ingenuity. For Kranzberg, and all concerned, it would be a nice coincidence.

At first, Taylor had worried that Carmichael was "afraid we were going to do more of the same old thing . . . Did we really know what a modern exhibit was?" An exhibit of gowns presented challenges, yes, but how about a modern exhibit of power machinery, with the prime artifacts being steam engines designed to run factories but also with devices that seemed to be infinitely variable, such as valve gear and indicators. Such an exhibit would need to be radically selective, and this was something new. Now, with John Ewers at his side, with Anglim and Lawless and a growing staff of creative men and women showing the artistic possibilities—and with a brilliant Hungarian émigré, Bela Bory, to take exhibits production in hand—Taylor felt confident, and Carmichael became an enthusiast for what he liked to call "a great exhibition machine." Carmichael, writes Larry Bird, "brought his psychological tool kit to bear on the management of the Institution's

campaign to realize its museum building plans." In an article published in *Coronet*, "a popular weekly within easy reach of the nation's supermarket checkout lines," Carmichael "linked the storied past of the Smithsonian Institution with the story of progress." Here would be a new museum that could dramatically reflect the power and authority of a great nation.[31]

Although Taylor had already tried something similar with *Science* and *Scientific Monthly*, Carmichael's appeal in a "general interest digest" was exceptional, perhaps unprecedented, for a Smithsonian secretary. Even a brief excursion into a weekly magazine like *Coronet* would have been unthinkable for his predecessors. (It would not be unthinkable at all for his successor, Dillon Ripley, who would create his *own* mass-media outlet, *Smithsonian Magazine*.) Carmichael was fully prepared for, even welcomed, a life in the public eye. Having come from academe, he had worked with trustees and had a good sense of how to get the Smithsonian regents effectively involved in policy and planning. That was an important factor in the authorization of the Museum of History and Technology, as was Taylor's quiet persistence and the synergy between these two men, as well as between Taylor and Multhauf. But in the end the public campaign was not as important to congressional passage of Public Law 573 as the new geopolitical realities that emerged out of World War II were. Always in the background was an image of the museum as a weapon in the cultural Cold War—and for some men in political realms it was in the foreground. To see how that could be, the next chapter begins a year or two before Ike's authorization of Public Law 573.

Travel through space is almost at hand; Mars and Venus will soon be on our visiting list. The split atom and the rays of the sun may propel our vehicles through the constellations of stars. We will need this museum.

—SENATOR CLINTON P. ANDERSON,
for the Smithsonian Board of Regents, May 19, 1961

CHAPTER 3 ▪ A Worthy Home for National Treasures

Early in 1953, Frank Taylor drafted the text for a brochure titled "A New Museum of National History and Technology for the Smithsonian Institution," a museum that would "illustrate with authentic original relics the elements of our technology and culture." The actual name still needed fine-tuning, but there again was that phrase, "technology and culture." And the appeal—the "simple terms" members of Congress might be expected to grasp—was "slick, informative, positive, and patriotic."[1] A new museum would present, Taylor wrote, "a stimulating permanent exposition that commemorates our heritage of freedom and highlights the basic elements of our way of life." The newly arrived secretary, Leonard Carmichael, contributed a foreword in which he emphasized that this museum was essential not only to display "the material evidence of our historic national growth and achievement" but also to "serve other urgent national interests." Such urgent national interests weighed heavily on the mind of a ten-term Republican congressman from Royal Oak, Michigan, who was chairman of the House Committee on Public Works and a

Smithsonian regent. His name was George Dondero, and in June 1954 Dondero introduced House Resolution 9500, which would eventuate in the Museum of History and Technology.

For long-suffering curators, this promised an escape from Arts and Industries, congested, untidy, forever dusty, or so it seemed. For Dondero the problem was far more important than taking leave of a building that had (as Taylor's brochure put it) "neither artistic merit nor historical significance" and whose "eventual removal is scheduled in every plan for rehabilitating southwest Washington."[2] Dondero could see that a more becoming setting should be afforded to "authentic original relics" such as the *John Bull* and Joseph Henry's Albany electromagnet, both dating from 1831, prototype telephone instruments of Alexander Graham Bell and Elisha Gray from the 1870s, and, of course, the *Spirit of St. Louis* and the Star-Spangled Banner. (An 8-by-10 photo in the brochure showed a flag that was "half hidden by other displays" and "cannot be fully unfurled.") But Dondero believed he could see something else: that the United States merited an exalted *technological* museum more than any other nation in the world and that the absence of such a museum in Washington provided aid and comfort to our mortal enemies in the Kremlin, not the least important reason being, as Secretary Carmichael put it, "the Soviet claims of priority with respect to the world's important inventions."

Carmichael had a point, for nowhere was official (and often dubious) history propounded more blatantly than in Soviet Russia. But when it came to museums, Dondero displayed more than a tinge of the lunacy later to be associated with various characters in Stanley Kubrick's *Dr. Strangelove.* Although Dondero was a military history buff, his lunacy pertained not to the technology of warfare but to art. For years, he had been delivering speeches on the House floor, intended for the *Congressional Record*, with titles like "Communism in the Heart of American Art," "Communists Maneuver to Control Art in the United States," and "Modern Art Shackled to Communism."[3]

Dondero was extreme even in the company of McCarthyite extremists, and no form of "modern art" escaped his opprobrium; all were communistic.[4] "Cubism aims to destroy by designed disorder," said Dondero. "Futurism aims to destroy by the myth of the machine. Dadaism aims to

destroy by ridicule. Expressionism aims to destroy by aping the primitive and insane. Abstractionism aims to destroy by the creation of brainstorms. Surrealism aims to destroy by the denial of reason."[5] Each -ism was "the weapon of the Russian Revolution," which, "having infiltrated and saturated many of our art centers, threatens to overawe, override and overpower the fine art of our tradition and inheritance." It would not have helped to ask what Dondero meant by "brainstorms," an expression almost always given positive connotations, or "the myth of the machine," a phrase Lewis Mumford would use for the title of a book whose keynote was technophobia. Dondero was past seventy and planned on retiring after one more term. So, a new museum exalting American technology became his top priority.

Dondero's 1954 authorization got snagged in a dispute over the siting of the building, there being a proposal by a private developer to make the museum the focal point of the "renewal" scheme for southwest Washington, some distance from the Mall.[6] But the delay was only temporary. Dondero introduced a new authorization in the next Congress, and now he had the best possible allies. Speaking to the fiftieth anniversary meeting of the American Association of Museums in June 1955, Vice President Richard Nixon expressed his approval of the measure *and* the approval of President Eisenhower, who had just had his happy visit to A&I with Mamie for the opening of *Gowns of the First Ladies*. After affirmation by the Joint Congressional Committee on Construction of Buildings for the Smithsonian (New Mexico senator Clinton Anderson, another regent, was co-chair), the authorization passed both houses of Congress and was signed by the president on June 26. Eisenhower signed a supplemental planning measure a few weeks later. Authorization and appropriation are quite different matters, and, in the case of the National Air Museum, the one was separated from the other by more than a quarter-century. Not so with the Museum of History and Technology. Eisenhower signed Public Law 573, the $33.7 million appropriation, in June 1956.

The architectural contract went to the venerable firm of McKim, Mead, and White, largely because it had been involved with planning and remodeling at Tufts during Carmichael's presidency and had won his loyalty. The museum design was the work of James Kellum Smith, the firm's last surviving partner.[7] The Commission on Fine Arts conferred approval in

the fall of 1957, and Senator Anderson broke ground in the late summer of 1958. It was clear from the initial renderings that the building was going to be immense: five stories plus a cooling tower and a basement outfitted with a state-of-the-art television studio and provisions for "remote" telecasting from each of the exhibit halls. In the basement and elsewhere in the museum, there would be the full range of facilities necessary for restoring and conserving artifacts (the "labs" that had been scarce in A&I). There would be all the facilities needed for producing exhibits from start to finish: cabinet shop, machine shop, paint, plastics, silk-screens, and more. On the assumption that many visitors would come "only once in a lifetime" and plan to spend an entire day, there would also be a cafeteria with a picture-window view of the Washington Monument.

The Museum of History and Technology was a construction project not matched on the Washington Mall until Gyo Obata's National Air and Space Museum and I. M. Pei's East Wing of the National Gallery two decades later. Gross floor area was 4.6 times larger than A&I and more than either the Museum of Natural History or the National Gallery of Art, the museum's two neighbors to the east. Taylor described a building "with good masses, good proportions, and very little in the way of ornamentation." There were to be three floors open to the public, the first 577 feet long and 301 feet wide (the two-football-field comparison was too tempting), with 175,000 square feet of exhibit area, the next two 491 by 216 feet, with about half as much exhibit area. In fourth- and fifth-floor offices, designers would have room for drawing tables and curators would have room for bookshelves and big desks. (From the collections, one of them selected a desk that had once belonged to engineer and inventor George Corliss.) The top floors would also accommodate specialized workshops and "reference collections" of interest to historians of technology—the sort of people Charles Blitzer might have misjudged as mere enthusiasts for "gleaming machines" but who were in fact on the cusp of an emerging discipline that would cast new light on the entire sweep of what was called Western civilization.[8]

The ground floor, with its entrance across Constitution Avenue from the neoclassical Department of Commerce, was to be almost entirely devoted to technological displays, ranging from autos and coaches to atomic energy

to agriculture and wood industries. A few of these were the planning responsibility of Philip Bishop; all the rest were the responsibility of Robert Multhauf. The central icon would be a Foucault pendulum demonstrating the rotation of the earth and suspended from 52 feet overhead. (The pivot was underneath the stacks of the fifth-floor library, where patrons could sometimes watch over the shoulder of a technician after he lifted the access panel for the motor.) The fully unfurled Star-Spangled Banner was to be the pendulum's complementary icon on the second floor, with its entrance from the Mall.[9] Nearly all of this floor and much of the third would be the responsibility of Anthony Garvan, who had a unique appointment: he chaired the Department of Civil History even while retaining his professorship at the University of Pennsylvania in Philadelphia.[10]

Because of Garvan's impeccable scholarship linking the study of artifacts to the analysis of culture, Multhauf held him in highest regard, as did Taylor, especially after finding how difficult it could be to enlist the services of "very successful and independent academic people." When the museum opened, curators with PhDs were in a distinct minority, and most of these were unknowns at the beginning of a career: Barney Finn, curator of electricity, and Sami Hamarneh, curator of medical sciences, for example, both from the University of Wisconsin. And there was Walter Cannon, curator of physics; Uta Mertzbach, curator of mathematics; Philip Lundeberg, curator of naval history; and Wilcomb Washburn, curator of political history, all Harvard PhDs. But Garvan was already an academic powerhouse, even though not yet forty, and Taylor believed that Garvan had the best possible answer to the question he imagined people asking: "What is the Smithsonian going to *do* in this building, just more of the same old thing?"

Nothing of the sort, was the gist of Garvan's answer; it is going to do much more than ever before. Garvan devised the thematics for an exhibit, or "exhibition" suits better, called *Growth of the United States* (*GOUS*), the aim of which was nothing less than "examining and evaluating American culture." It would occupy much of the museum's second floor, covering three centuries, 1640 to 1945, and it seemed dauntingly ambitious. But conceivable: at Penn, Garvan was professor of American Civilization, a burgeoning interdisciplinary program patterned on the one founded at

Harvard in the 1930s by Perry Miller and F. O. Mathiessen. (Washburn was a graduate of this program.) Although Taylor was concerned about the unusual administrative arrangement being difficult to sustain, as indeed it was, he was enchanted with Garvan's vision of "a museum within a museum," and also with his conceptual originality—the *John Bull* would be exhibited not in the context of railroad technology but, rather, as the centerpiece for an address to the rise of the corporation—and with his flair for the dramatic. A man who "had a Corvette which he drove at high speed from Philadelphia to Washington twice a week" stood in marked contrast to Taylor, the soul of measured reserve. Likewise reserved was Multhauf, and without any of Taylor's charisma. But Multhauf would ultimately have as profound an impact on MHT as Taylor and a more lasting influence than Garvan, although Taylor wanted nobody ever to forget how well they both recruited and how much they both "stimulated people around here."

With GOUS there was a problem, however, even after Taylor realized that he needed to replace Garvan as department chair with somebody who would be more readily available for consultation. It might be hard to disagree with a remark by Garvan's closest collaborator, Peter Welsh, about his "brilliant application of an idea to a very complex problem."[11] Still, GOUS was the cause of escalating aggravation among other curators, many of them in Multhauf's department, who believed that it robbed their own exhibit halls of their most attractive artifacts; should not the Eli Whitney cotton gin be in the Hall of Agriculture, the *John Bull* at least near the Railroad Hall? Did not the thirty-foot waterwheel from an eighteenth-century grist mill belong somewhere on the first floor? Garvan planned for GOUS to have five "units," each with dozens of individual displays. Two units were completed and opened, covering the period from 1640 to 1851; the other three were planned but never produced. And in 1969, after Garvan had returned to Penn for good, the first two were dismantled and artifacts dispersed, all but one: the framing for an entire house from Ipswich, Massachusetts—a very large house dating from the 1690s with an addition from the 1750s. Meant to illustrate the art of timber framing and joining "as it gained new strength in form and execution" (Garvan's specialty was vernacular architecture), the looming presence of the Hart

House, named for its original builder, never let anyone at the museum forget that Tony Garvan made no little plans.

Even though the Hart House was a white elephant, hidden for years behind temporary walls, the museum's second floor did feature an innovative sequence of eighteenth- and nineteenth-century period rooms called *Everyday Life in the American Past*. It was the creation of Malcolm Watkins, who moved over to the new museum from the Division of Ethnology in the Museum of Natural History, as did collections of ceramics, glass, textiles, furniture, and musical instruments.[12] Ceramics and glass, along with heating and lighting artifacts, a Hall of Numismatics, and a Hall of Philately and Postal History, went to the third floor. Here, too, was a military exhibit that featured George Washington's field tent and the *Philadelphia*, a Continental gunboat raised from the bottom of Lake Champlain in 1935, but was remarkably modest overall.[13] No matter how imaginatively designed the third-floor exhibits may have been or how strong the appeal to stamp collectors or coin collectors, or collectors of faience or stoneware, except for enthusiasts for antique firearms and Revolutionary War history, the uniformed guards might almost outnumber the visitors even in high season.

Architect James Kellum Smith died in February 1961 when the new building was half completed, and his successor, Walker Cain, imagined that the Mall entrance, the second floor, would be the main entrance. But visitors entering there would be walking in on a blank wall protecting the Star Spangled Banner from sunlight, and everyone knew that the real drama was on the first floor, starting with the pendulum—there were many others around the country, to be sure, but none in a location with anything like MHT's visitation. Youngsters and adults would crowd around, waiting to cheer whenever one of the wooden pegs got knocked over, and in the popular imagination the pendulum became an "authentic original relic" (remembering Taylor's brochure) just like the Star-Spangled Banner or the *John Bull*. Then, there were devices remarkable for their scale: a steam farm tractor and a Van de Graff generator (for creating high voltages), which both could be seen through show windows in front, and the stationary steam engines with their slowly rotating hypnotic flywheels.[14]

As a complement to the *John Bull*, there was another locomotive nearly a hundred years newer and yet already an antique, too. This was the 92-foot, 280-ton "1401," the green-and-gold Southern Railway locomotive that was one of ten used sequentially to pull the train with President Roosevelt's body from Warm Springs to Washington. Retired only five years later, it was now displayed so it could be seen from inside, close enough to touch, and through a show window facing Twelfth Street.[15]

■

NEITHER THE PENDULUM NOR THE VAN DE GRAFF, the 1401, the *John Bull*, the stationary engines, nor anything else on the first floor was the everyday responsibility of Bob Multhauf. But nearly everything on exhibit there bore his stamp one way or another.[16] After GOUS lost momentum and Garvan departed, there was no doubt that Multhauf was the strongest presence in the new museum next to Frank Taylor. He and Taylor were alike in many ways—they both fancied chemistry and both maintained an air of confident modesty—but they were also much different, not least in the degree of experience they brought to their first museum assignment. Taylor was nineteen when he reported for his interview with Carl Mitman in 1922, Multhauf nearly twice as old when he first met Taylor in 1954, and he had already seen and done a lot, with a wealth of practical engineering experience preceding his graduate study at Berkeley (a master's degree in East Asian history, with a thesis on Sino-Japanese diplomatic relations in the 1920s, and a doctorate in the history of science).

Multhauf's dissertation was titled "The Relationship between Technology and Natural Philosophy, ca. 1250–1650, as Illustrated by the Technology of the Mineral Acids," and esoteric though this sounded, it seemed well tailored to provide entrée into a tenure-track appointment in some new history-of-science program in academe (history of technology did not emerge as an academic specialty until the 1960s, a good part of the momentum coming from the new museum). But Multhauf was to have another experience that anticipated the experience of many others following in his footsteps at the Smithsonian. While working on his doctorate he imagined a career amid halls of ivy, not museums on the Mall. "Almost all

professional historians were employed within the academy," writes Peter Novick, by way of emphasizing that museums and the diverse realms later called "public history" were not where any PhD expected to be employed.[17] But Multhauf's graduate schooling had been disrupted when his major professor lost his job in a dispute over mandatory loyalty oaths—the first of several times the Cold War touched his career directly—and by the time he got his doctorate, in 1953, the academic job market was slumping.[18]

As a stopgap, Multhauf's dissertation was sufficient to land him a fellowship at the Johns Hopkins Institute of the History of Medicine in Baltimore, and while there he saw Taylor's announcement for the curator of engineering position in A&I. Among twenty or more applications, Multhauf's was the only one whose resume included a graduate degree of any kind. The doctorate appealed to Taylor as a badge of achievement the scientists would appreciate, and Multhauf's undergraduate degree in chemistry and experience in chemical engineering made him doubly attractive. After Taylor took him over to the Castle for a chat with the secretary, Multhauf was hired as quickly as Taylor himself had been long before.

Soon after Multhauf started, *Gowns of the First Ladies* emerged as an unqualified success, and more generous funds for modernizing other A&I exhibits were becoming available. Someone who had been a shipboard engineering officer seemed made to order for the assignment Taylor had next in mind, modernizing the Hall of Power Machinery—the featured artifacts were stationary steam engines of various sorts—and Multhauf set to work on that project in collaboration with Ben Lawless. Soon, Multhauf became a collector in his own right, acquiring an engine larger and more dramatic than any other, built by the Delaware firm of Harlan & Hollingsworth and used in a Charleston, South Carolina, machine shop. But long before the new power hall was completed, Taylor could see great potential in Multhauf and was handing him administrative responsibilities as the chair of a new Department of Science and Technology. Among his early tasks were getting rid of overly commercialized exhibits—or some of them, as long as resistance was not too strong—and shedding underproductive curators, of which there were several. Soon, in anticipation of the new museum being authorized, he would be filling quite a number of new curatorial slots.

When the proper purposes of the Smithsonian were being debated in the 1840s, Representative John Quincy Adams had expressed concern about the danger of the institution providing "monkish stalls for lazy idlers." So it appeared to Multhauf, who recalled being astonished by the number of curators "who were natives of Maryland and Virginia—not merely hacks but typical southern white crackers."[19] This may just have been the way things looked to someone who had spent several years in the free and easy climes of Berkeley, California, but Taylor would likely have agreed, at least in private. In A&I, Multhauf noticed the absence of "the quasi-academic atmosphere of the natural history museum," an atmosphere Taylor was anxious to begin emulating with Multhauf, *Doctor* Multhauf, to lead the way.

For showing the door to incompetents and "idlers," Taylor made certain that Multhauf would have the secretary's backing or, rather, that of John Keddy, described as an "irascible, hot-tempered hired assassin."[20] Multhauf would also have a free hand when he began recruiting for curators of engineering and transportation. At first his thoughts turned to the possibility of finding others like himself, with top-flight academic credentials. Taylor had already recruited two such men for other departments, Phil Bishop and Richard Howland, and Multhauf did get a few expressions of interest, notably from John B. Rae, a professor at MIT who would become the foremost historian of the American automobile. But he failed to land Rae, or anyone like him, so he had to look elsewhere, at the ranks of what he later called "amateurs and hobbyists."[21]

Not that he came to regret this necessity, not in the least; rather, he would always express great pride in this first generation of new curators, who were no more *just* amateurs and hobbyists than their predecessors had likely been just "crackers." His pride was shared by Taylor, who knew that doctorates would impress the scientists in Natural History but felt it was also important to have curators who were inspired "to find meaningful relationships in the history of technology, art, and cultural history," whatever their formal credentials. The two that Taylor singled out for extended praise in a 1964 address to the annual meeting of the American Association of Museums, just after MHT opened, were Jacob Kainen—artist, printmaker, and historian—and Howard Chapelle—marine architect and historian—neither of whom held a college degree.[22]

Multhauf regarded Chapelle as "the most eminent person on our staff" even after he had been able to hire several curators with showy academic credentials by the mid-1960s. Of the same sort as Chapelle was Edwin Battison, "a Vermont machinist and self-taught historian" (Multhauf's words again). Though not nearly as productive of publications, Battison had an exquisite understanding of mechanical things and built an exemplary collection of machine tools. He also helped topple conventional wisdom about the iconic Eli Whitney and the inception of manufacture with interchangeable parts, one of American history's sturdiest myths.[23] Even more so than Chapelle, Battison framed his research by defining problems and demonstrating to general historians the value of analyzing the actual workings of technological "hardware." There also was Robert Vogel, schooled at the University of Michigan as an architect but smitten by the ingenuity of nineteenth-century technologies (it was Vogel who sat at George Corliss's desk), who would save priceless archives and import the study of industrial archaeology from Great Britain. As enthusiastic as Vogel was John H. White Jr., "Jack" he was called, with a bachelor's degree in European history from a small college in Ohio, skill at a drafting board, and a fancy for "anything that was mechanical." White would prescribe the content of a Railroad Hall that remained essentially unchanged for forty years, and he would also become one of the Johns Hopkins University Press's premier authors. And there was Eugene Ferguson, a mechanical engineer with only a master's but an original thinker, a compelling writer, and an inspiring presence to his colleagues, who were supremely disappointed when he decided that Washington was not a place he enjoyed living and left for an academic appointment in Iowa after three years.[24]

The disappointment was short lived because a confidant of Multhauf's, a professor of the history of science at Yale named Derek Price, steered him to a Connecticut neighbor of his, Silvio Bedini. Most of the leading lights with the new museum, as with the emerging history-of-technology discipline, had come to this calling indirectly. Multhauf had been a chemical engineer and Price an experimental physicist, but Bedini's journey was the most roundabout of all. He was born in 1917 on a farm near Ridgefield, Connecticut, the second son of first-generation immigrants. He loved books, and in 1935 he enrolled at Columbia University to major

in comparative literature. Before graduating, however, he volunteered for the U.S. Army and was assigned to G-2, military intelligence, and a top-secret unit in Fairfax County, Virginia, called MIS-X, charged with enabling allied prisoners to escape or send coded messages. By 1943 he had advanced from buck private to master sergeant, and by 1945 he was liaison with the Pentagon.

When Bedini was discharged at age twenty-eight, he expected to return to Columbia. But his father was in failing health and wanted his sons to take over his landscaping business. (Once notable for its expansive estates, Ridgefield was being transformed into a suburb for New York commuters.) In his spare hours Bedini began writing for the "true science" comics designed to enliven elementary school curricula, stories like "Start the Music" (about the invention of musical instruments), "Words without Wires" (about telegraphy), and "Crazy Kelly: The Beginning of Modern Steelmaking." After acquiring an antique clock for $20, he started writing for a periodical aimed at antiquarian horologists, the *Bulletin of the National Association of Watch and Clock Collectors*.[25] And he wrote a book as well, about his hometown on its 250th anniversary, *Ridgefield in Review*, which included an introduction by the Columbia University historian Allan Nevins.

By the time Bedini's book was published in 1958, he was seeing a lot of Price, and he had also become good friends with another neighbor, Bern Dibner.[26] Dibner, born in Ukraine and educated at the Polytechnic Institute of Brooklyn, had designed and patented various "universal electrical connectors" that required no solder. He became a wealthy man when the firm he founded, Burndy Engineering, went public in 1956. Because of his interest in the history of technology and science, Dibner had amassed a library that Bedini called a "bottomless treasure-trove."[27] Making use of the Burndy Library's resources, Bedini began writing in a scholarly vein, beginning to pose significant questions in what he wrote. There was a manuscript on water clocks, for instance, which Price recommended to Mel Kranzberg for his new quarterly, *Technology and Culture*, saying that Bedini's analysis was "fundamental to the history of horology and has implications at several points to the history of machines and other technological devices." Kranzberg published Bedini's article in his spring

1962 issue, 48 pages including 30 illustrations and a notable problematic: how could a device of this sort appear in various countries over a long timespan, centuries, "yet apparently with little or no relation between these appearances?"[28]

Bedini had a keen eye for technology's visual essence, and as Ferguson put it, he also had "an uncanny ability to spot unlikely and obscure relationships."[29] Even though he was forty-four years old when Multhauf hired him, a career at the museum seemed predestined. Bedini was a "ten times as much" person and with boundless savoir faire—word got around the Washington press corps that he was the museum's "best interview." Within four years, he had been promoted to assistant director, and after that he served three long stretches as acting director, sixteen months total. Bedini's administrative dexterity became legendary, and he never went home at night without having cleared off his desk. Working at home, he produced a constant stream of publications. Everyone could see that he had the qualifications that might have been expected of someone in the director's office, *the* director, not the acting director. All but one. Even though Secretary Dillon Ripley was among Bedini's admirers, he could never have offered the job to a man who never finished college, no matter his experience, his scholarship, his charm, his range, his accomplishments.

His accomplishments: Bedini had "a prodigious capacity for getting things into print," quoting Ferguson again, and published nearly two dozen books. And he was good at just getting things done. Successive directors would leave him with full responsibility for the exhibit and publication programs, indeed for just about all the "curatorial affairs." He was directly responsible for several elegant exhibits, including *The Unknown Leonardo* in 1974, *Colon y su Tiempo* in 1976, and *Jefferson and Science* in 1981, and every other exhibit staged around the time of the Bicentennial was enhanced by his knowledge of the collections and his wealth of important contacts. (Bedini coauthored a book with Werner von Braun, who was instrumental in sending men to the moon, and for years he never missed his Friday luncheon date with astronaut Mike Collins, who had been there.) And he was a wise mentor to younger colleagues at the museum (I count myself among them), as well as the visiting fellows who arrived each fall. Always impeccable in silk ties and French cuffs, he loved nothing more

than squiring the queen or the ambassador during a visit, but he never lost the common touch that, incidentally, put much of his work in step with what became known as the new social history.[30]

■

BEGINNING IN THE EARLY 1960S, with the Museum of History and Technology nearing completion, Multhauf found that he could recruit curators with doctorates. His first was Walter Cannon (later Susan Fay Cannon), brilliant and tragic; his last was Otto Mayr, who would later occupy the MHT director's office before returning to his native Bavaria to head the Deutsches Museum. But Multhauf looked back most proudly at the people he had recruited at the start, sometimes in the face of continuing pressure to treat curatorial jobs as a matter of patronage (he recalled hiring Jack White despite pressure to hire someone else coming "directly from the White House"). Multhauf had no doubt that his "amateurs and hobbyists" were a remarkable lot because of their "feel" for technological devices and a visual sense his later recruits often lacked, not least because so many of them were instrumental in helping shape an organization called the Society for the History of Technology (SHOT) into the anchor for a new scholarly discipline that would grow and prosper in a symbiotic relationship with the Museum of History and Technology.

In the spring of 1958, just as the site for the museum was being cleared of the quonset huts that had been there since World War II, charter members of SHOT convened at the University of California in conjunction with a meeting of the Humanistic-Social Division of the American Society for Engineering Education, which was chaired by Mel Kranzberg, professor at Case Institute of Technology in Cleveland. Kranzberg was SHOT's spark-plug and editor of its journal, but the new organization's credibility was due substantially to support from Multhauf, on behalf of the Smithsonian, and from Lynn White Jr., president of Mills College in Oakland, whose scholarly eminence would be affirmed in the presidency of no less than four learned societies including the American Historical Association and who would get courted for the directorship of MHT. White chaired one of the sessions in Berkeley, with talks by Thomas Kuhn of the university's

history department and Multhauf, who spoke of "The Role of the Technical Museum in Engineering Education," specifically "the principles behind the new Museum of History and Technology."

Kuhn and White were soon to publish books that transformed the historiography of science and technology. Kuhn's *Structure of Scientific Revolutions* introduced the amazingly transportable concept of paradigms, while famed Sinologist Joseph Needham called White's *Medieval Technology and Social Change* "the most stimulating book of the century on the history of technology."[31] Although Multhauf would never make the kind of mark that Kuhn and White did, he was already making an impression on an emerging discipline as he steered MHT in a direction unlike any other museum's. A decade later, Kranzberg would point to "the largest collection of historians of technology in this country." When Frank Taylor called that collection of historians "the best in the world," Kranzberg would not have disagreed. By then Multhauf had become director of the museum that had immediately established itself as one of the most popular in the world, with visitation often nearing a million in April, traditionally the peak month.

Multhauf urged his staff over and over "to distinguish themselves as scholars and thereby distinguish the museum and the Smithsonian." More than urging, some would say he *demanded* it, and in no other museum in the world was such a demand made upon the curators. As outlets for publication, there were two new in-house periodicals, quite different from each other, but both aimed at presenting original scholarship: *Contributions from the Museum of History and Technology*, heavily illustrated and published frequently but irregularly, and a quarterly, the *Smithsonian Journal of History*. Most importantly, there was Kranzberg's *Technology and Culture*, which would enable specialists in the history of technology to make a mark in broader reaches of academe and serve a crucial validating function, just as the link with the Smithsonian had helped validate SHOT. Among Kranzberg's closest editorial collaborators was Multhauf, and among the first winners of SHOT's annual prize for best article were both Multhauf and Bedini; later, Ferguson, Mayr, and many others in MHT's orbit also received this prize.

In December 1958, Multhauf hosted SHOT's first annual meeting while co-chairing the program committee along with Northwestern University's

Carl Condit—whose eminence had been certified since Lewis Mumford lauded *The Rise of the Skyscraper* in the *New Yorker* in 1952—and who Multhauf was hoping to lure to the Smithsonian. (Condit being vitally interested in building construction, the two of them walked over from A&I to inspect the excavation for the new museum.) Kranzberg had arranged a joint program session with the American Historical Association and another with the American Association for the Advancement of Science and the History of Science Society. Participants included Lynn White, John Rae, and Ferguson, and the program readily confirms Brooke Hindle's fond observation about SHOT having begun "with a motley crew of scholars who were but slightly conscious of their common interest in the history of technology."[32] The prospect of a new Museum of History and Technology would be central to their awareness of that common interest. On December 29, with Multhauf, White, Condit, and Rae present, along with others well regarded in scholarly realms, among the public at large, or both (the University of Chicago sociologist William Fielding Ogburn, for one), Kranzberg convened the new SHOT executive council in Multhauf's conference room in A&I.

During the next quarter-century, Multhauf and three of his successors in the MHT director's office would host SHOT's annual meeting seven more times, and the museum would provide a substantial portion of the society's cadre of activists: one-third of everyone serving on the SHOT Executive Council for its first forty years would have Smithsonian ties, either as staff or through the fellowship program or both. Four would serve as SHOT president; seventeen would be awarded its highest honor, the Leonardo da Vinci Medal. The keynote for all this was sounded by Secretary Carmichael, who affirmed the society's objectives, eagerly participated in meetings, and wrote reviews for its journal. In the 1980s, after Kranzberg retired from the editorship, a permanent link would be forged through the museum's Archives Center and its responsibility for the society's records, a set of documents described by Lynn White as basic to understanding "the sprouting of an essentially new historical discipline on a global scale."[33]

■

MULTHAUF AND KRANZBERG HAD ANTICIPATED the completion of MHT at around the same time as the premiere issue of *Technology and Culture* appeared from Wayne State University Press. The press was timely, but it took much longer to finish the museum building. Even though causes for delay were manifold, it did not help that the architectural firm turned out to be on its last legs and changed hands in the middle of the project (becoming Steinman, Cain, and White). Nor did it help that the construction contract went to a Baltimore firm, Norair Engineering, which had managed well with the Goddard Space Flight Center and would later do nice work with several stations on Washington's Metro but was not nimble enough for a project involving change orders by the thousands. By 1960, construction was only 20 percent complete, and the cornerstone was not laid until Eisenhower had been out of office for several months. Nor was John Kennedy to preside over the opening. Rather, it would be Lyndon Johnson, and when he spoke at the formal ceremony on January 22, 1964, the nation was still in shock from the assassination in Dallas two months before.

Johnson reiterated the patriotic credo that had animated Eisenhower's authorization a decade before: "I hope every schoolchild who visits this capital, every foreign visitor who comes to this First City and every doubter who hesitates before the onrush of tomorrow will, some day, spend some time in this great Museum." The museum, he said, would be cause for "us all to celebrate."[34] But the world was not the same in 1964 as it had been a decade before, when the project was authorized, and the air was full of grim portent. Also in January, the Joint Chiefs of Staff urged Johnson "to undertake bolder actions which may embody greater risks" in Vietnam, and in August Congress passed the Tonkin Gulf Resolution, whose implications would becloud nearly everything that went on in the United States for years to come. Certainly those implications would have an effect on everyone formally charged—as a Smithsonian press release put it—"with placing before an estimated 5,000,000 visitors a year an exposition illustrating the cultural and technological development of our nation." As museum staff solidified ties with academe through SHOT and similar organization, there would also arise the first public controversies

over exhibits that would later multiply as narratives veered toward academic concerns theretofore largely foreign to the Smithsonian—narratives that sometimes cast doubt on the relationship of technological progress and social progress and were often hesitant about celebrating "the onrush of tomorrow."

*One wonders whether the time has not come for a
full-scale review, by outside advisory committees
and consultants, of the historical accuracy of
Smithsonian exhibits.*

—MRS. JOSEPH MARION (LILIAN) JONES, 1966

*In the history of technology, where no educational
tradition exists, we have come increasingly to be
recognized as the leading institution not only for
research in the field but for training.*

—ROBERT P. MULTHAUF, 1968

CHAPTER 4 ▪ Allies and Critics

The year 1964 was the year of *Dr. Strangelove* and *Fail Safe, One-
Dimensional Man* and the opening salvo of the free speech move-
ment on the steps of Sproul Hall in Berkeley, all heralding dark-side
apprehensions (in Brooke Hindle's ominous expression) that would soon
spread through the academy. These apprehensions would eventually af-
fect the careers of two senior scholars who fled campus chaos and sought
refuge in the director's office at the Museum of History and Technology,
first Daniel Boorstin and then Hindle. At the Smithsonian, 1964 meant
something different from what it did in California for Stanley Kubrick or
Sidney Lumet, or for Herbert Marcuse or Mario Savio. For Frank Taylor,
a man who rarely tipped his emotions, the staff party just before MHT
opened, forty-two years after he first knocked on Carl Mitman's door in
A&I, was the "happiest day of my life." Taylor knew that John C. Ewers,
Robert Multhauf, John Anglim, and Ben Lawless shared in his joy—as of
course did Leonard Carmichael, for whom the museum was the crowning
achievement of his ten years in the Castle.

A few days after the opening, Carmichael handed the secretarial scepter to S. Dillon Ripley, a man who would invariably be described as learned, gracious, and urbane, like Carmichael, but Ripley could even be called dashing: he could accept Rosalynn Carter's inaugural gown and then joyfully show Rosalynn and President Carter's daughter-in-law, Caron, the Beatles' psychedelic Rolls Royce, which he himself had driven from the Castle to the museum's parking garage after the presentation by John Lennon. Ripley became a public presence in a way that none of his predecessors had been, and he was destined to have an impact on the Smithsonian that transcended even Joseph Henry's a century before.

Like Carmichael, Ripley had roots in academe. But he had different ambitions. Ripley "aspired to nothing less than the re-invention of the Smithsonian as a great university."[1] The watchword of a great university is research, starting with free time for the faculty: regular days off to read and think, weeks off to travel to libraries and archives, sabbaticals to write. Multhauf best remembered his recruits who had the "wit and wisdom" to take advantage of a great opportunity. The first MHT sabbatical was a reward for Jack White, who had wrapped up his Railroad Hall with admirable dispatch, a crowded but comprehensible mélange of models and full-scale artifacts, old and new. Then he had taken on the exhibit of bicycles, buggies, and carriages, not his specialty, while also developing an appetite for research as he was being prodded by Multhauf. "Writing didn't come easy at first," said White. "It was like playing a violin."[2]

Then there was Wilcomb Washburn, who finished work on the Hall of Historic Americans in the spring of 1964 but had made it clear that he did not fit in comfortably with others in the Department of Civil History. To his mind, they were antiquarians and he was a scholar. Although Washburn got no rewards for modesty, Ripley agreed about the distinction, and he enabled Washburn to cut his curatorial ties and inaugurate an Office of American Studies, aiming especially to encourage graduate study in material culture.[3] Likewise, Ripley enabled Mendel Peterson to take the institution into a new world, underwater archaeology, which seemed fitting since it did have an archaeological treasure, the gunboat *Philadelphia*. And to provide a ready outlet for staff publications, Ripley backed Silvio Bedini's idea for the *Smithsonian Journal of History*, a richly

illustrated periodical aimed both at scholars and a general readership. Initially installed as editor was Walter Cannon, who would follow Multhauf as chair of the Department of Science and Technology. Later, with a new gender identity, Susan Fay Cannon collaborated with Ben Lawless on a witty exhibit explaining the pendulum. Cannon also published the best book yet written by an MHT curator, *Science in Culture*, winner of the History of Science Society's Pfizer Award, which had previously gone to several stalwarts of the Society for the History of Technology, including Lynn White Jr. and Cyril Stanley Smith.[4]

Ripley established a committee of notables called the Smithsonian Council, which would regularly bring academicians of the same caliber as White and Smith into Smithsonian precincts as critics and advisors. And, most importantly, through a new Office of Academic Programs headed by Philip Ritterbush, Ripley inaugurated "visiting research associateships" for the pursuit of studies in "the history of science and technology and their conjunctions with government, society, and ideas." At first these were administered by the National Academy of Sciences and were available only at the postdoctoral level, but soon predoctoral fellowships were being awarded as well. Among the first postdoctoral associates were Carl Condit, Thomas Hughes, and George Hilton. Condit worked on his two-volume *Chicago: Building, Planning, and Urban Technology*, Hughes finished his biography of Elmer Sperry, and Hilton finished his history of cable railways; all these books became prizewinners and did a great deal to put the fellowship program on the map. Completing dissertations as predocs were Harold Skramstad, working with Robert Vogel, and Merritt Roe Smith, working with Edwin Battison. Skramstad and Smith would go on to stellar careers in museum management (the Chicago Historical Society and the Henry Ford Museum) and academe (Ohio State and MIT), as would many others to come through the fellowship program over the years.[5] This program, indeed, would evolve into an organic link between museum and academic communities that remained intact until the turn of the twenty-first century and the secretarial regime of Lawrence Small, with his focus not on the increase of knowledge but rather on the bottom line (and, even more so, as would become so shockingly obvious, on his own selfish advantage).

Ritterbush also instituted formal ties with nearby universities, including a cooperative program in the history of science and technology with the University of Maryland. Along with Washburn, Multhauf and Malcolm Watkins arranged to teach courses at George Washington University. In response to a suggestion from Jack White that he might pursue an "accelerated" doctorate at Case Institute, where Kranzberg had instituted a PhD program in the history of technology, the first in the United States, Ritterbush and Kranzberg negotiated for a shared curriculum in history and museum work. This failed to materialize, but it was a rare setback. With Kranzberg, Ritterbush, and other collaborators, Ripley had effectively set the Smithsonian on a new course.[6]

■

AS FOR THE NEW MUSEUM BUILDING, Leonard Carmichael was immensely proud of its "full originality," and though it was certainly a contrast to all the neoclassical buildings nearby, visitors were hard-pressed to find anything displeasing about the design. Not one architectural critic was impressed, however. Before construction even began and he could see only architectural renderings, MIT professor Albert Bush-Brown wrote of "the pompous scale of the elevations, the dishonesty of structural statements and the jumble of proportions." After it was finished, the influential *Washington Post* critic Wolf von Eckardt called it "barely more attractive than the temporary buildings it replaced, only blown up to enormous proportions."[7] Ada Louise Huxtable, newly promoted by the *New York Times* as "the first full-time architecture critic at an American newapaper," simply hated the building. But the exhibits, she wrote, were "the real thing": "technically excellent . . . and with a minimum of artificial sentimentalizing."[8] Indeed, the exhibits almost always got good notices, and visitation in the first year, 5.4 million, may have been the most ever recorded for any museum anywhere. About a fifth of the exhibit space was occupied when the building opened, the largest single exhibit being the Railroad Hall. Within two years, the staff from Multhauf's department completed exhibits of road vehicles, ship design, timekeeping, communications, hand tools and machine tools, mechanical and civil engineering, mathematics,

medicine, dentistry, and pharmacy, pretty much filling the galleries on the first floor, while the second and third remained spotty.

The plan was to have twenty-four exhibits open by the end of 1965, thirty-six by the end of 1966, and forty-eight by the end of 1968. Of those exhibits slated to follow the first twenty-four, however, some in Philip Bishop's domain were drastically truncated (including iron and steel, his own research specialty) or never opened at all (forest products and coal mining, a big A&I presence because of Carl Mitman). Funding would later be made available for new exhibits on the third floor in the wake of a fire caused by a short-circuited computer, but otherwise the program had stalled only a couple of years into Multhauf's tenure as director; his fully scripted exhibit about chemistry, his own scholarly specialty, never saw the light of day. Bishop, terribly disappointed by his Smithsonian experience, soon retired to England. Multhauf never contemplated leaving, but he was disappointed, too, and some of his Department of Science and Technology cohort, once so brave and ambitious, began to get a reputation for chronic disaffection. What was the problem? Ripley decried "wars and necessary domestic programs [that] have swallowed up the federal dollar" and left MHT "on a near-starvation diet."[9] It was true that the debacle in Southeast Asia had imposed austerities, but there was something else.

Secretary Carmichael had always been an unabashed enthusiast for the new museum, especially the technological displays and the way the building was wired as "a great exhibition machine." He was warmly supportive of Multhauf both professionally and personally; when Multhauf was enlisted as editor of the History of Science Society's quarterly journal *Isis* in 1963, Carmichael blessed the union, calling it "a great compliment to Dr. Multhauf and through him to the Smithsonian."[10] Ripley's relationship with Multhauf was much different. As Ripley saw it, even with a curatorial staff "the equivalent of a full-fledged university [history] department" and designers who were "probably the best in the nation," Multhauf had not managed to avoid exhibits of machinery that were "shiny and new looking." What Ada Louise Huxtable saw as "the real thing," to Ripley only looked "pretty and nice."[11] The ethnologist Ewers was an ideal second-in-command, and Taylor had long envisioned him in the director's office after the new museum opened. But Ewers was overwhelmed by the demands

of the top job—Ben Lawless tells of seeing his desk literally papered with unanswered phone-message slips—and he had to be relieved after only a year amid rumors of a breakdown. Ewers returned quietly to a long career in the Museum of Natural History, following much the same pursuits as before Taylor tapped him to help plan the new museum.[12]

As for Taylor, he filled in at MHT while a search was conducted by a committee headed by Charles Blitzer. Ripley had his sights set on a high-profile scholar, his first choice being Lynn White Jr., who had written a book that took the understanding of technology in history to a new level of sophistication. But in 1965 there was a falling out between White and Ripley (the particulars are unclear), and the only viable candidates were "insiders," including Bedini, Washburn, and Multhauf. Ripley preferred Multhauf to any of the others—Bedini being a superlative curator but with no college degree, Washburn with a golden academic pedigree but an overinflated ego and no genuine interest in the museum except in settling old scores. So Multhauf would have to do for a while, but Ripley continued to keep watch for an available eminence from the academic world, perhaps someone anxious to escape the chaos that beset college campuses nationwide as the war escalated.

As director, Multhauf found so little room to maneuver around budgetary constraints—shades of the old days in A&I—that he elected to spend nearly a third of his tenure on leave, sometimes at the Deutsches Museum in Germany. He got no argument from Ripley, who made sure that important decisions were up to his confrere Blitzer. Blitzer would loom large in MHT affairs for more than a decade, the relationship often chilly. Unlike outside critics such as Huxtable, neither Ripley nor any of his "bright young men" (Multhauf's less-than-respectful expression for Ripley's assistant secretaries, who seemed to be of "a certain type") liked the new exhibits. They found it impossible to resonate with the idea of machines as works of art (the 1401 had been brought to a high polish before it was donated, its driving rods gleaming as if silver-plated, and even the uninitiated knew there was something "unreal" about its appearance). They believed that the proper role of museums was not to glorify gleaming machines but to "exploit the wide social relevance of knowledge." Ripley himself sometimes spoke of MHT as "Carmichael's museum," measuring it against Mexico City's Museo

Nacional de Antropología (MNA), which opened at almost the same time. MHT should have been a great museum but was not.

The comparison with MNA was unfair because the collection of pre-Columbian artifacts on display there was beyond any compare, and certainly beyond compare with what happened to be in a nation's attic. Multhauf had quickly found out what Taylor had long known—that the Smithsonian collections had none of the rich temporal diversity of the collections at London's Science Museum or any of the great continental museums. In an attempt to allay Taylor's fear about being perceived as just doing "more of the same old thing," Multhauf commissioned replicas of many sorts of antique devices—a fifteenth-century magnetic compass; a seventeenth-century mariner's astrolabe, reflecting telescope, and vacuum pump; a nineteenth-century planetarium. A seven-foot armillary sphere, a device of Tycho Brahe's that modeled astronomically important objects in the sky, was displayed so as to command the vista down the main corridor to the east of the pendulum.[13] Regarding concerns about social relevance, Taylor would later concede that he did not "believe . . . any of us had the background or experience to think in such terms." Yet he and Multhauf were both determined to steer clear of intimations about technologies of the past being merely a prelude to the present, a misperception that was prevalent in museums and popular histories. (Otto Mayr spoke in amused tones of books with titles like *From the Dugout Canoe to the Queen Mary*.) Nowhere was there a suggestion that older devices merely "led to" more sophisticated devices.

Moreover, the accusation often heard in the 1980s, that the museum had never paid attention to the dark side, is dispelled by a glance at some of the original labeling, in the armed forces hall at least, where one could read of Indian treaties being "ruthlessly violated" and the "all-out campaign of extermination" in the Seminole Wars. But there was no getting around the assumption that anything on display was being *affirmed* simply by virtue of being there "in the Smithsonian." And it soon became clear that any labels that were not smilingly bland and affirmative were likely to elicit expressions of annoyance. Even bland labels could do so: "Stick to the display of old dresses," a disgruntled visitor demanded in a letter to the *Washington Post*.

At one point Peter Welsh—who took over the faltering *Growth of the United States* when Anthony Garvan returned to his University of Pennsylvania professorship full-time—considered the possibility of acquiring a "railroad-flat slum dwelling" for the planned unit on the late nineteenth century, to convey something of "the long history of poverty" and the human cost of pell-mell industrialization and urbanization.[14] Nobody was surprised when Lawless warmed to the idea. Or Ripley, who wanted to dispel the "myth that all our ancestors were upper middle-class Protestant whites who lived like ladies and gentlemen."[15] It seemed to the secretary like "a splendid opportunity to put into practice many of the ideas we have thought of involving sounds, smell, and touch." And Charles Blitzer decided to appropriate the idea as his very own, saying "it just struck me one night that in fulfilling its responsibility a museum should show the seamier side of life." Excited about the prospect of exhibiting something so "real" ("I hope we can have rats living in the walls," he added as the idea grew on him) in order to offset "all those beautiful, gleaming machines," Blitzer repeated the sentiment in an interview for *Science* magazine: "it's the nasty side of life we're in danger of losing today."[16]

It was a remark all-too-readily misinterpreted, and critics of all sorts had a high time. An MHT curator: "Wonder if we should put up a Big Mary's sailors' flop-house with 'girls' and all," Howard Chapelle asked in a note to his pal Virginia Beets, Frank Taylor's administrative assistant. A *Post* letter writer: if the Smithsonian truly had "a responsibility to show everything," as Blitzer claimed, "can he afford to overlook the brothel, the abattoir, or the privy? How about a hanging, or better, a lynching?"[17] A *Star* editorialist: "One does not enshrine inventions that failed, or publish anthologies of the world's worst poetry. Let's concentrate on wiping out the ghettos, not memorializing them."[18]

Aghast at "the Smithsonian's worst press to date," an acolyte of Ripley's advised him to "avoid the association of your name with the scheme." He did so at once, as did Lawless, Welsh, and Blitzer (Blitzer came out of the fray with a new job title, however—no longer the Smithsonian's "director of education and training"). There would be no celebration of "the total culture," although the slum-dwelling tale kept reverberating nationwide for some time, even making it into *Life* magazine.[19]

This episode of course had echoes in the *Enola Gay* debacle, a proposed exhibit thwarted because of a public controversy (though with none of the comic-opera overtones of the "slum dwelling"). There would be other controversies in the 1990s involving exhibits that were already open to the public—with *The West as America* and with *Science in American Life*—but these were nothing new either. Right after the armed forces exhibit opened in 1965, for example, it fell under attack by an assistant professor at the University of Baltimore, Gerry Rolph, who wrote Ripley to say that he was shocked by the "staggering" number of "historical mistakes," thirty-one of them all told. The exhibit was largely the work of Mendel Peterson, a favorite of Ripley's, and Ripley came right to its defense, seeking affirmation from a distinguished committee of military historians, and he gained it readily. The exhibit, wrote Theodore Ropp of Duke University, "will surely leave even the most sophisticated visitor with strong impressions of its accuracy, meticulous craftsmanship, and careful chronological arrangement."[20] So much for young Rolph. But only a few days afterward, different questions of accuracy were being raised, this time in baldly threatening terms and by parties of real consequence.

■

TWO YEARS AFTER MHT OPENED, production of about half of the planned exhibits was not yet begun. Still, two dozen exhibits were open to the public, and for Multhauf that was a notable accomplishment; to take a "hall" from a preliminary proposal to a gala opening involved a sprawling central and supporting cast, with cross-purposes inevitable. "Scripting" could be painfully slow because many curators struggled with the challenge of compressing information into the prescribed length for "secondary" labels and "main" labels, much like what were later termed sound bites. (Eventually, the boundaries for length would be liberalized.) For assistance with scripting, Multhauf had contracted with several consultants with a flair for this kind of writing. One of his stalwarts was Yale's Derek Price. Another was Robert Chipman, chair of the Department of Electrical Engineering at the University of Toledo and, like Price, a charter member of Mel Kranzberg's Society for the History of Technology. It was Chipman

who scripted the museum's exhibit about the telephone, working in tandem with James King, yet another founding member of SHOT, who had been hired as curator of electricity in 1956, one of Multhauf's earliest recruits.

Multhauf was disappointed when King accepted a job offer from the American Institute of Physics after completing his Cornell doctorate in 1962, but for the *Contributions* series he did leave behind a three-part monograph on early electrical technologies, richly illustrated and overall quite an excellent piece of scholarship. King had included a history of the telegraph and the telephone, which paid considerable attention to Alexander Graham Bell's storied competitor Elisha Gray as well as to Bell.[21] So did the MHT exhibit. Not long after this exhibit opened, one Mrs. Joseph Jones had "inspected" it and "reported a number of objections" to her husband, Dr. Joseph Marion Jones. No obscure junior professors here, as with the conflict over the military exhibit. Lilian Jones (née Lilian Waters Grosvenor) was the granddaughter of Bell, and one of her brothers was Melville Bell Grosvenor, president of the National Geographic Society and the trustee of Bell's heritage in the upper reaches of the American pantheon.[22]

Although he had no role in developing the telephone exhibit, it was now the responsibility of Barney Finn, who arrived at MHT in 1962 as King's replacement. At age thirty-one, Finn was a year out of the PhD program in the history of science at the University of Wisconsin. Multhauf always urged his new curators to get serious about research and publication. Some responded quickly, some slowly, but in 1965 Finn finished the draft of an article for the new *Smithsonian Journal of History* based in part on Bell's notebooks in the Bell Room at the National Geographic. Multhauf told him to send it to Grosvenor for comment. Grosvenor passed it on to his sister and her husband, Dr. Jones, whom he regarded as authorities on Bell's contests over patents. They in turn reported that "only the informed and exceptionally diligent reader [could] avoid questioning the importance of Mr. Bell in the invention of the telephone." This led them to visit the exhibit, which confirmed Lilian's impression that it was "depreciatory of Mr. Bell's role in the invention of the telephone."[23]

Specifically, they objected to a label that seemed to allow unwarranted recognition to a German, Philipp Reis, for "transmitting voice" in the

1860s and to a main text titled "Alexander Graham Bell and Elisha Gray." "Whether it be a presidential race, or a horse race, or an invention race," Dr. Jones declared, "history seldom gives equal billing to the winner and the runner-up, and I submit it is not fair to do so with Bell and Gray." "From beginning to end," he concluded, "the Smithsonian exhibit reflects the host of unwarranted claims made against Bell, claims disallowed repeatedly by the Courts, and thus distorts history."

In a seven-page critique, Jones expressed his concerns directly to Grosvenor, who conveyed a copy to Finn, who knew that he had plenty of evidence to dispute what Jones had written. What mattered as a legal issue could mean something quite different to a historian or could mean nothing at all.[24] Indeed, there *was* evidence that Reis transmitted a human voice, and Finn could cite a book by the eminent electrical engineer Sylvanus P. Thompson titled *Philipp Reis: Inventor of the Telephone*; and yes, Gray's work *was* significant, particularly in illustrating "how two men will follow virtually the same technical road independent of each other." Historians of technology had no doubt that this happened and happened often, but when Jones phoned to discuss the matter, all he heard from Finn was a recitation of "stray wisps of claims, [all] disallowed by the courts." Whereupon Jones "opened up" with threats seldom if ever heard before by anyone at the Smithsonian:

I warned Finn that . . . he should be fully aware of what he was getting into: That after all that had happened, the descendants of Mr. Bell were not going to stand by idly and see Alexander Graham Bell's effort to protect his reputation go down the drain, that they were prepared to go to any lengths to prevent it—to [Finn's] superiors, to Congress, to the courts, and if necessary to the press.

By the time Smithsonian people heard a similar outburst about the *Enola Gay* in 1994, everyone was quite mindful of what could happen when someone "went to Congress" and what it meant to get "bad press." Even in 1966 this was not a threat to be taken lightly. But for a while the threat passed, with the Joneses under the impression that a new telephone exhibit was in the works.

So imagine Lilian's dismay when she visited the museum a year later

and found little change that amounted to anything. She composed a letter to Multhauf, now the director, which assumed an even more intimidating tone than her husband's. Yes, "some of the most objectionable panels [labels]" concerning Reis were gone. But "the basic grossest errors" concerning Gray's part in the story were still there, just as before. After her husband called Finn and got no assurance that anything was going to be fixed—or even that a new exhibit would not be "similarly biased"—it was Mrs. Jones who "opened up":

> It is deplorable that a great national museum should grossly distort the history of a major American invention and that specific errors should misinform the public so long after they are pointed out. This question naturally arises in our minds, and in the minds of many who have seen the telephone exhibit and with whom we have discussed the problems: If in the Smithsonian such perversions of history can occur with respect to the telephone, how often does it occur in other exhibits?

Mrs. Jones followed her accusations about "perversions of history" with the threat of a "full-scale review" (the remark quoted in the epigraph). In the 1990s, such threats would send the Smithsonian into a tailspin. Although he was almost always unflappable, Multhauf could see a need for damage control, especially after a letter he wrote to plead for the virtue of exhibits that paid attention to "the contributions of persons other than the 'immortals'" just got the Joneses more incensed. He immediately wrote them again, this time to promise that he was arranging to have the matter arbitrated by independent experts.

Multhauf called in a chit with SHOT patriarch Mel Kranzberg, whose close association with the Smithsonian—an association that Multhauf had taken care to facilitate—had been instrumental in getting the new society on solid footing. Kranzberg understood the problem and was soon riding to the rescue as chairman of a committee of notables and with an announcement that "the Society for the History of Technology is pleased to have the opportunity to be of service to our national museum and to interested citizens, in our effort to further knowledge and understanding of the history of technology." Kranzberg first suggested to Multhauf that the committee might regard complaints from the Bell family "as a histori-

cal problem" in itself, and Multhauf knew what he meant. (Parties like the Joneses would later get termed "stakeholders," and their views would sometimes weigh heavily regardless of their actual merit.) But Multhauf responded with an admonition to stick to "the question at hand," whether the invention of the telephone was a simple and straightforward matter or whether it "contains one or more neat little historical problems."

The Joneses were still agitated about the views of "professional academic iconoclasts" getting mirrored in "a national museum of the United States." But they welcomed the prospect of an investigation by a "distinguished and highly qualified" committee. And distinguished and highly qualified it certainly was. There was Kranzberg himself, a professor of history at a well-regarded Midwestern engineering school and the editor-in-chief of a well-regarded quarterly, *Technology and Culture*; there was Bern Dibner, an accomplished electrical inventor in his own right; there was Thomas Hughes, a professor who had just finishing a biography of Elmer Sperry for the Johns Hopkins University Press and was the foremost authority on the history of electrical engineering; and there was Cyril Stanley Smith, Institute Professor at MIT with a joint appointment in metallurgy and the humanities and—as Kranzberg put it, not exaggerating—one of the world's outstanding experts "on the history of technology in general." No professional academic iconoclasts here.

The task, as Kranzberg put it, was "to satisfy all the parties involved, or at least not widen the rift between the academic community and the Establishment." Finn had been tinkering with the labels, and by the time everyone had examined the evidence, the Joneses conceded that most "explicitly slanted" statements had been deleted—and yet they still saw *"an almost total reluctance on the part of the Museum to give witness that Bell invented the telephone."* Privately, Smith remarked, "I like the tone of the exhibit and think that it gives a good picture of the environment in which the invention occurred and the many different schemes that were tried before the commercially successful solution appeared. It would be quite wrong to show Bell alone and not reflect other peoples' claims." And it would surely be wrong, Smith added, if Bell "as an American and a regent of the Smithsonian, should be excused from historical criticism."

But no such provocative language appeared in Kranzberg's final report,

delivered in the spring of 1968. First, there was a bow to the museum: "We are particularly pleased that the exhibit shows certain aspects of the history of technology which are sometimes lost sight of by the public and even by some historians themselves. These include concepts of simultaneity of invention, the many problems involved in translating an idea into a workable device, and the description of how many people of different nations contribute to an innovation." Then, a bow to the critics: "Nowhere in the exhibit is it unequivocally stated that Bell actually produced the first practicable instrument and that the subsequent development of the telephone derived from improvements on Bell's original invention." Kranzberg went on to educate everyone about the signal import of the "developmental factor" and then to affirm that "Bell was the 'effective inventor' of the telephone and that the subsequent growth of the telephone followed from his effective invention."

The Joneses were dazzled. Such "a splendid contribution toward a solution of the problem," Joseph wrote in July 1968. Such "generous words about our work," replied Kranzberg. "We committee members learned a great deal from our investigations of this interesting and complex problem, and, to judge from the response of the Smithsonian, it is evident that our report will lead to a more comprehensive and hence more accurate exhibit on the development of the telephone." It would be years before there was a comprehensive exhibit, but Finn did put together a temporary exhibit concentrating on the year 1876 and featuring Bell's notebook entries and experimental equipment. As for Mel Kranzberg, he had proven himself a master of tact, persuading the Joneses that the Smithsonian *was* a worthy home for national treasures, that indeed it *was* the leading institution for research and expertise in the history of technology—and thereby quelling threats about anything like a "full-scale review." He had also staked an impressive claim to serving "the cause of historical scholarship and our national museum." And surely he had repaid a debt incurred for the times he had invoked the cachet of the Smithsonian connection on behalf of the Society for the History of Technology.

■

LOOKING BACK, IT IS EASY TO SEE that the Museum of History and Technol-
ogy and the Society for the History of Technology were linked at birth.
Ground was broken for the museum in 1958 only days after the society
was chartered in Cleveland, and the society's first meeting took place
at the Smithsonian that winter. Within a short time there was evidence
of a vital alliance, a *synergy*, and after Kranzberg had saved the museum
from a lot of embarrassment, or worse, there was talk in the Castle about
the museum being the "natural home" for the society, or certainly for its
journal. This was quite in accord with Ripley's vision of the Smithsonian
as "a great university" and ultimately he would provide the journal with
a home in the museum. But that was long afterward. During his first few
years as secretary in the late 1960s, he had a more pressing priority for
MHT. In the director's office, behind the glass doors on the fifth floor, he
wanted to see a senior academic, a Pulitzer Prize–winner maybe, a man
widely connected in the world of ideas, perhaps even connected politically
(the high-profile historians in recent presidential administrations rendered
such hopes plausible). Ripley was quite aware that Multhauf had done a
good job during the years the museum was coming together. So had Ewers.
And without Frank Taylor, there would be no MHT; everyone knew that.
But Ripley's ambitions far transcended theirs, far transcended Leonard
Carmichael's, and now he felt certain that the museum needed a far dif-
ferent sort of man than any who had taken the lead previously.

Nobody could have filled the bill better than Daniel Boorstin. Boorstin
was known to professional colleagues and even among the general public
as a historian who took technology to be a central element in American
history, and he was surely well connected politically—to several impor-
tant people in the Nixon White House, Daniel Boorstin was "Dan."
When Boorstin first came to Washington and opened talks with Ripley
and Blitzer, with Multhauf sitting by, his ostensible aim was to land an
appointment as a resident scholar, with MHT a place of quiet where he
could write the final volume of his trilogy *The Americans*. He had received
the Bancroft Prize for the first volume, *The Colonial Experience* (1959),
the Frederick Jackson Turner Prize for the second volume, *The National*

Experience (1965), and surely there would be a Pulitzer for the third, *The Democratic Experience*. But soon enough it was clear to Ripley and Blitzer that Boorstin was intrigued by the idea of becoming director, and when asked what he thought, Multhauf had to say that he liked the idea of a specialist in American history and of Boorstin in particular.[25] Things began to move quickly. Never having relished the administrative work he encountered as director, Multhauf happily accepted Ripley's offer of an assignment that was much like what Boorstin had originally come to discuss for himself, "senior resident scholar"; it was a job he would keep until retirement, nearly twenty years later.

When Ripley thought of bringing in a distinguished academic historian, whether or not this man would involve himself in actual administrative work was not an issue. Bedini had filled in for Multhauf twice, one time for more than eight months; besides, Ripley expected that important decisions would be his and Blitzer's anyway. But Ripley wanted more than a figurehead and was immensely pleased when it became clear that Boorstin had a vision for the exhibit program. He wanted exhibits based on narratives of the same sort that crowded the first two volumes of *The Americans*, narratives about inventive Yankees, about the "democratization of daily life." *Narratives* they would be; stories, not "halls." Exhibits would not exist simply because there happened to be a collection of this or that; objects from collections would be displayed, of course, but in the role of illustrations. Like books, exhibits would have a beginning, middle, and end, and by various means visitors would be encouraged to take them in a prescribed order.[26]

There was nothing original about this idea: Taylor's 1953 brochure had foretold exhibits with names like "The Impact of Mass Production on Daily Living." But Ripley knew (and regretted) that "story-based" exhibits had rarely been conceptualized with much success, not even in *Growth of the United States*, developed in Tony Garvan's keen mind and by the institution's premier designers. Now, Boorstin seemed to have the ideas, the imagination, and the ambition to mount exhibits that would fulfill "the solemn responsibility of the Smithsonian to reveal the social history of our nation."[27]

Boorstin's narratives were celebratory and patriotic, and they had an

unmistakable point of view: "American exceptionalism," a freighted expression to this day. He would draw in students and protégés who shared his passion for such narratives, and together they would stage, or lay the groundwork for, some of the most dramatic and educational exhibits the museum would ever produce. They even pleased Ripley and his boys in the Castle. But there was a splendid irony. As academic employment opportunities dwindled in the 1970s, more and more new PhDs would find their way to the Smithsonian and get jobs different from what they had once imagined in academe, just as with Robert Multhauf in the 1950s. They would embrace the new narrative conventions fostered by Boorstin but not necessarily his unflinching patriotism or his aversion to identity politics or to looking at "the limits of our achievement." Because their professional loyalties were with academe, exhibits would entail a fairly direct (one might say inevitable) progression from stories of celebration to stories with a bit of a critical edge to stories with considerably more. In the 1980s, an exhibit about black migration from the South would confront visitors with the degrading demands of racial segregation. Another exhibit would mark the bicentennial of the American Constitution with the story of a constitutional travesty, the World War II imprisonment of Japanese Americans, citizens of the United States.

All this happened long after Boorstin left the Smithsonian, and long after he took much note of what was going on there. But one day in 1991, he paid a visit to *The West as America: Reinterpreting Images of the Frontier, 1820–1920* at the Smithsonian's National Museum of American Art. There, he saw "extensive wall texts" (as the *New York Times* put it) telling how classic art and imagery aimed to further the ideology of Manifest Destiny. "Artistic representations of Indians developed simultaneously with white interest in taking their lands," read one of the main labels. "At first, Indians were seen as possessing a natural nobility and innocence. This assessment gave way gradually to a far more violent view that stressed hostile savagery." Although the exhibit's interpretation was squarely in the mainstream of the New Western History pioneered by Howard Roberts Lamar at Yale (a colleague of Blitzer's before he departed for the Smithsonian), to Boorstin it all shouted political correctness run amok.

There was a blank book in which people were invited to express their

reactions, and Boorstin did so. Soon his comments about the exhibit being "perverse," "destructive," and "no credit to the Smithsonian" made it into the *Washington Post* and into the halls of Congress.[28] Maybe it *was* perverse, one could use that word, and one could definitely say "preachy," as the critic for the *Times* put it.[29] But most notably it was a *narrative*, not a Hall of Western Art. It was a narrative with a beginning, middle, and an end, with a point of view, exactly what Boorstin had told Ripley, more than twenty years before, that Smithsonian exhibits needed to have: stories. One might say that Boorstin's chickens had come home to roost.

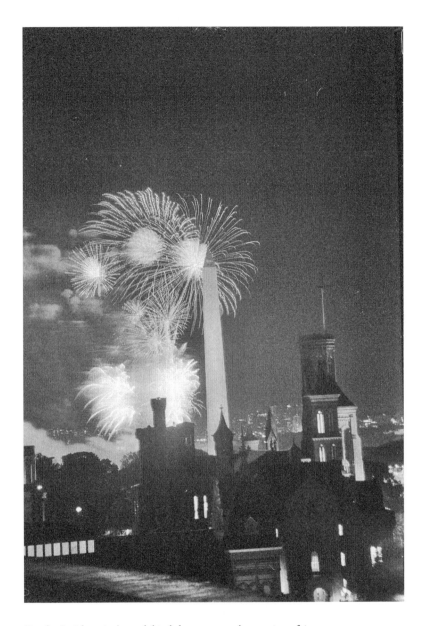

For the Smithsonian's 150th birthday party on the evening of August 10, 1996, fireworks light up the Washington Monument and the Castle.

SMITHSONIAN INSTITUTION ARCHIVES, IMAGE NO. 96-25380-35

Bronze statue of Joseph Henry, first secretary of the Smithsonian Institution (1846–78), and the "Carriage Porch" of the Smithsonian Castle. For more than eighty years following the statue's completion by sculptor William Wetmore Story in 1883, Henry faced the Castle. In 1965, Secretary S. Dillon Ripley turned him around to face across the Mall.

SMITHSONIAN INSTITUTION ARCHIVES, IMAGE NO. 79-12842-19

The United States National Museum, opened in 1880 and seen here at
the turn of the century, was renamed the Arts and Industries Building
after completion of the Natural History Building just before World
War I. It has kept that name, or just A&I, ever since.

Left, George Brown Goode, assistant secretary in charge of the National Museum, 1887–96. *Below*, his mentor, Spencer Fullerton Baird, Smithsonian secretary, 1878–87.

The induction ceremony for the first Copeland steam-propelled tricycle, built in 1888. The inventor, Lucius D. Copeland, is at the left, driving; the passenger is Frances Benjamin Johnston, later a noted Washington photographer. Standing at the right and facing the tricycle is J. Elfreth Watkins, Smithsonian curator of transportation, 1885–1903.

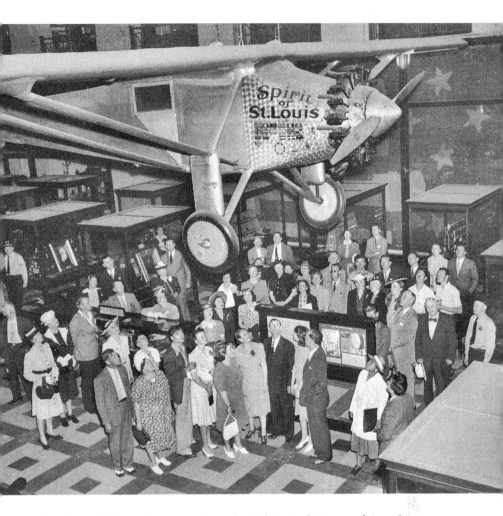

Opposite, seen in the early 1930s are the neoclassical National Museum of Natural History (*top*) and the so-called Tin Shed (*bottom*), the building between the Castle and Independence Avenue that had been intended as temporary but was later designated the National Air Museum.

Above, aloft in Arts and Industries with an admiring crowd below is Charles Lindbergh's *Spirit of St. Louis*, for many years the Smithsonian's prime attraction. To the right can be seen part of the Star-Spangled Banner, awkwardly folded.

Carl Mitman shares a laugh at his retirement in 1952 (*above*). Paul Garber, curator of the Aeronautics Division, is at the right. Mitman is pulling a long note from a miniature doghouse labeled "MHT" that reads, "Forty-one years is a heluva long time to serve an institution." Beside the doghouse is a fire hydrant labeled "The Budget." In Mitman's time, A&I's underfunding was readily evident in such exhibits as the unadorned ceramics and graphic arts shown below.

Classic Ben Lawless cartoonery. In "The Spill" (*top*), Robert Multhauf says, "Whoops," to Ben, whom he has just met for the first time, "that should be no problem to clean up!" Both caricatures are perfect. "The Finger of Blame" (*bottom*) was a device Lawless designed to take to meetings addressing exhibit planning and progress, or the lack thereof.

ORIGINAL ART IN AUTHOR'S COLLECTION, REPRODUCED WITH PERMISSION OF THE ARTIST

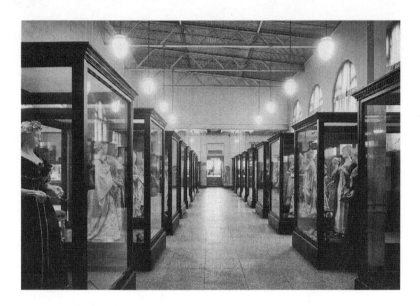

Costumes of the Mistresses of the White House (*above*), exhibited in monotonous rows of standard cases in the 1930s, and *Gowns of the First Ladies* (*below*), as the exhibit was re-created with all the features of modern design by Margaret Brown and Ben Lawless in the 1950s.

SMITHSONIAN INSTITUTION ARCHIVES, IMAGE NOS. 2010-2423 AND 44606

In a joyful image that appeared in newspapers nationwide, President Dwight D. Eisenhower and Mamie Eisenhower are seen at the opening of *Gowns of the First Ladies* on the evening of May 24, 1955.

SMITHSONIAN INSTITUTION ARCHIVES, IMAGE NO. 2002-10613

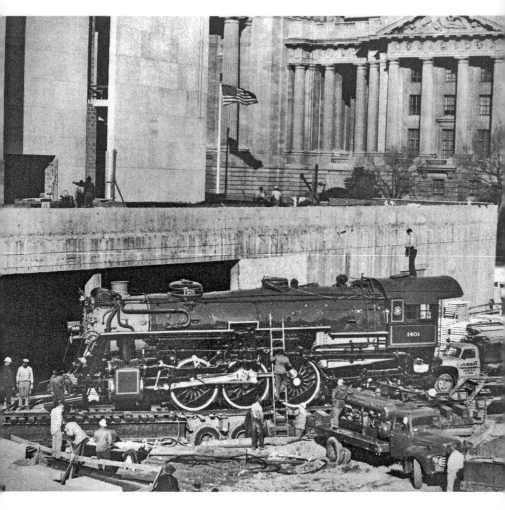

In 1961, the first artifact to be installed in the partially completed Museum of History and Technology, the 1401 locomotive from the Southern Railway, is moved in through the east-end picture window on the first floor.

Frank Taylor, seeing a forty-year dream materialize, stands on the fifth-floor terrace as the Museum of History and Technology nears completion in 1963.

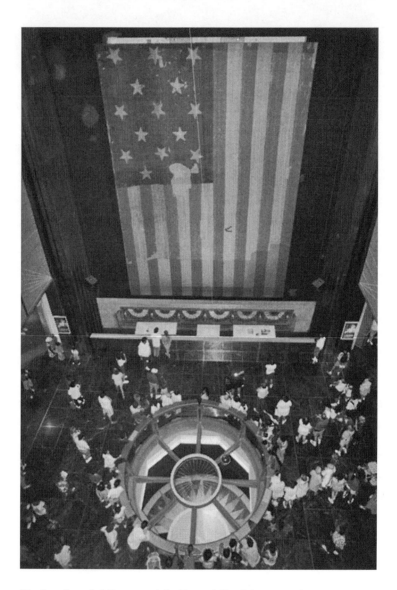

The Star-Spangled Banner and the Foucault Pendulum were the two signature artifacts of the Museum of History and Technology when it opened in 1964. Only the flag remained, displayed much differently, fifty years later.

SMITHSONIAN INSTITUTION ARCHIVES, IMAGE NO. 2008-2449

The classically styled Harlan & Hollingsworth steam engine, manufactured in
Wilmington, Delaware, on display in the Museum of History and Technology
in the 1960s. One of the author's first tasks as a museum employee was to set this
engine in motion once a day by means of compressed air and then tell the audience
about its history and technology.

SMITHSONIAN INSTITUTION ARCHIVES, IMAGE NO. 2010-3268

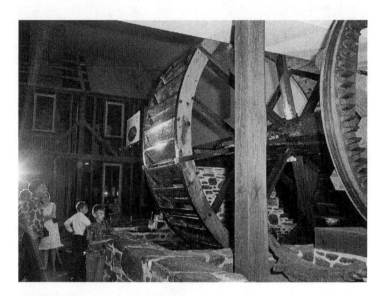

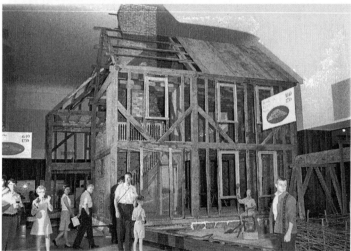

Scenes from the newly opened introductory unit of Anthony Garvan's *Growth of the United States*, 1967. The waterwheel (*top*) was from an eighteenth-century grist mill and the framing (*bottom*) was from an ancient residence in Ipswich, Massachusetts. Garvan's avant-garde thematic exhibit was destined for a short life, though the house would eventually become part of a different story.

SMITHSONIAN INSTITUTION ARCHIVES, IMAGE NOS. 2008-2220 AND 2010-3467

*The history of technology, one of the most dramatic
and most relevant chapters of our past, should have
a larger audience.*

—DANIEL J. BOORSTIN, 1965

CHAPTER 5 ▪ To Join in a Smithsonian Renaissance

When he delivered his inaugural address in January 1969, President Richard Nixon told the nation, "We have found ourselves rich in goods, but ragged in spirit; reaching with magnificent precision for the moon, but falling into raucous discord on earth. We are caught in war, wanting peace. We are torn by divisions, wanting unity." It was a whole country torn and wanting, of course, but the Smithsonian's Museum of History and Technology, whose opening five years before had provided Frank Taylor with the happiest day of his life, was in a predicament too. An exhibit program born in hopeful anticipation was disturbed by turf wars and chronically underfunded, and a director who had worked his way up from curator of engineering at the very dawn of the modernization program was seen by the Smithsonian secretary as a mere placeholder and was very likely feeling ragged in spirit. A week after the presidential inaugural, Secretary Dillon Ripley announced that in the fall Robert Multhauf would be turning the museum over to Daniel Boorstin, Preston and Sterling Morton

Distinguished Service Professor of History at the University of Chicago, where he had been a faculty member for twenty-five years.

Boorstin would be the first "outsider" in his position as director; following Carl Mitman, Frank Taylor, John C. Ewers, and Multhauf. Ewers and Multhauf were eminent in their own special realms of scholarship but none of the four was a household name by any stretch. Boorstin, by contrast, an urbane and prolific Rhodes Scholar, was, at age fifty-four, as famous as any historian in the world. A new book titled *Pastmasters* put him in the company of the discipline's Olympians—Francis Parkman, Frederick Jackson Turner, and Charles Beard—the author noting how his depth of knowledge in the history of technology "would be worthy of an expert."[1] Ripley could well take pride in calling Boorstin's appointment a "Smithsonian milestone" and expressing confidence in "the coming of age of the Museum of History and Technology as a national center for the study of our nation's history and the diffusion of knowledge in new and imaginative ways." (In praising the Museo Nacional de Antropología in Mexico City, Ripley had implied that MHT's exhibits were little more "imaginative" than in the old days in Arts and Industries.) For his own part, Boorstin spoke of the museum as "a place of liberation"—a place where "we can free ourselves from the provincialism of time and place." Here, he said, "we can see that things have been, and can be, otherwise."[2]

Boorstin was more aware than anyone else that the liberation could be his own, and no doubt he yearned for a place where things were "otherwise" than the way they had been during his last years on the campus at Chicago. It was not a happy time for many senior academics. And if not for an unreconstructed FDR liberal like Mel Kranzberg in Cleveland (he would lament to Multhauf, "I just sit down and cry—literally—about what is happening to our universities"), then certainly not for Daniel Boorstin. Boorstin had never been a foe of the welfare state, or even the leftist movements of the 1930s, which he called "an affirmation of community." But in the 1950s he was aptly described as "the political philosopher of American conservatism," and his contempt for campus radicals had suffused his 1968 *Esquire* article "The New Barbarians."[3]

Boorstin had once said of himself that he was not "a political person," and in *The Genius of American Politics*—the 1953 book for which the *Lon-*

don Economist dubbed him "the Burke of the Wabash"—he had deplored Cold War foreign policy: "Nothing could be more un-American than to urge other countries to imitate America," he wrote on the first page. The same year that *The Genius of American Politics* was published, however, Boorstin had been subpoenaed by the House Un-American Activities Committee (HUAC), a result of his student flirtation with communism, and he informed on his roommates from the 1930s while assuring the congressmen who questioned him that, no, their inquiries were not threatening academic freedom.[4] This was not a serious strike against him at the University of Chicago in the 1950s and early 1960s (he had dedicated his 1962 book, *The Image*, to the university as "a place of light, of liberty, and of learning"). But it would haunt him in the middle and latter 1960s, as the temper changed on nearly every university campus, even Chicago.

In his classroom lectures, Boorstin's young colleague Jesse Lemisch began citing his HUAC testimony "to illustrate the relationship between historical scholarship and political commitment."[5] Students for a Democratic Society denounced Boorstin, then *Radical America*, then mainstream reviewers of the second volume of his projected trilogy, *The Americans: The National Experience* (although it was also called "courageous, learned and most exciting" by George Dangerfield in the *New York Times Book Review*). After he lashed out in *Esquire*, everything at Chicago became an ordeal, even "faculty-club luncheons and the afternoon teas." Boorstin still had close friends on the faculty, William McNeill and John Hope Franklin among them, but he realized that he would need to start looking for "a place of liberation" and probably it would be somewhere beyond academe.

Liberation was what Boorstin hoped he had found when he met with Ripley and Charles Blitzer in the secretary's office, early in 1969, to talk about the possibility of a research position at MHT then ended up getting an offer to become director of one of the most popular museums in the world. Multhauf was in the meeting, too, and he recalled that Boorstin showed an unexpected "thirst for action," while Blitzer warmed to the prospect of having his "own man."[6] It took no more. Multhauf got the research appointment that he preferred to administration anyway, and Boorstin's only stipulation was that he have his mornings free from administration to work on his book.[7] Eventually he took over the museum's

east conference room, had it decorated to his taste, with the walls painted orange, and furnished it to accommodate a writing desk with "his trusty old Olympia," as well as space for his research assistants and private library. A man of humble origins (high school in Tulsa, Oklahoma, like John Hope Franklin) but towering ambition, as he was writing the third volume of *The Americans*, he had his eyes set on a Pulitzer the whole time.

Because of his enthusiasm for such topics as balloon-frame construction, condensed milk, and ready-made clothing, Boorstin was sometimes taken to be a lightweight. But his experience went back to a double first at Oxford, admittance as a barrister-at-law (with a wig) of the Inner Temple, London, and a Yale JSD. Most recently he had been honored with a Cambridge LittD, and he spent much of 1969 as senior fellow of the Henry E. Huntington Library in San Marino, California, where the ambience of the reading room evoked Cambridge or Oxford. This was no lightweight. He had thought deeply about American history, and as director of MHT he was far more opinionated about political matters than any of his predecessors. (Even though the museum was born amid Cold War rhetoric, it is unlikely that these men ever considered it a "political" place at all.) This was quite evident in Boorstin's remarks the day before he settled into his office on the top floor of the museum, with a view of the Castle across the Mall, the Washington Monument to the west, and the Capitol to the east:

At any time it would be an honor and privilege to join the Smithsonian Institution. It is a very special pleasure to come to join in a Smithsonian Renaissance under the inspired and elegant leadership of Dillon Ripley. But there are some features of our age which make it more than an honor, a privilege, or a pleasure, and have made it a duty and a challenge to come to the directorship of the great National Museum of History and Technology. For in our country today this is an age of apology, or self-denigration, and even of self-flagellation. We have come to believe, to advertise, and even to act upon the most uncharitable judgements of our country and our civilization . . . We have become obsessed with the limits of our achievement and have almost forgotten its extent.

The year 1969 saw Woodstock, the draft lottery, Chappaquiddick, "civil unrest." Historian Peter Novick wrote of 1969's "collapse of comity." In

November, a quarter of a million men and women would march through Washington to protest the war in Vietnam, and the U.S. Army would announce that Lieutenant William Calley had been charged with murdering civilians in the Vietnamese hamlet of My Lai. Boorstin felt an urgent need to counter a growing crisis of confidence with bold affirmation, to reclaim America's narrative: "Here we emphasize the positive. Without denying our failures, we underline and dramatize our successes."[8]

Given his reference to "our country and our civilization," Boorstin's first order of business was already clear. In his opening remarks he had added the word *National* to the museum's name, and soon it would be official: the National Museum of History and Technology (NMHT). This was fine with Ripley and Blitzer, and with Frank Taylor; indeed, Taylor had been wondering whether that might be a more suitable name. But another early move of Boorstin's was of a different sort and could have been interpreted as a declaration of independence from those three men, all of whom outranked him in the Smithsonian hierarchy, Blitzer as assistant secretary for history and art; Taylor as director general of an administrative entity called the United States National Museum, which included NMHT, Arts and Industries, and the Museum of Natural History; Ripley the secretary as the sovereign in his Castle. Before Boorstin arrived, Ripley had been repeatedly urged "to provide a more accurate acknowledgment of the role of the Afro-American in the national history," and—with Blitzer and Taylor in full accord—he had approved funds to develop an exhibit called "The Afro-American Experience," with the intention of it becoming a segment of *Everyday Life in the American Past*. Silvio Bedini, newly promoted to assistant director, supervised the project. Malcolm Watkins and other curators in the Department of Cultural History were involved, and the actual research and writing was in the hands of a young African American named Carroll Greene, who held a fellowship in museum studies through George Washington University. Bedini called the exhibit "a major priority in this Museum," underscoring Ripley's confession that "we have failed to give the true picture, to describe the whole panorama of our cultures."[9]

But shortly after arriving, Boorstin looked at Greene's script and canceled everything, saying (as Bedini recalled) that he was "not inclined to acknowledge the Afro-American in a separate exhibit" until such time

as the museum was "ready to proceed with exhibits . . . relating to other minorities and ethnic groups, such as the Jewish and Puerto Rican."[10]

Everyone understood that this was not going to happen. Local community activists interpreted the demise of the Afro-American History Project as, at best, an insensitive reaction to a change long overdue. In 1967, Ripley had established the Anacostia Neighborhood Museum in an old four-hundred-seat theater in Washington's 80-percent nonwhite southeast quadrant. That might have been interpreted as tokenism, yet Ripley had argued that the men and women, boys and girls, of Anacostia were intimidated by any "vast monumental marble palace" on the Mall, and the answer was "to bring the museum to them."[11] The rehabilitation of the theater became a top priority for John Anglim and Ben Lawless, the design of exhibits was determined in "long and prayerful meetings" by a local advisory council, and funding came from several foundations. As director, Ripley named John Kinard, whom he described as a "vigorous and decisive . . . thirty-year-old native Washingtonian who has worked in the Neighborhood Youth Corps and the Office of Economic Opportunity."[12] Ripley wanted visitors to the Anacostia Museum to get a sense that they *should* come see the "marble palaces" on the Mall, and two years later he invited the residents of Resurrection City—the name given Ralph Abernathy's Poor People's Campaign—to come in and use the facilities.

Still, Greene remarked that when he arrived, the Smithsonian library contained "fewer than twenty books on, by, and about African Americans." So, there was the Anacostia Museum over in Southeast, but there would be no exhibit of the Afro-American Experience at NMHT, on the Mall? Baldly racist? That was the charge the Congressional Black Caucus levied against Boorstin during confirmation hearings when President Gerald Ford nominated him as Librarian of Congress in 1975. It seems likely that Boorstin knew the script drafted by Greene (whose formal credentials were vague) would not have passed muster with "acknowledged scholars in the field of Afro-American history," surely not with his lifelong friend John Hope Franklin. Nor did racism necessarily follow from an aversion to identity politics; it could be quite the opposite, and if there was one theme that ran throughout Boorstin's trilogy, it was American pluralism.[13] Yet so many questions remained. What to make of his contempt

for abolitionists, Reconstruction, or Black Studies? In the book for which he won his Pulitzer, Boorstin denounced "the 'Black is Beautiful' mania" and "a flood of books and series of books, many of which had little or no scholarly or literary value."[14]

Even as he was being ranked among the "Pastmasters," Boorstin's philosophy of history, his sense that in the United States ideology could only be an ill-suited intrusion into political discourse, was being dismissed as naïve, if not perverse. But even a stern critic conceded that Boorstin had "an exceptional gift for discerning in the variegated aspects of life a distinctive American style, for explicating the significance of American pluralism and the American Pragmatic cast of mind." This was Richard Hofstadter in *The Progressive Historians* (1968), a book of uncommon wisdom and insight. A few years later, in "The Boorstin Experience" (a play on the titles in Boorstin's trilogy), another scholar could write that Boorstin was "passé among most professional historians" but add that he ably addressed "aspects of American life that have heretofore received little serious attention from other scholars."[15]

■

ONE OF THOSE SORELY NEGLECTED ASPECTS was technology, and even if one agreed with Hofstadter's remark that Boorstin never confronted the problem of conflict in American history but "simply abandoned it," there was no denying his originality and the possibility that he was exactly the right man for the National Museum of History and Technology just as it was emerging into its adolescence after an uneven beginning. Multhauf was quite sincere when telling Boorstin of his pleasure that "the museum should now have a director who is a specialist in American history." He also advised Boorstin to get his curators directly engaged with exhibits, lest they become (as he had seen happen when he was director and funds dwindled) "restless and troublesome."[16] But now that "putting objects on shelves in glass cases" no longer sufficed, not every Smithsonian curator knew how to play a constructive role in creating a good exhibit, a skill with limited opportunities for formal training.[17] In the Museum of Natural History "exhibit work" was not even part of curators' job descriptions.

At NMHT, Boorstin's task would be to identify and tap people who were truly up to the challenge. They might already be on the staff, for needless to say, no curator, no designer, had ever imagined an exhibit that would strike visitors as dull or that would suggest "uncharitable judgements of our country and our civilization." But right off, Boorstin started hinting that more likely they would be people from outside who would "bring new ideas and fresh life into the museum community."

First he floated names like Oscar Handlin, Edmund Morgan, and Arthur Schlesinger Jr., but he soon found that the crème de la crème at Harvard and Yale was reticent about accepting formal overtures, and there was an embarrassing misunderstanding with Brown University's Carl Bridenbaugh. Still, Multhauf and many of his history-of-technology cohort must have been pleased when Boorstin also mentioned Peter Drucker (at NYU), Lynn White Jr. (UCLA), Cyril Stanley Smith (MIT), and Carl Condit (Northwestern), the first three past-presidents of the Society for the History of Technology and Condit in line for the job. Multhauf was especially encouraged when whose name should come up but Melvin Kranzberg, SHOT's founder, secretary, eminent mediator—the controversy over the telephone exhibit was still fresh in mind—and editor of its journal, *Technology and Culture*. The journal was now ten years old and, as it had been right from the start, rich in contributions from the museum: the Autumn 1969 issue featured a well-wrought article by Harold Skramstad, who had just finished his George Washington University dissertation as a Smithsonian fellow under the tutelage of Robert Vogel.[18] Now he was working for Wilcomb Washburn in his Office of American Studies. Boorstin had heard about "Skram" from Washburn and also from Kranzberg and invited him over to NMHT for a talk. He saw at once that here was a "keeper," and he offered him a job as a special assistant.

Boorstin and Skramstad had never met; Boorstin and Vogel had talked only once or twice. Boorstin and Kranzberg, on the other hand, went way back. In the early 1930s, Boorstin, three years older than Kranzberg, had been Kranzberg's counselor at a co-educational summer camp in Colorado. In 1965, they had been among the principals at the conference in Delaware, sponsored by the Institute of Early American History and Culture, that proved to be a signal event in linking the concerns of "generalists" and

specialists in the history of technology. As soon as Kranzberg heard about Boorstin replacing Multhauf, he sent warm wishes and expressed confidence that Boorstin would keep urging his curators "to participate fully in the activities of SHOT, to which they have already made such important contributions." And so he did. The first official reception Boorstin hosted was for SHOT during its 1969 annual meeting, tastefully catered, unfailingly polite, and with the Foucault pendulum as its quiet but compelling centerpiece—and this was even as the annual meeting of the American Historical Association uptown was being rocked by a radical caucus taking its cues, in large measure, from Jesse Lemisch.

Over the next few years, Kranzberg and Boorstin corresponded about many things, including a history-of-technology survey for the Chicago History of American Civilization, a book series Boorstin edited. (Kranzberg initially agreed to be the author but later suggested that there were "good young men" who could do a better job, having in mind junior scholars who had come out of his graduate program at Case.) Kranzberg also critiqued the manuscript for the final volume of Boorstin's trilogy, *The Americans: The Democratic Experience*, which would win him both a Pulitzer and SHOT's equivalent of a Pulitzer, the Dexter Prize.[19]

In Cleveland, following the merger of Case Institute and Western Reserve University in 1967, Kranzberg felt increasingly uneasy about a diminished status and, soon after Boorstin landed in Washington, he also began looking for a new home, for himself and for SHOT and its journal. Given the shared aims and interests, the synergy, the museum had long seemed like a natural place for the society's headquarters, and Kranzberg made it clear that he was "very interested in exploring the possibilities of transferring my operations to the Smithsonian." Early in 1971, he spent a morning with Blitzer and an afternoon with Boorstin, Bedini, and some of the curators whose articles and reviews he had published in *T&C*, and Boorstin reported to Ripley that "everyone who talked with Mel seemed to favor his employment." Kranzberg, for his part, came away with a feeling that he "probably could do a great deal [for the museum] in providing direction and dynamism," and he told Boorstin that he "was almost ready to be fitted out with an office and two secretaries then and there."[20]

Even though Kranzberg eventually accepted an offer from Georgia Tech

and took "his operations" to Atlanta, he never burned bridges, and in 1973 when Boorstin announced his intention to step down, Blitzer was again in touch, this time to ask Mel about his possible interest in the directorship. Not me, not now, I'm happy in Atlanta, Kranzberg told him (in so many words), but Brooke Hindle at New York University would be perfect. And that is indeed what happened, with Hindle taking over in 1974. Throughout the latter 1970s and into the 1980s, when *T&C* did come to the museum (as the editorial baton passed to me), Kranzberg would be a familiar presence around the curatorial offices and in the fifth-floor dining room, as were many other men, and now a few women, active in SHOT who were pursuing research, maybe as visiting fellows, or who had just dropped by for a chat with one or another of the SHOT stalwarts, such as Multhauf, Bedini, Barney Finn, Otto Mayr, Jack White, or Vogel.

■

FOR BOORSTIN, "ATTRACTING THE ABLEST and most imaginative established scholars" was only a means to an end: changing the tenor of the exhibits. They ought to be expected to publish, of course, but in that realm Boorstin probably thought of his own work as sufficient to keep the museum on the map. (Not until 2012 would there be a director who was nakedly unpublished, to nobody's apparent concern.) Exhibits were something new to Boorstin, however, and it was the exhibits he wanted to push "toward a more total and more vivid, a more personal, a more participatory and a more communal recapturing of man's experience." The sentiment could have been Ripley's: in his 1968 annual report, Ripley had written about the need to emphasize "the ordinary, everyday people who built the railroads, sailed the ships and drove as well as created the machinery ... we exhibit." Boorstin was interested in "dramatizing and explaining the careers of history-making Americans," famous or not, but even more interested in building exhibits around narratives that stressed the ways in which Americans were blessed because of their lack of concern for ideology and a shared enthusiasm for novelty—legal, educational, and especially technological.

As historiography, Alan Howard Levy remarks, the "consensus" school had roots in Robert Hutchins's ideal of "a common heritage capable of

embodiment in a university curriculum," an ideal embodied in the University of Chicago's Great Books program. It was the equivalent of "the Americana scenes of Thomas Hart Benton, the ballets of Aaron Copland, the plays of Thornton Wilder."[21] Or, Levy might have added, music played on coin-operated jukeboxes or the cartoons of Rube Goldberg in the daily papers. When Boorstin first met with Ripley he realized that they shared an apprehension of living in "desperate times." What the museum needed to do first of all was to provide "a vista for the future which can inspire hope and confidence." What better, for starts, than an exhibit of *Music Machines, American Style* and, even better than that, an exhibit of the work of the beloved satirist whose name was synonymous with ingenious (indeed, overingenious but hopeful) technologies. This exhibit, featuring original drawings, sculpture, and three-dimensional "realizations of some of the fantastic comic-page inventions," was called *Do It the Hard Way: Rube Goldberg and Modern Times.* The curator was Anne Castrodale Golovin, who had come to the Smithsonian in 1962 (on almost the same day as Barney Finn, as it happened) and for most of the time since then had been working on the bravely conceived but ill-fated *Growth of the United States.* Golovin also wrote one of the essays for the *Do It the Hard Way* catalog, along with Boorstin and Goldberg himself.[22] Others enlisted for the project were Robert Widder, soon to be named chief designer for the National Air and Space Museum, and Bob Klinger and Don Holst, the museum's model-makers extraordinaire, who built two machines that epitomized Goldberg's Law: "Men will always find a complex method for doing a simple task."

Do It the Hard Way was to have a major spin-off, an authorized biography of Goldberg, and that project Boorstin arranged to put in the hands of a newcomer to the museum who had been his student at Chicago, and also a student of Joshua Taylor, the scholar who became director of the Smithsonian's National Museum of American Art in 1970. His name was Peter Marzio. Years in academe had endowed Boorstin with a good eye for young men who were the brightest of the bright.[23] When he met Skramstad and immediately offered him a job, Skramstad was twenty-seven. Marzio was even younger. Skramstad's father was a scientist, an official at the National Bureau of Standards; Marzio was born on Governors Island when

it was an army base, brought up by his mother, and the first in his family to go to college—he had done it the hard way. Both young men came to the Smithsonian as predoctoral fellows; the fellowship program initiated by Ripley and first administered by Philip Ritterbush was yielding just the kind of rich reward they had imagined. Marzio finished his dissertation just as Boorstin arrived. He taught briefly at the University of Maryland, he worked as Boorstin's research assistant, and then Boorstin arranged for him to write *Rube Goldberg: His Life and Work*, along with assuming a position as assistant curator of graphic arts. What better assignment, Marzio later wrote, "to combine my interest in fine art, printing technology, and social history."[24]

The eminence of the museum's Division of Graphic Arts never wavered. When Jacob Kainen left in 1966, his replacement was Elizabeth Harris, who first established her expertise along lines similar to Kainen's, with influential articles about printing and illustration processes, and then shifted her scholarship to printing presses. Marzio came aboard in 1969 and worked side by side with Harris for nearly ten years, never ceasing to marvel that his colleague actually had "a doctoral degree in printing."[25] Marzio himself was invariably perceived as "someone with great opportunities" (as Hindle told him early in his own tenure) and for several reasons, not least his instincts about exhibits, all kinds of exhibits. He quickly persuaded one of the curators struggling with plans for an exhibit on American science "how uncertainly and inadequately [these plans] dealt with technology and practical art." Within a short time, he had completed work on an exhibit of his own about news reporting and then spent a year as a Fulbright Fellow in Rome before taking the lead in one of the museum's major bicentennial exhibits, *A Nation of Nations*. Clearly, Marzio was on a very fast track indeed, and three years later the Boston publisher David Godine would publish his book about chromolithography, *The Democratic Art*, which he depicted as "a technological accomplishment with a vibrant social presence." Like Skramstad, Marzio went on to a stellar career in museum management, at the Corcoran Gallery of Art in Washington and, after 1982, the Houston Museum of Fine Arts, which he transformed into one of the country's finest.[26]

■

IN HIS RUBE GOLDBERG BIOGRAPHY Marzio remarked, as an aside, that Boorstin had a great advantage coming to the Smithsonian because he "was a novice in the museum world," which had rarely considered exhibits "designed for laughter." An old hand, so to say, would not have thought of *Do It the Hard Way*. Or *Music Machines American Style*: even though there were few other electromechanical devices as spectacular, as emblematic of American ingenuity, as the jukeboxes of the postwar years—Wurlitzers, Seeburgs—such an exhibit would just not have occurred to Robert Multhauf, still thinking of missed opportunities with a "Hall of Iron and Steel" and a "Hall of Chemistry." What distressed Multhauf most was that some fully scripted exhibits of this sort had never been funded, even though he thought Ripley might have been able to do so. Multhauf's tone was typically wry, but he could sound bitter when it came to Ripley: "To see him even once a year," he once remarked to me, "I had to make an appointment."

Although they were both men of learning and letters, no two could have differed more in presence or comportment than Multhauf and Ripley, and Ripley had put Multhauf in the director's office of a brand-new Smithsonian showpiece with mixed feelings. But Ripley, along with everyone else, was certainly aware that, over the years, Multhauf had begun to imbue MHT with an exhibit philosophy different from that of any other museum. His protégé and successor as curator of engineering, Robert Vogel—a curator who believed deeply in the capacity of artifacts to "speak"—could write that "the current philosophy of the National Museum completely rejects the classical 'cabinet' technique of the museum exhibition by which a collection of relics and artifacts is simply placed before the public . . . with no attempt to relate the objects to one another or to any other parameter of interpretation." "A story must be told," said Vogel, "and told effectively."[27]

To Boorstin, the museum seemed to be hovering somewhere beyond the classical cabinet technique but not enough into "stories," even though there were possibilities beyond count. And for all the qualms among academic historians—many younger ones, anyway—about his role in fostering the notion of American exceptionalism, Boorstin was nothing if not

a good storyteller. Nobody who had ever read his classic explanation of "the democracy of haste" could ever doubt that.[28] More importantly, no other historian could match Boorstin in giving "the role of technology a place of central importance in . . . modern American social and cultural development." So read the citation he would get from SHOT when he was honored for *The Americans: The Democratic Experience*.[29] The moment was his. On display were Rube Goldberg and music machines, a Model-T Ford phaeton just inside the front door and, off to the left, a post office that had spent its first 110 years in rural Virginia (and, to the right, the best bookstore in town, for history anyway). Also, Boorstin had begun planning a blockbuster exhibit on American pluralism, the historical subject closest to his heart, with major attention to crafts and trades and to the technologies of transportation, communication, and production. As Skramstad wrote many years later in a fond memorial, Boorstin "immediately saw a direct connection between the museum's possibilities and the intellectual ambitions of his own work."[30]

■

DURING THE EARLY 1970S, after several years when Congressional funding for exhibits was stingy except in response to dire circumstances (in September 1970 a third-floor fire did $750,000 of damage, and emergency funding enabled mounting new exhibits on communications technologies), money began to flow for exhibits to accompany celebrations marking two hundred years of American independence, the Bicentennial. The museum's budget doubled between 1969 and 1974. Boorstin, it happened, had been appointed by President Johnson and reappointed by Nixon to the American Revolution Bicentennial Commission, and in Washington the Smithsonian would be at the center of much of the celebration, with some two dozen special exhibits slated for NMHT alone, some of these modest but several ambitious and expensive. There was *We the People*, budgeted at a million dollars; there was *1876*, budgeted at $2.3 million; and there was *A Nation of Nations* (*ANON*), the exhibit on pluralism, budgeted at $3 million, nearly all from a special Bicentennial appropriation. *ANON* was to be Boorstin's showpiece. But more engaging to the museum staff was *1876*,

conceived as a "microcosmic re-creation" of the Philadelphia Centennial Exposition, and to be staged in Arts and Industries, the building to which the Centennial had given rise and where every senior curator and designer had begun his or her career.

All three of these exhibits were opened after Boorstin had turned his Smithsonian appointment into full-time research and then left the institution altogether to become Librarian of Congress. But they were done in exactly the spirit he envisioned thanks to his successor, Brooke Hindle, a historian who was less well known than Boorstin but much more fully invested in the workings of the museum. Hindle was unstinting in his admiration for Boorstin: "I have never ceased to admire your imaginative scholarship and your creative impact upon almost everything you touch," Hindle wrote as *A Nation of Nations* was coming together in the fall of 1975, along with the Smithsonian's most ambitious catalog ever, 670 pages edited by Marzio and published by Harper & Row, the same house that published *Rube Goldberg* in 1973.

But in addition to exhibits based on imaginative perceptions of the role of technology in the American past (and with catalogs that would attract trade publishers, theretofore unheard-of at the Smithsonian), Boorstin also imported, as seldom before, exhibits that served private interests or even baldly partisan ideologies. Not that this was anything altogether new. Previously, however, ideology had been served in a manner that was almost haphazard, inadvertent links between technological progress and social progress, links that Boorstin himself would never accept unquestioningly; a reviewer of the third volume of his trilogy noted Boorstin's distress at the way technology imparted momentum to "uncontrollable forces—the atomic bomb, the space race, the military-industrial complex."[31] Occasionally, exhibits had been self-serving insofar as the Smithsonian itself was concerned, the prime instance involving Secretary Charles D. Walcott's display of Samuel Langley's aerodrome with a label saying that it was "capable of sustained free flight" when in truth it had utterly failed. And sometimes, rather than purveying claims that were demonstrably untrue, the Smithsonian had simply served as a tool for government propaganda.

This role certainly predated Boorstin's tenure. An example, one among many, was a 1965 exhibit called *The Vision of Man*, 5,000 square feet spon-

sored by the U.S. Civil Service Commission that aimed to illustrate "the historic and creative partnership of science and the Federal Government."[32] (A "career guidance center" pointed young people toward "the fantastic future" via "the Free World's largest employer of scientists.") Here, the Smithsonian was only being used as a staging area for an exhibit slated for the Federal Pavilion at the New York World's Fair, and *The Vision of Man* did have an authentic historical component addressing early governmental involvement in scientific work with Lewis and Clark and the Coast and Geodetic Survey (its collections of antique scientific instruments were traditionally among the museum's richest). What materialized with politicized funding in Boorstin's time was different.

Early in August 1971 a note came over from George Schultz, director of President Nixon's Office of Management and Budget. "Dear Dan," it began. The familiarity was not unexpected; Boorstin and Schultz had been colleagues on the Chicago faculty, and Boorstin was well known to several denizens of the Nixon White House.[33] The topic was "productivity," the sine qua non of America's political economy. By 1971, however, the nation was snared in a "productivity crisis" Nixon thought to be so dire that he was on the verge of mandating a ninety-day freeze on prices, wages, and rents. Schultz wanted Boorstin to help turn things around by means of a major exhibit—first by serving warning that the nation had "not remained at the world's forefront of production," as it long had been, and then by showing "what can be done to restore our position by re-direction of available resources." The museum's reimbursement, Schultz told Boorstin, would come directly from the National Commission on Productivity, which was due to convene in Washington late in 1972, by which time the exhibit needed to be done.

Schultz was informed that producing a major exhibit in such a short time, if it were possible at all, would cost "umteen thousands of dollars." "Umteen" turned out to be a little more than $500,000, which (in a coincidence that did not escape the notice of critics) matched the original Smithsonian endowment. It was more than had ever been spent, to that point, on any exhibit at the institution, or probably anywhere else. A big part of the cost involved prototypes of "complex electromechanical devices"—untested they were, not like those music machines that could

serve faithfully in the neighborhood drugstore or tavern for years on end. Boorstin assigned management of the project to Harold Skramstad— quick, personable, ambitious, and not yet thirty—whom he had just named chief of exhibit programs. The title itself was newly minted: not a curator, not a designer, but rather a content provider (an expression becoming common in the world of exhibitry) and expediter. His first assignment was to get a draft proposal together in one week: "top priority," indeed.

John Anglim was seriously ill—he died in May 1972 at the age of sixty-one—so Skramstad and Ben Lawless worked together from the beginning, and it was a lively collaboration.[34] Lawless arranged for "Productivity" (always the working title) to go where the Hall of Iron and Steel had been planned before it fell victim to austerity measures precipitated partly by the war in Southeast Asia, partly by Ripley's diminished confidence in Multhauf, and partly by Multhauf's own fading interest in administrative initiative. Design and scripting was to be the work of two contractors, Ivan Chermayeff and James Baughman, one from New York, one from Boston. Chermayeff's involvement was at the urging of Lawless, who was increasingly enthusiastic about "outside talent"—in 1968 Lawless had contracted with Charles Eames, even then iconic, to design an exhibit called *Photography and the City: The Evolution of an Art and a Science.* Chermayeff was already known for his work on the American Pavilions at Montreal's Expo '67 and Osaka's Expo '70, as well as for many projects for the U.S. Information Agency and for his "corporate identity program" for the Chase Manhattan Bank. (His firm, Chermayeff & Geismar Associates, would design a set of logos for the Smithsonian itself, and much later, the elaborate display of the Star-Spangled Banner, *For Which It Stands*, 8,000 square feet of "experience.") Baughman was an old friend of Boorstin's. A historian at the Harvard Business School and editor of *Business History Review*, he was to receive $10,000 for scripting "Productivity," well beyond the salary of many NMHT curators.[35]

What Baughman developed, along with Chermayeff, Lawless, and Skramstad, was an exhortation on behalf of an ever-expanding GNP: The exhibit was officially named *If We Are So Good, Why Aren't We Better?* There were hardly any historical artifacts; instead, a mannequin of "mom" making apple pies had to carry the bulk of the interpretive load.

The question "What does mom need to make an apple pie?" introduced the concept and nature of inputs. "How did the pie turn out?" did so for outputs. Rhetorical questions abounded: "Which is better—a whole tiny pie or a small slice of a giant pie?" "Who should get the first slice?" "Who should get the biggest slice?"

Skramstad told Chermayeff that this was one of the best shows ever seen in the museum. For sure, it diffused knowledge "in new and imaginative ways," Ripley's ideal. But it was also freighted with ironies. Steel balls that were supposed to tumble one way or another through a "productivity maze" got loose on the floor and caused mayhem. Another machine that stamped metal souvenirs shaped like little question marks broke down repeatedly at first, but soon was made so extremely productive that the museum's escalators were put out of commission from discards falling into the machinery (to foster a sense of constant movement, the building had been designed with a rich complement of escalators). Then, there was the board game Baughman and Chermayeff devised together, modeled on a game historian Edmund Morgan had developed at Boorstin's behest. Morgan's game, called "The Price of Freedom," apparently worked all right. But "The Productivity Game" needed to be a lot better; one of the squares was appropriately labeled "Bad Investment." The board would not flatten out properly; the spinner would not spin; the instructions were illegible. Boorstin's assistant director for administration, a normally placid man named Bob Tillotson, complained to the manager of the gift shop that the game was a "real turkey," and thousands of them remained unsold even after the price had been cut from two dollars to fifty cents.[36]

Apart from its ironies, the show was inevitably freighted with ideology. A friendly critic voiced concern that "going outside" might harm the morale of a museum staff "whose advice is sought throughout the world, but often not by the Smithsonian itself." Even so, she noted with approval that the exhibit did signal NMHT's address to "large perceived national problems," another example being an exhibit in A&I about drug enforcement.[37] An unfriendly critic, a historian of technology at the University of Delaware, questioned whether "progress demands increased productivity" and wondered if it was proper for the Smithsonian to promote the notion that "a bigger GNP means a better USA."[38] The exhibit did hint at complex

issues: a short film depicted Frederick Winslow Taylor getting pursued by dozens of tiny standardized reproductions of himself. Nor was the "dark side" absent: there were images of pollution, "unfair distribution of wealth," even "size for the sake of size," with photomurals that included the World Trade Center. But surely there were valid objections to idealizing an "over-productive technology," as the cultural critic Lewis Mumford put it.

While they were not consumed by apocalyptic visions, as Mumford was, NMHT's curators mostly hated the exhibit. This was because it was almost all great expanses of graphics and virtually no three-dimensional objects (the big exception was a Model T set amid mirrors that repeated an image in semblance of a production line); because it had the flavor of a "science center" and not a history museum; because it was "propaganda"; because it assumed that exhibits needed to be "jazzier and more animated" ("why not dancing girls?" Multhauf liked to ask); and not least because it assumed that such exhibits required "a competence not available within the museum," including a chief, Skramstad, who struck many old-timers as condescending, even arrogant. Lawless and Skramstad became fast friends, however, and in conversation long afterward the two of them could recall the steel balls, the souvenir medallions, mom and her apple pies, and all that as "both a horror and a delight." Still, Lawless also remembered his own qualms about whether a partisan concern should be a concern of the Smithsonian. Whatever the answer, the exhibit the Nixon White House arranged to import into the National Museum is worth reconsidering in the context of charges twenty years later about the importation of "counterculture morality pageants."

While the windfall for the productivity exhibit came directly from the public purse, Boorstin had always made it clear that he would welcome private funding. Sears, Roebuck paid for a popular exhibit that was accompanied by Charles Eames's enchanting film titled "Toccata for Toy Trains," and, when it closed, Sears left the museum with a superb collection of toys. But sometimes funding from the world of business enterprise was laughably clumsy—*Shaving Through the Ages*, for instance, conceived and paid for by the Gillette Safety Razor Company and scheduled to open on the first of June 1973. Invitees to a reception the night before saw an exhibit designed so that it put a twin-blade Gillette Trac II on a plinth

much taller than those under the other shaving implements on display. The others were depicted as inferior, both symbolically and literally. In attendance that night were Gillette executives and representatives of its PR firm, Hill and Knowlton, several curators, and a young man from the *Washington Post*, Tom Shales, just beginning a career with the paper that would include a Pulitzer Prize in 1988. Shales filed a story that made the museum look silly ("Starring Trac II"), but his presence also induced a droll memorandum-for-the record by one of the curators, Rodris Roth, which included a description that Shales might have liked had he seen it: "blond, short beard & mustache, gold rimmed glasses, blue oxford shirt, red tie, blue pants & saddle shoes . . . really closely mouthed . . . this is an investigative reporter?"[39]

The coverage in the press also induced a "Dear Dillon" letter, expressing hope that "some products of the American Safety Razor Division" might be exhibited. The letter was from the Chairman of the Board of Philip Morris, which owned American Safety Razor.[40] Actually, there had already been a flurry of activity, which included changing a label calling the Trac II "the latest development," capable of giving a "closer, yet wetter shave," to one saying only that "experts in razor design" had long "been interested in the theory that two parallel blades give a closer shave" and that this had been "confirmed by photomicrographs." (NMHT was, after all, a museum of technology.) When the exhibit was finally opened to public view after a few days' delay, it included twin-blade models from Schick and Wilkinson as well as Gillette and American, along with several electric razors but not any "shaving implements from Before Christ," as Hill and Knowlton had initially overpromised.

All this sounds trivial, and perhaps it was, but the exhibit did afford Shales ample opportunity to point out how deeply immersed the museum was in private funding for exhibits—some of them far larger and more expensive, such as an upcoming maritime exhibit bankrolled to the tune of $1.5 million by the likes of Exxon and United Fruit (the "funding goal" was $2 million and the actual cost well beyond that). Might these exhibits include their own equivalents of a Trac II on a lofty plinth? Shales seemed to think it was a good question. The story gave a revered senior curator, Malcolm Watkins, an opportunity as well—to vent about the "policy on

the Director's part to cultivate corporate support for exhibits and other enterprises." This had worked out fine with Sears, Roebuck because there was "a minimum of PR exploitation." Not so with *Shaving Through the Ages*, said Watkins, who concluded that "exhibits like this can be very dangerous and they are essentially inappropriate for the National Museum."[41]

In the exhibit the public eventually saw, Gillette was downplayed and the attention actually seemed tipped toward American. But the labels still read like a trade show, not a history museum: "hailed as being the greatest improvement in injector shaving in 52 years" (American's Floating Head Razor); "designed in a distinctively feminine manner in the shape of a compact" (American's Flicker).

Later on, a *Post* correspondent suggested that "the successful operation of highly developed technological societies seems to be limited to two models: government control of industry, as in Russia; or industry control of government, as in the U.S.A." The museum would reject offers to finance exhibits celebrating hydrogen power, the "miraculous" automatic transmission, and more. In the 1980s, however, Ralph Nader would loose a squad of raiders to enumerate the exhibits that indicated some degree of "industry control," and they claimed to have found dozens, the STP Pontiac race car being far from alone. Actually, control was much too strong a word, for the self-interest imparted to exhibit storylines was usually subtle. When Marzio's *Henry R. Luce Hall of News Reporting* opened around the same time as *Shaving Through the Ages*, it included *Newsweek* and *Look* as well as *Time* and *Life*.[42] And when *American Maritime Enterprise* opened a few years later, one had to search the silk-screened fine print to realize that a dramatic large-scale model of the 1775 tobacco ship *Brilliant* had been funded by the Tobacco Institute or that the Tobacco Growers Information Committee had been involved in outfitting the nearby stage set intended to look like a colonial tobacco warehouse.

■

WHEN PURSUING AN APPROPRIATION for the new museum in the early 1950s, Frank Taylor had promised that exhibits would be designed "to instill in each citizen a deepened faith in his country's destiny as a champion of

individual dignity and enterprise, in each foreigner a renewed respect for our ever-expanding social and technical horizons." When Boorstin arrived in 1969 and announced that the museum "must be a place of patriotism—of enlightened unchauvinistic but still impassioned patriotism," he had merely reaffirmed such objectives, not invented them. Nor had he invented any new strategies for enlisting corporate financial support. A practice that Malcolm Watkins called "very dangerous" in the 1970s was already a practice of J. Elfreth Watkins (no relation) in the 1890s. But Malcolm's complaint was emblematic of growing curatorial concern about "PR intrusion," about devaluation of the phrase "museum quality," and even a resistance to Boorstin's top-down management style. Seated with a dozen others at the table in the director's conference room early in 1973, a veteran political history curator named Herb Collins, a man with a resonant southern accent, got everyone's attention when he told Boorstin, "We'll all still be here years from now, doing our jobs, but you directors, you-all come and go."

Collins had been hearing rumors, and, indeed, this was about the time Boorstin started negotiating with the Castle for the research position he had initially envisioned when he came to the Smithsonian. By the time of the Gillette embarrassment, Secretary Ripley had already announced a search for a new director, and that fall Boorstin exchanged the title of director for that of senior historian, obligated only to his private publication commitments. There were complaints that those commitments had too often come first even when he was the director; there were allegations (stirred up by the columnist Jack Anderson) that his several research assistants had been working on "government time." Boorstin had promised to make the museum "a more important, more attractive, more lively, and more seminal center for the study, interpretation, and reinterpretation of American civilization and the history of technology," and he had done that. But there was reason to doubt whether he had done much to put the museum in a position of "moral leadership," as he had also promised. NMHT was certainly better integrated into the universe of academic discourse, although expensive and elaborate prescriptions for integrating artifacts into their social universe would mostly gather dust after Boorstin was gone.[43]

Yet Boorstin had certainly made a difference, even if largely unex-

pected, by affirming the necessity of imparting drama to exhibits "in new and imaginative ways," a phrase of Ripley's that would echo and re-echo. Boorstin had agreed to bringing in celebrity designers such as Chermayeff and had enabled Lawless to take advantage of an exodus of talented and ambitious younger designers from the Eames Office in California. The first was Barbara Charles, who designed the Sears, Roebuck toy exhibit and the book Marzio wrote to accompany the news-reporting exhibit *The Men and Machines of American Journalism*. Later, along with her partner Robert Staples, she would launch a career with *We the People*, designing exhibits that often had themes with political resonance. The next was Bill Miner, who created a rain forest in the Museum of Natural History, renewed the exhibit of James Smithson's sarcophagus in the main entry to the Castle, and then re-created a world's fair of a hundred years past, *1876*, a triumph of museum stagecraft.

Boorstin also opened opportunities to in-house designers, notably Nadya Makovenyi, who, like Lawless, was formally trained as an artist and who likewise started out humbly, making silk-screens in the production shop. Lawless could see that Nadya was "uniquely talented," and he would hand her the responsibility for designing a half dozen exhibits, all of them memorable, before she departed for a job in top management at the Air and Space Museum.[44] Her first was the Hall of Photography, and there were plenty of other new "halls": News Reporting, Money and Medals, Printing and Graphic Arts, Stamps and the Mails, and Electricity. But the best exhibits were those in which Nadya was able to capture Boorstin's vision of "democratization," most notably *Suiting Everyone*—the first exhibit commemorating the Bicentennial—which celebrated "ready-made" clothing. Beginning with a scrim comprising hundreds of interlaced wire coat hangers and a congregation of store-window dummies, *Suiting Everyone* was a rich embodiment, as Boorstin wrote proudly, "of the powers of the museum to explore the obvious and uncover some unsuspected meanings in our everyday life."[45]

Suiting Everyone denoted a shift toward exhibits that were driven more by "concepts" than by "objects"—and even more by "design," by artistic creativity, than by either concepts or objects. It was actually possible to send compact versions of *Suiting Everyone* around the country on two-year

tours. Time was, in A&I, when the only things put on exhibit that were not "authentic original relics," not "real," were models. With a growing concern that "a story must be told" after MHT opened, it often became necessary to include other sorts of things to sustain a narrative, most often graphics but sometimes three-dimensional objects that might be real in a literal sense but were in no way "authentic." In the best-funded exhibits, audiovisuals and stage sets tended to dominate. "Period rooms" that visitors were expected to take as historic reconstructions were often the inventions of men and women whose forte was stage design. More and more exhibits included films in their midst, and these could steal away much of the attention from artifacts.[46]

At the time of the Bicentennial—when budgets first ran into the millions—NMHT's two premier exhibits exemplified the power of design in two distinctive ways. Both were conceived as narratives, as Boorstin had insisted should always be the ideal. *A Nation of Nations* was structured by Chermayeff & Geismar as a series of "units" that were visually isolated from one another and meant to be addressed in a prescribed sequence, like acts in a play. Artifacts imparted flavor, and there were some marvelous period settings, but one could not escape the impression that *ANON's* essence was its design, with a "track" through the exhibit that narrowed, then widened, and with some parts in shadow and others brightly lit.[47] With *1876*, a first impression was of "design" everywhere, as with *ANON*, because everything was so colorful and ebullient, so *stagey*, but actually the design of the *artifacts* was the whole story. To borrow a phrase from Nixon's inaugural, *1876* was rich in goods. And because it was *so* rich, a visitor could not help but feel immersed in an experience, the experience of another time and place. Both *1876* and *ANON* were carried through under the leadership of Brooke Hindle, Boorstin's successor. Hindle's tenure was marked by discord with Blitzer about the museum's "best directions," and by many disappointments, and yet the two exhibits were so successful that they would be more than sufficient to leave him with happy memories of his time in the director's office.

NMHT . . . is, by all odds, the central and most
important Institution in this country and probably
in the world in the collection and interpretation of
technology, science, and material culture.

—BROOKE HINDLE to Charles Blitzer, January 15, 1974

CHAPTER 6 ※ A Special Kind of Insight

Retired to San Rafael, California, with his wife, Lettie, Robert Multhauf began a museum memoir. His highest praise went to Anthony Garvan, Malcolm Watkins, and Robert Vogel; to Frank Taylor, of course; and to "the amazingly talented Ben Lawless." He also confessed to having hired "some real duds" after he got the idea that a history-of-science doctorate might be good curatorial preparation. And all he could say about Daniel Boorstin in retrospect was that Secretary Dillon Ripley must have been surprised "to encounter an ego rivaling his own."[1] At first, Multhauf was pleased that his successor was a prizewinning historian of "the American experience," but the honeymoon was brief, and he was relieved when the Boorstin experience ended in 1973, as were many occupants of NMHT curatorial offices. They were doubly relieved when the new director pledged to devote his full attention to the museum, especially to strengthening its natural alliances, something for which Boorstin rarely seemed to have time. There were books Brooke Hindle still wanted to write—about the

nature of emulation and invention, about his wartime experiences—but these could wait till later.

Hindle knew several of the curators already, some quite well, and admired them for what he called their "special kind of insight," not so much the case with Boorstin, who had dreamed, at least briefly, of luring eminent academicians into curatorial offices that were newly vacated. After four years, all forty-two curators who were in those offices when he arrived were still there, even those he found annoying or noncooperative. There were newcomers, however, each of whom would distinguish the museum by his presence. The most recent arrival was Paul Forman, who had been a Berkeley student of Hunter Dupree and a one-time research assistant of Thomas Kuhn, and who had taught at the University of Rochester before getting recruited to join Barney Finn in a renamed Division of Electricity and Nuclear Energy. Forman had set historians of science abuzz with an extended essay about quantum theory in Weimar, Germany, an essay so original that it would get dubbed the Forman Thesis.[2] Down the hall was Otto Mayr, who had been trained as an engineer at the Technical University of Munich, married an American, and taught at the Rochester Institute of Technology for eight years, after which he returned to the Deutsches Museum, in 1965, to work on his doctorate in the history of technology. Multhauf arrived in Munich not long afterward, on sabbatical, and Mayr immediately caught his eye. A contract to catalog MHT's rich collection of cybernetic devices led to a position as curator of tools, a position whose genealogy began with Eugene Ferguson and Silvio Bedini.[3]

The third newcomer was Peter Marzio, who had been Boorstin's student at Chicago. The fourth, Harold Skramstad, had not become a curator, but Hindle reaffirmed his responsibility "for keeping large thematic exhibitions on the track and on schedule."[4] Then, Hindle was confronted by curators who insisted that Skramstad was an unwelcome presence and that this situation would be inevitable no matter who from "the front office" was charged with "imposing exhibits on the staff," as Margaret Klapthor put it. Most disaffected were the curators of the numismatics collection, Vladamir Clain-Stefanelli and his wife, Elvira, both Romanian-born. The Stefanellis had recently acquired a collection Ripley called the world's largest "hoard of gold coins amassed by one person," Joseph P. Lilly, the pharmaceutical

magnate.[5] Although "hoard" sounded rather indelicate, there was no doubt that the Stefanellis enjoyed the unwavering support of the secretary and everyone else in the Castle. In his role as chief of exhibition programs, Skramstad had been assigned to work on an exhibit with the Stefanellis. It was a collaboration destined to fail—a husband and wife with Old World sensibilities about hierarchy thrown together with a bright, brash youngster—and their clash proved Skramstad's undoing at the museum. When Hindle "detailed" him to a minor Bicentennial project, a set of photo albums, he began looking for another job and soon landed a good one, as director of the Chicago Historical Society.[6]

Hindle would bring some of his own friends from academe and from the museum world into NMHT offices on visiting appointments, notably Klaus Maurice, a senior curator at the Bayerisches Nationalmuseum in Munich, and Dupree, the most eminent historian of American science.[7] Academics with formal consulting arrangements would be uncommon, however, in deference to some of Boorstin's ill-starred initiatives. Responding, for one, to a suggestion from Charles Blitzer that Harvard's Bernard Bailyn could help with plans for a new institute, Hindle expressed concerns about "artificial" attempts "to relate such people with our curators" and foresaw a situation "even more disastrous than Dan's attempts with Carl Bridenbaugh and other mavericks."[8]

Hindle arrived just as a large number of exhibits were in the process of research and development, and he quickly realized that the new conventions for casting scripts in a contextual mode put some curators in distress.[9] But even though he was disappointed with much of the scripting he reviewed in draft—Klapthor got four single-spaced pages of unrelenting criticism of what she had written for *We the People*—almost never would there be another exhibit like "Productivity" in which an academic outsider was assigned a central role. An exception was MIT's Cyril Stanley Smith, who would have creative control for an exhibit called *Art and Technology*, one of the most imaginative and elegant ever staged at NMHT. *Art and Technology* was designed by Barbara Charles and Bob Staples, Eames Office veterans now established on their own on Capitol Hill, and also working with Klapthor on *We the People*.

Hindle's tenure was something of a heyday for freelance design firms, as

planning for Bicentennial exhibits was well under way while Boorstin was still director, and Ben Lawless had imparted his enthusiasm for enlisting the "outside talent" that was flowering in response to the opportunities afforded by the Bicentennial. In time, an NMHT exhibit with a contract designer, *American Banking*, would prove to be an embarrassment, and others were agonizingly slow in their development because of friction with designers accustomed to having their own way with both "content" and display, often on the assumption that the two were not readily separable. From the start, John Anglim had warned Taylor and Multhauf about this potential pitfall. But there would be marked successes as well, and even triumphs.

■

HINDLE HAD IN COMMON WITH BOORSTIN a long career at a major university, but he was a few years younger, and he had different enthusiasms, experiences, and allegiances, and this was why he understood "a special kind of insight." In the 1930s, when Boorstin was reading law at Oxford, Hindle was studying naval architecture at MIT. During World War II he served in the Pacific as a radar maintenance officer aboard the escort carrier USS *Chenango* (his last book would be a war memoir, *Lucky Lady and the Navy Mystique*). Boorstin was called "Mr." because he was a barrister but not a PhD; with Hindle it was "call me mister" because that was the navy way. Hindle was from Philadelphia, WASP to the core. Boorstin grew up in Tulsa and was never a "hands-on" sort of guy; he could not have loved tinkering with an antique clock, as Bedini did, or making a clavichord, as Mayr did. Boorstin's schoolmates would have thought him owlish. He was also Jewish and had to learn to live with backhand compliments about "not being the kind to which one takes exception."[10]

Boorstin had actually known Mel Kranzberg much longer than Hindle had, since their days at that summer camp in Colorado during the Great Depression. He was also acquainted with Northwestern's Carl Condit, with Cyril Stanley Smith (who had been at the University of Chicago until 1961), and with some of the others who were helping Kranzberg impel the history of technology as a new academic discipline; Thomas Hughes, for example,

was a postdoctoral fellow at the museum when Boorstin arrived, working on his biography of Elmer Sperry. Boorstin was occasionally engaged with these men directly, as at the 1965 "Technology in Early American History" conference in Delaware when he shared duty as commentator with Eugene Ferguson. But he was never active in the American Historical Association, as Kranzberg had been, nor was he allied with Kranzberg in fostering the Society for the History of Technology, as Hindle was. Hindle wanted to integrate SHOT's concerns, and concerns of the museum, with those of the mainstream historical profession. Like Boorstin, like Kranzberg, Hindle was disturbed about the growing influence of a younger generation of historians who seemed obsessed with conflict and "the limits of our accomplishment," with the dark side, an expression he used often; his loyalties were largely with the consensus school, whose chief protagonist was Boorstin. Still, he foretold a new and even revolutionary Smithsonian generation whose focus was on both the relationship of technology and culture and the world of academic scholarship. To these men and women, the American Association of Museums was pretty much a foreign country.

It was because of where he looked for affirmation that Hindle's distress was palpable when he had his first confrontation over an exhibit. It was called *American Banking*, and it was curated by the Stefanellis, whose expertise in numismatics was vast but, as Hindle quickly realized, insufficient when it came to American history. The Stefanellis had succeeded in getting rid of Skramstad, who had studied American history, and it was also clear that they were never going to get along with anyone from the design firm that had been hired, Joseph Wetzel Associates, from Boston. "The great potentials for a good exhibit have been willfully destroyed," wrote Mrs. Stefanelli to Hindle, because of Lawless's yen to enlist "glamorous" designers. Lawless saw things quite differently: Wetzel's design was "a dazzler, worthy of the big time," but there was no overcoming "the intricate ways the Stefanellis had to stifle imagination." With Bedini backing him up, Hindle tried to beg off, pleading that no suitable space was available for the exhibit, but a letter to that effect to a representative of the bankers was intercepted by Bedini's secretary Nancy Long and marked "NOT SENT. Secretariat disapproval."[11]

The political reality was that there *would be* a banking exhibit, even if

Hindle believed that it failed to measure up to the critical precepts of academe and, even worse, included a catalog subtitled *Chartered for Progress*. It was quite proper for the Smithsonian to celebrate two hundred years of American independence, Hindle thought, but banking as an emblem of progress? Could the title not be something better comporting "with the Smithsonian image," Hindle implored a vice president of Burson-Marsteller, the public relations firm representing the bankers? Not possible, he replied.[12] As throughout most of history, more power was lodged in the Castle than with the lords and nobles. Blitzer had once told Multhauf that if he did not exercise power and "get involved" with such decisions on Ripley's behalf, he "would have nothing to do." As time passed, he would get involved more and more, and the time would come when the Castle would brook no dissent.

■

HINDLE INHERITED OTHER EXHIBITS that were problematic, though none quite like *American Banking*. Curators accustomed to planning exhibits whose starting point was "a collection" were often as uncomfortable with the challenges of storytelling as they were with designers they thought temperamental and pushy. Day-to-day supervision of exhibits under development was aggravating and time consuming, and, like his predecessors in the director's office, Hindle usually left this supervision up to Bedini. Hindle tried to devote much of his own personal energy to bringing the museum closer to the scholarly mainstream and to repairing some of the fractures that had resulted from conflicting aims and allegiances during its first decade. The results were mixed. Wilcomb Washburn, for example, had been responsible for creating the museum's Hall of Historic Americans but then became so disenchanted with "fossilized" exhibits (Ripley's expression) that he began recommending that the collections simply be photographed and then sold off. Most curators took their sacramental obligations seriously and responded as one might expect, pretty much ostracizing Washburn. Hindle tried to find a way to get Washburn "back into a constructive relationship with NMHT," but Washburn, with Ripley's approval, continued to set his own course elsewhere in Washington with

the Office of American Studies. "No loss," said Multhauf, who regarded Washburn as a showboat.[13]

On the upside, Hindle put through visiting appointments on his own authority, and he used his influence to secure predoctoral fellowships for promising youngsters like Ferguson's student David Hounshell; he especially enjoyed hosting luncheons for the fellows, who in Boorstin's time might come and go after a full school year never having met him. Hindle wholeheartedly backed Paul Forman's bid to become editor of the Albert Einstein Papers and he sought to establish a formal relationship with the new Woodrow Wilson Center for International Scholars.[14] Both came to naught, but Hindle was successful in launching an evening seminar at the intersection of technological and economic history, and he reaffirmed Boorstin's initiative with the Doubleday publishing firm to sponsor an annual lecture series, with luminaries and black-tie receptions. Doubleday funded the first series at $40,000, bringing in Daniel Bell, Saul Bellow, Sir Peter Medawar, Arthur C. Clarke, and Eduardo O'Gorman to address "Technology and the Frontiers of Knowledge."[15] Hindle would sometimes feel a need to remind curators that the museum was "not a university," no matter what Ripley said, but clearly he loved the touches that gave the feel of academe.

By the 1970s, one of the most promising means of enhancing the prestige and influence of any academic organization was to establish a research institute or center, and early in his NMHT tenure Hindle got an opportunity to do so. It had its origins years before, when a group appointed by President Eisenhower drafted legislation to enable creation of a board to plan a National Armed Forces Museum. The president had discussed this with Secretary Leonard Carmichael, who agreed to the museum's establishment under Smithsonian auspices. But the National Armed Forces Museum Advisory Board (NAFMAB) was not authorized by Congress until three years later, and for various reasons the project never gained headway. First, there were concerns about such a museum casting the nation in a "militaristic" light, and Frank Taylor and Mendel Peterson insisted on it being the proper responsibility of *their* museum, MHT, to present "a balanced picture" of the military's role in U.S. history, both in war and in peacetime. Then, within a few years, the war in Southeast Asia

put a brake on funding for nearly all Smithsonian exhibits, certainly on plans for a museum with no site and only a rudimentary collection and likely to be seen as "just a war museum" in any event.

Throughout the 1960s, NAFMAB was chaired by John H. Magruder III, a retired Marine colonel, who changed strategy time and again. In 1971, he sought to catch the Bicentennial bandwagon and regroup at the Washington Navy Yard or perhaps downriver on the Potomac at Fort Washington, with the centerpiece to be the Civil War ironclad *Tecumseh*. But salvage of *Tecumseh* from the bottom of Mobile Bay, if feasible at all, would have cost tens of millions of dollars, and after Magruder's death in 1972, NAFMAB plans, any that still existed, were depicted in the local press as a "Disneyland of War." In her dissertation cleverly titled "A Modest Show of Arms," Joanne Gernstein London sums up NAFMAB's failure thus: in spite of the constant maneuvering, it "never . . . convinced MHT curators, official arbiters of the Washington landscape, or the Congress that building an armed forces museum on the Mall, near the Mall, or [anywhere] in Washington was appropriate."[16]

Only one part of the original plan was left to be salvaged, though it was not insubstantial. The NAFMAB authorization had provided for an institute for "scholarly research into the meaning of war, its effect on civilization, and the role of the Armed Forces in maintaining a just and lasting peace by providing a powerful deterrent to war." What was left would be this institute, named the Dwight D. Eisenhower Institute for Historical Research, and in 1972 Ripley authorized its establishment "as a component of the National Museum of History and Technology." Plans were being developed as Boorstin was phasing out, but he did take care to affirm the institute's mission: "to take the war out of military history and to put military history in the context of our whole civilization and not just in the context of armed conflict."[17] Then he handed supervisory authority over to Bedini, who entrusted implementation to the senior curator of naval history, Philip Lundeberg, a World War II naval hero.[18] Lundeberg was to draft two "models" for the center's structure to be sent to Ripley and Blitzer for their consideration. One was to spare no expense and the other to be minimalist, with only a director, administrative officer, two part-time curators from the museum staff, a librarian, and clerical help.

The expensive option—with a directorate of six, four "professorial chairs," funding for twenty-one fellows with long- and short-term appointments, and a budget of $450,000—garnered little enthusiasm in the Castle, and when approval came, after a long delay, it was only for the minimalist option, funded at a third as much.

This was disappointing, but definitely *not* disappointing was the selection of the director: Forrest C. Pogue, author of the official history of Supreme Headquarters, Allied Expeditionary Force, as well as the immensely readable *Pogue's War: Diaries of a Combat Historian* and a biography of army chief of staff George C. Marshall—that project ongoing and eventually to reach four volumes.[19] Pogue was also the executive director of the George C. Marshall Foundation and Marshall Research Library on the campus of the Virginia Military Institute in Lexington, Virginia, which featured a museum designed by Ben Lawless in 1964. Except for Boorstin, no historian so illustrious had ever landed at NMHT, and Hindle could not have been more pleased, given the import he attached to integrating the museum with broader currents of American history and also (as he put it in a note to Blitzer) "making the worlds of understanding represented in this Museum known to the historical profession."

Shortly thereafter, James C. Hutchins, the last director of NAFMAB, joined the Eisenhower Institute as Pogue's administrative officer, and along with Lundeberg, they organized a major conference in August 1975 cosponsored by the U.S. Commission on Military History: the Ninth Quinquennial Conference of the Commission Internationale d'Historie Militaire. More than 160 historians attended, nearly the same number as attended the Society for the History of Technology's "Two Hundred Years of American Technology" conference a few weeks later. It was a busy time at NMHT for scholarly gatherings. "We do stand on a pinnacle here," Hindle wrote to Blitzer in a self-assured tone unusual for him, "and we ought to be able to choose to move in our own best directions."[20]

Worlds of understanding . . . our own best directions. Hindle had in mind another move that was in the works. Bedini was arranging with his friend, patron, and erstwhile Connecticut neighbor, Bern Dibner, for establishment of a rare book library as an integral part of the museum, to be called the Dibner Library for the History of Science and Technology. Dibner

donated a quarter of his holdings at the Burndy Library, including ten thousand published works, many extremely rare; more than three hundred incunabula (printed works before 1501); and a number of manuscripts, as well as eight hundred portraits and a collection of historic scientific instruments, including Louis Pasteur's own microscope. The gift was contingent on the library being "housed adequately for public use by visiting scholars and students as well as members of the museum staff," and Hindle hoped it would engender research by curators with "academic backgrounds." (It escaped nobody's notice that the Department of Science and Technology's nine PhDs outnumbered the combined total for the other four departments but also that satisfactory productivity did not always correlate with advanced degrees.) In October 1976, the Dibner Library opened in a space on the museum's first floor adjacent to the Leonard Carmichael Auditorium. It included an exhibit gallery in the foyer, which proved ideal for Cyril Stanley Smith's *Art and Technology* and Bedini's own *Jefferson and Science*, compact and elegant, of the sort sometimes called "boutique" exhibits. But the first-floor location, however nicely designed, was intended to be only temporary. And therein lay Hindle's big disappointment, and certainly Bedini's—all the more disheartening coming in the wake of the remarkable coup of landing the library in the first place.

■

THE ULTIMATE PLAN FOR THE DIBNER LIBRARY, as well the museum's own library and reading room, a new archives center, the Eisenhower Institute, and at least one other research institute, was to house everything in an addition to the museum, another floor atop the first five. "The sixth floor" dominated planning discussions almost from the day Hindle arrived. "None of the NMHT's needs are so pressing at this time as the Sixth Floor Addition," read a document Hindle and Bedini coauthored. "At one stroke, this addition will create a new atmosphere, making the museum a primary scholarly center."[21] If everything went according to plan, construction would be completed in 1978, when Hindle and Bedini, comrades from the start, would perhaps move into a sixth-floor suite for senior historians along with Multhauf.

A new atmosphere, a scholarly transformation—these were a lot of eggs for one basket, and quite a number of dreams went unfulfilled when Blitzer and Ripley never warmed to the plan and sixth-floor funding never materialized. Bern Dibner felt that a bargain had been broken, and there would be no endowment for a research institute linked to the Dibner Library (of the kind he later funded at MIT, where it was given spacious quarters next to the Sloan School of Management). Nor would there be a Center for the History of Science and Technology, as pitched by Nathan Reingold, editor of the Joseph Henry Papers. After finally getting the first volume published in 1972, Reingold longed to escape from what he now foresaw as a lifelong task in relative obscurity. He envisioned himself directing the center, orchestrating dialogues in which his would be the leading voice.[22] Nor would there be a Luce Chair or Luce Historian of Technology "to encourage academic experimentation and creativity," on the order of the Luce Professorships at Cornell and other universities, a proposal Hindle had pushed with the aim of "seating here first-rate historians who are sensitive to the three-dimensional world of technology and who will work creatively with our holdings and our expert staff."[23] Nor would there be a suite for senior historians, and the archives center would eventually have to be located somewhere else.

Instead of getting to keep tabs on a bustling construction project right overhead, Hindle was increasingly distracted by contention with Blitzer as he sought to manage a large and temperamental organization. There were those forwarded "Dear Dillon" letters—from the chairman of the Coca-Cola board, for example, who told of "being skewered by employees and friends" who had visited the museum and seen "that the advertising section contains eleven Pepsi Cola ads." These would always induce snappy action, in this case a solemn promise for better exposure for Coke.[24] Much of what ended up on Hindle's desk seemed trivial. Continual complaints about the basement cafeteria, a Marriott Hot Shoppe, should have stopped short of the director's office but often did not, especially if the complainant was a popular administrative assistant who insisted that the food "often tastes peculiar" or a scientist from the Conservation Analytical Lab who was certain that it induced her fainting spells. Peculiar food, fainting spells, dusty exhibits, dicey alarm systems, drafts, pests, parking, midnight frisks

in curatorial offices, the elaborate fountain on Constitution Avenue that never worked right and after a while never worked at all—more of this came directly to Hindle's attention than one might imagine.[25]

Then there were the personnel issues. Curators sometimes treated the museum's "sub-professionals," many of whom had a better knowledge of the collections (and often a stronger work ethic), like maids and butlers. But when activists sought to gain some of the rights and privileges of curators, Hindle had to step in to protect what Multhauf called "the limited number of available rewards." In a similar vein, Hindle felt that he needed to be vigilant about keeping the museum's focus on "American technology, American science especially as related to technology, and the material dimensions of American cultural, social, and national history." This focus was often endangered, he feared, and in private he would propose the pruning of "marginal operations" and limiting the "monument-tending requirements of our memorabilia collections." While his good intentions were beyond question, nobody directly involved was pleased when word got around about his concern for "association [items] or high style crockery us[ing] up our scarce resources."[26]

There were three retirements: Grace Rogers Cooper, stellar for thirty years as curator of textiles and textile machinery; Ed Battison, the expert but cranky curator of timekeeping devices and light machinery; and Sami Hamarneh, a specialist in Islamic medicine.[27] This enabled Hindle to advertise openings and trust in getting superior applicants in a slack academic marketplace. (U.S. universities awarded more history doctorates in the early 1970s than ever before or since.) To replace Hamarneh, he hired Ramunas Kondratas, just out of graduate school at Harvard. He also opened talks with Gary Kulik, a student of Hunter Dupree at Brown who had been a medic in Vietnam and then become curator at Slater Mill Historic Site in Rhode Island. Kondratas's research was in the history of public health, Kulik called himself a labor historian, and both of them irritated old-timers who could see no connection with "the collections." "Oh, that's *just* what we need," said J. Jefferson Miller, the curator of ceramics (or "high style crockery," a "marginal operation" to Hindle), when Kulik introduced himself at lunch and said that he studied working people.[28]

Any one day could take Hindle to emotional extremes. There might

be the pleasure in lauding Forman for the "individual intellectual effort" embodied in his exhibit of particle accelerators, *Atom Smashers*, or in confirming agriculture curator John Schlebecker's promotion to a pay grade that was rarified territory, for "the reputation and leadership you have attained in the academic world."[29] But always there would be confrontations with curators who had been denied promotions or were not meeting deadlines for an onrush of exhibit commitments. None was more painful than with Susan Fay (née Walter) Cannon for "failure amounting to insubordination."[30] It would not be unfair to call Hindle straightlaced, and he struggled through correspondence with friends who were concerned about Cannon. To Harvard's Bernard Cohen, who had originally recommended Cannon to Leonard Carmichael in 1962, Hindle wrote, "As you may know, he seems to be putting himself through a personal meat-grinder . . . he has announced to the newspapers that he is a 'male-female.' All this would be irrelevant if it did not get in the way of his performance as a historian and as a curator." Cohen must have sensed Hindle's despair when he closed by saying, "We still hope for the best."[31]

Hindle's correspondence consumed hours of every working day. Most important were the letters of thanks to donors: $5,000 from J. Willard Marriott Jr., $2,500 from General Electric, $7,500 from the Alcoa Foundation, $25,000 from Ashland Oil, $250,000 from Time Inc., $101,588 from the Tobacco Institute, $400,000 from the American Bankers Association (the larger donations usually entailed publicity photos with corporate PR people). There was correspondence with NYU grad students and with professional peers, as when Hindle warned the academic vice president at Boston University about interdisciplinary programs being inherently fragile. To Richard Leopold, who had shared an idea for his upcoming presidential address to the Organization of American Historians, Hindle outlined strategies for working toward curatorial research agendas that would be "more useful to generalist historians." He would fret about the museum projecting an image of excessive concern for "objects which take their value primarily from the existence of a rabid market of collectors."[32]

He also had to compose internal memos by the dozens: memos addressing possibilities for "separating curators from historians" (by which he sometimes meant curators with doctorates, sometimes curators who

were strongly inclined to research and writing, no matter their educational level); memos about finding better ways to reward enthusiasm, imagination, and "responsiveness" (a favorite expression of his); memos about "improving the present structure." The memos about "structure" often seemed labored and took on a desperate tinge as it became more evident that Blitzer was displeased with Hindle's failure to turn the place around. Their relationship degenerated, and Hindle eventually told Blitzer that he had "difficulty conceiving your state of mind."[33]

■

NO MATTER WHAT OTHER PROBLEMS Hindle might be facing, the content and tenor of exhibits required increasing attention, especially the repeated admonitions of the Smithsonian Council. "The social and economic dimension of exhibits should be dealt with more effectively," said the chair in 1974 and, more pointedly, in 1975: "commitment to the social context of the history of technology is not adequately realized in many areas."[34] Hindle agreed entirely, but many of the curators still thought in terms of *collections* to be exhibited—that is, the building blocks would be sewing machines, timepieces, or telephones—and many could not get attuned to "complex interactions." "The most indirect, clumsy, and difficult way to explain abstractions is with physical objects," Jack White had said to Boorstin. As Barney Finn met weekly with colleagues to talk about an "integrated" exhibit of the history of American science, Frank Taylor was naturally pleased that they were taking on a "very difficult but important subject."[35] Still, he thought the preliminary script he saw was "rather thin on examples of how the interactions of scientific advancement and 'society' will be exhibited." What to do? Taylor urged Finn to identify "a knowledgeable, creative, and diplomatic individual who will devote the next five years of his career to masterminding and ramrodding the exhibit." But years before, a writer-editor employed by the museum had reminded Taylor that "when it comes to turning out suitable labels that can appeal to our broad popular audience, most of the curators fall quite flat." Taylor himself had a different take: "The basic problem here is that most (not all) curators consider exhibits a nuisance."[36] With publications, yes, curators could at

least appear to be at work, and if they really were at work and what they published was worthwhile, the rewards would be immediate and tangible.

Curators with the most education often seemed to have the most difficulty with exhibit scripts. There was maritime curator Melvin Jackson, for example. The exhibit he inherited from Howard Chapelle lacked social context altogether: "Just get all the models you can and throw 'em in there," was how Multhauf characterized what Chapelle had done. Jackson began working on a script for a new Hall of American Maritime Enterprise in 1970, and six years later he was still struggling with issues like the ebb and flow of government subsidies, stories without a glimmer of "exhibitability." Where Jackson had succeeded, however, was in getting rich donations, and donors were becoming so impatient that there were rumblings of lawsuits.[37] With money in hand, Jackson was able to hire a succession of freelancers as scriptwriters, but this never worked because of the differential in what Bedini called "subject expertise." (Jackson, after all, was a student of Harvard's legendary Samuel Eliot Morison and had also commanded a ship in the merchant marine.) This was terribly frustrating for Hindle because the presence of well-credentialed scholars like Jackson was exactly why he could make a credible claim to the museum having "more strength in the history of technology . . . than any university."[38]

Ben Lawless kept insisting on the need to have somebody in a position similar to what Boorstin had carved out for Skramstad. He wanted Peter Marzio. "I have an enduring affection for his honesty and his capacity for real work," Lawless wrote. "Our relationship would probably be stormy, but effective." With the Skramstad experience in mind, Hindle resisted for a long time, but finally he asked Marzio to draft a position description for a new "assistant director of presentations." The qualifications, Marzio wrote, would include "a knowledge of history, an ability to write, an innate sense of exhibit artistry, a tenacious belief in high quality, and deep experience as both a scholar and an exhibit producer."[39] Miraculously, he managed to do this without seeming egocentric or self-serving. Hindle had made no promises, but he knew that Marzio was a rare curator "who did not consider exhibits a nuisance." On the contrary, he had shown repeatedly that he thrived on them. *A Nation of Nations* (*ANON*) was a team effort that included Grace Rogers Cooper, Barney Finn, Otto Mayr, Jack

White, Malcolm Watkins, and several others, most notably the curator from the Division of Philately, Carl Scheele, who evidenced a marvelous visual sense.[40] But the exhibit never really came alive until Marzio returned from his Fulbright in Italy and went about collecting the array of neon signs—"Chinese American & Spanish Food," "Goldberg's Pizzaria," and the like—that became *ANON*'s signature.

By the time Hindle was ready to make a radical change in the museum's management structure, however, Marzio was considering an offer to become the director of another museum. A little earlier, Hindle would have tried to persuade him to stay, but now his relationship with Blitzer was fast deteriorating, his disappointments multiplying. An energy-and-environment exhibit for which he had high hopes was not going to happen. Multhauf, who was to have been directly involved, had warned that he did not think "the museum exists to scare the hell out of visitors."[41] Yet everyone knew that this would have been a perfect vehicle for putting technology squarely into "social context" and also providing "a link between the world of ideas and the world of policy," the mission of the Woodrow Wilson Center. So with the exhibits, Hindle would have to content himself with what had been accomplished already. "I do not know whether you have heard reports on the Nations and 1876 exhibits," he wrote to Multhauf, who was away, "but I do believe they are great successes with 1876 being a real smash . . . We are all hoping we can rest on our oars somewhat as far as colossal exhibits are concerned."[42]

■

THIS INTEGRATION OF TECHNOLOGY AND SOCIAL CONTEXT was never better expressed in Smithsonian exhibits—maybe in exhibits anywhere—than in *ANON* and (quite differently) in *1876*. *ANON* filled as much of NMHT's second floor as had *Growth of the United States*, and it initially had its own separate entrance on the west side of the building. The design was by Chermayeff & Geismar, the same New York firm that had been responsible for "Productivity" during Boorstin's time. Whereas that exhibit went heavy on electro-mechanical gimmicks, however, *ANON* had none. Rather, it was rich in silk-screened text and epitomized the new story-driven approach.

"Objects do not speak for themselves," wrote Hindle in the introduction to Marzio's catalog, "or at best they speak very softly." The point of view was unmistakable. Here was a nation whose strength derived from diverse cultural traditions even as a common bond was forged, to a large extent through innovative technologies.

The idea of an exhibit like *ANON* derived to some extent from *Growth of the United States* ten years before but even more so from the story-driven work of Charles and Ray Eames, whose pathbreaking *Mathematica: A World of Numbers* had opened at the Los Angeles Museum of Science and Industry in 1961.[43] NMHT's other Bicentennial blockbuster was story-driven, too, but it was also collections-driven, and much more. The story was carried not by extensive labeling but by facsimiles of gaudy commercial signage and by the exhibit's very location, the venerable National Museum building of 1881, Arts and Industries, which curators had been so anxious to escape not long before. Now they contemplated a return in a mood of nostalgia, knowing that the building itself, the terra-cotta, the exposed metallic roof and rafters, the rotunda once commanded by the "Spirit of Freedom," would add immeasurably to the drama. The exhibit *1876* was accurately termed a "microcosmic re-creation" of the Philadelphia Centennial Exhibition, the world's fair to which the National Museum owed its inception.

Heading a group of curators from all over the museum was Robert Vogel, one of Multhauf's first recruits, in 1955, who in the time since had taken liberal advantage of Multhauf's invocation to "distinguish himself as he distinguished the museum." But Vogel would have been the last to deny that the real power behind the exhibit was its designer, Bill Miner, still a Smithsonian newcomer, suitably empowered perhaps because A&I was where designers first began to make their presence felt in Smithsonian precincts.[44] Miner, a veteran of the Eames Office, appealed to Ben Lawless's enthusiasm for outsiders with a touch of brilliance, even if "difficult." What he created in A&I was not just an educational and artistic success, like *ANON*, it was a *theatrical* success. Everyone involved had a sense that *1876* was the Smithsonian's best foray ever into show business.

Miner succeeded in combining the virtues of both collections-driven and story-driven exhibits into what, many years later, would get dubbed

"immersive" design. It was not just an exhibit; it was an experience. Slated for a two-year run, it actually lasted more than twenty and, as it came down piecemeal, the disappointment was palpable. Igor Drovenikov was a senior researcher from the Institute of History of Science and Technology at the Russian Academy of Sciences who would visit the Smithsonian occasionally. Even though he had official business elsewhere, A&I was always his first stop because *1876* was the exhibit he loved best in all the world: "a romantic invitation into the past century," he called it. When it was no more to be seen, in the mid-1990s, he told Smithsonian friends that he was crushed. Then, there was the *Wall Street Journal*. In the context of an editorial about the Smithsonian's alleged takeover by "activist curators from the academic left," the *WSJ* shed tears over "the Smithsonian's plans, now moving steadily along, to close down, of all things, the remarkable exhibit celebrating American industry and culture (from the Centennial Exhibition of 1876) set up in 1976 and housed in the Arts and Industries Museum."[45]

The remark about a hijack by "the academic left" was questionable, for the new style of text-driven exhibitry was owing much to the influence of a *WSJ* favorite, Daniel Boorstin. Still, rarely again would a major exhibit ever be staged just because there was a "good collection." Almost always, a "theme" would be required, such as the mass production of clothing, or a topic like news reporting or banking, or even an abstraction like productivity. Exceptions were rare, although there were a few. Otto Mayr and Klaus Maurice curated *The Clockwork Universe*, first in Munich and then at the Smithsonian in 1980–81, an exhibit featuring an extraordinary collection of German clocks and automata dating from the century after 1550—more than a hundred devices representing "a high achievement in technology" lent by several dozen museums and private collectors. Actually, *The Clockwork Universe* was built not only on a rich collection but on a subtle and elegant concept: a mechanism depicting cosmic motions "on a small, humanly comprehensible scale," also furnishing "methods and structures of thought by which man could explore, on a larger scale, the mysteries of the universe in which he existed and could interpret this universe as clockwork."[46]

One other exhibit staged at the same time also was collections-based.

There was no concept, subtle or otherwise, and unlike *The Clockwork Universe*, there was nothing extraordinarily valuable. This exhibit was called *The Nation's Attic*, and it was Ben Lawless's last bow before he set out on a new freelance career that would last even longer than his career at the Smithsonian. Ben loved to celebrate eccentricity, and here was *eccentricity*: decorated ostrich eggs, crystal walking canes, the national water meter collection. It was all displayed in an imaginary attic that was another of Nadya Makovenyi's remarkable stage sets. Ben was nearly as happy about *The Nation's Attic* as about *1876*. Many of us were.

After *The Clockwork Universe* and *The Nation's Attic*, the museum rarely again produced "collections-driven" exhibits except on a very small scale—a single machine on a platform, say, or an artisan's tool kit in a glass case. But that was the situation at one Smithsonian museum, and in 1976 a signal event had taken place across the Mall and a few blocks closer to the Capitol. It was a celebration of the Bicentennial far more extravagant than any exhibit staged at or by NMHT—the dedication of the National Air and Space Museum. NASM traced its origins back to the air museum first spun off in 1946, to be tended in improvised spaces by Carl Mitman. In 1971, after twenty-five years, Congress had finally approved funding to go with its authorization, and the new building had famously been completed on time and under budget.

NASM started out as if recapitulating the history of the old National Museum, beginning in 1881. The staff came largely from the ranks of military aviation retirees, and even those trained as historians thought of NASM as the most exciting museum in the world. It unabashedly presented itself—and was popularly regarded—as a place of *celebration*. Coming in the front door, one confronted priceless icons, the Milestones of Flight, one after another: the Wright *Flyer*, *Spirit of St. Louis*, *Glamorous Glynnis*, the Bell X-1 in which Chuck Yeager broke the sound barrier. It was breathtaking. Over at National Museum of American History (as it was renamed in 1980), there would be new exhibits celebrating George Washington and Franklin Roosevelt, very fine exhibits showing the potential of a "commitment to social context" (Washington was "a figure upon a stage," while "technological advances in communications" were essential to FDR's success), but for drawing big crowds nothing could compete with

the National Air and Space Museum, with all its technological treasures proudly front and center and "context," "concepts," and all that sort of thing simply not worth much bother. And was there reason to separate what was there from "more earthly technology," asked Joe Corn, author of *The Winged Gospel*, one-time NASM fellow, and eminent Stanford historian? The question was only rhetorical.

Two of the Smithsonian's most respected curators. Grace Rogers Cooper (*top*) is seen with two of the first mechanical sewing machines, her curatorial specialty. C. Malcolm Watkins (*bottom*) poses in the colonial kitchen featured in *A Nation of Nations*. Cooper was responsible for suggesting the name of the Museum of History and Technology. Watkins, an ethnologist, left the Museum of Natural History to join with historians of technology when MHT opened and he later established its Department of Cultural History.

The Museum of History and Technology's deputy director Silvio Bedini poses with a bust of Thomas Jefferson and the theodolite he used to survey Monticello (*left*). Bedini was expert in many technological realms, but his favorite was the history of surveying. *Below*, his diorama of Andrew Ellicott and Benjamin Banneker, dubbed "the first black man of science," surveying Washington, D.C.

LAYING OUT THE NATION'S CAPITAL

At the entrance to the first exhibit bearing the name of its sponsor, the *Henry R. Luce Hall of News Reporting*, curator Peter Marzio discusses the "newsboy," a designer's storytelling embellishment, with visiting White House correspondent Sarah McClendon. Following ten years as the Museum of History and Technology's curator of graphic arts, Marzio's career culminated with a remarkable thirty years as director of the Houston Museum of Fine Arts.

SMITHSONIAN INSTITUTION ARCHIVES, IMAGE NO. 2011-0727

The three secretaries who led the Smithsonian from 1928 until 1964, a period of austerity and then rich funding. *From left to right,* Leonard Carmichael (1953–64), Charles Greeley Abbot (1928–44), and Alexander Wetmore (1944–52). In concert with Frank Taylor, Carmichael secured congressional authorization for the Museum of History and Technology.

Charles Blitzer (*above*), who, as Dillon Ripley's assistant secretary for history and art from 1968 until 1983, sought to push the exhibits toward what he considered greater cultural relevancy. John C. Ewers (*below*), the Plains Indian scholar who worked for ten years beside Frank Taylor and Robert Multhauf in planning the Museum of History and Technology exhibits, served as director briefly and then returned to the Museum of Natural History as senior ethnologist.

SMITHSONIAN INSTITUTION ARCHIVES, IMAGE NOS. 78-17406-35A AND 92-1794

Opposite, on January 29, 1959, a crowd gathers to watch the dedication ceremony for a U.S. Army Jupiter-C, a missile designed under the direction of Werner von Braun, at what became known as "Rocket Row"—not without a measure of controversy— next to Arts and Industries.

Above, a curious juxtaposition in the rotunda of Arts and Industries. The plaster model of Thomas Crawford's "Statue of Freedom," which was placed atop the United States Capitol in the 1860s, is joined by a model of the Mariner IV satellite from the 1960s. The Mariner IV flew by Mars and sent home the first close-up images of another planet.

Museum people. *Top, left to right,* Larry Jones, Jack White, John Stine, and Bill Withuhn pose for a photo by Robert Vogel after the first test run for the *John Bull,* October 1981. White was an honored senior curator; Stine, the museum's grand master of mechanics and logistics. *Bottom,* in 1977, at a photo op after receiving a grant from the Certain-teed Corporation, maker of building supplies, curator Rodris Roth (*left*) poses with museum director Brooke Hindle, Certain-teed's Edwin Harper, curator Anne Castrodale Golovin, Dorothy Wackerman of Certain-teed, and James Lyons of the Smithsonian's Office of Membership and Development.

Karen Loveland, the Smithsonian's beloved and much-honored filmmaker, at her editing machine (*above*). Otto Mayr, during his stint as acting director of the National Museum of History and Technology, poses with a much older machine, the museum's rare Holtzpaffel lathe from the eighteenth century (*below*).

Exhibits dominated by "pieces of the True Cross." *Top, Milestones of Flight* at the National Air and Space Museum, with the Wright *Flyer* in the center. *Bottom,* *1876*'s "Machinery Hall" with an Otis Steam Elevator reaching to the ceiling of A&I and the flywheel of a steam-powered refrigeration compressor visible just below one of the lighting fixtures.

Exhibits spotlighting the ingenuity of the Museum of History and Technology's premier designer, Nadya Makovenyi. *Top, Suiting Everyone* (1974), with a panorama of store-window mannequins introducing an exhibit about the production and marketing of "ready-made" clothing. *Bottom, American Maritime Enterprise* (1978), featuring a full-scale hands-on re-creation of a ship's foremast and rigging, with models and marine art in a lesser role.

SMITHSONIAN INSTITUTION ARCHIVES, IMAGE NOS. 74-9467-14 AND 78-12155

Opening day at the National Air and Space Museum, July 1, 1976. Touring the gallery called *Apollo to the Moon*, from right, Director Michael Collins, Vice President Nelson Rockefeller, President Gerald R. Ford, and Smithsonian secretary S. Dillon Ripley.

SMITHSONIAN INSTITUTION ARCHIVES, IMAGE NO. 76-8431-12A

A scene from Karen Loveland and Ben Lawless's award-winning *Celebrating a Century* (1976), a movie made to complement *1876*. Cast as architects and engineers for the Centennial Exposition in Philadelphia, from left, Robert Vogel, Bill Miner, Frank Taylor, an actor from Arena Stage, and Lloyd Herman, director of the Smithsonian's Renwick Gallery opposite the White House.

SMITHSONIAN INSTITUTION ARCHIVES, IMAGE NO. 75-15344-25A

In February 1984, outgoing secretary S. Dillon Ripley poses with secretary-elect Robert McCormick Adams (*above*). Shortly after being selected by Adams as director of the National Air and Space Museum in 1987, Cornell University astrophysicist Martin Harwit poses with a model of the *Enola Gay*, the airship that would lead to his downfall seven years later (*below*).

National Museum of American History director Roger Kennedy accepts Althea
Gibson's Wimbledon trophies in 1988 (*top*). A year later, curator Tom Crouch poses
in the doorway of a stage set simulating the grocery store of a dispossessed Japanese
American in *A More Perfect Union*, the museum's most brave and daring exhibit
(*bottom*).

Top, Secretary I. Michael Heyman and National Museum of American History director Spencer Crew (1997). *Bottom*, Secretary Lawrence Small and donor Kenneth Behring (2001).

The National Air and Space Museum . . . opened in a large and distinctive new building in 1976, is a monumental testament to the belief that the history of flying machines—aircraft and spacecraft—is unique and separate from the history of more earthly technology.

—JOSEPH J. CORN, 1983

CHAPTER 7 ▪ The Winged Gospel

In 1944, Charles Greeley Abbot retired as Smithsonian secretary at age seventy-two, the first secretary to outlive his time in office. For half a century his consuming interest had been the Smithsonian Astrophysical Observatory—he became the director in 1907—and in his eighteen years as secretary he had rarely given his undivided attention to the National Museum. Still, one of his books closely mirrored the concerns of Frank Taylor and Carl Mitman, 383 pages of *Great Inventions*, with a substantial text and more than 180 illustrations.[1] It was Abbot, too, who secured Works Progress Administration support for *The World Is Yours*, the Sunday-afternoon radio series that often dramatized science and invention. And in June 1941 he implored Congress to show "our gratitude and appreciation" for scientists and inventors "through the medium of a live, dynamic museum of engineering and industry." Then came Pearl Harbor, six months later, and it seemed that half the Smithsonian went off to war, including Taylor. Abbot started thinking about retirement so he could get back to

his studies of solar radiation, which he believed to be "the fundamental problem of meteorology," without interruption.[2]

As with every previous secretarial transition since the first one in 1878, Abbot's successor was promoted from inside. Alexander Wetmore's science was earthbound, although he was no less passionate about avian paleontology than Abbot had been about mapping the infrared solar spectrum. Wetmore had been hired as superintendent of the Smithsonian's National Zoological Park in 1924 but was almost immediately promoted to assistant secretary in charge of the National Museum.[3] As before, the Department of Mechanical and Mineral Technology in Arts and Industries (A&I) was treated as a poor relation by the scientists, whether "over there" in the Natural History Building or next door in the Castle, and a long time went by before Wetmore got to know Taylor, who was starting out as a "lab apprentice" just as Wetmore was finishing his doctorate at George Washington University. But it was different with Mitman. By 1924 Mitman was already a Smithsonian presence at age thirty-five, an expert and well-connected curator and a polished and prolific writer then in the midst of publishing a series of articles in *Popular Mechanics* on "mechanical powers": the screw, lever, inclined plane, and so forth. And Mitman's department vaulted to a whole new level of visibility with the arrival of Charles Lindbergh's *Spirit of St. Louis* in 1928, attracting more visitors by far than anything else on display and soon coming to represent "the Smithsonian Institution" (or, as it was often called, "Smithsonian Institute") in popular perception. As Taylor remarked years later, if you looked like a tourist and asked a cabbie for the Smithsonian, he would go right to A&I.

In addition to campaigning for a new museum, throughout the 1930s Mitman organized Smithsonian exhibits at expositions in the United States and abroad. During the war, even as Mitman was struggling to keep A&I open with a skeleton crew, Secretary Abbot appointed him chairman of a committee charged with exploring ways to deploy the institution's resources in the Allied cause. In concert with men from the National Research Council, the American Council of Learned Societies, and the Social Science Research Council, Mitman was instrumental in establishing the Ethnogeographic Board, a clearinghouse for information of possible use to the armed forces in "non-European areas of the war," especially Micronesia,

Melanesia, Indonesia, and Africa.[4] When President Roosevelt instructed government agencies to prepare strategic plans in hopes of avoiding another depression of the sort that followed World War I, Wetmore had Mitman compose the contribution from the National Museum.

With thirty years on the job, Mitman was the institution's ranking authority on technological history, not least because he had gone abroad to visit the Deutsches Museum in Munich and the Science Museum in London, where the Wright *Flyer* had been on exhibit since 1926. Thus, he struck Wetmore as the natural choice when he needed to put somebody in charge of a new museum authorized by the 79th Congress and signed into law by President Harry S Truman on August 12, 1946. It was called the National Air Museum, and it was to be the repository first and foremost for the *Flyer*, which Orville Wright had agreed to retrieve and bequeath to the Smithsonian in return for a promise by Secretary Abbot to clear up its misrepresentation of the Langley aerodrome. Orville regarded this misrepresentation as a perfidy aimed solely at salvaging the reputation of another secretary who had headed the institution for nineteen years and spent $50,000 of War Department money to no good end.

In *Great Inventions*, published in 1934, Abbot had still equivocated. True, when Glenn Curtiss flew the aerodrome in 1914 after having made "certain changes," this did not "prove definitely that the great Langley machine was capable of sustained flight" in 1903. Yet "many experts were convinced that it was so because of the success attained with a similar powered model."[5] It was so? *What* was so? That the aerodrome was capable of sustained flight? This was the perfidy. But in 1942 Abbot clarified the matter to Orville's complete satisfaction in a paper that detailed what Curtiss had done to enable the aerodrome to fly in 1914 when it could not fly in 1903. The cause was not, as Langley claimed, its awkward launch from a houseboat in the Potomac; however launched, it simply could not fly. Abbot called the Wright *Flyer* the machine "to which all the world awards first place."[6] Orville was appeased. The *Flyer* would be on its way home as soon as the war was won, to be accorded "the highest place of honor."

Public Law 722 authorized the Smithsonian "to investigate suitable lands and buildings for selection of a site for said national air museum," but for now the highest place of honor would have to be the rotunda of

A&I, even though the building was overcrowded and in none too good repair. Why not a new building, or, if not new, at least roomy? That was clearly what General H. H. "Hap" Arnold had in mind when he set about collecting a "full set of World War II aircraft" to donate to the Smithsonian. Confident that "young people were more interested in aviation than anything" (just as he was), Arnold envisioned a museum occupying one of the wartime manufacturing plants then being sold as "surplus." He also envisioned a museum much like the Army Air Forces Museum in Dayton, Ohio, with a strong emphasis on military planes. Passionate about the creation of an independent air force, Arnold believed that such a museum "would prove to the American public the importance of military aviation and would help future generations launch careers as pilots and aeronautical engineers."[7]

But Congress was in favor of locating the museum in Washington, and Orville Wright had stipulated that the *Flyer* be exhibited in the context of its innovative *technology*, not military history. Moreover, the Smithsonian had the *Flyer*'s only rival for popular esteem, the *Spirit of St. Louis*, as well as other storied aircraft such as Wiley Post's Lockheed Vega, the *Winnie Mae*, and even the Wright brothers' 1908 machine, with which they had staged a demonstration for the War Department at Fort Myer, Virginia, so impressive that nine years later Congress appropriated an unheard-of *$640 million* to supply the Allies with twenty thousand planes. So Congress now called for the establishment of an advisory board to plan for a Smithsonian museum that would present "a complete history of the airplane, starting with the first Wright airplane and carrying through every other type of airplane both commercial and military."[8] The board comprised three military men and two civilians. Its immediate task would be to find a site, assuming A&I to be strictly temporary.

Orville Wright expected a new building, and he died in 1948 confident "that there would be a second-to-none U.S. Air Museum in which [the *Flyer*] would be the premier Exhibit, displayed in a setting appropriate to its unique character and merit like the crown jewels."[9] It took thirty years from the law's passage for this second-to-none museum to materialize, however. In that delay, historian Alex Roland writes, "is embedded the answer to the question of what purpose the museum was meant to serve,

education or celebration." Who was to own the *Flyer*'s narrative? "Crown jewels" sounds like a narrative of unabashed celebration, and the legislation President Truman signed in 1946 included the word "memorialize." But it also defined one purpose of the museum as "provid[ing] educational materials for the historical study of aviation."[10] Teaching or memorializing? Educating or celebrating?

∎

THERE WAS ANOTHER PROBLEM, practical not philosophical. Congress had *authorized* a Smithsonian Air Museum, yes, but an *appropriation* for a new building was something separate, and the Appropriations Committee could not even consider the matter until the advisory board had identified a suitable site, obtained all the necessary permissions, and priced it out. While that problem was being addressed, the *Flyer* would get suspended in the rotunda of A&I. As for General Arnold's collection of warplanes, they found a temporary home near Chicago in an enormous (but now empty) plant where Douglas Aircraft had made C-54 Skymasters, the Air Force's primary wartime transports. For a few years, the adjacent Army Materiel Command's Park Ridge Airfield was known as Orchard Field Airport, then in 1949 it was renamed O'Hare International Airport in honor of Lt. Commander Edward Henry "Butch" O'Hare (1914–43), the first naval aviator to receive the Congressional Medal of Honor, for valor in the Pacific Theater of Operations. Best publicized among the planes that Arnold had saved for posterity was the *Enola Gay*, which also saw action in the Pacific Theater, and when the whole collection was turned over to the Smithsonian in 1949, a well-circulated news photo showed Colonel Paul Tibbets and two of his *Enola Gay* crewmen posing with Mitman.[11]

After the Korean War began in mid-1950, the Douglas plant was designated for reactivation, and Mitman and the Air Museum's advisory board were told that the Park Ridge facility had to be vacated by January 1952. This proved to be a false alarm—there was no need for a hasty evacuation—but Mitman was sixty-three, he had worked very hard for the Smithsonian for most of his life, and he was thinking about retirement, perhaps already aware that he would not live much longer. Paul Garber, the curator in

charge of the aeronautical collection, had been with the Smithsonian almost as long as Mitman, but he was younger and more energetic (and more captivated by the winged gospel), and it fell to Garber to find a place to store dozens and dozens of airplanes, U.S. Army Air Forces planes and captured enemy planes, not to mention what the navy was holding for the Smithsonian at Norfolk, Virginia. Prior to the war, Garber could display nearly all the most important airplanes in the collection, but now there were far too many.

He arranged for storing the planes that could not be displayed at Andrews Air Force Base near Washington, but this was only temporary, "until the museum can take them on its own premises." Garber needed to relocate his collection somewhere nearby, and according to Smithsonian lore, he "persuaded a pilot friend to assist him in conducting an aerial survey of the Maryland and Virginia suburbs from the cockpit of a Piper J-3 Cub." Close to Andrews and not five miles from the Mall, they spotted a twenty-one-acre parcel of woodland that was under the jurisdiction of the National Capital Park and Planning Commission, which relinquished it with no delay.

The woodland was in Prince George's County, Maryland, on the site of two unincorporated communities: Suitland, named for nineteenth-century landowner Samuel Taylor Suit, and the more pleasantly named Silver Hill.[12] With almost no budget for anything like erecting buildings, Garber persuaded the Army Corps of Engineers battalion at nearby Fort Belvoir to clear the land and build roads and the navy to supply, at cost, the first of the cavernous "prefabs" that would eventually number more than a dozen. Downtown, there was the Tin Shed, which had been erected by the War Department between the Castle and Independence Avenue in 1917 and subsequently turned over to the Smithsonian. Along with its presence in A&I and Rocket Row outdoors, this would be the extent of the air museum until 1976.

ALEXANDER WETMORE WAS NOT KEEN on devoting attention to plans for museums to be filled with technological artifacts, and he decided to step down. He had served the shortest time in office of any Smithsonian secretary, retiring at the end of 1952 in order to pursue the research that was always his true love.[13] Leonard Carmichael, who took office at the beginning of 1953, was different from Wetmore and Abbot. He was not from inside the institutional hierarchy, and he was not devoted to a scientific discipline, save what could be called "physical psychology." As a child he had read Shakespeare, Thackeray, and Trollope. Before entering college at Tufts, he had read Josiah Royce's *The Spirit of Modern Philosophy* and William James's *Principles of Psychology*. He loved both psychology and history, and he would have completely understood Eugene Ferguson when he remarked,

> A museum is something like a Sunday school in that the visitors to either are not subject to the same rules of mental discipline as they are in an ordinary school. They will carry out their part of the learning process when it is attractive to do so . . . The incentive provided by examinations and grades are not available to the curator, any more than they are to the Sunday school teacher.[14]

Right off, Carmichael asked Taylor for an update on prospects for a new museum of history and technology. Because the fiftieth anniversary of the Wright brothers' first flight was approaching, he also requested an update from the spokesman for the air museum advisory board, Grover Loening. Taylor was optimistic; Loening could only lament the continuing failure to stake out a location for a new building or even to "build up a much more sympathetic ear in Congress."[15] In the first years after the museum was authorized, Mitman was inclined to go along with the National Capital Park and Planning Commission when it recommended a site "quite distant from the city."[16] By the time Carmichael arrived and Mitman retired, however, the advisory board was looking in the vicinity of the existing Smithsonian buildings, and prodded by the secretary, it soon focused on a site across Independence Avenue, between Ninth Street and Twelfth.

There needed to be a preliminary study, and after Carmichael secured

a $25,000 donation from each of two aircraft trade associations, he went straight to McKim, Mead, and White, the same architectural firm to which he would award the contract for the Museum of History and Technology. The McKim plan for the Air Museum included a main gallery stretching almost the entire length of the building, three city blocks—like a hangar—without a gallery devoted to civilian aircraft but with a great deal of space dedicated to military planes, and room for even the largest of them, the *Enola Gay*, 99 feet long and with a wingspan of 141 feet. Total square footage would be double that of the Natural History Museum.[17]

The Park and Planning Commission would not approve, largely because a building "the size of a 'junior pentagon'" (as the chairman of the Redevelopment Land Agency put it) would interfere with other plans for the city's southwest quadrant, plans involving I. M. Pei in what is often called a "last hurrah of the Modernist movement."[18]

Now, all attention fell on a site on the north side of Independence Avenue, the Mall side, between Fourth Street and Seventh, directly opposite the National Gallery of Art. Co-chair of the Joint Congressional Committee on Construction of Buildings for the Smithsonian was Senator Clinton Anderson of New Mexico. When Anderson introduced a bill to reserve this parcel for the Air Museum, he set off a round of combat between supporters of his bill and a bill introduced by Arkansas senator J. William Fulbright on behalf of "the nation's artistic community." Fulbright's bill would authorize a center for the performing arts on the same site—it was a competition between "arias and airplanes," as the *Post* put it. Those favoring arias (or sometimes "arabesques") insisted that a performing arts center needed to be downtown, while airplanes belonged someplace in the suburbs (they did not go so far as to say "someplace out of sight"). On the contrary, argued Loening, the Air Museum should be centrally located as "a memorial to enshrine the greatest mechanical relic in the world," the Wright *Flyer*. The Cold War figured prominently in the debate, with performing artistry being depicted as an effective means of winning hearts and minds. But Loening would ask congressmen, "Do you want to inspire the youth of this country with the world's first airplane—or by teaching them to dance?"[19]

As with the authorization of the Museum of History and Technology,

patriotic sentiment won the votes. Aviation, said Senator Anderson, was "one of the few great human achievements that have originated, developed, and come to possibly their greatest flowering in the United States." And with construction of MHT about to get under way as a monument to technology and engineering, Carmichael now threw his weight behind the Air Museum as a "monument to aviation," a monument that was *spiritual*, not merely "material and mechanical." For its most avid supporters, as Alex Roland sums up, "the Air Museum was to be a house of worship: America was the religion, Orville and Wilbur Wright were the most visible saints, and the 1903 *Flyer* was the true cross."[20]

Senator Anderson's bill passed handily, and Public Law 85-935 put the Mall site for the National Air Museum on reserve. The date was September 6, 1958. Two weeks earlier, Senator Anderson had turned the first shovel of earth at the Museum of History and Technology groundbreaking. A few weeks before that, Mel Kranzberg had chartered the Society for the History of Technology (SHOT), whose fortunes would be intertwined with MHT's for years to come. The summer of 1958 was surely a time for beginnings: other new initiatives included the National Aeronautics and Space Administration (NASA), designed to fund research, and the National Defense Education Act (NDEA), designed to fund student loans and support education in science and technology in order to further "national security goals." With the National Air Museum, however, the only trouble was the funding.

Securing funds would be the topmost priority for a director, and finally there was one. Mitman's title had been Assistant to the Secretary for the Air Museum, and between his retirement in 1952 and 1958 nobody even held that position. When a search was opened for director, Paul Garber's name came up, but the men in the Castle dismissed him as someone who knew a great deal about airplanes but not enough about "what they meant" about history.[21] It was a perception that would dog nearly everybody connected with the Air Museum for a long time to come. In the Castle there was a sense of needing someone "of national stature," but that was not exactly the case with the man who got the job, Philip S. Hopkins, whose chief attribute seemed to be a "good personality." In his six years as director, his one accomplishment, though not a small one, was a contract

with an architectural firm. No more McKim, Mead, and White, which had been absorbed in 1961 by a firm headed by Walker O. Cain, who was actually the chief designer of MHT. So instead of a firm with roots in the nineteenth century, the architectural commission for the Air Museum went to a partnership that was less than ten years old and had completed only one major project, the Priory Chapel of the Benedictine monastery in St. Louis, a quirky but quite compelling building.[22]

The firm was Hellmuth, Obata, and Kassabaum (later HOK), and it was just taking off into a steep ascent: from parochial schools in St. Louis suburbs to the Priory Chapel to the Houston Galleria and Xerox PARC in 1970 and King Saud University in Riyadh, a $3.5 billion construction project, in 1975. For the Smithsonian, besides the Air and Space Museum, HOK would also design the Udvar-Hazy Center in Chantilly, Virginia, where the *Enola Gay* would go on permanent display in 2003. George Hellmuth, Gyo Obata, and George Kassabaum were graduates of the school of architecture at Washington University in St. Louis, and Obata—who would be chiefly responsible for designing the museum on the Mall—also studied with Eero Saarinen at the Cranbrook Academy of Art in Michigan.[23] There was $510,000 to begin planning, but years would go by before construction was funded and Obata could really get down to business.

When Dillon Ripley became secretary in 1964, one of the first challenges he confronted was this lack of an appropriation for construction, combined with a perception among his closest advisors, Charles Blitzer and Philip Ritterbush, that it was a moot point anyway because the people involved with the Air Museum "were not intellectually prepared to tell a story that connected aviation to the rest of American history and that they were biased toward highlighting the military aspects of aviation."[24] The Commission on Fine Arts was especially troubled by their enthusiasm for a display of rockets visible from the Mall. Ripley was determined to find someone with a more solid resume than Hopkins, and he did get a man of genuine accomplishment, if not quite "national stature." His name was S. Paul Johnston, and he was more secretive about the S initial than even S. Dillon Ripley about his.

Johnston was a MIT graduate who had worked for Alcoa in the 1920s, developing lightweight alloys for aeronautical use, then coauthored a

technical reference, *Aviation Handbook*, edited *Aviation* (now *Aviation Week and Space Technology*), helped organize the emergency aircraft production program during World War II, published a book titled *Wings after War* and directed postwar bombing surveys in Europe and Japan, and became research coordinator for the National Advisory Committee for Aeronautics, the predecessor to NASA. When Ripley tapped him for the Air Museum, he had been director of the Institute of Aeronautical Sciences (IAS) for eighteen years. In 1963 the IAS was merged with the American Rocket Society into the American Institute of Aeronautics and Astronautics. The name change was suggestive of a change in the wind for the Air Museum as well. Following a recommendation by the Smithsonian's Board of Regents, bills were introduced in both houses—the Senate bill by the omnipresent Clinton Anderson, who co-chaired the construction committee for ten years—to change the name, and in 1966 the National Air Museum Amendments Act made it the National Air and Space Museum (NASM) as well as formalizing NASM's status as official repository of artifacts from NASA.

Senator Anderson was involved because the act also reauthorized new construction even though construction had plainly been authorized in the 1946 legislation. The National Air Museum Amendments Act was introduced at almost the same time in the late summer of 1964 as the Tonkin Gulf Resolution—the United States was going to war. It took two years to get the Air Museum act passed, as Public Law 89-509, and six more years to get an appropriation. The Senate Committee on Rules specified that no appropriation should be requested "until there is a substantial reduction in our military expenditures in Vietnam." Even so, Ripley tried to insert a request into the budget year after year. And in an imaginative attempt to sidestep the "Vietnam clause," he even proposed that funds be appropriated solely for the basement parking garage and that proceeds would then enable the museum itself to rise on this foundation. Nothing worked.

■

WHEN A SMITHSONIAN SECRETARY hires a museum director, he has expectations. Ripley's expectations for Brooke Hindle at NMHT in 1974 were that he light a fire under a demoralized curatorial staff and that he do something to make the arrangement of exhibits more intelligible. His expectations for Johnston in 1964 were twofold: that he find a way to get the new museum funded in the amount of $40 million or so and that he also light a fire, although it was pretty evident that the staff problem at NASM was likely to persist no matter what. At History and Technology there were scholars, productive scholars who placed high value on research and publication and were well regarded in academe. The editorial office for *Isis*, a top-flight academic quarterly, was there, as was the editorial office for the new *Smithsonian Journal of History*. There were curators with doctorates in history from the best universities, curators with less schooling but whose work was published by the best publishers. At NASM, by contrast, there were military retirees, few postgraduate degrees, almost nobody to be called a historian, whether or not well schooled. Nearly everyone on staff seemed to be afflicted with a "self-referential frame of mind"; nearly everyone believed that aeronautics (and now astronautics) was *intrinsically* exciting and shared a sense of awe at the exploits of "magnificent men in their flying machines." Their mission as museum people, therefore, was simply to facilitate an emotional response, perhaps just by enabling other people to get up close to the objects of their own affection.[25]

Except for residents of the Smithsonian Castle, this seemed like enough of a mission. It would not be easy to persuade anyone at Air and Space that their museum represented something else magnificent, "a magnificent opportunity to demonstrate the scholarly potential of museums," as Ripley put it. But Johnston did his best to meet Ripley's expectations regarding the exhibit program. He mapped plans for exhibits that addressed the "motivation" for flying and even the "misuse" of aviation "for aggressive and destructive purposes." " 'Themes' rather than 'things' " was how Johnston summed up "A New Look for NASM," and indeed the thematic possibilities did seem rich: Flight and Public Policy, Flight and the National Economy, Flight for Exploration and Research, Flight for Public Welfare, Flight for

Profit, Flight for Fun.[26] The possibilities were rich, but the capacity of the NASM staff to realize them was another matter—or, rather, their interest in realizing them was—and Ripley was not won over, nor was anyone in his Castle cohort. Joanne Gernstein London writes of their "quiet contempt . . . for the NASM project." Alex Roland writes of Ripley's high passion for bringing new art museums into the Smithsonian fold—five of them in Washington, plus the Cooper-Hewitt in New York, and seven new research and support facilities—and then remarks that "no one ever mistook Dillon Ripley for having a particular affection for the Air and Space Museum."[27]

Johnson might well have commiserated with Robert Multhauf at MHT: Multhauf was sincerely trying to do the right thing, to carry out a mandate to finish installation of the exhibits as they had long been planned, and it was not going to be good enough, certainly not if Ripley's measure was the glorious anthropological museum in Mexico City or the otherworldly intellectual aims of Charles Blitzer. In October 1967, Ripley named Blitzer to the position of assistant secretary for history and art and put NASM within his purview. How was a scholar with a doctorate in British history, a man who "had never come within miles of the Pentagon" and had nothing but disdain for "gleaming machines," to get along with Johnston, Garber, or anyone else at NASM, all of them technological enthusiasts who loved gleaming machines and especially the warbirds? Not very well, and it was almost as if Ripley deployed Blitzer to force Johnston out. After Johnston left in 1969, disillusioned and embittered, Ripley returned NASM to the domain of the assistant secretary for science, Sidney Galler. Frank Taylor, who was one of the few "technical" men Ripley admired, was made acting director, just as happened at MHT when John Ewers had to resign after only a year as director.

It was not as if Ripley wanted to abandon the quest for an appropriation. He may have had "no particular affection" for the NASM collection, but the success of the Apollo 11 mission in July 1969 made him quite aware that this might be the most popular museum in his entire domain, however he might feel about it personally. (In the 1990s, the Newseum in Arlington, Virginia, ranked the moon walk as number two among "the twentieth century's top 100 stories," the Wright brothers' first flight as number four; one and three were Pearl Harbor and the atomic bombing of Hiroshima

and Nagasaki.) NASA historian Eugene Emme had urged Ripley as early as 1967 to exploit the public-relations potential of the moon landing to secure the appropriation, and when Nixon invited Ripley to a dinner in California honoring the Apollo 11 astronauts, he showed how well he could assume the persona of a true believer in the winged gospel:

> Now, if ever, the American people need . . . a living monument which honors and promotes that sense of adventure you have so eloquently described as "The Spirit of Apollo." It seems the ideal place, a showcase on the nation's Mall, for the recent accomplishment of N.A.S.A. as well as the unique history of America's technological breakthroughs in air and space.[28]

When the "moon rock" went on display, guarded like the Hope Diamond, it attracted 200,000 viewers in one month. In a memo titled "Love That Moon Rock," Ripley's assistant secretary for public service reported that gift shop sales had tripled.[29] What would happen when the Apollo 11 command module arrived?

Just after the moon landing, Ripley launched a search for a new director, with Blitzer chairing a committee that included two assistant secretaries and Nathan Reingold, of the Joseph Henry Papers. The committee set its sights very high and in the first few months turned down more than a dozen candidates who seemed well qualified, such as Dr. Emme, who had established the NASA Historical Office in 1960, after SHOT's Mel Kranzberg suggested the idea to Keith Glennan, NASA's first administrator.[30] Finally, a candidate appeared who was acceptable to everyone, David Hazen, dean of engineering at Princeton. Heaven forfend that anyone who wanted the job would be "wedded to hardware," as Reingold put it. Hazen was not, and even Blitzer thought him worthy, saying that he showed "genuine sympathy toward new ideas for the NASM, combined with a certain becoming judiciousness."[31] But then Hazen withdrew, and the search committee went into neutral.

This lack of forward motion was exacerbated by the perpetual inability to secure an appropriation for a new building. After a meeting of the regents in the fall of 1969, Chief Justice Warren Burger informed President Nixon about "the tremendous surge of interest among all Americans"

engendered by Apollo 11 and about the crying need for "a great education and exhibition center which will show to the Nation and the world our ability to develop technological skill and to perfect inventive engineering for the benefit of all mankind." The only response was a brusque note from Nixon's assistant for domestic affairs, John Ehrlichman, saying that the cost of fighting a war in Southeast Asia would not permit such an expenditure in Washington. In 1970, SHOT weighed in, at the urging of Emme, with Kranzberg drafting a letter for Multhauf to send to Ripley that expressed "the concern of historians of technology for the development of the National Air and Space Museum as a center for the display of the artifacts and professional research in the history of aeronautics and astronautics." Frank Taylor responded, saying there was hope because of a growing disinclination on Ripley's part "to accept the war as a valid reason to delay."[32]

Ripley's inclinations were irrelevant, it seemed, but not Barry Goldwater's. Goldwater had just returned to the Senate after a four-year absence following his defeat in the 1964 presidential election. Forceful as ever, even charismatic to those who shared his politics, Goldwater had been growing increasingly restive not only about the funding impasse but about the stalled search. At the top of the search committee's list by 1970 was General Keith Barr McCutcheon, a decorated Marine aviator with a graduate degree from MIT. Blitzer and the others were urging that he be offered the job, but Ripley procrastinated. Finally Goldwater, himself a general in the Air Force Reserve, had had enough. It looked like the Smithsonian was in a "state of crisis," and he said as much in a Senate speech on May 19, 1970, and again to the House of Representatives two months later. The long absence of a director, he declared, was unmistakable evidence that Ripley had no honest interest in the Air and Space Museum, not even when the United States had sent men to the moon.

Even though the secretary seemed to pay little attention to the senator, he did announce that the search would begin anew in the fall. (General McCutcheon, it turned out, was terminally ill and died in 1971, at age fifty-five.) Ripley had not been reticent about saying that a military man might not be the right choice in "the present political situation." But he knew that the military man who turned up in February 1971 was absolutely right. He was perfect.

■

MICHAEL COLLINS HAD AN UNCLE who was chief of staff of the U.S. Army. His father, an army man for thirty-eight years, had served as aide-de-camp to General John J. Pershing in the Philippines, in Mexico when he was chasing down Pancho Villa, and in France during World War I; he had retired as a major general. Mike was born in Rome in 1930, graduated from West Point, attended the Air Force Experimental Test Pilot School in California, trained as an astronaut, flew with John Young for three days in Gemini 10, worked Mission Control during the Apollo 10 flight around the moon—the first look at "the dark side"—then went back to the moon when Neil Armstrong and Buzz Aldrin landed. After the Apollo 11 mission, he retired from NASA, but took a post as assistant secretary of state for public affairs. He had been working with the State Department for about a year when he was offered the NASM job.

Ripley found Collins absolutely captivating (his phrase), and of course his fame and prestige were beyond measure. Nobody could have been happier about Collins than Senator Goldwater, but he still decried the absence of a museum where Americans could enjoy "the incomparable inspirational feeling which their heritage in flight and space can offer . . . where they can gain a feeling of pride in human accomplishment."[33] The senator kept at it, making speeches, arranging a face-to-face meeting with the president, and finally he got what he wanted. Goldwater would often be called "the father of NASM," but actually, it could not have been otherwise once Collins was on board. In the 1972 budget, Nixon would enable a request for a $40 million construction fund to go forward. On May 17, the Commission on Fine Arts approved Gyo Obata's design. The National Capital Planning Commission approved on June 29, just after the president signed the appropriation bill. Ground was broken in the fall.

All that had gone haywire with design and construction at the Museum of History and Technology went right with Air and Space, and it took less than four years to complete what had taken nine with MHT. The Rhode Island construction company, Gilbane, put on a vastly more polished performance than Norair, the Baltimore firm that built MHT, had done. Gilbane was a proponent of a novel system called construction

management. In concert with the project manager from the General Services Administration, and with NASM management and Gyo Obata, Gilbane pushed construction in accord with a strategy called fast tracking, "working with the architect on planning and scheduling activities from the very beginning," and with contracts being awarded as design was being developed.[34] *On Time and Under Budget!* the Smithsonian press release shouted, and a publicist taking a look back might have called NASM a success the likes of which had not been seen since the swift and inexpensive completion of the first National Museum (A&I) in 1881. Although there would be no pleasing the critic called "our infallible Cassandra," the *New York Times*'s Ada Louise Huxtable (she described the building as "a cross between Disney World and the Cabinet of Dr. Caligari"), *Washington Post* critic Wolf von Eckhardt assessed the building as "an appropriate and harmonious finale to the grand architectural concert on the Mall." To the untutored eye, Gyo's building could readily pass for Orville Wright's "second-to-none" dream, and certainly the expanses of glass looked more like a national museum should look than the cloister across the Mall from whose rib it had come. Long afterward, after Oriole Park at Camden Yards in Baltimore, after Edificio Malecon in Buenos Aires, after fifty major projects, Gyo would still remember the National Air and Space Museum with special pride and affection.[35]

Following a flyover by Navy Thunderbirds and the arrival of Secretary Ripley, Chief Justice Warren Burger, and President Gerald Ford together by carriage, the doors were thrown open to the public on Thursday, July 1, 1976. President Ford called the museum "the perfect birthday present from the American people to themselves." There was the Albert Einstein Spacearium with a state-of-the-art Zeiss planetarium projector, a gift from the Federal Republic of Germany; there was a 485-seat IMAX theater with a screen five stories high and a spectacular film, "To Fly," funded by the Continental Oil Company; and, of course, there was a library and archive because the museum, said Mike Collins, "should not only display artifacts, but act as a catalyst in exchanging information, to grow into a true national center for aero-space historical research." Most importantly, there was 200,000 square feet of exhibit space.

HOK and its subcontractor, Research and Design Institute (REDE),

developed a set of design concepts that "dovetailed perfectly with [Ripley's] interest in integrating Smithsonian museums and exhibiting NASM's collections in broader context."[36] Not many of the HOK/REDE concepts actually materialized, however. Curators pleaded a lack of time. But mostly it was just a lack of interest in "broader" matters when they believed the intrinsic fascination of the artifacts on display would be sufficient to attract crowds larger than had come to any other museum. They were right. So there was no Flight and Public Policy, no Flight and the National Economy. No planes in the context of "the destruction they wrought." No *Enola Gay*, but there were many reasons for this omission.

Collins would quickly form a bond with Brooke Hindle and especially with Silvio Bedini—the two rarely missed a Friday luncheon date—and in Mel Zisfein, Collins found a deputy as versatile and industrious as Bedini.[37] It was because of Zisfein that bits of the HOK/REDE proposal actually did materialize, even bits of what S. Paul Johnston had proposed in the 1960s. But who needed this sort of thing when you had the Wright *Flyer*, the *Spirit of St. Louis*, the *Winnie Mae*, the X-1? The Apollo 11 command module and moon rocks? Most people who worked at the museum in its earliest years perceived it as a place of celebration, pure and simple, as did the people who flocked through the doors, often overwhelming the guards assigned to keep a count on their hand-held clickers. Every year the academics and intellectuals on the Smithsonian Council would plead for "more commitment to social context"—the word *context* repeated so often that it began to sound trivial—with less "romanticization and glorification," more about "how things go wrong, how science and technology can be misapplied."[38] More of the dark side.

But how could anyone argue with an unrivalled success? Given the close-knit relationship with both the aerospace industry and the military aviation community (how could anybody personify this better than Mike Collins?), the likelihood of NASM muting "romanticization and glorification," much less getting into "how things go wrong," seemed more than remote.

Collins understood that the museum stood to benefit from evidence that scholarly credentials made a difference, and as curator of the Space Department he named Paul Hanle, a Yale PhD in the history of science

who would later become associate director for academic affairs.[39] Collins also appreciated the importance of scholarly productivity, and for a newly created Department of Science and Technology, he began hiring well-credentialed historians who showed promise of "honoring the museum as they honored themselves." Often they arrived as fellows, as had been the experience at MHT. One of the first was Richard Hallion, with a doctorate from the University of Maryland, who was curator of science and technology from 1974 to 1980 and later returned as Charles A. Lindbergh Visiting Professor of Aerospace History. Another was Tom Crouch, with a doctorate from Ohio State, who also arrived in 1974 and spent part of the 1980s at the Museum of American History but then went back to Air and Space as senior curator of aeronautics. From the start, both showed themselves to be "producers," Hallion concentrating on military topics, Crouch on civilian aeronautics and in the process becoming the foremost authority on the Wright brothers. But in the 1980s their careers began to head in diametrically opposite directions, toward a monumental clash in the 1990s, but that is a story to be told later on, when returning to the *Enola Gay*.

■

THOUGH MICHAL MCMAHON CALLED the Air and Space Museum, not unfairly, "a giant advertisement for the aerospace industry," it did shepherd a collection of "authentic original relics" (remembering Frank Taylor's phrase from his 1953 brochure) that was perhaps not matched anywhere else in the world, a collection that covered the entire saga of flight from its very beginnings, and with the immense privilege of being the automatic repository for historic artifacts from the space program.

When the Museum of History and Technology opened, it had authentic relics like the *John Bull* and Joseph Henry's Albany electromagnet, but it also displayed many replicas and reproductions, and its central icon, the pendulum, was, after all, "just a gadget." The museum also mixed the unique and the perfectly ordinary.[40] As its exhibitry moved into story-driven realms, designers arrayed what was "real" cheek-by-jowl with "props." Period rooms that people were expected to accept as authentic reconstruc-

tions of something "historic" might be no more than stage sets for artifacts that needed "staging" to enhance their interest. In the Hall of American Maritime Enterprise, for example, there was a "tattoo parlor" that sprung almost entirely from the designer's imagination, just to provide a setting for a tattooist's kit and an array of patterns that came from the Arizona mining town of Bisbee, far from anything maritime.[41]

NASM did not need to do this sort of staging. It had the *Flyer* and the *Spirit* and the *Winnie Mae* and the X-1 and the Apollo 11 capsule. It had Chinese kites from the Centennial. It had so much. And it had 87,000 people in the door in just one day, nearly 10 million in one year, not one of whom imagined that any of the artifacts comprising the *Milestones of Flight* could be anything but an absolutely authentic piece of the True Cross. Was there reason for separating all this from "more earthly technologies," in a different museum, to restate Joe Corn's rhetorical question? It was arguable. At History and Technology, there were "association" items of dubious provenance, show-biz memorabilia of which there are multiples (and some of which, confessedly, was not even authentic).[42] For decades, a device called the Kelly Converter was displayed as a milestone in steelmaking technology—its label announced that it predated the Bessemer process in England—until a senior fellow who combined historical with technical expertise proved that it never had worked and never could work.[43] A similar debunking might await the Francis Life Car, with a story of heroism told for more than a century in a dozen different settings. A veteran curator even expressed doubts about the Star-Spangled Banner being the flag that actually flew over Fort McHenry by the dawn's early light.

But that was deliberately provocative. Suffice it to say that the older museum across the Mall, with fewer treasures of Wright *Flyer* rank, faced a growing challenge in making its exhibits appealing to audiences of all kinds, but it also had greater opportunities for staging them as imaginative and dramatic "experiences," a mode of display soon labeled postmodernist, in contrast to the Air and Space Museum's neo-traditionalism.

*The idea that the process of tramping through
vast halls past countless objects, pictures, signs,
and diagrams is somehow educational . . . [is]
particularly unfortunate.*

—EUGENE FERGUSON, 1965

I'll teach history to anybody I can get my mitts on.

—ROGER KENNEDY, *Newsweek*, 24 April 1989

CHAPTER 8 ▪ Celebration or Education?

I t took no time at all for the National Air and Space Museum to establish
itself as the most popular museum in the world. After two years, Michael
Collins left it to the day-to-day guidance of his deputy Mel Zisfein and
moved over to the Castle, as undersecretary of the Smithsonian Institution,
a post most recently held by Robert Angus "Rab" Brooks, a scholar of clas-
sical philology who was also an Air Force veteran and assistant secretary
of the army in the Johnson administration. Technological enthusiasts had
rarely gained Secretary Dillon Ripley's total confidence, but Collins, like
Frank Taylor, was an exception. Besides, Ripley knew that nobody could
get a more attentive hearing than Collins when time came to consider the
Smithsonian's annual budget request on Capitol Hill.

Meanwhile, across the Mall at the National Museum of History and
Technology, Brooke Hindle cleaned out his desk in the director's office
at the same time as Collins did at NASM, but reluctantly and under cir-
cumstances quite different. Hindle had been brought in to turn the place
around, and when Ripley did not think this had happened after four

years, he had Charles Blitzer advise him to step aside and accept a quiet sinecure as a senior historian. He would not be expected to do any more than enhance the scholarly prestige of the Smithsonian. In that regard, Hindle would disappoint nobody.

At Air and Space, Zisfein went after the director's job, but Ripley offered it to Noel Hinners, a PhD in geochemistry from Princeton who most recently had been the associate director for space science at the National Aeronautics and Space Administration, and before that NASA's director of lunar programs. Even though Hinners would not have been first choice with NASM constituents from the military aviation community—who would always prefer a retired general with lots of flight time, a man passionate about celebrating technical virtuosity and human derring-do—the search and selection process went quickly and smoothly.

Not so at NMHT, which by 1978 had a reputation as a difficult challenge because of a curatorial staff thought to be "defensive" about its prerogatives, and the demands from the Castle. (Tellingly, NASM was considered a "science" bureau akin to the Astrophysical Observatory in Cambridge and was not part of Blitzer's "history and art" domain.) When Daniel Boorstin left the director's office in 1973, it had taken four months to recruit a replacement. This time it took a year and a half. Silvio Bedini had served as acting director several times already and would not do so again; instead, he too got a sinecure, in the new Dibner Library, with a pleasurable title: keeper of the rare books. So, for an "acting," Ripley thought immediately of Peter Marzio, the emergent star in the curatorial ranks, even though he was younger than all but one of his forty-four colleagues. But Marzio was already looking beyond the Smithsonian, and he soon departed for the director's job across town at the Corcoran, the city's oldest and largest privately funded art museum.

Next on Ripley's list was Otto Mayr, older than Marzio but a curator only a few days longer, both having been hired by Boorstin in the summer of 1969. Though easily annoyed, Mayr could be as charming as Marzio when the spirit moved him. Among his other virtues was a fine sense of the relationship between technology and culture (or, as he preferred, *Zeitgeist*), as signaled in *The Clockwork Universe*, "an ideal world, rational and harmonious," and two remarkable articles in *Technology and Culture*.[1] He

was also skilled with antique technological devices, and with a handcrafted clavichord his dream was "to play Beethoven's sonatas."[2] Mayr accepted Ripley's bid at once, and for the Smithsonian Council he prepared a report on the museum's programs, personnel, and budgeting that was the most thorough it had ever seen.[3] Then he rationalized the process of proposing exhibits, theretofore muddled: "State the main theme in a simple declarative sentence," it began, a challenge many curators found difficult.

Mayr was eager for a formal appointment as director, but soon it was clear he would not get it and there would be only a strained interregnum. Mayr seemed peevish around people with whom he did not share intellectual concerns, and when he turned the desk in the director's office to face the wall, as he had done in his curatorial office, he was obviously making a statement. He bemoaned "the slump in which the Museum finds itself" and the arduous task of achieving "any visible improvement."[4] Ripley and Blitzer wanted to hear of a renaissance, or more than an elaboration of "a general malaise," anyway—as most certainly did Mayr's colleagues—and Mayr did have well-wrought plans for major exhibits. There would be one on industrialization (*Made in America*, to succeed *1876* in A&I) and another in 1982 marking the 250th anniversary of George Washington's birth. Mayr could engender almost no collegial enthusiasm à la *1876*, however, and in the summer of 1979, after fifteen months, Ripley rewarded him for his efforts with a sabbatical and stepped up a formal search.[5]

Having been assured by Blitzer that the museum "would be a fitting home for *Technology and Culture*," Mel Kranzberg threw his hat in the ring, dutifully filling out his federal employment form.[6] The job would very likely have been his, but he had to withdraw when his wife, Deaux, fell ill and moving from Atlanta to Washington became impossible. Harold Skramstad might have been interested a little earlier, but now he saw too much potential where he was, at the Henry Ford Museum; in a bold temper, he even considered renaming it the National Museum of History and Technology when the Smithsonian abandoned that name in 1980, and luring the *T&C* editorial office to Dearborn.[7] Other candidates would create a buzz, Nate Reingold from the Henry Papers for one, and after that, silence, a situation reminiscent of the Air and Space search before Mike Collins showed up. But this time there was no superman to soar into the picture.

The man finally appointed NMHT director was so dark a horse that virtually nobody at the museum had ever heard of him. His resume bespoke an interest in architectural history, and he had won an award for the best article published in *Minnesota History* (he was from St. Paul), so the past was not a foreign country to Roger Kennedy. But a national museum, or any museum, that definitely was. Kennedy was nothing if not a quick study, however, and he would settle in for nearly fourteen years, three times as long as any predecessor. Including those who served as acting directors, he counted seven predecessors, and he saw that in attempting to cope with problems "in seven different ways," they had "led the place back across its own former tracks many times over." That was not Kennedy's intention, and he would leave more tracks of his own than any other director, before or since.

Just after he accepted Ripley's offer in 1979, Kennedy ran into a young man who was assistant director of the Woodrow Wilson Center for International Scholars, who struck him favorably, and who volunteered his "views about the museum." In a long letter from Michael Lacey, Kennedy got the sort of advice he might have received from someone else in the Castle such as Blitzer. "You don't need any more experts on clocks or gowns or trains over there," Lacey declared at the beginning. Much of what followed would have been too petty for Kennedy to credit; Lacey wrote, for instance, of the "lassitude, fatuousness, and constant water cooler grousing on the part of those who are supposed to be keeping the sacred flame."[8] But Kennedy did appreciate the reminder of his opportunity to make appointments for vacant slots and anticipated retirements. Up until the late 1970s there had been very little staff turnover at the museum; in the 1980s, Kennedy recruited more than a dozen curators, as well as historians and archivists, and he replaced more than a third of the men and women brought in a generation earlier to get the Museum of History and Technology up and running.

For some newcomers, the museum seemed to pose an attractive alternative to the campus, as had been the case with disaffected senior academics like Boorstin and Hindle. "The groves of academe are becoming less and less enchanting," wrote Paul Forman. In a candid moment, Gary Kulik con-

fessed that "my idea of hell is having to meet your eight o'clock class while wearing your tweed coat with elbow patches." Kulik had come from a New England textile museum, as did Helena Wright, Marzio's replacement, but some new recruits lacked a preservationist's reverence for historic artifacts even if they did accept their value as historic evidence. Quite a few wanted to teach, and most felt allied to an academic mainstream that had little regard for the antiquarian prejudices ("associationism and collectitis," to recall Hindle's bugbear) presumed to have infected history museums in the past. Still, the idea of creating exhibits that would be seen by millions often had a strong appeal to men and women who might count sales of the books they wrote in four figures or maybe only three. And everyone took it for granted that exhibit proposals would need to show allegiance to ideals of critical inquiry, not just enable "showing a collection," or they would stand little chance with the academic advisory panels now summoned routinely.[9]

■

KENNEDY WAS UNLIKE ANY OF HIS PREDECESSORS, either in training or in temperament. To Robert Multhauf, he seemed like a man who thought "he was capable of anything." This had not exactly been the case, for Kennedy had failed more than once, even in a run for political office. As the Ford Foundation's vice president for finance, at least as Skramstad would tell it, Kennedy gained a reputation as "the man with the reverse Midas touch." Still, his experience was remarkable. He was serving as the Ford Foundation's vice president for arts when he got the NMHT job at age fifty-three; before that, he had been head of the foundation's Office of Financial Affairs. After a stint in the navy, Kennedy had gone to Yale, earning his BA in 1949, thanks "to the anonymous authors of the GI Bill." He attended law school at the University of Minnesota and worked briefly as a trial lawyer. In the Eisenhower administration, he had been a special assistant to the secretary of labor, secretary of health, education, and welfare, and attorney general. After that, he held financial and investment positions with the University of Minnesota and the Northwestern National Bank. He served

as a Supreme Court and White House correspondent for the National Broadcasting Company and worked on NBC documentaries, including the much-honored *Victory at Sea*, before moving to the Ford Foundation.

Multhauf got his impression of Kennedy from his apparent willingness to step into any situation, familiar or not, and trust his instincts to carry him through safely. It happened his first day on the job at the museum, after a late-afternoon recital in the Hall of Musical Instruments, a surprise welcome planned by Claudia Kidwell. Kennedy had invited a *son et lumière* expert from MIT to talk about creating a spectacle as a sort of billboard. Seated in the director's office, along with Kennedy, Jack White, and the *son et lumière* man, Guido by name, I suggested that this might be more appropriate for a place like the Boston Museum of Science than for a history museum and listened to White run through a quick list of what was "downstairs in the exhibit halls." Kennedy got the point and after that would repeatedly stress that "we are a history museum rather than a gadget-demonstration museum." This also influenced his move to change the name to the National Museum of American History (NMAH), which might seem counterintuitive but had the effect of eliminating any implication that technology was just about "gadgets" and not part of history, perhaps the most vital part. This perception also influenced his decision to get Ripley's approval for endowing an editorial home for *Technology and Culture* when Kranzberg announced his retirement, thereby reaffirming not only an allegiance to the history of technology but also a tangible link with academe previously marked by Multhauf's fifteen-year editorship of *Isis*. The museum's letterhead still included the phrase "Science, Technology, and Culture."

Actually, the session with Guido was a "test" of the sort Kennedy liked; it was a good part of what made working for him "both invigorating and daunting."[10] He was already well aware of what was "downstairs" and also what needed "reinstalling." As soon as he knew the director's job would be his, he had asked for a ten-year exhibit plan: schedule, staff, and square-footage. The plan called for "replacing all obsolete and ineffective exhibits," three-fourths of what was there, in time for the museum's silver anniversary in 1989.[11] With virtually all of the first floor and a good part of the third filled with technological devices, it did not take long for Ken-

nedy to see how much of the museum's heft came from these collections, which influenced his choice for the first high-profile exhibit. Boorstin had signaled his intentions for addressing the interaction between technology and culture with the Rube Goldberg exhibit, *Do It the Hard Way*. Kennedy had a signal, too. The occasion would be the centennial of President Franklin Roosevelt's birth, in January 1982, and the theme would be FDR's mastery of new media, especially broadcasting. Called *The Intimate Presidency: Franklin Delano Roosevelt, Communication, and the Mass Media in the 1930s*, the exhibit brought Art Molella, newly arrived as a curator of electricity, right into the innermost whirl of museum activities, from the teak-paneled director's conference room, with its view of the Castle, to the shops in the basement: carpentry, plastics, paint, silk-screen, and the nook where an old-world craftsman named John Wink could fabricate a bracket to hold any artifact in any position.

When Kennedy ran for office in Minnesota, it was as a Republican (opposing Eugene McCarthy, as it happened), but his management style resembled FDR's. Not that he made a practice of setting people against one another, not deliberately, but he would call someone in and tell him that he was "the one person who can do this job" and then, a few minutes later, tell someone else the same thing. He could show a sudden flash of anger and slam his palm on the table. Once he threatened to throw a quarrelsome curator out his fifth-floor window. In a private luncheon, he might violate a personal confidence in an offhand remark. He read people skillfully, yet he could be seduced by a charlatan—someone who promised to help him "master" new information technologies, for example, or would "return coal-burning locomotives to American railroads"—and he would soak up flattery with a faraway gaze. Josiah Hatch, a young man with an Oxford classics degree whom Kennedy made his staff assistant and then put through law school at Georgetown, dubbed him "the Oz."

But Kennedy did not hide behind a curtain, far from it. He was a master of beaux gestes.[12] He could write a humble memo beginning, "I'm aware I blew it . . . Could we start fresh?" He would ask a young historian he hoped to lure into the fold to "please give me a chance to come see you again." On cold winter mornings he would sweep into the museum in a fur cap and long coat (people liked to think it was vicuña) and sometimes

pop right into a curatorial office with an idea that had come to him on his way from home. Perhaps a whole wall of dental mirrors so people could see a seemingly infinite number of reflections? Perhaps taking half of the often-deserted third floor and "making it into a model of the human brain"?

Kennedy made a striking figure, lanky and a little lopsided (he had been hit by a truck while riding a bicycle through Central Park), with blue eyes and a fireside-chat mode of address. Expecting starchiness, an interviewer would be enchanted by the way Kennedy "drapes his leg over the arm of a chair, kicks off his loafer, wiggles his foot . . . and lets the ideas flow."[13] And he fancied having a way with Broadway tunes, once calling an important meeting in an acoustically friendly freight elevator and singing for the seated assemblage beforehand. The response was mixed, but for sure Kennedy had a sense of drama, a presence, a flair for thinking on his feet, far beyond any predecessor at the museum, maybe anywhere in the Smithsonian.[14]

When asked "how many people work for you?" he answered, "depends on how you count, four—or five hundred." By "four," he meant people close enough to hear him when he called out from his desk. Ben Lawless was just beyond calling distance, several doors away, and Kennedy was not one to share the stage with an equally charismatic figure like Lawless, almost exactly the same age and looking enough like him that they were sometimes taken for one another. After Kennedy made it clear that Lawless would not have the leeway he had come to expect, he gave notice, though they remained friends. As a parting gift, Kennedy gave him a go-ahead for *The Nation's Attic*, an exhibit he had wanted to do for years, with all the pleasurable oddities he knew to be tucked away in reference rooms, from the silk purse made from a sow's ear to "the napkin that dried Napoleon's lips after his morning coffee the day he left for exile on the island of Elba."[15] Nadya Makovenyi designed a set that mimicked the light and shadow of a cluttered attic perfectly, and soon enough she too departed, for the Air and Space Museum. Rarely again would there be anyone involved with NMAH exhibit design who had her sort of passion, or Ben's.

But Kennedy did want (as he put it) "slam-bang scholars" such as David Noble and T. J. Jackson Lears, or young people with obvious promise, such as Michael Beschloss—only twenty-seven when Kennedy installed him

as a curator of political history, Margaret Klapthor's domain for decades. Often they did not last long, in part because of a chilly reception by an aging staff that Michael Lacey had characterized as "curdled." Beschloss engendered no warmth when he insisted that his office be soundproofed, and Noble seemed unwilling or unable to distinguish between ally and antagonist.[16] He soon returned to academe, as did Lears, and Beschloss used the museum as a stepping-stone to news-media stardom.[17] Young men and women of only slightly less prominence and promise came and stayed, however, as curators in traditional fields like engineering, graphic arts, and military history; in promising new fields such as information processing; and sometimes in fields such as labor history that had been foreign to the museum because they seemed to lack a traditional sort of object-centeredness.

Even though steeped in academic values, in the intrinsic worth of words and ideas on paper, most new curators thought seriously about what might be "exhibitable." It was not always easy. When asked to elaborate "eighteenth-century themes" that could be used in an introductory exhibit to the whole museum, for example, Kulik had trouble transcending the strictures of a scholarly monograph, making asides about what "Edmund Morgan has cogently argued" and the like. Such curators needed reminders that academic critics wanted them "to embrace the nuance of scholarly discourse in a medium clearly unsuited to it."[18] Kulik flourished nonetheless, becoming a special favorite of Kennedy's, who backed his bid to become editor of *American Quarterly*, pushed him up through the administrative ranks, and was even thought to be grooming him as the next director.

Helena Wright, trained as an archivist, and Jeffrey Stine, trained in the history of technology as it intersected with environmentalism, both proved to be solid additions to traditional curatorial domains, graphic arts and engineering.[19] They also played crucial editorial roles with *Technology and Culture* after Kennedy brought it to the museum in 1981. So did Molella, who was liberated by Kennedy from the obscurity of the Joseph Henry Papers and handed a sure-fire exhibit about communications, à la Boorstin, Marzio, and *News Reporting*.[20] Molella was installed as an administrative power for the rest of Kennedy's time in the front office—and long afterward, as it turned out, as director of the Lemelson Center for the

Study of Invention and Innovation, a richly endowed semi-independent entity founded in 1995.

Kennedy also persuaded the most versatile and prolific curator at the Air and Space Museum, Tom Crouch—"tired of large, shiny things," he said—to come across the Mall and made him a department chair, along with Molella. Two of Kennedy's recruits would be elected as president of the Organization of American Historians, Pete Daniel and James Oliver Horton, and no longer could Mike Lacey say that the museum was "not a significant center for learning about the American experience."[21] There was a Tuesday-afternoon colloquium that, week-in and week-out, alternated well-wrought presentations by museum staff with talks by invited scholars from all over the world. Bernice Johnson Reagon, curator of community life, was awarded a Macarthur Foundation "genius" grant; Jeffrey Stine would receive the Distinguished Service Award from the American Society for Environmental History. Four people at the museum when Kennedy arrived were to get the Society for the History of Technology's Leonardo da Vinci Medal. Distinguished fellows such as Berkeley's Lawrence Levine and Yale's Robert Gordon took an active role in museum projects.

Kennedy was always hosting visitors from show business and sports, so everyone got used to seeing not only top-tier academics like Marcus Cunliffe and Herbert Gutman but also Jessica Tandy, Ginger Rogers, Gene Kelly, Kitty Carlisle Hart, and Nancy Sinatra, even Michael Jackson, prowling the exhibits with Kennedy as he held forth. Kennedy's contacts from his Ford Foundation days were legion, and he might be spotted at lunch with Andrew Goodpaster, the superintendent at West Point, or even with his old boss Mac Bundy, who became a professor of history at NYU after he left the foundation in 1979 and whom Kennedy called "the smartest man I ever met."[22]

■

WHAT DISTRESSED KENNEDY ABOUT THE MUSEUM IMMEDIATELY, on the first day he had a chance to look around in the fall of 1979, was the absence of racial diversity. He saw a sort of plantation, with white curators and

administrators holding title to the top two floors, and black guards and laborers below, and even the handful of African American technicians and specialists—who wore lab coats, wheeled carts, and otherwise served at the beck of curators—still made to feel less than welcome in the "staff dining room" next door to the director's office, where prices were lower than in the basement cafeteria and the meals were served by waiters. A few older curators flaunted their racism long after they would have been punished in academe or most places in the business world. Not a single employee in a job rated as "professional" was listed as "minority."[23]

Kennedy could not see that any serious effort had ever been made to comply with the Smithsonian's Equal Opportunity Policy, not even to go after a grant that supported minority recruitment. He sought a grant at once where he had lots of connections, at the Ford Foundation, and in his discretionary fund he found the money to hire a bright and personable Harvard doctoral candidate in West African history, William H. Harvey Jr., as his research assistant.[24] Bill Harvey was also to take a lead role in "recruiting other minority candidates," with funding to come from the Castle, at least temporarily, and through his efforts two young African Americans were hired as departmental program assistants. One was Fath Barfield, who had been valedictorian at Washington's National Cathedral School for Girls in 1972 and was now a Harvard doctoral candidate in American Civilization. The other was Spencer Crew, a Rutgers PhD who had been teaching at the University of Maryland Baltimore County. Kennedy told a foundation official that each of the departments "should have within it a person whose background is broader than (or at least substantially different from) that possessed of the white male Director, a white male Chairman of one Department [Barney Finn at the time], and a white female Chairman of the other Department [Claudia Kidwell]. The mere presence of such minority persons, young and vigorous, and unintimidated, will change the way a large institution operates."[25]

Kennedy overpromised, yet the change would ultimately be more than he could have imagined. As Fath Davis Ruffins, Fath Barfield would remain at the museum for more than thirty years, finally becoming curator of African American History and Culture. But Crew was destined for

management. He could not have felt comfortable at first, not with some of the senior curators blithely condescending about "what we are doing for Spencer" and others ready to harp on his lack of "museum experience" while having arrived themselves with no such experience. He did get a boost from Molella, who involved him directly with the FDR exhibit. After that, Crew moved on to the new Archives Center headed by John Fleckner, whom Kennedy had recruited from the State Historical Society of Wisconsin.[26] Then Crew became a curator, then a departmental chair, then deputy director, and eventually it would be Crew who succeeded Kennedy in the director's office, not Kulik, who had lost Kennedy's confidence and departed for a position at Winterthur, the decorative arts museum in Delaware.

As he was on his way up, Crew had been joined by several other African Americans in the professional ranks, Kennedy's recruits, including Bernice Johnson Reagon and James Oliver Horton. Crew had also been responsible for one of the first exhibits to play off edgy thematics, or at least the experience of "the ordinary everyday people" that Ripley had thought it so important to bring into the exhibits. Crew's exhibit was called *Field to Factory*.[27] It addressed the migration of African Americans from the south to northern industrial cities during the interwar years, and like so many exhibits based on a theme but no particular collection, it seemed heavy on text and graphics and shy on "authentic relics." But there was one experience that invariably brought museum visitors up short. Turning a corner, they were confronted with two doorways, one for WHITE, one for COLORED. For some, it was a shocking first; for others, it was an unpleasant remembrance of things past, and not so far past at that. The two doorways were a simple device but suggestive of the sort of didactic power that an exhibit might embody. Kennedy was especially proud of *Field to Factory* and anxious to point out that many visitors, not just African Americans, "share[d] with each other and with most of the rest of us the experience of having gone from someplace where we grew up and thought we belonged to some other place where we had to make a new life."[28]

At first, Kennedy devoted his attention to recruiting men and women who would enhance the museum's scholarly reputation, but after *Field to Factory* opened he became enamored of the "jostling process" of creat-

ing exhibits that would enable him to educate everybody he could "get his mitts on." An exhibit *could* be educational, notwithstanding Eugene Ferguson's pessimism about the futility of "tramping through vast halls." Kennedy might have no Hope Diamond to show off, no Apollo Command Module, but there was high drama inherent in those two doors—WHITE and COLORED—designer Jim Sims's reinvention of a past reality. There was high drama, too, in a Star-Spangled Banner that would be visible only briefly on the half-hour as a curtain was lifted, when it was "revealed rather than flaunted." That was another designer's invention, in this case Peter Wexler, whose recent work had included a redesign of the Hollywood Bowl in collaboration with Frank Gehry. And there was drama in a photomural of a great president seated at the edge of a pool in a swimsuit, his expression supremely confident and yet with his legs withered and useless, an image rarely seen but hard to forget. "Education is show business," Kennedy said. "Our job here is to do things as dramatically as possible."[29]

Kennedy envisioned a process of imparting to exhibits a drama theretofore absent. Partly this would help address the problem Hindle could not solve—namely, that the exhibits linked one to another in a sort of maze and the ordinary visitor could rarely get oriented once losing sight of a landmark like the pendulum. ("No rhyme or reason"—the contrast could not have been greater with Air and Space, its galleries on two levels in neat rows, with the main corridors always visible.) Kennedy wanted to make the most of the silver-anniversary plan, a succession of blockbuster exhibits and "associated events," films, books, live performances. Sometimes he overreached, but there was no doubt that he had an instinct for dramatics unlike anybody else who had ever held his position. It seemed to complement his love of soaring rhetoric.[30] Here, for example, was Kennedy introducing to Ripley and Blitzer his plans for *GW: A Figure upon a Stage*, slated to follow *The Intimate Presidency*:

We have thought too primly upon the 250th Anniversary of Washington's Birth, and upon what that event means to our bothered and still noble national experiment. We may, with luck and energy, do quite early what might otherwise require a decade of events: give to this dispirited and snarlish city, and to a discouraged nation, in our time, a

set of coordinated symbols which can tell us much of what we are, and help us feel much better about ourselves. It is high time we ceased being embarrassed by the celebration of large figures and large symbols. We are too wry, too wincing, and too prone to put each other down and pull down those ancient figures which never were larger than life, but were as big as life, which is big enough.[31]

Kennedy said he had "a partner or two" for associated events, that "set of coordinated symbols," to lift a city "dispirited and snarlish." Ripley had a ready smile, Blitzer did not, but one can imagine them both looking happy with the spirit of the proposal.

■

AND TECHNOLOGY, IN A MUSEUM WHERE technology in history had long commanded center stage? "Ah, there's a fascinating point," Kennedy continued. "It is *not* true at Mt. Vernon, as it is at Gore Place or Kedleston, that the mills are on the horizon when you stand at the window, yet even at Mt. Vernon one can ask: did they know what they were getting in for?" People had to scurry to determine that Kennedy was talking about Waltham (Gore Place) and Derbyshire (Kedleston), but they understood that he wanted to link the Washington exhibit with another on "the kind of industrialism that disrupted the eighteenth-century social order." Some would say that Kennedy never understood that this disruption was not "fueled by internal combustion."[32] Actually, he probably did understand, but he liked the resonance of the phrase too much to be deterred by a technicality—internal, external, whatever—and he liked the prospect of an exhibit so much that in the spring of 1981 he sent a dozen of his people on a tour of English industrial-revolution sites such as Ironbridge, Bolton, and Kew: curators, designers, even specialists and technicians, "sub-professionals," who were likely to be involved in an exhibit about "the internal combustion of the eighteenth-century social order." The tour concluded with a formal dinner at the Science Museum in South Kensington, with the director, Dame Margaret Weston, leading a conversation about exhibits founded on provocative themes or ideas and exhibits founded on rich collections.

With the Science Museum's treasures all around—Newcomen, Arkwright, Wedgeworth, Babbage—even the American visitors most immersed in academic concerns had to confess some allegiance to the power of artifacts.

After the museum contingent returned, Kennedy arranged for Hindle to take the lead in creating a major exhibit on American industrialization. They agreed on a timeframe, 1790 to 1860, and a name, *Engines of Change*. It was to be driven to some extent by an idea—or, rather, a question: why did the United States industrialize so rapidly?—but much more so by the physical presence of machines and stories about "the people who invented, built, operated, and owned them." "We didn't want mere words, documents, and received opinion to dictate the exhibition's form," said Hindle.[33] The site was not to be A&I, as originally thought, but rather the aged MHT Tool Hall, planned a quarter-century before by Ferguson. The designer was to be Constantine Raitsky, who had proved his flair for dramatizing technological devices with *The Clockwork Universe*.[34] Now he got to design stage sets: a clockmaker's shop to go along with the facsimile of an 1850 machine shop that had been Ferguson's work and, most dramatically, the *John Bull* as "the resplendent centerpiece," posed on a truss of the first iron bridge in the United States, with a backlit photomural behind that was impossible to distinguish from a panorama of gorgeous fall foliage. The "social effects" of industrialization such as labor strife got some attention but too little in the opinion of the resolutely Marxist David Noble, who was planning an exhibit of his own on the dark side of industrial automation and was a constant thorn in Hindle's side. Hindle's relief was palpable when Noble resigned while *Engines of Change* was still in the works.[35]

Before coming to the museum, Kennedy had never paid much attention to "old machines," but he quickly came to his own conclusion about their inherent drama and that his best was the *John Bull*. In 1980, after it had been tested and found to be safe for operation on its 150th birthday, Jack White readied it for a celebration on the Chessie System's Georgetown Branch. These were, he wrote to a friend, "the most exciting days of my life."[36] He would never forget "the steaming of the *John Bull*" on a fall day in 1981, on tracks adjacent to the C&O Canal; neither would anyone else who was there, certainly not Roger Kennedy. At the museum, Kennedy was planning for outdoor displays that would give pride of place to another locomotive

and to an array of 50-foot windmills—classic Great Plains windmills for pumping water interspersed with high-tech wind generators—to replace the "dispirited fountain" at the Constitution Avenue entrance.

The locomotive was to be another from the Pennsylvania Railroad (as was the *John Bull*), a streamlined art deco masterpiece from the 1930s, one of a fleet designed for Washington–New York passenger trains after the electrification of that line. These locomotives, denoted as GG1s, especially appealed to Kennedy because of the involvement of Raymond Loewy in their design and livery.[37] GG1s were being phased out by Amtrak after fifty years of service, and a phone call from Jack White was all it took to get a promise. The plan was for a display on the museum's east lawn, a GG1 in dramatic juxtaposition to the 1401, the steam locomotive staged just inside the glass wall of the railroad hall.

As would happen more than once with Kennedy, dreams collided with practicalities. Costs would often be a sticking point, but more important with the windmills was the reluctance of the Fine Arts Commission to permit such an odd intrusion (even as the commissioners had to concede the appeal of renderings by Washington architect George Hartman), and with the locomotive, there was a delicious irony. The tunnel conveying trains under the Mall and the museum's east lawn, the brand-new Washington Metro, would not support a 225-ton locomotive overhead.[38] (Nobody had forgotten that during World War II a GG1 fell through the floor of Washington Union Station.)

Still, Kennedy managed to signal the museum's continuing commitment to the history of technology, to "what the museum can do well," in many other ways. There was the new name, intended to banish any implication that "we regard technology and history as separable." (No disrespect to Grace Rogers Cooper, he was saying, but the name chosen in the 1950s was not suitable.) There was *Loose the Mighty Power: Impressions of the Steam Engine in America*, an exhibit first staged in the museum in 1980 and then sent on the road by the Smithsonian Institution Traveling Exhibition Service. The strongest affirmation was Kennedy's pledge to underwrite the editorial operation of *Technology and Culture*, $100,000 annually for five years, a pledge he would renew twice.[39]

FOR ALL THAT HE MAY HAVE APPEARED to believe himself "capable of anything," Kennedy knew he needed advice about the world of visual display. He sought out Washington architects like Hartman and New York stage designers like Wexler. He also enlisted a transition team of Ivy League historians, but he came more and more to rely on young people in his immediate orbit, such as Bill Harvey and Josiah Hatch. Harvey, the son of a clergyman, was the sharpest even in sharp company, and relished the role of Doubting Thomas. Hatch often warned Kennedy about the difficulty of trying "to build an intellectual structure into . . . shows from the top down." It was gospel among the curators that exhibit ideas should be their own, and Hatch could see that many of them had no interest in "vehicles for conveying ideas." What they wanted was "a means of displaying x number of objects."[40]

Kennedy had many plans for exhibits with an "intellectual structure," but he made certain to placate the old-timers by facilitating exhibits aimed essentially at "displaying objects." Musical performance was among his special enthusiasms, and the music curators were encouraged not only to play but also to exhibit rare and beautiful instruments that had been locked away in storage.[41] Notable from the unfailingly industrious Division of Graphic Arts was *The Fat and the Lean: American Wood Type in the 19th Century* and from the Division of Photography, *Western Views and Eastern Visions*. Sometimes temporary exhibits coincided with a professional meeting in Washington, or an anniversary—the centennial of the American Red Cross or the American Federation of Labor or the Brooklyn Bridge.[42] *The Changing American Farm*, commemorating the 150th anniversary of the invention of the reaper by Cyrus McCormick, featured a replica of his original 1831 machine and several modern farm machines. The newest and largest was a 1977 Axial-Flow Combine donated by International Harvester, which also funded the exhibit. The catalog depicted a machine offering "versatility, comfort, and improved energy efficiency" even as the text skipped lightly over the downside of "huge acreages of single crop cultivation."[43] An exhibit of bank notes with elaborate security measures was forthrightly called *Highlights of the Chase Manhattan Bank Money*

Collection. From farm machinery to paper money, rarely was there not an exhibit somewhere in the museum that did not reflect what Malcolm Watkins had decried as "PR intrusion."

But always there were exhibits that simply reflected enthusiasm for what curators had in their collections, be it cipher machines or photophones, and a new exhibit went up nearly every month. An exhibit could cost next to nothing—$94.51 for *The American Skating Mania: Ice Skating in the Nineteenth Century*—and it was a truism that it might garner as much good press as something far more costly and pretentious. *The Search for Life: Development of Genetic Technologies in Twentieth-Century America*, lavishly funded by the pharmaceutical industry and another of stage-designer Peter Wexler's creations, was a disaster, whereas an exhibit on Japanese pharmacy that cost $673.50 was a popular and critical success. So was Carlene Stephens's *Inventing Standard Time* and *Einstein: A Centenary Exhibition*, designed by Makovenyi and curated by Paul Forman in collaboration with a newcomer at Air and Space, Paul Hanle.

When it came to larger exhibits with an "intellectual structure," Kennedy heard repeatedly from his transition team that these would best be framed in terms of "the new social history" and its "concern for achieving historical perspective on the everyday activities of ordinary people."[44] *Field to Factory* fit the mold; *GW* certainly did not, but Kennedy had already made clear that it was "high time we ceased being embarrassed by the celebration of large figures and large symbols," and he always remained skeptical of what he perceived as academic faddishness. He knew that two of his brightest curators disagreed about the new social history, and at one point he challenged each to make his case. Kulik and Forman were ensconced on different "sides" of the museum—actually, different departments on different floors—but technology in history concerned them both.[45] What is the best way to provide intellectual structure, Kennedy asked them. To take the museum "one or two steps beyond conventional exhibitry and traditional history-museum scholarship," Kulik recommended hiring from what he called "my cohort"—that being "the first wave of graduate students to benefit from the conceptual and methodological breakthrough of the new social history." There should be a half-dozen such people on the staff, with expertise in folklore, family history, the history

of religion, of consumption and leisure, fields then rising to "dominance" in elite universities and new interdisciplinary programs. It did not seem to matter to Kulik that they might relate so tangentially, if at all, to the things the museum traditionally collected, and one can imagine Kennedy wondering about this as he waited to hear from Forman.

Forman was briefer, more modest (Kulik stationed himself at the center of "a talented core of young history museum professionals"), and in the end Kennedy found him more persuasive. Yes, the new social history was prominent in parts of academe (Forman would not concede "dominant"), and, yes, it was providing "a needed corrective to the partiality of our representations of the past, and, more important, to the partiality of evidence in conventional historical argument." Nevertheless, Forman warned, "it would be a great mistake to attempt to give it first importance in this museum." More than a mistake, it would be "folly." How could we ever compete "with the university-based charioteers of social history"? Why would we want to try? The museum stood much more in need of "people researching, collecting, exhibiting in twentieth-century science and technology," doing so in many possible areas, but one for sure: "the technical, commercial, cultural, and (yes!) social history of the electronic computer."[46]

Kennedy would continue to tread politely around Ivy League academics, but actually he agreed about the folly of attempting to compete with "university-based charioteers." Eventually he recruited a curator whose specialty was Native American folklore and another who was expert in family history, but he never stepped far from "traditional museum scholarship" and from a preference for new curators expert in the relationship of technology and culture. One of the first was David Allison, a Princeton PhD with an undergraduate degree in computer science, whose assignment was to stake a position in "the technical, commercial, cultural, and social history of the electronic computer," just as Forman had advised. Allison would build "a repository of material and information on the role that information technology plays in shaping our society," and eventually *Information Age*—14,000 square feet of historic artifacts along with fifty computerized displays—would receive SHOT's Dibner Award for Excellence in Exhibits in the History of Technology and Culture.[47]

The main lesson Kennedy absorbed about exhibits had little to do with interpretation and everything to do with staging. The most eloquent of his outside advisors was Richard Rabinowitz, a Harvard PhD who felt bored by the "inertia" of academic life and went on to make his mark through the American History Workshop, which now claims to have "created more than five hundred successful and innovative history programs." Rabinowitz's success was owing, more than anything, to his realistic concept of the audience for historical exhibits: intelligent and curious, yes, but definitely not people "who framed their observations according to the discourse of cutting-edge scholars." Exhibits were "essentially theatrical," and they were best put in the hands of "playwrights of memory" capable of applying "the same dramatic and visual techniques that make, say, a great production of Macbeth into a life-altering experience."[48]

So the museum audience, whether family vacationers or school children, did not have the same interests or expectations as the audience for scholarly discourse. How could this not be obvious? For Kennedy, the point was reinforced by conversations with old hands like Skramstad, who insisted that museums required "communication strategies totally foreign to an academic setting."[49] Still, Kennedy had in mind exhibits that were about much more than "displaying *x* number of objects." He wanted exhibits that would enable him to get his "mitts" on people, and he expected his staff "to demonstrate their capacity to work together in the interest of major statements by the Museum as a whole." It had happened before, with *1876*. That got Bicentennial money, but in the 1980s "major statements" were contingent on private funding, and ultimately it was the availability of such funding, or its absence, that set priorities. Some of what Kennedy envisioned never materialized—"Men and Women," "Renewable and Non-Renewable Resources," "Nineteen Eighty-Four" (or, if it did, it was in diminished form: *Men and Women* got subtitled *Dressing the Part* and addressed the definition of gender roles through costume).

But some of his visions did materialize because private funding was there, most notably for two blockbusters in the late 1980s. *Information Age* addressed a topic whose import nobody disputed, but this exhibit would never have been staged on such a grand scale, almost twice as extensive as any other exhibit in the building, had it not been for $4.3 million from

IBM. Another "major statement" was *A Material World*, which addressed the "stuff" from which things were made—hundreds of different kinds of things, from spinning wheels to surfboards—and provided a sterling opportunity, as Kennedy put it, "to present objects that are related to many, many people, not just the rich and great, in a serious way."[50] Social history! But it was unlikely that this exhibit would have been staged as the introduction to the entire museum, displacing even the pendulum from first floor to second, had it not been for the money provided by DuPont that included a contingency about how—or, more precisely, where—it would be spent.[51]

A Material World was based on an idea perfectly suited for a museum exhibit, the design was suitably dramatic, and yet it was rather old-fashioned in the way that artifacts were arrayed either in a straightforward chronology or in family groupings: bicycles, guitars, washing machines. There were rarities such as an automobile made largely from wood, fine jewelry made from aluminum, even an aluminum violin, but most were ordinary. What did it mean that materials were "natural" or "synthetic," or that something was made of the "proper" material, made of the right stuff? These were good questions, and *A Material World* certainly was educational, but there was still the matter of a "challenge." That was the primary aim of Robert McCormick Adams, the University of Chicago anthropologist who succeeded Dillon Ripley as secretary in 1984.

■

CHALLENGE WAS A GOOD PART OF WHAT RIPLEY missed seeing when he had compared the new museums in Washington and Mexico City. Rather than pushing the issue, however, he had simply shifted his attention to initiatives such as new art museums, popular publishing ventures, or crowd-pleasing annual events such as the Folklife Festival. But nothing was more important to Adams than "deepening the Smithsonian's intellectual structure." He probably would have agreed with a critic who called *A Material World* "an endorsement of happy consumerism," and at a press briefing when *Information Age* opened, he sent a murmur through the crowd when he decried its lack of a critical edge. Such an exhibit as this, he said, needed

to be about more than "a succession of increasingly powerful artifacts"; it needed to address a potential for technologies "introducing secondary, unexpected changes in our perceptions of ourselves and others . . . or in the problems we perceive as pressing and seek to answer."[52] And there ought to be exhibits that went another step beyond, exhibits that made people "feel uncomfortable." Those WHITE and COLORED doorways in *Field to Factory* did that, but Adams had other ideas in mind, as did Kennedy.

Adams and Kennedy never got chummy, partly because of a clash in personal style. This was not like Ripley and Multhauf. Here were two tall and elegant men, each in his prime, but Kennedy was always quick with a bon mot, always eager to get his mitts on an audience, while Adams could be aloof around people when they did not share his interests, or even when they did. Partly it was because of divergent views about popular culture. No exhibit enjoyed such a burst of popularity as the "Mobile Army Surgical Hospital" set from *M*A*S*H*, the TV series that aired from 1972 to 1983, and Kennedy loved posing in the cockpit of *Swamp Rat 30*, the 270 mph dragster featured in *A Material World* as a "symphony" of new materials making possible "things never done before."[53] This was not about "deepening," however, and Adams remarked that he was "frequently made uncomfortable by the kinds of stuff that the curators decide is important here," a remark that some of the curators took as a deliberate insult. Still, his vision and Kennedy's did converge in significant ways, especially in their dedication to "offer[ing] the public a social critique of technology."[54]

In his role as senior historian in the 1980s, Brooke Hindle developed *Engines of Change* with Kennedy and Adams solidly behind him and a young collaborator, Steve Lubar, yet another University of Chicago PhD, at his side. Hindle knew that artifacts could not *really* speak for themselves (or they "could speak only softly," as he put it), and he worked hard on social critique. But there was so much that could not be illustrated with artifacts, only with text, and exhibit designers never tired of reiterating that people did not come to museums to read books on the wall. There was the same problem with some of the smaller exhibits like *Pesticides on Trial* and *Science, Power, and Conflict.* Stanley Goldberg's *Building the Bomb*, an exhibit commemorating the fortieth anniversary of Hiroshima and Nagasaki, was certainly not lacking for dramatic artifacts. Right there in

one of the main corridors, close enough to touch, were two atomic bomb casings, a "Fat Man" and a "Little Boy." These attracted plenty of interest, but there was no opportunity to try to explain the decision to deploy atomic weapons or other tough concerns.[55] Goldberg would sometimes take a docent's stance near the exhibit, answering questions, and did find a certain grim humor in being asked whether these were "the actual bombs dropped on Japan."

Building the Bomb was planned as the pilot project for a 10,000-square-foot exhibit to be called "Entering the Nuclear Age," aimed at showing "how closely social, political, and technical factors are interwoven in American culture." Among other things, it would have focused on "the environmental and social costs of any innovative technology," and the human cost. A foundation concerned with environmental causes provided seed money, but there was no response to Goldberg's call for $1.22 million in outside funding, and thus it fell to a different exhibit to elaborate a "social critique" most fully at the Museum of American History. As with "Entering the Nuclear Age," the central event was to be World War II, but the exhibit would be presented in the context of the two hundredth anniversary of the U.S. Constitution—the last of a twelve-year series connected with the Bicentennial. *A More Perfect Union* it was called, and it addressed a grave constitutional *failure*, the imprisonment of 120,000 Japanese-Americans during World War II, two-thirds of them Nisei—sons and daughters of Japanese immigrants born here, citizens of the United States.

No Smithsonian exhibit had ever been framed in terms so likely to stir up controversy. It was one thing to upset the Grosvenors of the National Geographic Society, or to provide free advertising for razors or soda pop, or even to take money from the Nixon White House. But everyone expected the Constitution to be commemorated—celebrated—as "the Miracle at Philadelphia." And when that did not happen? Curator Tom Crouch and Kennedy at his most persuasive managed to make a case for dramatizing the story of how "racial prejudice and fear upset the delicate balance between the rights of the citizen and the power of the state." The drama was powerful. Here, in a room at Manzanar, a California "internment" camp, a man tells his eight-year-old daughter, "I was only eight years old when we moved out here." The man and the girl occupy the room by means of

a designer's sleight-of-hand, an ingenious projection. But nearby, all too real, a jeep struggling up an embankment during the worst of the fighting in Italy, the Allied invasion spearheaded by the 442nd Battalion, a Nisei unit recruited from the internment camps, many of its men with family and friends living behind barbed wire.

"Sad and disturbing," *Newsweek* called the exhibit, and it was. But it also signaled "a tough new spirit," a dedication to the proposition that the National Museum needed to become a "forum" rather than a "temple." *A More Perfect Union* affirmed the didactic power of an exhibit with a strongly articulated point of view, even if the message departed from celebration, *especially* if it departed. None of the framers believed it would be possible to create "a perfect union." Here was a reminder that we could only strive toward "a more perfect union." Throughout the Smithsonian, administrators and curators began pondering opportunities that might be posed for other such reminders, or at least for enabling voices to be heard that had not been heard before. At the Museum of Natural History, African voices in the Africa Hall. In the Experimental Gallery in Arts and Industries, voices of the homeless. At the National Museum of American Art (NMAA), a look at frontier images that one scholar called an opportunity "to re-examine a visual territory ... in a bold conceptually and perceptually interesting manner" and another called "perverse, historically inaccurate, destructive [and] no credit to the Smithsonian."[56] The "no credit" remark was, of course, Daniel Boorstin's, Librarian of Congress Emeritus and once the director of the National Museum of History and Technology (and one can only imagine what he might have said about *A More Perfect Union*).

The West as America brought so many people with real political power to a boil that NMAA director Elizabeth Broun thought it advisable to make changes in ten labels, although she insisted that "no intellectual points or interpretations were changed."[57] But all this was merely a warm-up for a crisis of representation whose effects would linger. It had distant origins, back to Joseph Henry's concerns about funding from the public purse and the Smithsonian being "brought under direct political influence." And it had immediate origins, in a report to Secretary Ripley from the chairman of the Smithsonian Council, Gordon Ray, with regard to the Air and Space Museum. The report ended, "While supporting the optimistic and future-

oriented spirit of NASM, we feel that greater attention should be directed to the ambiguous role of warfare . . . We can better control our destiny if we better understand how things go wrong, how science and technology can be misapplied." In the next chapter, things go wrong but not at all in the way that Gordon Ray meant.

*Smithsonian as a whole and Air and Space
curators in particular sometimes took a skeptical
or disparaging attitude toward aviation, flight,
air power, space exploration, even science and
technology per se.*

—JOHN CORRELL, "War Stories at Air and Space," 1994

*For whatever it costs to buy influence, you can
now have your own version of our nation's history
displayed and opposing views suppressed at the
Smithsonian Institution.*

—MARTIN HARWIT, *An Exhibit Denied,* 1996

CHAPTER 9 ▪ A Crisis of Representation

One day in the fall of 1993, five men sat down to lunch in the staff dining room at the National Air and Space Museum. Three were from the museum: Martin Harwit, who had been a professor of astrophysics at Cornell University before Secretary Robert Adams named him NASM director in 1987; Tom Crouch, whom Harwit had persuaded to return from the Museum of American History to chair the Department of Aeronautics; and Michael Neufeld, a Canadian who had completed a Johns Hopkins PhD in 1984, come to the museum as a fellow in 1988, and after he published *The Skilled Metalworkers of Nuremberg*, was hired by Harwit as an aeronautics curator and assigned to an exhibit slated to open on the fiftieth anniversary of VJ Day, August 15, 1995. The plan was to call it "The Crossroads: The End of World War II, the Atomic Bomb and the Origins of the Cold War."

The fourth man was General Monroe Hatch Jr. (USAF retired), head of the Air Force Association (AFA), a 501(c)(3) educational organization founded by General H. H. "Hap" Arnold, who had commanded the

Army Air Forces during World War II and was responsible for persuading Congress to authorize a National Air Museum in 1946. The fifth was John Correll, editor-in-chief of *Air Force* magazine, which was committed to the AFA's mission of "educating the public about the critical role of aerospace power in defense, advocating air power and strong national defense and supporting the United States Air Force, the Air Force family and aerospace education" but also not unfairly tagged as "a deep-pocket aerospace lobby" or similar terms. The museum had a friendly relationship with the AFA, sometimes lending it aircraft like the Bell X-1 to display at its conventions, and Harwit had first contacted Hatch in the hope, even the expectation, that the AFA might contribute financial support for the exhibit.

According to an NASM planning document, the artifacts slated for display in the "Crossroads" exhibit included a Japanese *Ohka* "piloted suicide bomb," a "Fat Man" plutonium implosion bomb, and the 53-foot forward fuselage of the Boeing B-29 Superfortress from the 509th Composite Group that President Truman deployed to drop a "Little Boy" uranium bomb on Hiroshima, the *Enola Gay*. (There would be a "Little Boy" displayed under the plane's open bomb-bay doors.) These "engines of destruction"—a phrase coined by President Franklin Roosevelt in 1934—were to command the exhibit's first three segments (units, in museum parlance), each visually isolated from the others. Then, visitors would turn a corner and come upon a fourth and then a fifth. The fourth unit was to be the exhibit's "emotional center." It would treat "the bombings of Hiroshima and Nagasaki themselves . . . the dimensions of the destruction and suffering." There would be "bomb-damaged artifacts" and "pictures and film of the victims, however upsetting that may be to some visitors." The fifth and final unit, not strong on visuals like the fourth, but with plenty of text, would address "the debatable character of the atomic bombings."[1]

Hatch and Correll had already seen the planning document and made it obvious that they would be adversaries, not collaborators. As Harwit later recalled, "They immediately lit into us." Too much about the devastation at ground zero, they said, too much about alleged moral ambiguities, way too much that seemed to cast a shadow over the heroism of the American armed forces. That was the "package of insults," the remark by General Paul Tibbets, who commanded the Hiroshima mission, widely quoted later

on.[2] But Hatch and Correll also had objections to the museum's pledge that the exhibit would go beyond "dogmatic belief in the official explanation that dropping the bomb prevented a bloody invasion," objections to describing the justification as "debatable." NASM's plan was not only to show what atomic weapons wrought at ground zero but also to convey "a nuanced picture of the decision-making" that led to their deployment. The first was a story that could merge photos and artifacts with "heart-rending vignettes," and here was where Crouch hoped "to enthrall the visitor with human-interest stories" as he had done in *A More Perfect Union*. The second would address "the latest scholarship on the decision to drop the bomb." This was Neufeld's responsibility, and it would be the sort of book on the wall toward which exhibits had been trending as curators took more and more of their cues from issues that concerned academic historians.[3]

After a tense two hours, Hatch and Correll were introduced to Neufeld's assistant, a young curator named Joanne Gernstein who had finished her master's degree at Cornell in 1987 and come to the museum at almost the same time as Harwit and Neufeld. Gernstein told of being in touch with veterans of the 509th Composite Group, and that the *Enola Gay*'s navigator, radio operator, and tail gunner were friendly and supportive of the museum's plans. Only slightly mollified, Hatch and Correll told Harwit that they wanted an instrumental role in planning the exhibit. In the first of what Correll later termed "a number of hostile exchanges," Harwit said he could not do anything of the sort. But he did promise that when a first draft of the script was done he would see that Correll got a copy.

It was a fateful moment. Outside parties who might have self-serving motives had rarely been given the privilege to see work in progress (it was denied even to the Grosvenors of *National Geographic*), but afterward it would become a commonplace demand by self-proclaimed "stakeholders."[4] As for Harwit and everyone else at NASM, they would soon learn what it meant to get branded as disrespectful (or much worse) by veterans of the war in the Pacific. More importantly, they would learn what it meant to have run afoul of adversaries whose power reached throughout the Pentagon and especially the halls of Congress.

A leaked copy preceded the draft that went over to Correll's office in Virginia in January 1994. (Because so many NASM docents and volunteers

were retired military men who agreed about the "package of insults," leaks were torrential, and rumor had it that even the deputy director was feeding information to the right-wing *Washington Times*.) For a document that would need to be scissored into one- and two-paragraph fragments and then silk-screened on dozens of separate plaques and panels, it made quite a package, on the order of fifty thousand words; including Xeroxed photos, it ran to several hundred pages and may have taken time for Correll to digest. But if he just paged through to that fourth unit, "Ground Zero: Hiroshima and Nagasaki," he could get the drift. Here "the mood" would change "from well-lit and airy to gloomy and oppressive," and on display there would be stopped clocks and incinerated lunch boxes and religious icons, artifacts borrowed from the Hiroshima Peace Memorial in Japan. There would also be a great many photographs, large, awful photographs, along with a video of men and women who had been scarred and disfigured but survived—they were called *hibakusha*, "explosion-affected persons"—and the walls would display texts such as this:

> On the morning of August 6, 1945, 544 first and second year students and eight teachers of the First Hiroshima Municipal Girls' High School were clearing rubble to create a firebreak . . . some 300–500 meters (1,000–1,650 feet) from the hypocenter. They took the full force of the blast and heat. Most died instantly. A few apparently survived the initial explosion only to die in the flames that followed. It is estimated that perhaps 15 of the 544 girls survived.

When he moved on to the final unit, "The Legacy," Correll could read about questions that remained unanswered and decisions that remained "hotly contested." Was Japan already on the verge of surrender? Was Truman's decision based on domestic political concerns? Was the hard-wrought and brilliant creation of the Manhattan Project not intended for a practical purpose? And then he could read on about matters like mutual assured destruction, nuclear terrorism, and the failure of the Air Force to provide flying opportunities "for anyone other than white males." These could never have struck Correll, or Hatch or just about anyone, as anything but extraneous to the story of the *Enola Gay*.[5]

In March 1994, a month after receiving the draft from Harwit, Correll

published a "Special Report" on "The Smithsonian and the Enola Gay," accusing the museum of betraying its formal mission to portray "the valor and sacrificial service of the men and women of the Armed Forces . . . as an inspiration to the present and future generations of America." He then followed up with "War Stories at Air and Space" in the April issue of *Air Force*. Some of what he wrote about history and "cultural angst" would have jibed with the evolving perceptions of Harwit and most of his colleagues; they were now beginning to see that it was one thing for Paul Fussell to write that a dead Japanese soldier "had glorified his family and his Emperor" and that "for most Americans, the war was about revenge against the Japanese" but needlessly, even recklessly, inflammatory for the National Air and Space Museum to say that Americans were fighting "a war of vengeance" and that the Japanese were fighting "to preserve their unique culture against Western imperialism."[6]

Even with a caveat about "graphic photographs of the horrors of war"—a sort of PG rating that could be interpreted as gratuitous—Harwit understood that the ghastly scenes at ground zero were excessive. But he also knew that the part about NASM's mission was simply in error: what Correll quoted about "valor and sacrificial service" was actually from the charter for the National Armed Forces Museum that had been authorized by Congress in 1961 but never funded, in part because of concerns about projecting a "warmongering" image in the midst of an agonized war in Southeast Asia. The tone of NASM's formal authorization, which includes a phrase about "provid[ing] educational material for the historical study of aviation and space flight" is entirely different from the authorization of the aborted Armed Forces Museum, which concludes, "The demands placed on the full energies of our people, the hardships endured, and the sacrifice demanded in our constant search for world peace shall be clearly demonstrated."[7]

The distinction was almost always lost in the ensuing war of words. But it did not matter, for there was no doubt about what Correll had succeeded in doing; he had precipitated a confrontation that brought the *Enola Gay* to the forefront of national attention and resulted in a more sustained barrage of publicity, nearly all of it unfavorable, than the Smithsonian had experienced in its entire history.[8] Thirty years before, a young curator

newly arrived at the Museum of History and Technology, Barney Finn, had remarked that "a bit of controversy . . . can often be beneficial."[9] Now, Paul Ceruzzi, a veteran NASM curator who was not directly involved with the exhibit, would confess conversationally that he "dreaded seeing the newspaper every morning." The Smithsonian, its reputation damaged as never before, had been taught a powerful lesson in being careful what you wish for.

Reference to the purposes of a nonexistent Armed Forces Museum was irrelevant, for "The Crossroads" could be read as "tendentious and moralizing" even by a historian sympathetic to NASM's aim of addressing "human consequences." This was Richard Kohn, who had served as chief of Air Force history from 1981 to 1991 but was now a professor at the University of North Carolina and chair of the Curriculum in Peace, War, and Defense. To Kohn, the weight of the horrific words and graphics was "clearly on the Japanese side."[10] Some of the writing was exceedingly awkward, and with its remarks about what "some scholars have argued" and what "others have argued," the script repeatedly violated a truism about the folly of addressing museum-goers as if they cared about historiography, or even understood the meaning of the word. Yet the advisory board, ten scholars, saw a "solid" effort in need of only "a little refining." Especially encouraging were the remarks of Richard Hallion, a stalwart of the original NASM curatorial staff in the 1970s and now Kohn's successor as chief of Air Force history. "Overall," wrote Hallion, "this is a most impressive piece of work, comprehensive and dramatic, obviously based on a great deal of sound research, primary and secondary."[11]

In truth, the response of the advisory board suggests a lack of serious attention, presaging an even more damaging lack of serious attention on the part of the Smithsonian Board of Regents a decade later. The script needed "refining" for sure, not least because it reflected the overconfidence of a director who seemed to believe that his own eminence combined with the cachet of the institution would carry the day and a senior curator who a few years before had brushed away criticism of another controversial exhibit at the Museum of American History, *A More Perfect Union*. Or, rather, it was mostly a silver-tongued Roger Kennedy who had brushed away the criticism; there was nobody at NASM with anything like Ken-

nedy's gift, however. The NASM script should never have gone out the door without a ferocious rewrite. If that had been done, and if essentially supportive critics such as Kohn had been given due heed as the exhibit was being developed—and if there had been anyone at NASM with any skill at handling a "situation"—the outcome might have been different. Instead, the best to be said in retrospect was that "the idea of presenting such an exhibit at the National Air and Space Museum seems . . . a kind of inspired folly."[12]

Correll launched a campaign to force NASM to its knees, bringing a congressional vote of censure and leaving the museum in ashes and sackcloth, charged with importing "the familiar ideology of campus political correctness . . . into our national museum structure." These were the sort of words expected from an attack dog like John Leo. But even the *Washington Post*'s Pulitzer Prize–winning book critic Jonathan Yardley, looking back six years later, would write of Secretary Adams sending NASM and "the great complex of [Smithsonian] museums off on an orgy of bowing and scraping before the new academic orthodoxy."[13]

■

FOR MOST OF 1994 THERE WERE FRENZIED EFFORTS to appease the Air Force Association and the American Legion, which proved to be a more formidable antagonist, although Harwit inexplicably believed it might be sympathetic. The American Legion spoke not for a military-industrial complex that regarded NASM as a key element of its publicity apparatus, as the AFA did, but rather for hundreds of thousands of fighting men who had risked death and believed they were saved from further risk—an invasion of the Japanese mainland—by what happened at Hiroshima and Nagasaki; nearly seven thousand of their comrades had died in the battle for Iwo Jima, an eight-square-mile island only 750 miles from Tokyo.[14]

In April, Harwit named an independent "Tiger Team" to "review the script for signs of imbalance," and it found plenty. In May, Harwit and Adams agreed on a new name: "The Last Act: The Atomic Bomb and the End of World War II." As "a line-by-line-review" of the script began along with representatives of the American Legion, the AFA compiled a

"summary of changes" with a list of "what they've deleted." The deletions included all suggestions "that the $2 billion spent on the bomb was a factor in using it," "all quotes by officials or military leaders who opposed or criticized the decision to use the bombs," and "all references to Japan being close to collapse when bomb used." Every mention of Japanese internment camps was gone. So were "all photos of dead Japanese victims of bomb (except one)," "most photos of injured survivors (leaving six)," and "numerous artifacts related to children who died in the bombings." Finally, the new script repeatedly referred to Truman authorizing use of the bomb "ONLY to save lives, not partly for other reasons," and to an invasion, had it occurred, leading to "one million casualties (not tens of thousands)" and the war lasting until 1946 "or later."[15]

On Sunday, August 7, 1994, a day after the forty-ninth anniversary of Hiroshima, the *Washington Post* published an op-ed piece by Harwit titled "The Enola Gay: A Nation's, and a Museum's Dilemma." The dilemma had nothing to do with any "display of undue compassion for those on the ground." That was no longer an issue, for everything intended to evoke such compassion had been purged (or nearly everything; there were still those six photos). The dilemma had to do with the museum seeking to honor veterans of the Pacific theater at the same time it told "the full story surrounding the atomic bomb and the end of World War II." Harwit ended with what sounded like a plea for patience and understanding: "We have found no way to exhibit the *Enola Gay* and satisfy everyone. But a comprehensive and thoughtful discussion can help us learn from history. And that is what we aim to offer our visitors." By then, however, "the full story" sounded like nothing but wicked political correctness to the punditry, and to many of the nation's lawmakers as well, and Harwit got no patience or understanding. He hardly knew what hit him.

The *Wall Street Journal* demanded to know "what is going on at the taxpayer-funded Smithsonian and how long is it going to be allowed to continue?" The *Washington Post* was unremittingly hostile; Charles Krauthammer spoke for the majority of syndicated columnists when he decried "prejudicial rubbish." Then in the wake of the 1994 congressional elections, triumphant Republicans began sounding off: Peter Blute of Massachusetts, Tom Lewis of Florida, and, most quotably, Speaker of the House Newt

Gingrich, whose "sick and tired" was repeated in the press endlessly. Along with House Majority Leader Dick Armey, Majority Whip Tom DeLay, and Chair of the House Republican Conference John Boehner, seventy-eight congressmen signed a letter demanding Harwit's dismissal. Senator Nancy Kassebaum introduced S. Res. 257, quoting extensively from the National Armed Forces Museum authorization and expressing the sense of the Senate that the NASM script "is revisionist and offensive to many World War II veterans." Kassebaum thought it would be best for the airplane to be exhibited in Nebraska, the state she represented and where it was made. The *New York Times* was a rather lonely and unsteady defender of the museum, saying that it "would probably have worked its way to a more balanced exhibition without pressure from Congress."[16]

■

LATE IN 1994 THE MUSEUM HAD RELEASED the much-revised "final" script, but it was too late. After a last dispute about whether the number of U.S. casualties averted by avoiding an invasion would have been 229,000 or 63,000, any appeasement of critics was impossible, and the American Legion was calling on the Smithsonian secretary (and on President Clinton) to take the exhibit away from Harwit and his curators or, better, to see that it was canceled altogether.[17] By this time, the secretary was no longer Robert Adams, the scholar who had taken office with an aim of staging exhibits "that make people feel uncomfortable" and had hired Harwit so that he could promote "confrontation, experimentation, and debate." After ten years, Adams had left the institution and was now far out of the line of fire, in a faculty office at the University of California, San Diego, finishing his big book, *Paths of Fire: An Anthropologist's Inquiry into Western Technology.*[18] So the task of canceling the NASM exhibit and replacing it with something "much simpler" fell to Adams's successor, Ira Michael Heyman, who had been in the job for just four months when he announced at a press conference that he was taking "direct charge" of an exhibit that would be designed "to permit the Enola Gay and its crew to speak for themselves."

Like Adams, Heyman was an academic. A Yale Law School graduate and

one-time clerk for Chief Justice Earl Warren, he had been a law professor at the University of California, Berkeley, for fifteen years before becoming vice-chancellor in 1974 and chancellor six years later. At first, he indicated that he would support the besieged NASM staff; the pressure from the Air Force Association and the American Legion, he said, reminded him of attempts to dictate books and curriculum in university courses.[19] But when it looked like there might be a real threat to the Smithsonian's federal budget, that it could be "zeroed out"—a threat voiced repeatedly by Ted Stevens, a veteran of the war in the Pacific and chair of the Senate Rules Committee—Heyman confessed to what he called a "basic error." It was *not* possible to achieve the purposes that Harwit intended, "to couple a historical treatment of the use of atomic weapons with the 50th anniversary commemoration of the end of the war."

To the *Washington Post*, the NASM exhibit had been "scuttled." The *Baltimore Sun* preferred "junked," while "scrapped" was the *Boston Globe*'s expression. To a kinder and gentler *New York Times*, "plans had been altered"; the Smithsonian employee newsletter, *The Torch*, described the exhibit as "scaled down."[20] Scaled down to "a comfy, sanitized version of history," was the way the *Washington City Paper* put it. Whatever the expression, Heyman claimed that a Smithsonian secretary taking "direct charge" of an exhibit was not unheard of. While he might not have been able to cite a precedent, what he did do was devise an exhibit acceptable to the Air Force Association, to the American Legion, and to the legislators who had threatened recrimination (but were still far from finished with the errant Smithsonian; now, Senator Stevens had scheduled hearings on its "management practices," and his hearings were invariably inquisitorial). The new script, which Heyman claimed to have developed "with no formal consultation process," mentioned casualties only in passing and said nothing about alternate scenarios for surrender, nor did it even hint at any topic that could be defined—in a term new to popular discourse, and usually misunderstood—as revisionist. Rather, the exhibit was about the *Enola Gay* "as the ultimate development of the B-29" and "the first airplane to strike an enemy with an atomic weapon *and after that, period*," the words of General Tibbets, who now pronounced himself "pleased and proud of the exhibit."[21]

NASM's exhibit titles never included the name of the airplane itself, and Harwit had initially outlined his plans for an exhibit about strategic bombing without mentioning the *Enola Gay* either.[22] But that was Heyman's straightforward name for the exhibit, *The Enola Gay*. The script was sixty-five pages, not hundreds and hundreds. Where the Japanese *Ohka* was to have been displayed, there were photomurals detailing the *Enola Gay*'s arduous restoration at Silver Hill—a tour de force in technological ingenuity because the plane had not been designed or fabricated with any thought of disassembly, some of which, perforce, had been roughly handled. Even the Fat Man was gone, replaced by one of the four engines, though the Little Boy was still there in the bomb bay. The fuselage was burnished as if it had been something like George Washington's sword.

In Heyman's words, the script focused on "the object itself." Were there broader areas of reference? Was there any "context," an overworked and yet still meaningful term? There was none. In the *New York Times Magazine*, David Sanger wrote, "The Enola Gay is flying solo on the Mall in Washington"; in the *Baltimore Sun*, Arthur Hirsch labeled it "Enola Lite"; in *Harper's*, Tom Englehardt described "a technician's exhibit."[23] Richard Hallion, who had been Crouch's curatorial colleague in NASM's early years (their names linked like a pair of entertainers, Crouch and Hallion), called the exhibit "a beer can with a label."[24] Where one might have found more information was in an illustrated book whose text comprised a cleanly edited version of NASM's final script. The book was already in print and already being advertised by the Smithsonian Institution Press: $19.95 for *The Last Act*. But Heyman had told Sam Johnson, a Texas congressman just named to the Board of Regents by Gingrich, that the book would never see the light of day, and it never did.[25] After swinging in the breeze until May 1995, Harwit had been told by Heyman to submit his resignation, and he had now gone home and set to work on a book of his own.[26]

Harwit titled his book *An Exhibit Denied*. In 477 pages he recounted "the most violent dispute ever witnessed by a museum." Considering his humiliation, the book seemed oddly restrained; one of his first acknowledgments went to the Air Force Association for permission to quote from the information in its files. But Harwit left no doubt about his own sensibilities. At the beginning of the book, he voiced his concern about influence

and suppression that appears as an epigraph to this chapter. At the end, he sounded an alarm about the Smithsonian becoming "the government's organ for disseminating propaganda," and he wrote this about the man who made sure that NASM's *Enola Gay* book was suppressed: "Once a Congressman Johnson tells the National Air and Space Museum that it has no business teaching history, or orders one of its exhibitions to be shut down, or bans the publication of this exhibition's catalogue, it becomes difficult to see where his concern for patriotism and national self-image will stop. It becomes a dangerous game."[27]

Tom Crouch had once told Father John Dear of the peace and justice organization Pax Christi, "You have no idea of the forces opposing this exhibit, not in your wildest dreams—jobs are at stake, the Smithsonian is at stake." The Smithsonian suffered badly, no doubt; its reputation for exhibits presented by men and women who were omniscient had been, in common perception, subverted by revisionism. The public came to equate this term, theretofore unknown beyond the halls of academe, with the tactics of a self-anointed cultural elite with a leftish political agenda—for casting opprobrium all but interchangeable with communism. Those who knew Crouch from his impeccable scholarship on the Wright brothers and other aeronautical pioneers would have known that the shoe did not fit. But it was only against many expectations that he escaped demands for his dismissal, as did Neufeld, who faced even more vicious opposition after word got around that he was not a citizen of the United States.

Still, rather than bearing out Eugene Emme's lament about NASM failing to become "the center for world research as might have been hoped for," museum staffers would carry on with a remarkable legacy of scholarly books, including, but certainly not limited to, Neufeld's Dexter Prize–winning *The Rocket and the Reich: Peenemunde and the Coming of the Ballistic Missile Era*. Alex Roland, a Duke University historian whose involvement with the museum went back to the director's search in 1982—when Mel Kranzberg was a candidate—had predicted that its offending curators "would get taken out on the Mall to suffer a flogging" but after that there would be forgiveness. This is about what happened. With popular passions diverted, Neufeld eventually emerged with his scholarly reputation intact; so did Crouch, who said that he never once stepped into

the gallery where the *Enola Gay* fuselage was exhibited for four years but stayed on as NASM's senior historian of aeronautics, becoming a familiar face on PBS specials, avuncular and articulate.[28] Harwit survived, back where he came from. At age sixty-four, he renewed his relationship with Cornell as professor of astronomy emeritus and in 2007 he was awarded the Catherine Wolfe Bruce Gold Medal for lifetime achievement, an award that had previously gone to Edwin Hubble, Hans Bethe, and Fred Hoyle, with whom Harwit had done postdoctoral work at Cambridge. The Society for the History of Technology, which had passed a motion of censure, fell under fire for unseemly "political meddling," but this was soon forgotten. Former SHOT stalwart Richard Hallion never really recovered his good name in scholarly realms, however, not after having sent Crouch a handwritten note saying that the script needed only "tweaking" and then, when reminded of his duty as Air Force historian, calling the exhibit beyond salvage and the bombing "morally unambiguous."[29]

Perhaps the saddest story was that of Stanley Goldberg, who, without incident, had put a Fat Man and Little Boy on display at the Museum of American History in 1985 but failed to get expected funding for an ambitious exhibit called "Entering the Atomic Age." After an interval in which he played a key role in creating *A Material World* at NMAH, he was named to the advisory board for the *Enola Gay* exhibit at NASM. He eventually resigned in protest of what he regarded as Harwit's blunders.[30] But Goldberg also wrote the most perceptive (and witty, as was his way) analysis of the whole controversy, "Smithsonian Suffers Legionnaire's Disease," published in the May–June 1995 issue of the *Bulletin of the Atomic Scientists*, a journal once edited by Robert Adams's spouse, Ruth. After that, Goldberg took responsibility for a collaborative exhibit with the Russian Academy of Sciences on the history of the space race and also set to work on a biography of General Leslie Groves, the military head of the Manhattan Project. Afraid of another controversy, however, Heyman put a lid on funding for the space race exhibit, and Goldberg was only part way through the research for his book when he was fatally stricken with a rare disease.[31]

■

THE ASSUMPTION OF SECRETARIAL CONTROL OVER EXHIBITS, which Adams began and Heyman made absolute, had little or no effect on the critical scholarship that Smithsonian curators produced for trade publishers and academic presses. For audiences that were usually (but not always) small and specialized, they wrote books of unquestioned distinction, two of many examples being *Brotherhood of the Bomb: The Tangled Lives and Loyalties of Robert Oppenheimer, Ernest Lawrence, and Edward Teller* (2002) by Gregg Herkin, NASM's curator of military space, and *Toxic Drift: Pesticides and Health in the Post–World War II South* (2007) by Pete Daniel, senior curator in the Division of Work and Industry at the Museum of American History. But the effect on exhibits—what the curators did that reached millions, tens of millions—that was a different story.

The NASM confrontation was uniquely explosive because it touched a nerve of war and remembrance on a fiftieth anniversary, and fiftieth anniversaries are always freighted with emotional baggage because, as Rosalind Williams puts it, "they mark the threshold where individual memory begins to be transformed into collective memory." But a confrontation had probably been foretold since Adams arrived in 1984, certainly since he awarded the director's job to Martin Harwit in 1987. Harwit understood that he got the nod because Adams believed (as had Ripley) that "aviation and spaceflight were not just the domain of the military or the aerospace industry" and that Adams "wanted the museum to address broader issues of public interest." Quite unlike the man who preceded him, one-time B-52 pilot Walter Boyne, or any previous director, Harwit regarded the museum's celebratory image as a stigma. Born in Prague in 1931, he had grown up in Istanbul and come to the United States at age fifteen, in 1946. He had been in the army in the 1950s and witnessed atomic bomb tests at Eniwetok and Bikini in the Marshall Islands. But he had never flown in combat, the sine qua non for "acceptability to the air and space community," as a NASM official put it a few years later. Why the men of that particular community? "Because they are the ones who we want to make the donations. It [the directorship] should be one of theirs, one of their own."[32]

As an MIT PhD and a co-founder of Cornell's program in the history

and philosophy of science and technology, as well as a professor of astrophysics, Harwit was both scientist and scholar, and some of his ideas about history were evident at NASM long before the *Enola Gay* hit the headlines. There were small changes, epitomized in a new label for the museum's V-2, which had formerly referred to a "milestone in the progress of rocket technology" that "pointed the way to development of rocket boosters for launching satellites" and mentioned "death and destruction" almost in passing. Now, the label read, in part:

> Concentration camp prisoners built V-2s under unimaginably harsh working conditions. Thousands perished in the process . . . More than 1500 V-2s hit southern England alone, causing 2000 deaths . . . V-2s killed a total of 7000 people and terrorized millions . . . Because the V-2 could not be precisely guided, anyone within miles of the general target could be hit without warning.

Here was a glimpse at a dark side formerly absent in NASM exhibits, but implicit was the assurance that "we weren't the bad guys." For the Air Force Association, the first strong indication that Harwit was pursuing "a political agenda" postulated on "a hostile view of airpower" was *Legend, Memory, and the Great War in the Air*, an exhibit about World War I that featured the drama on the ground at an Allied airfield—a *stage set*, already familiar in some of the exhibits at the Museum of American History—and *not the airplanes themselves*. There was a Fokker, a SPAD, and a Sopwith Snipe but "fenced off and dimly lighted." Historic planes from three countries as *props*! The gist of the storyline was that "popular culture, nationalism, and even the requirements of postwar commerce shaped a collective memory of World War I aviation."[33] As Joanne Gernstein London put it to me, visitors were being asked "to think about what they knew about the war and how they had come to have this knowledge." But to John Correll, the message of the exhibit and its companion book was that it was wrong to romanticize fighter pilots, the Red Baron and the like, and military aviation. The book ranged into the horror of strategic bombing up to the present and even gave "credence to speculation that '70,000 civilians were killed as an aftermath of the bombing campaign in the recent gulf war.'"

Of what possible relevance was the Gulf War? How far, Correll won-

dered in his "War Stories at Air and Space," could NASM be diverted from its proper mission? Much, much further, he soon began to see. Coming up was "The Crossroads," another exhibit featuring an on-the-ground perspective, this one on World War II. Something would have to be done about that.

■

BUT IT WAS NOT JUST DOINGS AT NASM. For critics of Robert Adams's Smithsonian as it reached up and down the Mall and beyond, there was *A More Perfect Union* at American History, there was *The West as America* at American Art. There were the "What's Wrong?" signs in the Museum of Natural History about dioramas reflecting a "Western-scientific-anthropological worldview" and treating humans as "more important than other mammals." There was the *Underclass* exhibit in Arts and Industries, with visitors being invited to take a look from the vantage of a morgue slab. How far could "a political agenda" be pushed, especially if it were true that "most museum goers prefer a seamless and uncontested past devoid of controversy or recrimination," especially if what they seek is "solace in a nostalgic past"?[34] Announcing that he was "not running an entertainment facility," Adams sought to test this assertion. His remark was unduly provocative, yet there were good arguments for change, at least a mild sort, a "move away from the traditional heroes, politicians, and objects in glass cases and toward a wide, fluid, social-history approach," as the *Post* put it.

Even mild change along such lines was problematic, however, because it seemed to privilege "opinion." After Heyman's intercession with the *Enola Gay*, when he claimed to be separating "fact" from opinion, academic critics charged that he had suppressed thoughtful discourse or had done something much worse. To assertions that Americans yearned to be "liberated" from the conceits of a "cultural elite," historian Mike Wallace responded, "If the Orwellian recasting of suppression as liberation is not rejected, if the right is allowed to frame the issue this way, the Smithsonian's humbling may herald further repression."[35] However the issue was framed, there was no doubt about the Smithsonian having become snared in the

rhetoric of America's culture wars, the same rhetoric that was sinking the National History Standards because they lacked (as Lynne Cheney put it) "a tone of affirmation."

True, the academy was notorious for its "morality pageants." This posture even characterized an occasional book from the Smithsonian, and nobody seemed to notice. But exhibits designed for the eager audiences that crowded Smithsonian museums, millions of people, people from all over the country, all over the world? There, the assumption about the primary goal had always been that it was "to set standards, to confer status, and reflect accepted truth, not search for it," as Adams's erstwhile Chicago colleague Neil Harris put it.[36] But after the *Enola Gay* hit the headlines, the public became intimate with an expression that had largely been the province of academics, *revisionism*, which was taken to mean a deliberate departure from truth. "We think there are some very troubling questions in regard to the Smithsonian," said Peter Blute, the Massachusetts congressman, "not just with this *Enola Gay* exhibit but over the past ten years or so, getting into areas of revisionist history and political correctness."[37]

With the "troubling questions" about the Smithsonian that echoed and re-echoed in the wake of the "Republican Revolution" in 1994, even a reliably liberal U.S. senator, Dianne Feinstein, could question why the institution was attempting "to interpret history" rather than simply to ascertain and recount what had actually taken place, just the facts. There would be various explanations. According to Newt Gingrich, the Smithsonian had become "*a plaything for left-wing ideologues.*" It had been transformed by the "new museology," by "a wholesale embrace of the worst elements of America's academic culture," Heather MacDonald added later.[38] Attentive to a congressman's remark that "tidying up the hallway doesn't erase the fact that the rest of the house is a mess," Heyman had gone in search of other "unbalanced presentations" and shelved several exhibits that were planned. An exception was the space race exhibit, which Gregg Herkin carried through in an attenuated form, but Heyman told the National Press Club that another planned exhibit, on the Vietnam War, would be postponed while "the dust settles."[39] There was yet another major exhibit that had raised some dust and attracted Heyman's attention, *Science in*

American Life (*SAL*). What was different about *SAL* was that it had already been opened to the public, with a fanfare, on the first floor of the National Museum of American History.

SAL might have celebrated the thrill of discovery on the frontiers of knowledge. It might have affirmed science as an activity that is not part of society but *above* it because of its selfless quest for objective truth. Near the beginning there was a unit called "Science for Progress," but there also were units about DDT, about PCBs, about Three-Mile Island, about the *Challenger* explosion, and even a little bit about the atomic bombing of Japan. There was a "family fallout shelter" from the 1940s. At the entrance, on a stage set representing a late-nineteenth-century laboratory at the Johns Hopkins University, an audio track had a man in a white lab coat musing about turning his back on "pure science" and *patenting* a new substance that was sweet, like sugar—saccharin, it was called. Soon, a vocal segment of the scientific community was expressing displeasure with the exhibit's emphasis on crass motives and on case studies depicting "science's failures to a much greater extent than science's triumphs."

Heyman began expressing "a certain amount of sympathy with that viewpoint." Take the letter on display in which prominent scientists urged President Truman not to use the bomb. Where was the "balance"? Where was "any reference to scientists who took the other side"?[40] John Heilbron, a historian of science who was a former colleague of Heyman's at Berkeley and who had been put on a committee charged with diagnosing the exhibit's ills and "recommending cures," said that curators and academic consultants had failed to take "sufficiently into account the views of other interested parties."[41]

■

PLANS FOR AN "INTEGRATED" EXHIBIT on the history of science in America dated back to the early 1970s, spurred by the enthusiasm of Barney Finn and his sense that the museum's collection of apparatus illustrating "the technology of science" was rich and varied enough to fill the entire west end of the first floor. For years, Finn convened a group of departmental

colleagues every week, to work and rework plans for this exhibit. Although nearly all were PhDs, most were taxonomists at heart, not comfortable "going beyond the material culture of the laboratory to the social culture and ideology, and beyond that to the social meaning of scientific activity in American civilization"—these the words of Paul Forman, the group's, perhaps the museum's, best critical thinker.[42] Even the learned and inventive curator of classical physics, Walter Cannon, would list page after page of artifacts in his collection—sextant by Stackpole, theodolite by Kubel, spectroscope by Grubb, and so on—while providing only spare narratives about "the social meaning of scientific activity," and he was disinclined to do anything with ideas which seemed to overreach the capacity of exhibits for illustrating abstractions. "The asymmetry of the Columbian exchange," for example, was a favorite theme of the Brown University historian Hunter Dupree, a visiting scholar in the mid-1970s.

Finn's project was stalled when Roger Kennedy arrived in 1979. Kennedy was quick to note the potential for becoming "the nation's history of science museum" but only, he said, if its people were able "to impart to our public the sense that there are some large unifying ideas in science, and in history." His response to plans for a grand "Hall of American Science," Finn's dream, was deliberately evasive. Instead, he sent newer curators in search of such ideas, and when Art Molella proved his mettle with the FDR show, Kennedy asked him to assemble colleagues to identify "narratives in which the American public has grappled with the implications of living in a scientific and technological age." Eventually, two dozen were chosen, case studies tracing the emergence of the scientific enterprise in the late nineteenth century and its subsequent permeation of public institutions, the workplace, and the home. Many were designed as set pieces, such as the Johns Hopkins lab and a suburban "rec room" from the 1950s.

This would be no departure from the design of other exhibits already in the works, such as *Information Age*, and no departure from a well-established historiography that sought to delineate the scientific enterprise in its most inclusive sense. It would remain debatable from then on, however, whether more was gained than lost when the authority of the museum was transferred from artifacts it exhibited and validated to "the stories being

told . . . the context into which objects were being placed." There could be only one descriptive label for an artifact but any number of possible stories. Finn called this "the arrogance of ideas."[43]

After *SAL* was in planning for several years, it began to look like it might get no further than Finn's Hall of American Science. Then, in 1989, the museum got a promise of full funding by the American Chemical Society (ACS), several million dollars. With no less than a dozen men and women responsible for scripting various units, it proved to be a difficult show to carry out. There were knock-down-and-drag-out debates involving the exhibit's independent advisory council, half appointed by the Smithsonian, half by the ACS. A new designer was brought in partway through.[44] The exhibit opened in April 1994 to generally favorable notices but, as it happened, just as the Air Force Association had begun to threaten the Air and Space Museum with betraying its proper mission. Everyone wants to have his or her occupation or profession portrayed in laudatory terms, and there were hints of displeasure about *SAL*'s dark-side excursions right from the start—DDT? mushroom clouds?—but only hints until after the nation's right turn in the November 1994 elections and Heyman's cancellation of the *Enola Gay* exhibit two months later. Call it blood in the water.

Like Harwit at NASM, Molella hardly knew what hit him. And unlike the situation with *A More Perfect Union* in the 1980s, there was no Roger Kennedy to turn on the charm and persuade critics that their ire was misplaced.[45] Kennedy had gone on to the National Park Service, and his successor at NMAH, Spencer Crew, had a charming way of his own but little of Kennedy's brio. Hoping to emulate the tactical successes of the Air Force Association with NASM, senior executives of the American Physical Society (APS) and the ACS (the latter now claiming to have been "blindsided") posed an ultimatum: revise, revise, get that thrill of discovery on the frontiers of knowledge back into the exhibit or face the wrath of Congress. Understandably concerned about threats to the Smithsonian's appropriation, Heyman ordered changes both to *SAL*'s labels and to audio tracks like the one in the Johns Hopkins lab—not as extensive as the demands from outside but significant nonetheless. It seemed that *any* changes would affirm the precedent: "You can now have your own

version of our nation's history displayed and opposing views suppressed at the Smithsonian Institution," was how Martin Harwit would express it in *An Exhibit Denied.*

Men in business suits who claimed their profession had been dishonored could never gain sympathy the way that khaki-clad veterans of the war in the Pacific could, and discord over *SAL* never reached the same intensity. But the *Washington Times* and the *Wall Street Journal* eagerly entered the fray, providing a forum for all manner of partisan complaint. Christina Hoff Sommers, a Clark University philosophy professor, condemned the transgressions of *SAL* as part of an assault by "multiculturalists, radical environmentalists, feminist theorists, and others of the cultural left."[46] Robert Park, director of public affairs for the APS, detected not only a dark-side preoccupation in *SAL* but also what he called "postmodernist social constructivism," a mysterious affliction to much of his Internet audience and certainly a puzzle to most people at the museum. In truth, an exhibit like *SAL* did have a postmodernist flavor; it depicted science in the context of one set of apparent realities when another set could just as well have been chosen—and had been, years before, when I helped plan an exhibit whose working title was "American Science: The Grand Adventure." But all that was really clear from Park's critique was how easy it was to replay a narrative that was now well established, subversive "revisionist" ideologies being imported into the National Museum to the dismay of a justly aggrieved constituency.

The *Enola Gay* episode attracted nationwide, even worldwide, attention, and its outcome can arguably be termed a tragedy. But the *SAL* episode was more an instance of history repeating itself not as tragedy but as farce. It was at the Museum of History and Technology where narrative storylines had entered the discourse in the 1960s, and the idea of giving stories a bit of a critical edge started to gain ascendance a few years later. Plans were rarely secret, and groups of the sort later termed stakeholders might get wind of an exhibit being developed and ask to weigh in. This is what had been going on at Air and Space, at first, before the process careened out of control. But with *Science in American Life* the sequence of events was different. An elaborate and hard-wrought exhibit had opened to the public

after having passed muster with a duly constituted committee of experts, half of them appointed by the organization that provided the funding, and *then* there were demands for changes, to which the secretary acceded.

Throughout the ranks, everyone involved with exhibits remained apprehensive. If an exhibit displeased some particular stakeholders, and if they had any appreciable political muscle, then they could appeal for changes. Better than trying to impart "messages" of any kind, said an official who was echoing Senator Feinstein, exhibits should be presented in an objective mode that allowed people "to make up their own minds." But what they would be allowed to make up their minds *about* was for the most part innocuous. There was one notable exception, an exhibit called *Between a Rock and a Hard Place: A History of American Sweatshops, 1820–Present*, which opened at NMAH in the spring of 1998 and ran for six months. The centerpiece was a stage set re-creating a notorious apartment compound in El Monte, California, where illegal Thai immigrants, virtual slaves, had been found sewing garments for brand-name apparel makers and retailers. A representative of the American Apparel Manufacturing Association told the curator that "by sponsoring this highly politicized exhibit, the Smithsonian Institution is engaging in a taxpayer-funded smear against the U.S. apparel industry." Sam Johnson, the Texas congressman, announced that Gingrich had appointed him to the Board of Regents "to keep historical revisionism under control." But Secretary Heyman told reporters, "We have confidence in the American public's desire for candor and appreciation for important political stories," and the show went on.[47]

Nearly unprecedented was the main label signed by Spencer Crew and associate NMAH director Lonnie Bunch explaining "why museums mount this kind of exhibit." Certainly an original supplement were looseleaf notebooks with copies of newspaper stories, op-ed pieces, and letters both pro and con that were right there on a table for visitors to peruse.[48] The exhibit did close with an upbeat unit on "Good Industry Practices," which reviewers called a loss of heart by its creators.[49] But with razor wire and with bundles of clothing actually made by the Thai workers, *Between a Rock and a Hard Place* had real dramatic power. Why was it there at all, in a post–*Enola Gay* Smithsonian, with Secretary Heyman's approval, in the Frank Taylor Gallery of the Museum of American History? Was it because

part of the $285,000 funding came from the National Retail Federation and Kmart, in addition to support from the Union of Needletrades, Industrial and Textile Employees (UNITE)? Was it because a small portion of the cost was borne by the Department of Labor, and Labor Secretary Alexis Herman said it was important to "open a world that few of us have ever seen and probably fewer think about"? Was it because an influential California congressman, Democrat George Miller, gathered the signatures of forty-six colleagues on a petition to Heyman? Maybe. Or maybe it was because Heyman, whose own politics at the University of California had been liberal, thought a measure of atonement was in order. *Between a Rock and a Hard Place* was scarcely exceptional insofar as it was drenched in politics. But it was bravely conceived, and on that score it *was* unusual.

■

JOSEPH HENRY, THE SMITHSONIAN'S FIRST SECRETARY, had warned about the danger of the institution becoming "a popular establishment depending on popular reputation for its support" and the related danger of a popular establishment (a museum) falling "under direct political influence."[50] This had happened from time to time in the years since but never with such impact as when the man with the most power on Capitol Hill was Newt Gingrich, the declared foe of "countercultural morality pageants." Gingrich might lose his power, as he did, but it seemed pretty certain that, henceforth, Smithsonian exhibits telling stories with a potential to displease powerful interest groups were going to be rare.

How about discordant news of the Smithsonian being a regular feature in the local, and sometimes national, press, however? This was to continue into the new century, often as intense as news of the engagement in the culture wars of the 1990s. In 2000, a new secretary arrived who would be accused time and again of leading the honored Smithsonian Institution astray. Robert Adams had faced the same accusations, but not everyone agreed. About Lawrence Small there was little disagreement. In his 1995 article, "History and the Culture Wars," Richard Kohn famously wrote that what happened with the *Enola Gay* exhibit "may constitute the worst tragedy to befall the public presentation of history in the United States

in this generation." Had he been writing a decade later, Kohn might have revised that judgment about the "worst tragedy." Most of the next chapter is about tragedy, and scandal, and its tone and temper may seem different from everything in the book up to this point. But I believe it is essential to an inclusive narrative of the Smithsonian Institution and the problem of history, and I trust this will be obvious to readers. The concluding chapter returns to exhibits—style and substance, design and narrative, the conventional and the innovative—and a suggestion about a pair of archetypes that may persist well into the new century, one neo-traditionalist and the other postmodernist.

*All this talk about bringing us into the 21st
century is coming from somebody who hasn't the
slightest idea of what the institution is all about.*
—BARNEY FINN, 2001

*Mr. Small's disposition was ill-suited for the
position of Secretary . . . The Secretary must set
the ethical tone, not sidestep it.*
—INDEPENDENT REVIEW COMMITTEE,
Report to the Board of Regents, 2007

CHAPTER 10 ▪ Small's World

Joseph Henry, it bears repeating, did not want responsibility for a
museum. He accepted only on the assumption that this would be tem-
porary, and only when Congress came through with an appropriation
that enabled him to separate "diffusion" from what he most cared about, sci-
entific research, "the increase of knowledge." His successor, Spencer Baird,
felt differently, however, and in 1881 a building was completed next door
to the Castle that was called the United States National Museum. Its first
two functions, as defined by Baird's protégé George Brown Goode, were
to be "a museum of record" and "a museum of research." A third function,
education, was to be served through "illustrating, by specimens, every kind
of natural object and every manifestation of human thought and activity."[1]
Thirty years later, after Secretary Charles D. Walcott opened the "New" Na-
tional Museum on the other side of the Mall, "natural objects" were moved
over there, and it became known as the Natural History Building while
the old National Museum was renamed the Arts and Industries Building.

In A&I, Carl Mitman and Frank Taylor did their utmost to foster and

enhance the display of "manifestations of human thought and activity," technological devices and "historical relics." But, over in the Castle, the men in charge of the institution almost never shared their passion, not until Leonard Carmichael became secretary, the seventh, in 1953. While Taylor was the moving spirit behind the Museum of History and Technology, authorization and funding were contingent on Carmichael's verve and political savvy in a new world-historical context, the Cold War. Carmichael made people believe that the United States *needed* this museum.

On instructions from the secretary, Taylor began staffing MHT even before Congress had assured the money for construction, and Carmichael was pleased by what he had accomplished, together with Robert Multhauf, by the time the museum opened its doors to the public in 1964. There was no doubt about the men and women they recruited deserving immense credit. Even the *New York Times* critic Ada Louise Huxtable, who said *nothing* good about the new building, praised their exhibits. But praise was scarce from the eighth secretary, S. Dillon Ripley, who privately would refer to MHT as "Carmichael's museum." Not that he ignored it. A guidebook credited Ripley with enabling visitors "to hear the sounds of a giant steam locomotive" and "to smell the chocolate in a nineteenth-century confectionary" (John Anglim's doing, actually), and he was instrumental in getting the grounds spiced up with avant-garde sculpture.[2] Still, Ripley turned most of his attention to new initiatives, of which just a sampling suggests the range: the fellowship program, the Woodrow Wilson International Center for Scholars, and the Archives of American Art; art museums designed for elite audiences, such as the Hirshhorn, Sackler, Renwick, and Cooper-Hewitt; and outreach to popular audiences through the Anacostia Museum, *Smithsonian* magazine and Smithsonian Exposition Books (conceived as a rival to Time-Life), and the Festival of American Folklife. And the Air and Space Museum, of course. For many Smithsonian visitors, Air and Space was Ripley's signature, though some of them were more taken with his carousel on the Mall.

In Ripley's first few years, however, he knew that nothing in his domain was more attractive to tourists than the marvels of invention in the new Museum of History and Technology, and he was content to leave it with Multhauf, even though they rarely spoke and he had his eye out for an aca-

demic celebrity as a replacement. In theory, final say about directors—not only for MHT but for all Smithsonian "bureaus"—was the province of the Board of Regents, led by the vice president of the United States. But the regents all had other concerns and rarely weighed in on routine matters. In the same way, "the Castle" related to the bureaus as to a confederation of fiefdoms with inherent rights and privileges. This was assumed to encourage creativity and productivity, and museum directors and senior staff regarded their prerogatives as similar to those of deans and tenured professors at a research university. (Ripley furthered this notion by referring to his "faculty" and parading them on the Mall in academic regalia.) Once in a while, the secretary would assert a sovereign right for "reasons of state"—insisting, for instance, that a bureau director carry through with a project not to his liking, as happened with Brooke Hindle and *American Banking*. Still, the secretary would sometimes yield contested terrain, as when Ripley allowed Daniel Boorstin to go his own way with the loaded issue of identity politics. And prior to 1984, with the regime of Robert Adams, no secretary had ever taken office intent on influencing, let alone controlling, the basic tenor of historical exhibits.

Adams believed that the Smithsonian's history museums had an obligation that was beyond just illustrating "manifestations of human thought and activity." In David Hackett Fischer's colorful language, they needed to do something more than "gathering facts like nuts and berries."[3] Exhibits needed a presupposition, a postulate, an "edge"; they needed to pose a "problem" and provoke thought and even controversy, like good scholarship. This view coincided with changing perspectives elsewhere in the museum world, even at Colonial Williamsburg—where the mission had been to celebrate the lifestyle of Virginia's planter elite—with the vice president for research saying, "I want [the public] to go away disturbed. I see this museum as a device to make Americans look at aspects of both the past and the present that they may not want to see."[4] Much of the time, Adams's aims coincided with Roger Kennedy's at the National Museum of American History, where there was an unorthodox plan afoot for marking the bicentennial of the Constitution in 1987, and at the National Air and Space Museum, Martin Harwit got his job that same year because he agreed on the necessity of "uncomfortable" exhibits.

But when Michael Heyman became secretary, in 1994, he acted as if there had been a decisive shift in the relationship of the Castle and the bureaus, and that the secretary had absolute power. In the history museums, it looked to Heyman as if exhibits were in the hands of men and women whose world of discourse was verbal, not visual, and who were using "the academic voice in their scripts . . . in a context where the audience takes them as authoritative statements." How many words, how many silk-screened paragraphs, would "weary exhibition-goers . . . be willing to read?" And was not the Smithsonian "moving to a point where a torrent of words overwhelms the objects visitors come to see?"[5] These were valid concerns. Diverting attention to "a torrent of words" arguably diminished the very purpose of a museum, with "the display of art or artifacts" (and the assumption that people should pay attention to them) figuring in every definition. But it was not just the "torrent" per se. It was that "academic voice." In overturning plans for a high-profile exhibit at NASM, insisting on changes to a NMAH exhibit that was long in the works and finally on public view, and putting other projected exhibits on hold because of possible political concerns about the "voice," Heyman tipped the balance. On the basis of a manifesto from the Castle in August 1995 stipulating that "the Secretary has authority to approve or disapprove any Smithsonian exhibition at his discretion," Heyman's successor Lawrence Small would never have the slightest doubt about the extent of his power.

■

AS A REGENT, HEYMAN HAD BEEN LEADING THE SEARCH for Adams's successor when suddenly he stepped forward as a candidate himself and his fellow regents gave him the job, even though this represented a break from a 150-year precedent—Heyman would be the first Smithsonian secretary without a scientific discipline. (Even Carmichael, a physical psychologist, was not an exception; nor was Adams, both anthropologist and archaeologist, well acquainted with digs in Iraq's Cradle of Civilization.) At first, nobody anticipated that Heyman would want to assert direct control of the exhibit program, which was not yet in an obvious state of crisis. Rather, what they most expected was that he would show himself to be as

good at raising money as he had been at Berkeley.[6] Ripley had been able to persuade men like Joseph Hirshhorn and Arthur Sackler to turn fabulous collections over to the Smithsonian, but he was dismissive of the ritualistic aspects of fundraising. Adams had nothing like Ripley's connections with the super rich, and he rarely went after private funds, even as federal appropriations for exhibits had all but vanished after the Bicentennial. With Ronald Reagan in the White House and retrenchment the watchword, there was a tacit understanding that Smithsonian appropriations were to be limited to salaries and upkeep. Money for exhibits would have to come from the private sector.

Any truly energetic pursuit of such donations had always been fraught with ambivalence throughout the institution. What about attached "strings," or at least a perception of strings? More importantly, would private funds not come to be seen as a *substitute* for appropriations rather than a supplement? This danger was partly why the Smithsonian had no development office of the sort integral to the administration of any university. Individual curators would pursue donors on their own volition with little or no oversight. Under Michael Collins, the Air and Space Museum solidified its connections with corporate benefactors whose names appeared over and over in and around the exhibits, but at NMHT the donations during Hindle's four years as director rarely amounted to much—recall him writing individualized thank-yous for very small gifts.[7] Even in Roger Kennedy's time, donations in the millions from DuPont and IBM were decidedly anomalous. But a new sensibility about funding was emerging by the mid-1990s, especially when the tour of *America's Smithsonian* had to be abbreviated because only four $10 million corporate partnerships were secured instead of the expected ten. This was embarrassing, and at the urging of the regents Heyman established a national board to raise funds for major initiatives; he also encouraged the bureaus to follow suit. At NMAH the job fell to Ronald Becker, the associate director for administration, wise and adept, who was able to line up people whose world was "serious dough." The first chairs were Ivan Selin and then Richard Darman, both of whom moved back and forth between high government posts and immensely profitable consulting and private equity firms—Selin, a co-founder of American Management Systems and its CEO until the late 1980s, made

the first individual million dollar gift to the museum; Darman, a partner in the Carlyle Group, ultimately helped raise tens of millions.[8]

■

AT THE OUTSET, HEYMAN SAID THAT HE PLANNED TO STAY for only five years, until 2000, when he would be turning seventy. But he certainly would have been welcome to stay longer because he was so effective at energizing the institution's fundraising capabilities. In fiscal year 1999 alone, there were twenty donors who gave more than a million dollars, including the largest gift ever—$65 million from aircraft-leasing magnate Steven F. Udvar-Hazy for the Air and Space Museum's aborning satellite in Virginia.[9] Another donor enlisted by Heyman would later give enough to get his name cut in stone at NMAH, now the National Museum of American History: Kenneth H. Behring Center.[10] Udvar-Hazy was publicity-shy; Behring was not. Bald and bulbous (his own description), he was sometimes mistaken for Alfred Hitchcock. Or he could have been an old stand-up comic, half of a team with Mike Heyman in his signature bow tie, with an equally toothy grin and at least a foot taller.[11] But Behring had the luck and whatever else it takes to have accumulated $495 million—the *Forbes* magazine estimate—and he had expensive enthusiasms, some cruel or self-indulgent, others admirable; he told a writer for the Smithsonian's monthly newsletter, *The Torch*, that he planned to raise $150 million for the foundation he established to distribute wheelchairs worldwide.

Behring was born in 1928 and grew up in Monroe, Wisconsin. He sold cars, sold real estate, opened a chain of "Car-a-Mat" car washes, and then founded a construction company that built a city in Florida, Tamarac (Car-a-Mat spelled backwards), for "active adults." In the 1970s he moved to California and built Blackhawk, a gated community in Contra Costa County whose residents included John Madden, the pro football Hall of Famer and Emmy-winning NFL analyst. In 1988 Behring bought his own NFL team, the Seattle Seahawks, and ten years later sold it to Microsoft's Paul Allen for $100 million more than he had paid. He collected "classic" cars, many of them once owned by celebrities—Clark Gable's 1935 Dusenberg roadster, Rita Hayworth's 1953 Coupe de Ville—and he built

a museum at Blackhawk that "glowed" in a way Charles Blitzer would have detested.[12]

Believing that his glamorous cars blended "art, technology, culture, and history," Behring had an idea that a nearby university might become a partner in his museum. He tried Stanford first, then the University of California; thus began his collaboration with Heyman, then Berkeley's chancellor. They agreed that the auto museum and an adjacent Museum of Art, Science and Culture, with artifacts from the university's collections in anthropology and paleontology, would be operated by the Behring Educational Institute "in connection with" the university. When that connection was broken after Heyman left the university, Behring looked him up at the Smithsonian. He had another idea. Along with his cars, Behring told of developing a passion for big-game hunting. He had mounted "trophies" from faraway places but no place to show them off. How about donating them to the National Museum of Natural History along with a check?[13]

Behring and Heyman settled on $20 million to pay, first, for renovation of the rotunda, where "The Biggest Elephant Ever Shot by Man" had been the museum's signature since the 1950s.[14] Then there would be an update for the Hall of Mammals, where stuffed animals posed in glassed-in dioramas, "passive, silent, wrenched from context."[15] Until Udvar-Hazy's, $20 million would be the institution's largest gift, nearly four times more than Jerome Lemelson's initial 1994 donation to the Museum of American History for founding a Center for the Study of Invention and Innovation.[16] There was controversy, as there always would be with Behring. Among his trophies were four Kara Tau argali, or bighorn sheep, at the top of the endangered-species list. Behring had the right permits, however, and nobody denied that $20 million could do a lot for a timeworn museum centerpiece and an exhibit hall that had not been touched since the modernization program fifty years past.

Heyman accepted Behring's check happily, and work on the renovation moved ahead. Designer Jeff Howard restaged the elephant more "naturally," with simulated droppings and all, and Behring's name was writ large on the walls overhead. But completion of the new exhibit hall was still years off; the pace seemed awfully slow. Then in 2000 a new secretary took office, and he was on the phone to Behring first thing to say that the work

at Natural History could be expedited if there were more money. No, that sounded like good money after bad, said Behring, who had never felt very welcome when he stopped by the museum to see how things were going. Behring recalls exactly what he heard the secretary say next: "Why don't you take a look at American History, because that is the one that really I would like to see something happen to." Behring recalls this, he says, because he had come to believe that he owed his country a debt of gratitude, and he could think of no better way to repay that debt than "to modernize the [American History] Museum's exhibits and to showcase the American Dream."[17]

■

ON MONDAY MORNING, SEPTEMBER 13, 1999, four years after the *Enola Gay* faded to the back pages, the secretary-to-be was introduced to the press in the Enid A. Haupt Garden behind the Castle and atop the subterranean Ripley Center.[18] Several regents were present, including the five who had served on the search committee co-chaired by former presidential chief of staff and Senate majority leader Howard Baker and by Wesley Williams Jr., a partner of Covington and Burling, a top Washington law firm (Eric Holder would be a partner from 2001 until being named attorney general by President Obama). Baker was asked about other candidates. There had been several, he said, who first struck the committee as "more in the line of succession of the Smithsonian." Barber Conable, a former New York congressman and president of the World Bank, told of interviewing eminent scholars and university presidents, and not expecting to select anybody from beyond academe. Also on the search committee were Anne d'Harnoncourt, director of the Philadelphia Museum of Art, and Hanna Holburn Gray, president emeritus at the University of Chicago, and Conable said that he imagined the pick would be someone like them.

Baker added that the committee had made a call "almost impossible to describe in words." But there had been a sense among some of the regents that it was time for somebody with "financial savvy and managerial panache," and Conable's final word was, "It's hard to imagine a better person to lead the Smithsonian into the next millennium than Larry Small."[19]

Since the 1950s, Smithsonian secretaries had all been cut from the same mold: very tall, well turned-out gentlemen with great presence. Now, Washington journalists who profiled Small saw "a well-to-do-Ivy Leaguer" (Larry Van Dyne in *Washingtonian*) and "a linebacker-sized man with rimless glasses and a hard-working salesman's smile" (Bob Thompson in the *Post*).[20] At fifty-nine, he could have been mistaken for a maturing movie star—think Nick Nolte, likewise born in 1941. Small was often said to have been in business, and that is how he spoke of himself, "thirty-five years in business." But his career had actually been in banking and finance, not what people usually have in mind as "business." Because it entails management, perhaps? "One of the best managers in America," said one of the regents. And what clinched the deal with the search committee were "the extraordinary responses we got when we consulted with people who have worked with Larry."[21]

At this point, an impertinent reporter might have asked whether any of the regents had ever read Philip Zweig's 1995 book about Walter Wriston and Citibank, where Small had worked for twenty-seven years. There had once been talk of Small as successor to Citibank chairman John Shepherd Reed, who had himself succeeded Wriston, the financial wizard who saved New York City from bankruptcy in the 1970s. But Zweig's *Wriston* was full of unflattering references to Small, concluding with the stunning tale of how Reed "began to have nagging doubts about what he called 'Small's world,' the institutional and corporate business [that was] a goodly chunk of Citicorp." He was risk-averse, "yet he produced a lot of risks." Wriston thought Reed should have fired Small, but what he did instead was demote him from an imperial vice presidency with 38,000 employees reporting to him, to an office with just "one secretary." A stunning tale and a stunning explanation from Reed: "When you're paying guys $1 million a year you assume they know what the fuck [they're] doing."[22]

His prospects somehow intact, Small got a call "out of the blue" and departed Citibank for a position as president and chief operating officer of the Federal National Mortgage Association, Fannie Mae, the quasi-governmental agency that was the nation's largest investor in home mortgages. According to *The Torch*, Small "played a key role in fulfilling the company's mission of expanding affordable home ownership for

millions of low-, moderate- and middle-income Americans ... including committing to finance $1 trillion in targeted lending to families of modest means."[23] Now, after eight years at Fannie Mae and with $4.2 million in compensation for his final year, Small had been named to a position that paid less than a tenth as much, but—it seems worth repeating—is often considered to be the nation's minister of culture. Its most tangible presence was the world's largest museum complex. On that morning in the Sculpture Garden, with Larry Small standing there with his friend Wesley Williams, looking like a million bucks, it would have been hard to imagine what was to come during the next few years: the opening of dramatic "immersive" exhibits and two glorious new museums, yes, but these would be occasions interspersed with, and largely overshadowed by, scandal and even tragedy.

Small had spent a lifetime in finance, but did that make him "a stranger to the cultural world"? Not at all, according to a Smithsonian publicist. He was "an accomplished guitarist, collector of art from Brazilian rain-forest cultures, and a longtime member of numerous boards of cultural organizations." There was his Brown University degree in Spanish literature and his devotion to Flamenco, the Andalusian genre of song and dance. There were the Amazonian artifacts that he collected. But it was too much of a stretch to claim that Small's background was anything like that of his predecessors, any of them, even Heyman, chief clerk to the chief justice, chancellor of a great university, and the Interior Department's deputy assistant secretary for policy. The way Small would approach his duties— that, too, was different. In the 1990s the source of controversy had been exhibits called "countercultural." A decade on, with the exhibits sedated, the source was going to be the secretary himself, his management style, his priorities, and ultimately his ethics. A remark by NMAH's veteran curator of graphic arts, Helena Wright, the heir to Jacob Kainen and Peter Marzio, was quoted widely and with great delight: "It's 'Network,' it's Peter Finch, it's 'We're mad as hell and we're not going to take it anymore.'" As it turned out, Wright and her colleagues, and the public, were going to have to take it for seven years.

IN WRISTON, PHILIP ZWEIG CALLED SMALL "a Jewish kid from the Bronx who could have passed for WASP," this to the embarrassment of "unwitting associates" who might say something disparaging about "them." Small remarked that as a young man he "was oriented to the exotic side of life," and as Citibank was expanding worldwide in the 1960s, he sought a post in Chile because he wanted "to see naked Indians."[24] By the time he moved into the Smithsonian Castle in 2000, though, he was a determined "process man" with little empathy for the sometimes meandering ways of scientists and scholars, the sort of men and women who filled the Smithsonian's curatorial ranks. Small soon showed that he "view[ed] the life of the mind with astonishing indifference"—so said Milo Beach, formerly of the Freer and Sackler Galleries. Beach was one of a half-dozen museum directors who resigned within months after Small became secretary, having come to understand why he was best remembered by Citibank associates for his "authoritarian style and low tolerance for dissent."[25]

The *Washington Post*, which had rarely printed anything good about Robert Adams, the "establishment radical" who marched the Smithsonian into the culture wars, would never have anything good to say about Larry Small, not after a very brief honeymoon with the usual gush: "He collects guitars, Lionel trains and art from the Third World; he also speaks several languages and carves time out for long bike rides around metropolitan Washington."[26] The regents ignored dissatisfaction with the secretary even as bureau directors were resigning, one after another, and "Dump Small" stickers were appearing on bumpers and briefcases of curators never before known as excitable. But Small could play well in the anti-intellectual ambience of the early George W. Bush years. In a column criticizing the *New York Times*'s Maureen Dowd for siding with Small's critics, Morton Kondracke suggested that Small was being sniped at not because the Smithsonian was not in need of an overhaul but "because he lacks a Ph.D."[27] Senator Thad Cochran, a regent, expressed delight that Small was giving a comeuppance to "so-called scholars" (one can only imagine what Cochran thought of an expression like "the life of the mind"), and Small made it clear from the start that he intended to treat bureau directors, no matter their scholarly

or scientific standing, as middle managers with little or no leeway to set priorities about much of anything, certainly not the Smithsonian's most public face, the exhibits.

This presumption was tied to grander ambitions. Before he retired in 2011 at age seventy, Small promised, he would find the wherewithal to catch up with nearly $2 billion in deferred maintenance and to renovate the institution through and through. But that was not his grandest ambition. For that, he invoked a phrase trendy elsewhere but foreign to the Smithsonian to say that he would identify and promote centers of excellence—just a handful—while allowing whole programs, whole disciplines, to "die out." This was no evil design of Small's alone: in 2000, the Smithsonian Council had advised that "certain museum research functions will have to be streamlined, consolidated, or eliminated." Nor was there anything wrongheaded about Small's plan to transform entire museums and make the new exhibits so appealing to patriotic sentiment that there would "always be lines waiting to get in." The prime candidate would be American History; Small had already promised this to Behring, in return for Behring's pledge of $80 million, this in addition to the $20 million for Natural History. But first, Small wanted to take care of what the press called some top-down change.

"Barely three weeks into his tenure," a long article in the *Post* began, Small announced a reorganization aimed at "bringing together those components of the Smithsonian that have natural connections and common priorities": Science; Finance and Administration; Business Ventures; Art and International Collections; and American Museums and National Programs. Heading Smithsonian Business Ventures (SBV) was Gary Beer, who had actually been brought in by Heyman from the Sundance Institute in Colorado and charged with expanding "commercial revenue streams."[28] Far and away the most notable of Small's picks for his top-level staff was the new undersecretary for American museums and national programs, Sheila Burke, executive dean of the Kennedy School of Government at Harvard and before that the legendary alter ego for Robert Dole, twenty-seven years in the Senate and 1996 Republican presidential candidate. Small knew Burke because they were both on the board of the Chubb Group of Insurance Companies (the Smithsonian bought insurance from

Chubb, and here was a glaring conflict of interest to which not all the regents were privy). In a position once the domain of the fastidious, almost otherworldly Charles Blitzer, political insider Burke was as striking an anomaly as was bottom-liner Small himself in an office occupied not long before by S. Dillon Ripley, but Small would rely heavily on Burke from the start and in 2004 promote her to CEO, a term never before heard in Smithsonian precincts.

The first bureau director to learn firsthand about Small's "low tolerance for dissent" was Michael Robinson, who for sixteen years had headed the National Zoological Park, 175 acres of woodland along Rock Creek landscaped by Frederick Law Olmsted.[29] For two decades, the Giant Pandas acquired after President Nixon's visit to China in 1972 had ranked with the Hope Diamond and the moon rocks as prime Smithsonian exhibits. But Ling-Ling died in 1992 and Hsing-Hsing had to be euthanized in November 1999, just before Small took office—and now Small said he was being asked repeatedly "whether there will there ever be Pandas again." Without consulting Robinson, he arranged with the China Wildlife Conservation Association for two replacements, Mei Xiang and Tian Tian. The price was $18 million, roughly divided between $8 million from Fujifilm (which got its name on a new panda enclosure and also a monopoly on the sale of film in all Smithsonian gift shops); $5 million from Discovery Communications (which got rights for behind-the-scenes filming for "Animal Planet"); and the rest from Federal Express, Marriott International (Small was on the Marriott board too) and the Chubb Corporation, and Roger Sant, co-founder of the vast AES Corporation, a global energy supplier. Sant was a regent and, as chair of the executive committee, he would later become Small's last defender as he sank amid revelations of "multiple spending abuses" and be forced to commission the independent review that brought Small down.

The new pandas would be welcome visitors (they were only a loan) to almost everyone except Robinson, who believed that the money could have been better spent on a physical plant in dire need of rehabilitation. After broadcasting his displeasure—even telling Small that there would be new pandas "over my dead body," according to zoo lore—Robinson was dismissed.

Then, Small returned his attention to the Museum of American History. Before Behring signed his pledge for eight $10 million annual installments, he had extracted many commitments from Small and Sheila Burke. His name carved in stone at both entrances, yes, but Behring said that "what was most important was what people experienced inside the halls."[30] When he toured NMAH with Small, Burke, and Spencer Crew, and was shown through featured attractions—*Field to Factory*, *A More Perfect Union*, and *Science in American Life*, as well as *American Encounters*, about the relations of Native Americans, Hispanics, and Anglos in the Upper Rio Grande Valley—what a displeased Behring saw was "a multiculture museum." Worse than that, "It just showed the things we did wrong, not the things we've done right," not "what made this the greatest country in the history of the world." What he wanted and needed to see was "everything taken out and really do an *American* history museum."[31]

This remark did not pack the wallop the Manhattan Institute's Heather MacDonald had dealt in her "Revisionist Lust"—"an America characterized by rigid class barriers, ever-growing economic inequality, predatory capitalists, and oppressed minorities"—but it would have sent a shudder through any other secretary, and surely it did with Crew, who was justly proud of *Field to Factory*, his own exhibit. But not Small, who noticed that the exhibits they had toured spotlighted perfectly ordinary people—a merchant seaman!—while telling very little about heroic generals and statesmen. Small was said to be as "mystified and annoyed" as Behring was, and he might have reached back for a remark of Roger Kennedy's about celebrating "large figures and large symbols." What was a Museum of American History without "the leading actors?"[32]

As a start toward "an *American* history museum," Small told Behring of a planned exhibit called *The American Presidency: A Glorious Burden*, and he told Crew to assemble a team and make it happen. When Crew responded that this would entail a great deal of research and take three or four years, Small answered that his timeframe was absurd and the research was a matter of "looking in the encyclopedia."[33] The exhibit was to be ready before the presidential inauguration in January 2001, about eight months off. To the surprise of many old hands, in that short time Crew's team actually produced a 7,000-square-foot exhibit crowded with nine

hundred objects and a rich complement of videos and interactives. Even if academic reviewers found it wanting in "intellectual depth," the exhibit received plaudits in the *Post*, which in recent years had habitually found fault with everything about the Smithsonian.[34] The rush sent costs beyond $14 million, but Small had found the money, from Cisco Systems and Chevy Chase Bank, from the History Channel, and nearly half the total from Behring. Part of the quid pro quo were the huge red banners that went up on the outside of the building, proclaiming thanks. The History Channel was happy with the exclusive rights. Behring was happy because the exhibit was one he'd want his grandchildren to see.[35]

Behring might have been even happier had he witnessed a scene I myself witnessed a few years later. I was sitting on a bench in a main corridor, taking notes. A few feet away was a marble bust. A young girl walking past with an older man paused and asked, "Who's that, grandpa?" The man didn't know but stepped closer to read the inscribed name and said, "Why, that's Kenneth E. Behring." Improvising, he added, "He's the guy who made this place."

■

BEHRING WAS NOW ROUTINELY IDENTIFIED as "a California philanthropist" who was funding a transformation of the Museum of American History.[36] Next up would be a show on the role of the military "in defending freedom and democracy" and then another "honoring individuals who made great contributions to our country and who epitomize 'the American spirit.'"[37] But with the cost of exhibits stretching way beyond $100 per square foot, even $80 million would only begin to pay for new exhibits throughout the museum, so Behring ventured into fundraising himself. Small was never as successful at this as he was expected to be or would later claim to have been, and, off the record, people who worked with him said they were surprised that his Rolodex wasn't bigger and there was so much reliance on "cold calling and form letters." He was not very adept at delicate negotiations, either. Said one donor, "Larry pitches too hard and too fast."[38] Still, after two years he could claim $200 million in hand or at least pledged, the largest single promise besides Behring's being $38 million from a woman

toward whom Behring had steered him. This was Catherine Reynolds, who had made a fortune as large as Behring's, hers from financing student loans. She liked to recall how she was told by Rev. John Whalen, one-time rector of Catholic University, "Honey, if you can figure out how to do well and do good at the same time, you have won the game of life." Reynolds had done well, and in 2000, at age forty-three, she established a foundation. Now, she said, it was time to do good.[39]

Of the $38 million promised to the museum, $26 million was slated for an exhibit to be called "The Spirit of America," Behring's idea, and the rest to endow an award for "achievement"—Catherine's husband Wayne was the founder of the American Academy of Achievement, which annually picked a slate of living Americans and honored them with something called the Golden Plate. Fifty years before, Wilcomb Washburn had created a Hall of Historic Americans, and John Ewers congratulated him on his "penetrating analysis" and his skill in creating a "meaningful, exciting series of dignified exhibits."[40] But the planned Hall of Achievers? Very few curators could see anything dignified about that.

Reynolds hit the news just as opposition to Small's "streamlining" was turning into unveiled hostility. Small seemed unruffled, appearing on CBS News Sunday Morning, playing his guitar and showing Rita Braver his Amazonian masks and model trains and then waving from the cab of a big steam locomotive with railroad curator Bill Withuhn at the throttle. But Storrs Olson, a senior ornithologist at the Museum of Natural History, had told a Virginia congressman, "In the short 15 months since [Small] assumed office he has become surely the most reviled and detested administrator in the Institution's history."[41] The congressman was Frank Wolf, and Wolf's district took in Front Royal, site of the National Zoo's Conservation and Research Center (CRC), a 3,150-acre breeding farm devoted to biodiversity. On April 4, 2001, Lucy Spelman, Small's newly appointed zoo director announced that the CRC was slated for elimination as part of a "redistribution of resources."[42] Likewise doomed was the Center for Materials Research in Suitland, Maryland, founded in 1963 as the Conservation Analytical Laboratory, which specialized in fragile painted artifacts made of wood and paper. So was Karen Loveland's Smithsonian Productions, the film unit founded by Ripley with the encouragement of Charles Eames.[43] And

so was one of Ripley's proudest initiatives, the program of postdoctoral and predoctoral fellowships that brought in scores of visitors every year.[44]

But it was Front Royal about which people were most passionate. Joseph Henry's aim of fostering a scientific institution had actually stood the test of time. At the beginning of the twenty-first century, the Smithsonian employed more than four hundred scientists. Many were engaged in collections-based taxonomy, worthy but far from any cutting edge. Still, their capacity to enlist support was like a mirror image of what happened when NASM's *Enola Gay* plans became public. Environmentalists and scientists nationwide spoke up, and then politicians with serious heft, such as Virginia senator John Warner and Congressman Wolf, in his eleventh term, who called the CRC a "crown jewel."[45] It may not have quite been that, but the center did survive, perhaps because Wolf was a senior member of the House Appropriations Committee, with control over the Smithsonian budget (shades of the "zeroing out" threat posed in 1995). So did the Center for Materials Research, after Maryland's senators got language into the appropriations bill to protect it, as Wolf had done with Front Royal. Suitland also got a big boost after September 11 when the Smithsonian started getting pleas from New York for help in restoring damaged artwork.

In the midst of all this, there was Catherine Reynolds and her Hall of Achievers. A few days after Small fell under siege because of the announced closings, there was a party, paid for by Reynolds and hosted by the secretary. The *Washington Post*'s Bob Thompson portrayed its ambiance in his article "History for $ale":

> On May 9, 2001, Catherine Reynolds gave a luncheon party to announce a $38 million gift to the Smithsonian from the charitable foundation that bears her name. In attendance in the dining room at the Smithsonian Castle were U.S. Senators, Supreme Court Justices, Nobel Prize winners and a bevy of other notables including Coretta Scott King, skater Dorothy Hammill, actress Olivia de Havilland, and AOL/Time Warner Chairman Steve Case. The U.S. Fife and Drum Corps played a fanfare. Patti Austin sang "God Bless America." Reynolds got a standing ovation.

These were people who had been inducted into Wayne Reynolds's Academy of Achievement, or soon would be (Small among them), which was

going to bear a close relation to the new Smithsonian exhibit "The Spirit of America." With all planning, Reynolds told reporters, she expected "a hands-on role."

■

DONALD KENNEDY, THE STANFORD PRESIDENT who got snared in a financial scandal in the 1990s, had recently remarked that "there is nothing new about donors wanting to be players; universities confront this all the time." So did the Smithsonian. DuPont had prescribed exactly where *A Material World* would be located; Jerome Lemelson had prescribed a program aiming to make science and invention "exciting to young people"; Behring had demanded a "real *American* history museum." But no donor had ever boasted so openly about being a "player." Said Reynolds, "You just don't write a check and go away." As most of the curators saw it, Small and Burke had "given away the store for some sort of cheesy hall of fame." Then word got out that Reynolds had been handed authority to nominate ten of the fifteen members of the selection committee. This was news to everyone in the museum, right up to the director.

After twenty years, after working his way up to the director's office from a departmental assistant on soft money, Spencer Crew resigned. He was going to the Underground Railroad Freedom Center in Cincinnati, still on the drawing board. "I am not running away," he insisted. "I am running to something ... a once-in-a-lifetime opportunity."[46] Reminded of "all the departures" of bureau directors, a Small publicist said that these were "for a variety of reasons and do not represent a pattern of dissatisfaction."[47] But dissatisfaction was palpable at meetings of the Smithsonian Congress of Scholars, which comprised nearly everyone engaged in research. "Before this," an old hand remarked, "you could not have gotten a half-dozen [curators] to agree on anything important." Now, a "letter of concern" was drafted and addressed to the regents. The gist was that Small and Burke had "obligated the Museum to relationships with private individuals that breach established standards of museum practice and professional ethics." Out of thirty-six curators, only two told Helena Wright, the museum's representative to the Congress of Scholars, to "include me out." One of

them, Withuhn, claimed to have received a threatening phone call in the middle of the night. Nothing like this happened to the other one, Steve Lubar, who saw a "donor education opportunity," a chance to enlighten Reynolds on "established standards of museum practice." A series of meetings followed, sometimes with a Disney Imagineering veteran as facilitator, sometimes with the participation of distinguished academics, who did not always feel the same way as the aggrieved curators did. One told of having had "a wonderful time in 1991 defending the Smithsonian's 'The West as America' exhibit against its overwrought right-wing critics," but now, ten years later, she "found considerable common ground with Cathy and Wayne Reynolds," and she was disappointed that the press cast the conflict in "tired old terms . . . left over from the culture wars."[48] Nevertheless, five months after the gift was announced, Catherine Reynolds was still incensed by the attitude of the curators, as was her husband Wayne. Bob Thompson quoted Wayne thus:

> Well, they've certainly done such a wonderful job of exhibiting all those light bulbs and drag racers and ceramic pots. And that for the first time maybe in the history of the museum they might actually have something that they'll have lines of people waiting to see to inspire their kids to be great, to have input and make a difference in America. I think it just frustrates those curators and "scholars"—I use scholars in quotes because I don't know what their credentials are—who for thirty years have been collecting movie posters and coins and ceramic pots. That there's somebody who comes in there who really doesn't have the emphasis on collecting things but on inspiring kids, it freaks them out.

Lubar made a brave try at "donor education," but the curators were indeed freaked out, and accommodation was impossible. In February 2002, Catherine and Wayne walked away. What could never be resolved, said Catherine, was their own desire to show "the power of the individual to make a difference," while their curatorial adversaries (in a veiled allusion to their leftist propensities, imaginary for the most part) could think only in terms of "movements and institutions." Small expressed regret at a failure of "admirable intentions," but in the end, as with his attempt to close the research centers, he had lost a highly charged dispute quite meekly. There

seemed to be reason to question not only his priorities but also his capacity for leadership, as had happened when he worked elsewhere.[49]

■

MORE QUESTIONS WERE SOON TO COME. The previous summer, news had broken of an investigation by the U.S. Fish and Wildlife Service. In keeping with his South American enthusiasm, Small had acquired a thousand "Amazonian artifacts"—baskets, necklaces, capes, headdresses, masks, spears, arrows—which were displayed in a "private gallery" where he sometimes arranged fundraising dinners. At issue were charges that more than two hundred of the artifacts were decorated with "plumage from rare or endangered birds." Small's collection had been pictured in *Smithsonian* and in *Architectural Digest* along with the story of how he and his wife, Sandra, bought artifacts "on trips to remote villages in north central Brazil in the 1980s." This was not in accord with the story from Small's own lawyers, who said that everything came from an anthropologist in North Carolina, who was paid $400,000 after she showed that she had "the proper permits." The federal investigation hung fire until January 2004, when the U.S. attorney in Raleigh filed charges, and Small pled guilty to a violation of the Migratory Bird Treaty Act of 1918, one of the first federal environmental laws.

For "a class B misdemeanor," Small was sentenced to two years probation and a hundred hours of community service, but the Justice Department would not accede to his idea for community service. Small wanted to "read up on the old law with the aim of modernizing it." While that might conceivably have been useful, his remark about this being better "than having me read for the blind or hammer nails for Habitat for Humanity" did not endear him with the authorities or, when it got around, with anyone else.[50] This was the *secretary of the Smithsonian Institution*, where ethical conduct was a given and where ornithology was still an honored specialty. While in high school, the new director of the Natural History Museum, Christián Samper, had assisted "a team of scientists conducting an inventory of bird species native to the cloud forests of Colombia."[51] Even if

there had been no misdemeanor, there certainly was a question about the propriety of Small having "his own private museum of Amazonian bird feather art in a D.C. apartment."[52] The question now was how Small could keep his job. The answer was simple: his fate was solely in the hands of the Board of Regents, and among the regents, there were some of Small's closest friends, Roger Sant and Wesley Williams. Also, there was Small's executive assistant, James Hobbins, who had been the liaison between the regents and four successive secretaries. For decades, everyone had trusted Jim Hobbins implicitly, and now everyone agreed about "the feather issue"—that it "has not impaired, is not impairing, and will not hereafter impair" Small's ability to run the institution.[53]

Actually, Small *had* lost his ability to run the institution, but for more than two years there was no scandal, no tragedy, that could "impair" his ability to hang on, and there were plenty of both. There were deaths at the zoo: a Masai giraffe, a pigmy hippo, a lion, and two zebras that, so the charges read, "were not fed enough to survive cold weather." There was the deal to rent the Spencer F. Baird Auditorium in the Natural History Museum for the premiere of *The Privileged Planet: The Search for Purpose in the Universe*, a film from the Discovery Institute, dedicated to "intelligent design." Even as visitation fell 40 percent after September 11 and it seemed obvious that all possible sources of revenue needed to be tapped (the Baird Auditorium rental fee was $16,000), Small took a beating every time a new commercial venture was announced—fast-food franchises in the cafeterias or a torrent of made-in-China trinkets in the gift shops. At one point, an internal document was leaked indicating that naming rights for nearly every single piece of Smithsonian real estate was for sale, even the most sacred, and this was confirmed when Samuel P. Langley's name was erased from the IMAX theater in the Air and Space Museum in favor of the name of a $10 million donor.

On behalf of the Congress of Scholars, Helena Wright attested to the damaging effects of the commercial branding of public space, yet Small survived. Sometimes he even flourished. There was one major exhibit or museum opening after another, with the secretary always at center stage, looking tanned, hearty, and happy, and reaping marvelous publicity. But he

was rarely seen apart from these openings, and gradually it became evident that he was gone much of the time, as was Sheila Burke. They were not on Smithsonian premises; they were not even in the city. The ranking minority member of the Senate Finance Committee, Iowa's Charles Grassley, had a nose for this sort of thing, and it looked to him like nobody was paying attention. Or maybe the problem was worse.

The end was foretold in the spring of 2006 when news broke of a fiscal scandal at Fannie Mae back in the 1990s that involved Small.[54] Grassley thought this would merit an audit of executive compensation at Small's Smithsonian, and what better place to start than its often-suspect Smithsonian Business Ventures. The proper official to conduct such an audit, as with any governmental agency, was called the inspector general. The Smithsonian's inspector general, Deborah Ritt, was new on the job but sufficiently concerned by what she found at Business Ventures to ask for an audit of all Castle officialdom. Then she got a call from Small, who told her that her office "was being manipulated by a few disgruntled employees." Or so she said. Small denied that there was any such call. But a few weeks later Ritt resigned, and A. Sprightly Ryan, her former general counsel, took her place on an interim basis. Reminded by Grassley of proper procedure, Ryan promised to send her findings not to Small but to the Board of Regents.

Early in 2007, Ryan reported to an audit committee newly established by Roger Sant, Small's loyal friend and defender. The audit showed that Business Ventures had actually made more money back in 1999 than it did in 2006 (by which time the institution had completely recovered from the post–September 11 slump in visitation and launched many new initiatives aimed at improving the bottom line). The conclusion? "Small's pursuit of profit has largely failed."[55] But *private* profit, that was something else. Small was slated to receive more than *$900,000* in 2007. This was nearly three times what he had been paid when he started, and some regents were aware that Dillon Ripley never made more than $100,000 annually. The issue of compensation did not seem important to Sant, who was under the mistaken impression that Small "had raised more than $1 billion in private donations." But what did get Sant's attention were questions about Small's expenses, always potentially dangerous because they can signal ethical transgressions. It would be well, he thought, to go over a few provisions

in Small's 1999 employment agreement, which Hobbins had negotiated without any input from the regents.

On January 24, 2007, Sant suggested to Hobbins and the Smithsonian's general counsel, John Huerta, the desirability of revising Small's employment agreement in order "to gain clarity." There was, for example, a stipulation about first-class air travel, which Small always interpreted as including accommodations and miscellaneous expenses pertaining to travel. Sant told Small that he thought Grassley might believe this was stretching a point, and Hobbins and Huerta told Small they agreed. But in replying Small bared his "authoritarian style and low tolerance for dissent," bared this for all to see, as it turned out. "I'm not willing to discuss giving up one iota of what the Institution agreed to provide before I came to work," he wrote. "Nobody can expect that the Secretary should modify 7 years of practice to conform to some new interpretation." Here, too, was that penchant for secrecy. Small added that he did "not want any of my comments passed along to Roger [Sant] . . . until we are completely comfortable."[56]

There would be no comfort. Small did not succeed in keeping Sant, or anybody else, in the dark. As a bemused Smithsonian staffer put it, an email was about as private as skywriting. In February, the *Post* began publishing a series of articles on Small's financial affairs even as Grassley was preparing a report on "an 'anything goes' culture by the Smithsonian secretary and his staff." He was also about to request a freeze on the $17 million increase in the institution's appropriation. Sant continued to defend Small, insisting that anything in Ryan's report was "far outweighed by his performance as Secretary." But Small was now facing *three* separate hearings on Capitol Hill, Grassley's freeze was pending, and Sant knew there had to be an official investigation. To look into "issues raised by the news reports and by Senator Grassley," Sant contacted Charles A. Bowsher, who had been comptroller general of the United States (head of the General Accounting Office) for fifteen years, from 1981 to 1996. When Small heard that Bowsher had consented to head an independent review committee, he knew, in a phrase, that the jig was up. On March 26, 2007, he sent a letter to Chief Justice John G. Roberts, chancellor of the regents, saying, "I really see no compelling reason for me to continue to lead the Smithsonian."

For once, the regents gathered their wits and quickly named an acting

secretary. It was Christián Samper, director of the Museum of Natural History. Samper was born in Costa Rica in 1966 and grew up in Colombia, soon getting on a very fast track indeed. He studied biology at the Universidad de los Andes in Bogotá; he took a Harvard doctorate in botany; he headed Colombia's delegation to the United Nations Convention on Biological Diversity; he became deputy director of the Smithsonian Tropical Research Institute in Panama; and then he became director of a major Smithsonian museum at age thirty-seven. One of his first moves as acting secretary was to reaffirm scholarship as a top priority of the institution, and to redirect funds to the fellowship program. He also put himself in the running for the secretary's job, but he was *so* young. The job went instead to someone exactly Small's age, born in 1941, G. Wayne Clough.[57] Clough was president of the Georgia Institute of Technology, and his academic and administrative distinction was matched by fundraising successes about which there was no dispute. Two capital campaigns there had yielded nearly $1.5 billion. For the Smithsonian history-of-technology contingent, still substantial, Clough was an especially happy choice. At Georgia Tech, he had been instrumental in establishing both the School of History, Technology, and Society and the Melvin Kranzberg Chair.

Sheila Burke had made it known that she wanted to be secretary, but she had no chance when faced with charges similar to those that brought Small down. (Between them, Small and Burke had taken 950 days of leave in seven years.) Gary Beer, CEO of Smithsonian Business Ventures, resigned amid evidence of multiple spending abuses, including 160 unauthorized trips in limousines. "I don't do yellow cabs," he was reported to have remarked. Said Senator Grassley, Beer "must have thought he was living in the emerald city when he paid the Oz and Oz Town Car Corporation . . . to provide him a gold-plated ride."[58] Beer's resignation was followed shortly by that of Hobbins, who had overseen every aspect of Small's tenure, and once assessed him as "perfectly suited to the times in which he served." Hobbins had destroyed the transcript from a meeting of the Board of Regents in which Small's compensation was discussed.[59]

With Small gone, the report from the Independent Review Committee seemed almost anticlimactic. There were multiple abuses, but one in par-

ticular stood out, the "blank expense authorization" from Hobbins, who also facilitated measures to isolate the inspector general and the general counsel and to prevent the regents "from having any meaningful oversight of the Secretary's office."[60]

■

HOW COULD IT HAPPEN THAT A MAN whose "attitude and disposition [were] ill suited to public service" was chosen to lead the Smithsonian Institution? In the boom times of the late 1990s, there was the general admiration for high-level business expertise and the notion that a businessperson might be inclined to stay out of trouble. As it turned out, there were troubles nobody could have imagined. In hindsight it seemed clear that the regents left everything up to insiders who had been co-opted by the secretary. They met only three times a year and then only briefly. Their nominal leader was often absent. Everything was secret. All the systemic failures had been outlined as early as the summer of 2001 in an article in the *Washington Times*. Paul Forman was quoted as saying that the regents were "thoroughly insulated from information about the real life inside the institution." "However well intentioned," he added, they were "terribly ignorant."[61]

The secrecy? "It is policy," said General Consul Huerta; besides, there was not enough room for outsiders to attend the meetings. The regents traditionally met in a room 25 by 36 feet but could have arranged to meet anywhere, even in an auditorium. As with Stanley Goldberg when he was barred from talking about the *Enola Gay* at the Museum of American History's weekly colloquium, "not enough room" seemed to be the refuge of scoundrels. But scoundrels, truly? The word perhaps befit Small, at least at the end of his tenure when he was overtaken by greed, and perhaps it fit one or two others in the Castle, but not Sant and his fellow regents. Eventually, Sant did enlist the Independent Review Board and insist that its report be taken seriously: "We have identified problems and are learning from our mistakes," he said. If the whole sad tale has a hero, it would be Senator Grassley, a Washington insider not universally admired. But it was Grassley who alone took note of Small's "circumvention of gener-

ally accepted accounting rules to meet earning targets in order to increase bonuses for top executives" at Fannie Mae. He sensed that this past infraction did not bode well for "the type of leadership needed to protect the nation's treasures at the Smithsonian."[62]

Berkley W. Duck III concludes *Twilight at Conner Prairie*, his book about a struggle for control of a small history museum in Indiana, on an optimistic note, writing that in the wake of "mismanagement and accounting scandals in the for-profit sector," governing boards "now conduct their operations in a more disciplined fashion . . . requiring attendance at meetings, permitting delegation of authority only within prescribed limits."[63] Are *all* governing boards more disciplined? Is the elite Board of Regents responsible for conduct at the highest levels of the Smithsonian more disciplined? Senator Dianne Feinstein, as chair of the Senate Committee on Rules and Administration, instructed the regents to "step up to the plate and ensure more vigorous oversight and accountability." Time will tell if they do.[64] At least Roger Sant can feel certain of a positive legacy. A man of enormous personal wealth, Sant endowed a 23,000-square-foot exhibit in Christián Samper's Museum of Natural History, an exhibit that opened in September 2008, a few weeks after Clough moved into the secretary's office. And in 2012, when Kirk Johnson, vice president at the Denver Museum of Science and Nature, succeeded Samper, Johnson's title was Sant Director of the National Museum of Natural History.

Mention of the $15 million Sant Ocean Hall, as dramatic as any exhibit anywhere in the Smithsonian, can serve to put this narrative back on course. The next chapter retraces the early years of the twenty-first century, but this time focusing on spectacular exhibits and addressing modes of storytelling. Had not Small been corrupted by power, he would have been able to look back and take pride in the two largest and costliest exhibits ever staged at American History, *America on the Move* and *The Price of Freedom*, and in the opening of two immense museums, the National Museum of the American Indian and the Air and Space Museum's Steven F. Udvar-Hazy Center (not even to mention the $200 million renovation to the Smithsonian American Art Museum and National Portrait Gallery in the historic Patent Office). Except for *The Price of Freedom*, paid for and overseen by

Behring, Small had little to do with the planning or funding for any of these projects, but they were finished and opened on his watch, and with the news media out in force, he stood on the podium to christen all of them. Credit would have been his to claim, if only . . .

In separating story from non-story,
we wield the most powerful yet
dangerous tool of the narrative form.
—WILLIAM CRONON, 1990

CHAPTER 11 ▪ Timely and Relevant Themes
and Methods of Presentation

Some meetings initiate action; many are just a substitute. But this meeting was about action. On a Friday morning in late June 2001, Spencer Crew welcomed an accomplished group that had been enlisted to address "the most timely and relevant themes and methods of presentation for the Museum of American History in the twenty-first century." The group was gathered in the museum's presidential reception suite. NBC news anchor Tom Brokaw was there. So was Bill Russell, basketball great and now a best-selling author; Charles Townes, co-inventor of the laser and Nobel laureate; Eric Foner, past president of the American Historical Association and the Organization of American Historians; and seventeen others of similar rank and status. It had not been long since Catherine Reynolds and her Hall of Achievers hit the news, leaving the museum staff in high dudgeon. Two curators, two only, were permitted to attend the meeting, but with an understanding that they were not to speak. All they could do was "sit still and listen" (as one of them put it afterward)

while Lawrence Small extolled the donors he had signed up, especially Kenneth Behring—who was there at the meeting and spoke whenever he felt like it. The Blue Ribbon Commission was what the group was called. Small said it was Behring's idea and that Behring was paying the expenses. There was a murmur.

Sheila Burke took it from there. Her pick to head the commission was Richard Darman, chair of the museum's advisory board and an old friend from her years with Senator Dole on Capitol Hill. Darman, a former head of the Office of Management and Budget, was the managing director of the Carlyle Group, one of the top three private equity firms in the world. Regent James Baker, who had been secretary of state while Darman was with OMB, called him "absolutely brilliant at boiling down complex issues to their simplest form." Darman got the job. Even a curator present at that first meeting, having been silenced and scarcely inclined to look back agreeably, would call his performance masterful.

With introductions over, Darman moved the commissioners right into a discussion. Some of the historians veered off on tangents having to do with "master narratives" and "multiple voices," and the most distinguished among them, Columbia's Foner, pushed for exhibits that addressed "conflict, inequality, and dissent." When Burke responded that the Smithsonian management was not averse to dark-side stories but "needed to be sensitive to politics and the press," Darman cut her off.[1] Darman listened respectfully to all the academics, but he was less concerned with exhibit narratives and voices—at least to begin—than with the museum's physical space. The "central core," designed for the pendulum, was "dark and claustrophobic" when it should feel bright, open, and engaging. It cried out for transformation, said Darman.

Spencer Crew's associate director, Ron Becker, warned that this would have to be accomplished in the context of a building needing an overhaul so extensive that it might not be possible to keep the doors open while work was in progress. The heating, ventilating, and air-conditioning systems—installed by a low bidder forty years before—had never worked well, and the fire safety measures required major attention, along with lighting, restrooms, elevators, escalators, and much else. The makeover Darman's group eventually endorsed called for a dramatic atrium and translucent

staircase from the first floor to the second, where the Star-Spangled Banner would be presented as the museum's prime icon—its display, as much as anything, the Smithsonian's penance for sins involving the *Enola Gay*.

When Darman's group first met, funds for restoring the Star-Spangled Banner ("the SSB," it was called) were already assured, from Polo Ralph Lauren, and the job was almost done. But the SSB was to be staged at the heart of an 8,000-square-foot-exhibit, *For Which It Stands*, that would dramatize "the American flag's many layers of meaning in American life." The only contract so far signed for this exhibit was for "concept," not detail design or production. The contractor was Chermayeff & Geismar, the much-honored New York firm responsible for *A Nation of Nations* in the 1970s, one of the more compelling exhibits ever. The ultimate design challenge this time would be to maximize the flag's dramatic impact while minimizing exposure to airborne particles and ultraviolet light, taking precautions that would prevail as if it were the Shroud of Turin. *For Which It Stands* still required scripting and funding. Transforming the "central core," that still required funding, too, about $76 million as it turned out.

But Darman's group defined the needs and opportunities for this transformation in short order—moving right along, per James Baker's promise—and then took off into a discussion of timely and relevant themes and methods for the exhibit halls, themes that would enable the museum "to present, in some reasonable measure, the fullness of American history." It was a resonant phrase, the fullness of American history, and would entail more than one day's thought and discussion; there would be another meeting early in September and great volumes of email, but Darman was able to deliver the commission's report in the spring of 2002. He was right on time, but in the phrase endlessly repeated after September 11, the world had changed. Following the attacks in New York and Washington, there was a precipitous drop in museum visitation. The driveway from Constitution Avenue was now barricaded. Taxicabs could no longer drive up to the front doors. Getting through the doors was a trying experience, much like getting out to the gates in an airport. And within a few weeks Spencer Crew was gone to Cincinnati and a search was under way for a new director. The Reynoldses were gone, too. There would be no Hall of Achievers. In Catherine's view, the museum's "so-called scholars" were lacking in the

wit or wisdom to display anything more uplifting (as her husband Wayne put it) than "light bulbs, drag racers, and ceramic pots." She was wrong; Wayne was wrong. The curators may have had no tolerance for a Hall of Achievers, but some of them were eager to get on with plans for exhibits having timely themes and methods of presentation.

What were "under-represented subjects" that the Blue Ribbon Commission thought needed attention? Only a few of these men and women had ever had any direct engagement with museum exhibits, and the suggestions were not of much help.[2] For academics, stories were told with "words and verbal images," not artifacts, and one of them spoke for the import of doing something on "capital formation, the access to capital, and its relation to the broad middle class." Huh? Let's see the object list for *that* one, curators would have muttered. Overall, however, the commission's report had a constructive effect, not least in its good words for a "staff of professionals who enjoy a high degree of respect among their peers," a rebuke to vain parvenus who had Small's ear. Nor could there be a quarrel with the conclusion that here was "one of the world's great museums," the Smithsonian's number three in terms of visitation, and yet it was deficient in "aesthetic appeal, organizational coherence, and the perception of substantive balance."[3]

One might argue for the virtues of the museum a lot like it already was, not so much incoherent as rich in "not-so-obvious connections," as the NMAH curators put it in a respectful response to the report of the Blue Ribbon Commission and as the *Washington Post*'s art critic put it in deriding the notion "that the 'nation's attic' should become the nation's history class."[4] The report itself took note of a present capability for fostering "cognitive dissonance or mystery among visitors [that] may stimulate questioning and learning." In the far reaches of the third floor, for example, an adventuresome visitor could wander from Money and Medals to Textiles, then Ceramics, then Musical Instruments, and then into Printing and Graphic Arts.[5] When it came to staging exhibits that seemed offbeat or whimsical but might readily stimulate questioning and learning, the staff excelled. At the time, the irrepressible Larry Bird was exploring cultural implications of the paint-by-number fad with a display of work by Ethel Merman, Andy Warhol, and J. Edgar Hoover, among many others.[6]

There was chef Julia Child's kitchen and the wonder of "all its hundreds of utensils and gadgets," just moved to the museum from Cambridge, Massachusetts, and there was the framing for the two-and-a-half-story house taken down in Ipswich in the 1960s and reassembled on the second floor of the museum. It took decades, and Anthony Garvan (whose idea it was originally) had been dead for several years, but this rechristened Ipswich House was finally turned into a provocative exhibit, thanks to funds from the National Association of Realtors, telling of all the families that had lived *Within These Walls* over a span of 250 years.

Paint by Number, Bon Appétit: Julia Child's Kitchen, Within These Walls, and other such exhibits drew appreciative audiences and almost always garnered upbeat publicity—*USA Today* even ran a photo of Secretary Small enjoying himself while "daubing a brush." A potpourri of good stories, yes, but a substantive imbalance throughout the whole museum, that was the charge. What about exhibits that addressed history in its broad outlines? Only one came close, *The Glorious Burden,* on the American presidency.[7] This was the exhibit that Behring prodded Small into insisting the museum produce, with stories covering "the fullness of American history" in a textbook sense, and it was a respectable if not scintillating achievement. When it came to other such comprehensive exhibits, however, Behring would not have warmed to the commission's push for "inclusiveness in the treatment of race, ethnicity, and gender," which sounded just like "a multiculture museum," his bugbear. Nor would he have appreciated a caveat about "undue donor influence," even though he must have expected something of the sort. But no matter: two more exhibits meeting with Behring's full approval were "required in the gift agreement," as the Blue Ribbon Commission's report put it, somewhat ruefully.

With the Hall of Achievers a nonstarter, Behring had been promised an introductory exhibit called *America's Museum, America's Stories.* There was also to be a military history exhibit, *The Price of Freedom.* Both were to feature what press releases called "cutting-edge techniques," and a third exhibit of the same sort, *America on the Move,* was in the works with funding from other sources. Cutting-edge meant "immersive," packed with voices, videos, and computerized interactives. A few years later, when Harold Skramstad wrote of exhibits with "a variety of high-tech and 'high-touch'

media to provide a larger 'vocabulary' to connect museum to visitor," he had in mind exhibits exactly like these.[8] Together, all three would cover some 75,000 square feet, 40 percent of the museum's available exhibit area ("giantism" was a word most critics could not avoid). And all three, but especially *America on the Move*, were to be designed in a way that put artifacts "in period settings that scrupulously re-create their historical context." Or so said Secretary Small in the September 2003 *Smithsonian*. In truth, the period settings—stage sets would be the better term—were the collaborative inventions of curators and designers, chosen from among various possibilities as the best storytelling vehicles, and that is what made the exhibit thoroughly postmodern: here were *apparent realities as social constructs*, like a literal reading of Hayden White's remark that "any historical object can sustain a number of equally plausible descriptions or narratives of its processes."[9]

Take the locomotive from the Southern Railway, the 1401, the first artifact ever installed in the Museum of History and Technology. Since 1964, it had stood in splendid isolation, meant to be appreciated for its power and gleaming presence—green with silver and gold accents—the only supplementary drama being some rather pallid sound effects, a bell, a whistle, escaping steam. In *America on the Move*, the 1401 was shifted a few feet and became part of an "experience." If they read the extensive labels, visitors would understand that they were in the midst of a minidrama. The locomotive was pausing at the station in Spencer, a North Carolina town midway between Atlanta and Washington, D.C. Whether or not they read the labels, they would get to stand just outside the cab, look in, and eavesdrop on a conversation between the engineer and fireman about the need "to hammer to get back on schedule." Next door, in the station, they would hear a salesman who was waiting for a connection tell of his traveling life and an African American school teacher (a mannequin, like the others) sitting on the other side would recount the humiliation of her ejection from a segregated Pullman. The teacher, Charlotte Hawkins Brown, was from "real life," the salesman, Rollo "Tubby" Hutchins, was fictional.

Many other narratives, cast with real or imaginary characters, could have been sustained as apparent realities involving the 1401. There was even a

question about why it could not have just remained in splendid isolation, unimaginably powerful, rather than getting obscured by the detritus of "new-think display theory."[10] It might have been pulling FDR's funeral train, flying the white flags denoting an "extra" and bedecked in black crepe. It might have been in the railway's shops, which were located in this same town, Spencer, with the driving rods off and a grimy mechanic renewing brass bearings. Or it might have been starting its last run, on a branch-line "local" in 1951, before getting consigned to scrap by a modern diesel.

Because the Southern was the first Class 1 railway in the United States to drop the fire in all its steam power, the "diesel revolution" would have been an obvious story to tell in a museum of technology. But attention to stories of race, class, and gender was thought to be more timely and relevant (one can imagine Behring calling the Spencer station scenario "academically faddish"), so there was none of "the dirt, the smells, and the vague aura of danger of a locomotive under steam," a comment by Robert Casey, who reviewed the exhibit for *Technology and Culture*. Casey was the veteran curator of transportation at the Henry Ford Museum, where one might actually experience such an aura of danger in the roundhouse and working locomotive repair shop out in Greenfield Village.[11] With their bows to social context, however, the set pieces chosen for *America on the Move* might be seen as a suitable and well-timed counterpoint to the noncontextualized airplanes at NASM's Udvar-Hazy Center, likewise slated to open in 2003.

■

AS FOR *THE PRICE OF FREEDOM*, IT OPENED A YEAR LATER with set pieces conveying a "triumphalist reading of U.S. military campaigns as a perennial struggle for freedom from tyranny." It happened that the opening was right in the midst of the assault on Fallujah, Operation Phantom Fury, and the timing could not have been worse.[12] Still, there was no doubt at NMAH that military history could provide entrée to a broad sweep of the American past, beginning with the wars of independence. So could the history of transportation, even though *America on the Move*'s narratives commenced later (and of course omitted movement by air, the

province of another Smithsonian museum). But the other exhibit Small had promised to Behring aimed higher, much higher, than *The Price of Freedom* or *America on the Move*. *America's Museum, America's Stories* was to omit nothing, to present "a chronological, biographical, and thematic introduction to American history," to *all of American history*, as well as "an index" to each of the museum's other exhibits. Most of the west end of the second floor had been set aside, with a picture-window view of the Washington Monument and plans for a 360-degree theater, the Behring Theater. Curatorial teams worked long and hard to conceptualize an exhibit "giving visitors the opportunity to discover, celebrate, and reflect on the history they share as Americans," but years after its promised opening, the museum still had no introduction to American history. (Nor did it have all of Behring's $80 million, even with his name inscribed everywhere on the walls and of course with his bust in a main corridor.)

The project had shades of Tony Garvan's grandly envisioned *Growth of the United States* in the 1960s. How *could* a museum exhibit address "all of American history"? Naturally there would be artifacts to exemplify "ideals that have shaped the nation," democracy, freedom, opportunity. But there was more to American history than that. Democratic ideals could be fragile and freedom a sham, as Roger Kennedy and Tom Crouch had shown in *A More Perfect Union*. Economic opportunity could be elusive, and old-timers were put in mind of Charles Blitzer's remark about the museum's responsibility "to show the seamier side of life" and the plan to acquire and exhibit a "slum dwelling." If a slum dwelling, why not a brothel, abattoir, a privy? Why not a hanging or a lynching? Lynching in mind, what about slavery?[13]

Any plan to exhibit a history "that Americans share," would be forced to choose among "vantage points" and separate story from nonstory, most likely avoiding the dark side. There would be countless temptations to cut corners on historical authenticity, especially with Disney Imagineers now in the wings as advisors. When the Museum of History and Technology opened in 1964, at the heart of most exhibits were "the collections," just as before in Arts and Industries. But what was there in the collections to illustrate conflict, inequality, dissent? Graphics, props, and audiovisuals could help, but to many curators the ready-made solution was more lati-

tude with scripts, room for analysis as well as description, and this would make for contention with designers, not to mention harried editors trying to uphold guidelines about the length and complexity of labels. "Books on the wall"—at worst they diverted attention from artifacts meriting contemplation; at best they were largely ignored. Curators sometimes felt that designers deliberately made labels hard to see and read.

The upshot of this dilemma was increasing reliance on cutaway rooms and backdrops to establish context at a glance. At first there might actually be historic structures, transplanted from elsewhere (the house from Ipswich and the old post office from West Virginia, for example, and the plan for *GOUS* was to go right out and get a slum dwelling slated for demolition). Or at least they should be faithful re-creations, as with the rural schoolroom and army bunkhouse in *A Nation of Nations*. But more and more of them were only reasonable facsimiles, and some not even that. The distinction between what was truly historic and what was not became blurred and sometimes was denied altogether. This could be a small matter. In *The Price of Freedom*, the same academic critic who remarked on a "triumphalist reading" of American history also noted George Washington's uniform being "half authentic, half replica," an instance of "national heroes [being] retroactively constructed by overlaying the past with material from the present."[14] On a different scale, one among many examples of blurred distinctions in *America on the Move* was the opening vignette, which put the visitor in an exact place and time past—Santa Cruz, California, in 1876—and left the impression of more exactitude to follow suit. To one side was *Jupiter*, a classic "American"-type locomotive of the sort Daniel Boorstin extolled; to the other, a farmland panorama and a sectioned boxcar partly loaded with produce. The story was "the great transformation in agriculture and agricultural distribution that railroads brought to the western U.S."[15] *Jupiter* was indubitably "historic," having come from Philadelphia's Baldwin Locomotive Works in 1876; the boxcar, though meant to be perceived as equally historic, came from a Washington, D.C., woodshop shortly before the show opened.

Except for *Jupiter*, nothing here was "historic," nothing at all. About this "seamless" merging of what was historic and what was not, the Henry Ford's Casey commented:

I was left wondering what difference it would make if the boxcar were real and the *Jupiter* were fake. Would the audience care? Would it affect the larger narrative being spun out? The boxcar, the *Jupiter*, the simulated railroad ties and barrels of spikes that serve as audience barriers all merge so seamlessly that it is equally easy to believe that everything is a prop or that everything is real.

Casey was reminded of an article that Brooke Hindle published while he was director of this same museum: "How Much Is a Piece of the True Cross Worth?" To judge from *America on the Move*, Casey concluded, the answer would be "less than you might think."[16]

"Museum piece" or nothing of the sort? Casey recognized that this might trouble readers of *Technology and Culture*—many of whom were museum professionals—but that ordinary museum "goers" would be unlikely to care at all. These would be men and women, boys and girls, who expected to be entertained and perhaps educated, but educated about history, not postmodern exhibitry. And there was another question that might not be of much general interest but would certainly concern the watchdogs of the media. In neighboring Washington realms, it would be called "influence peddling." *The Price of Freedom* could be seen to embody the ideology of Kenneth Behring insofar as it cast a "protective umbrella" over *all* American military engagements, including wars "to set the physical boundaries of the nation" (as Lawrence Small put it) and the wars started by President George W. Bush, when even chief curator David Allison conceded that "not all American wars are about freedom."[17]

And how about situations suggestive of a quid pro quo, as in *America on the Move*? In times past, sponsors had rarely interfered with exhibit content, and even the public acknowledgement of sponsorship was usually inconspicuous. It took serious detective work to find an attribution to DuPont in *A Material World*, and not until 1993 did a permanent exhibit carry the name of a sponsoring firm, the *O. Orkin Insect Zoo* at the Museum of Natural History.[18] The insect zoo cost a few hundred thousand dollars, a pittance, but in the 1990s the cost of major installations started approaching the cost of entire museums not so long before. *America on the Move*, with its companion, *On the Water*, was planned for nearly all

the space on the east end of NMAH's first floor, with some two dozen elaborate set pieces. This would be, said curator Bill Withuhn, "the most important public education project ever on the history of transportation in the U.S."[19] Big talk, but there was one thing for certain: it was to top all records for cost. In 1997, the U.S. Department of Transportation gave the museum $3 million, not to fund an exhibit but to provide "seed money" that would enable recruiting staff, enlisting advisors, and contracting for a conceptual design to serve as a "sales tool" for raising another $21 million.

It worked. There were million dollar donations from each of six trade associations, $3 million from the State Farm Companies Foundations and another $3 million from the History Channel. And then the big one, $10 million from General Motors, and word soon got around of the exhibit being subtitled *The General Motors Hall of Transportation*. Even though Small's role in all this was not apparent, there was no corporate villain quite like General Motors, and Ralph Nader's Commercial Alert charged Small with bringing the Smithsonian "to the brink of turning itself into a government-funded Hall of Hucksters." "There should be a congressional investigation," wrote Nader, "in order to determine how to disentangle this storied Washington institution from the tentacles of corporate commercialism." Katherine Ott, head of the NMAH branch of the Congress of Scholars, decried the "commercial branding of public space," and Pete Daniel asked, "Will there be an upside-down Corvair?" TomPaine.com resuscitated the tale of General Motors "deliberately destroying clean, efficient and popular public transit," and the *Post*'s ever-alert Bob Thompson wondered why anyone would be surprised that the exhibit ignored "environmental issues, dependence on foreign oil, or how American automakers—with an assist from big-car-loving Americans—figured out how to avoid fuel economy standards by repackaging cars as SUVs."[20]

The museum's new director, Brent Glass, wrote to the *Post* in protest, and a General Motors vice president denied influencing the exhibit's content in any way whatsoever, or even seeking a public relations coup.[21] And yes, at first the sign with the General Motors subtitle was obscure and dimly lit. But later, a very large sign appeared that upstaged all other signage while designating nearly all of the east end of the first floor as General Motors territory. The upstaging surely made a difference to other

firms that donated millions, especially to the newer maritime exhibit, but it probably mattered not at all to the average visitor. *America on the Move* was a spectacular success, with noisy throngs every day, even with an off-season opening in November 2003. History of Technology Department chair Steve Lubar said he was not at all surprised, explaining, "You've got a lot going for you with transportation artifacts . . . people just love this stuff."[22] There was a wide array of vintage motor vehicles, from a California hot rod from the 1950s to a prewar Indiana school bus.[23] There were two locomotives (three, counting the *John Bull,* not far from the entrance). There was a car from the Chicago elevated (the "L") that provided a memorable immersive experience—riders talking to one another as the car moved along—only one among many. Still, when it came to artifacts that fascinated people, American History always struggled to compete with its own offshoot, Air and Space (which usually drew about twice as many visitors, year in and year out), and NMAH would have had a much harder time competing with NASM's Udvar-Hazy Center had it not been twenty-eight miles out of town.

At the Udvar-Hazy, there would be scarcely a hint of "new think display theory," no immersive experiences, no scrims, no supergraphics, no props, no need. Except for discrete videos on small screens, artifacts would be exhibited in the same mode as they were exhibited in A&I before even a whiff of modernization, the assumption being that they were intrinsically interesting and, because they were, "design" was as superfluous as extensive labeling. The Udvar-Hazy was a place where you could get close enough to the *Enola Gay* to see your own reflection, and since 2012 visitors have been able to step to within a few feet of the Space Shuttle *Discovery* and almost touch the blackened heat-shield tiles. (The low-altitude flight of *Discovery* into Dulles in the spring was a "happening" for the ages.) Just as *America on the Move* epitomized postmodernist contextualism, the Udvar-Hazy epitomized artifact-centered neo-traditionalism—the two styles, it seems safe to predict, that will define Smithsonian exhibitry for a long time to come.

SECRETARY LAWRENCE SMALL, HAVING KEPT A HIGH PROFILE during his first two years in office, became virtually invisible after his downsizing plan collapsed and Catherine Reynolds took her money elsewhere. He was seen in public mainly in conjunction with a remarkable succession of openings that took place in 2003 and 2004. The one on the Mall that made the most news was the opening of the National Museum of the American Indian in September 2004, less than a year after the openings of *America on the Move*, the Steven F. Udvar-Hazy Center, and the Kenneth E. Behring Hall of Mammals in the Museum of Natural History and shortly before another Behring exhibit, *The Price of Freedom*, opened in American History. When a TV highlight clip showed Small marching in a colorful procession on the Mall along with 25,000 Native Americans, he was incorrectly identified as museum director Richard West, a Southern Cheyenne; it was as if people had forgotten what Small looked like. Still, it was an exciting time for the Smithsonian, and all those special events did give Small a series of opportunities to stand tall, flash his great smile, and hold forth with the press out in force, still sounding like a man in command.

One after another they came: exhibits so elaborately conceived they could have been museums of their own, and two magnificent new buildings, one on the Mall just across Seventh Street from Air and Space, the other administratively linked to Air and Space but situated in open country near Washington Dulles International Airport, in the Chantilly area of Fairfax County. It was a matter of opinion which of the two new museums was the most spectacular, but the Udvar-Hazy got a great rush of publicity because the opening date was so perfect: December 17, 2003, exactly a hundred years after one of the most memorable dates in American history, the event long denoted as "Kitty Hawk" and now called "the powered flight centennial," the day the Wright *Flyer* flew.

At NASM, Donald Engen, vice admiral retired, had succeeded the disgraced Martin Harwit. Like Harwit, Engen had spent a term as a visiting fellow before becoming director, during which time he wrote an engaging memoir, published in 1997 as *Wings and Warriors: My Life as a Naval Aviator*. In 1998, he closed NASM's *Enola Gay* exhibit, none too soon from

several perspectives, not least the airplane's state of dismantlement—for it was never truly "the *Enola Gay*" on display but only a part of the fuselage, along with one engine and odds and ends.[24] All the rest lay in pieces at Silver Hill, like Humpty Dumpty. Now, its reconstruction was going to require a supreme effort, tens of thousands of man-hours, to enable its fully intact display at the Udvar-Hazy Center on that 2003 centennial.

Transfer of the 176-acre site for a NASM "annex" had been approved in 1986 by the Federal Aviation Administration, headed at the time by Donald Engen himself. In the summer of 1998 Engen kicked off a capital campaign for NASM along with Heyman, but in the summer of 1999 he lost his life in a glider accident near Lake Tahoe. Engen had been a test pilot, so it was both tragic and ironic. But his death did impart momentum to the fundraising effort, and the buzz by 2003 was welcome respite for Small, who was getting lambasted for "turn[ing] the Smithsonian into a GM billboard," *Commercial Alert's* take on *America on the Move*. One imagines a rare mood of elation in the Castle when the opening of the new facility in Chantilly hit the headlines. "A visual, spatial, and architectural thrill," proclaimed the *Post's* architectural critic, Benjamin Forgey. "Let the romance begin!"[25]

"A colossal structure for a spectacular collection," said Peter Jakab, the curator for *The Wright Brothers and the Invention of the Aerial Age*, NASM's new exhibit of the *Flyer*. The Udvar-Hazy Center, nearly 1,000 feet long and ten stories high, with an IMAX theater and a soaring observation tower named in memory of Engen, was surely "a testament to aviation's power to move the imagination and the checkbook."[26] As a boy in Budapest, its benefactor had thought about airplanes as "the sudden spirit of freedom . . . the only way to reach into a bigger world, a world representing his future."[27] After coming to the United States, Steven F. Udvar-Hazy founded an aircraft-leasing firm that would make him wealthy enough to donate $65 million to get the center up and running. Other checkbooks had opened, too, and Jakab (who proudly shared Hungarian origins with Udvar-Hazy) expressed confidence that still others would soon cover the total cost, more than $300 million, and enable the display of twice as many aircraft as the eighty on display at the center when it opened.

Indeed, this is what happened, twice as many, although eighty was awfully impressive. The *Enola Gay* was situated off to the left of the entrance, where the first thing a visitor encountered was a SR-71 Blackbird, "the fastest, highest flying operational jet-powered aircraft ever built." Even though rendered obsolete by reconnaissance satellites, it "still looks like the aviation future that small boys dream of"—or so said the *Post*'s Ken Ringle, who called the *Enola Gay* "a coldly beautiful technological marvel" and whose affection for the Udvar-Hazy "fantasy factory" and for John R. "Jack" Dailey, Engen's successor as NASM director, matched the contempt he had often expressed for Harwit, for Tom Crouch and Michael Neufeld, and for Robert Adams.[28]

Udvar-Hazy press kits referred to the mode of display as "enhanced open storage." But it was not like the open storage that had once prevailed in A&I, with fine silverware interspersed with "old black machines." This was a museum with treasures galore, and they needed very little "enhancement." On that score, it could not have differed more from *America on the Move*. Janet Davidson, a curator who helped devise many of *America on the Move*'s most lively set pieces, said, "We wanted to buck the notion that you're in a museum." Part of the reason for this quite remarkable confession, unstated, was that there were not many artifacts packed with their own drama. (A great green steam locomotive of a sort most people had never seen was one thing, but the green city bus nearby was just everyday life.) At the Udvar-Hazy, dramatic artifacts were everywhere, and the only thematic touch was the lightest imaginable, a few topical groupings. The Blackbird was the focal point of "The Cold War," which was between "Korea and Vietnam Wars" and "World War II," which in turn faced "Commercial Aviation."

Because of this, the *Enola Gay* was at one end of a long row of warplanes that began with a McDonnell Phantom, a Grumann Intruder, and a prototype Lockheed-Martin Joint Strike Fighter but was also nose-to-nose with another Boeing plane, the Dash-80, the prototype of the 707 jetliner.[29] The juxtaposition seemed bizarre, but Secretary Small skipped lightly, writing in *Smithsonian* that this was the place where "two eras meet, each with a legacy of momentous consequence."[30] As with all the other aircraft, both the B-29 and the 707 were accompanied by plaques with a checklist of

specifications and a paragraph or two of narrative. The *Enola Gay*'s said nothing about human agency or what happened at ground zero, or even about American customs for naming warplanes:

Boeing B-29 Superfortress *Enola Gay*

Boeing's B-29 Superfortress was the most sophisticated propeller-driven bomber of World War II, and the first bomber to house its crew in pressurized compartments. Although designed to fight in the European theater, the B-29 found its niche on the other side of the globe. In the Pacific, B-29s delivered a variety of aerial weapons: conventional bombs, incendiary bombs, mines, and two nuclear weapons.

On August 6, 1945, this Martin-built B-29-45-MO dropped the first atomic weapon used in combat on Hiroshima, Japan. Three days later, *Bockscar* (on display at the U.S. Air Force Museum near Dayton, Ohio) dropped a second atomic bomb on Nagasaki, Japan. *Enola Gay* flew as the advance weather reconnaissance aircraft that day. A third B-29, *The Great Artiste*, flew as an observation aircraft on both missions.

—*Transferred from the U.S. Air Force*

This spare text was followed by the specs: wingspan, length, weight, speed, horsepower, ordnance, armaments ("'Little Boy' atomic bomb" only), then the size of the crew (twelve men) and manufacturer (Martin Co., Omaha, Neb., 1945), and finally a mysterious unexplained number: A19500100000.

A handout for the press preview and the opening claimed, "This type of label is precisely the same kind used for the other airplanes and spacecraft in the museum. Its intent is to tell visitors what the object is and the basic facts concerning its history. Over the twenty-seven years of its existence, the museum has carefully followed an approach which offers accurate descriptive data, allowing visitors to evaluate what they encounter in the context of their own points of view." NASM could have done better. With some of its artifacts, there had been no single "approach" over the years, nothing of the sort. Like NMAH, if much more modestly, different distinctions between story and nonstory had expressed "alternate versions of reality"—as when curator David DeVorkin revised the labeling with

the German V-2, which formerly had been identified merely as "the first operational rocket" and addressed the technology of booster phases, not the death and destruction when the rocket descended. With the *Enola Gay* at the Udvar-Hazy, it was remarkable how unhelpful—how *unfactual*—the label was, even on its own terms. Why did it find its niche in an unexpected theater of war? Of what tactical import were the speed and power? The range? The pressurized compartments for the crew? Why no defensive weaponry? How did it happen that a Boeing plane came from a different manufacturer in Omaha? How many B-29s were there, anyway, and how much did they cost?

Here you had a museum label that might have been deliberately designed to show that information is not knowledge, and Jack Dailey had little more reason to believe he had met a delicate explanatory challenge than Martin Harwit did.[31] When he was director of the Deutsches Museum, Otto Mayr decided that visitors did not read exhibit labels because "they don't have time, and the exhibit environment makes reading hard."[32] This was surely true of any popular Smithsonian exhibit, so crowded, so noisy, where simply *being there* (and taking pictures) seemed to be the goal of most visitors and only a handful made any effort to read any of the hard-wrought prose. With the *Enola Gay*, however, a reporter from the West Coast noted that NASM's "unwillingness to court argument leaves it to visitors to fill in the blanks."[33] Nobody could spend any time in the vicinity of the *Enola Gay* without realizing that people *did* want to know more, often quite a bit more, and—unless they happened to be with a forthcoming docent—they did not know how to fill in the blanks.

■

AT THE PRESS PREVIEW, THE UDVAR-HAZY CENTER was teeming with eminences and celebrities like actor John Travolta and aerobatics champ Patty Wagstaff, and with genuine heroes such as John Glenn and Neil Armstrong. And there was General Paul Tibbets, who piloted the Hiroshima mission. Mr. Udvar-Hazy spoke only briefly, as did Chief Justice William Rehnquist as chancellor of the Smithsonian Institution. It was the chairman of the Board of Regents, Vice President Dick Cheney, who gave the keynote,

calling the center "a monument to the great achievements of flight and to the even greater possibilities of the future." Judging from the bulk of editorial opinion, there was scant understanding of a petition endorsed by E. L. Doctorow and Barry Commoner (along with dozens of academics) declaring that the display of the *Enola Gay* reflected "extraordinary callousness." After an elderly man from Ohio threw a red liquid resembling blood on the fuselage (and was arrested for what might have been construed as an act of terrorism), a large sheet of acrylic went up to protect against a repeat, and Dailey was asked about "the lack of information on the number of victims." "To be accurate, fair, and balanced," he said, "inclusion of casualty figures would require an overview of all casualties associated with the conflict, which would not be practical in this exhibit."[34]

Dailey rarely seemed evasive, but this had the flavor of a well-rehearsed talking point; even Secretary Heyman's minimally scripted 1995 exhibit at NASM had made vague reference to "many tens of thousands of deaths." But nobody pressed Dailey further. Here, after all, was a man who had spent thirty-six years as a Marine aviator, flew hundreds of missions in Vietnam, and retired as a four-star general. He commanded respect, as did his assessment of the plane as "a magnificent technological achievement." News reports almost always included a remark about the *Enola Gay* display having an "apolitical" or "objective" tone, and because of its location nose to nose with the 707—a very familiar airplane—it might be taken as such, with visitors getting little sense of its unique historical burden. Accounts in the news lumped it willy-nilly with artifacts significant in entirely different ways. "The *Enola Gay* . . . the *Concorde* . . . and various rockets, missiles, satellites, fighters and jetliners," ran an AP story. "*Concorde*, Boeing 707, spy plane, *Enola Gay*," was the lead in the *Chicago Tribune*.[35]

Edward Hallett Carr wrote in *What Is History*, "The facts speak only when the historian calls on them: it is he who decides to which facts to give the floor, and in what order or context." Here in the *Enola Gay* was an agent of destruction that was central to the biggest news story of the twentieth century, and yet it was accompanied by a text making only passing mention of that story, or any other. Nor was there anything like an enhanced exhibit "vocabulary" of the sort that amplified *America on the Move*. Back in 1994 the men from the Air Force Association charged that

Martin Harwit was dead wrong in constructing a plot that included a look at ground zero and addressed the question of using the bomb in the first place. Others were sure that it was dead wrong to omit ground zero, or to omit that question, but a document signed by Congressman Sam Johnson called the *Enola Gay*'s mission "one of the most morally unambiguous events of the 20th century." So what *was* the story? An exhibit like *America on the Move* was premised on the assumption of history's "malleability," the assumption that "two or more stories can be told about the same set of events" (or the same artifacts) and that the museum's job was to select the most timely and relevant. And, if that was the case for the *Jupiter* or the 1401, or the V-2 for that matter, why not the *Enola Gay*? The perils of fiftieth anniversaries were past, "the greatest generation" almost gone, weapons of mass destruction timely and relevant.

■

BY ONE ACCOUNT, THE SMITHSONIAN WAS INVOLVED in thirty-six exhibit controversies between 1984 and 1998.[36] Whenever these involved history, people often talked past one another about the *nature* of history. Historians take the word *history* to mean different things: what happened in the past, the evidence of what happened, the way in which narratives are constructed and reconstructed—or, rather, *revised* in light of new questions or new information. But a perception of revisionism as the distortion or denial of the one *correct* story—that was not fostered solely by men like Sam Johnson and Newt Gingrich. In 1994, a few days after Harwit was sent packing, the Senate Committee on Rules and Administration convened hearings on "future management practices" for the Smithsonian. The committee was under the chairmanship of Ted Stevens, the Alaska Republican who had first threatened the Smithsonian budget when alerted to *The West as America*'s "perversity" by Daniel Boorstin. (He never saw the exhibit himself.) Stevens was at once a veteran of the Pacific theater in World War II and a Senate veteran by virtue of the federal largesse he had funneled into his state. He also had a reputation as "a grouch and a bully," well deserved.[37] After he had Representative Johnson read a statement about the national museum's fundamental duty to teach "what is good

about America," Stevens asked why taxpayers should be expected to support work on exhibits that contradicted "commonly accepted viewpoints" about what really happened.

With witnesses from academe and from the Smithsonian, even with Secretary Heyman, Stevens made little effort to mask his disrespect. But this was not so with California Democrat Dianne Feinstein, who tried to be considerate of the scholars who had been flayed by Stevens and by others on the committee such as Wendell Ford of Kentucky, the Democratic whip. It was soon obvious, however, that Feinstein was starting from nearly the same premises as Stevens, Johnson, and Ford. Was it, she asked, the role of the Smithsonian "to interpret history"? What had happened since the days when she majored in history at Stanford and what she learned from her textbook "was essentially a recitation of fact, leaving the reader to draw their own analysis?" Feinstein was referring specifically to her courses with the professor she remembered best, Thomas A. Bailey—a powerful academic presence in the 1950s—and she might have been shocked to learn that Bailey's narratives could be anything but a "recitation of fact." Evidence abounds. About the origins of World War I, in the 1940 edition of his textbook one reads about the pressure on Congress from "interested financial and industrial groups." In the 1946 edition, there is a denial of any such pressure and an assertion that the United States went to war solely "because she was attacked." Peter Novick recounts how Bailey once told a publisher that his manuscript, *America Faces Russia*, had great sales potential because the army could use it "for indoctrination purposes."[38]

The irony of Feinstein's reference to Bailey probably escaped everyone on Capitol Hill, maybe even Speaker Gingrich with his Tulane doctorate in history. But what *had* happened? Gingrich and the other lawmakers all would have agreed with Heather MacDonald that the Smithsonian had been transformed by a "new museology . . . a wholesale embrace of the worst elements of academic culture."[39] And there was no denying a disparity between how the historical enterprise was conceptualized by most historians and by most everyone else, not just denizens of right-wing think tanks like MacDonald. New questions arising with the passage of time and changing contexts? New concerns about what was timely and relevant? Informed choices between story and nonstory?

Revisionism? The term was equated, at very best, with poor judgment or bad manners—Nancy Kassebaum's Senate resolution of September 1994 called the planned NASM exhibit "offensive." At worst it was seen as deliberate and mendacious "disregard for truth."[40] Congressman Johnson remarked, "We want the Smithsonian to reflect real America and not something that a historian dreamed up." ("Real America" sounded a lot like Kenneth Behring would sound a few years later.) Revisionism put some people in mind of the fanciful films of Oliver Stone and Mel Gibson. And there would be President George W. Bush, branding as revisionist the reports about the absence of weapons of mass destruction in Iraq—revisionism simply as a term of Newspeak opprobrium.

The authors of a book on history in transport museums write, "The most important thing is to make visitors aware of the provisional nature of all knowledge of the past, and to help them to develop the confidence and the skills needed to come to their own conclusions based, at least in part, on what historical scholarship has to offer."[41] *The provisional nature of all knowledge of the past.* Hear MIT's John Dower: "It is a daunting task to try and convey to the public the idea that critical inquiry and responsible revision remain the lifeblood of every serious intellectual enterprise."[42] Yet people understand that they do not always see the past, including their own past, in the same terms they once did. Things that once seemed important no longer do, and vice versa. They revise. People also take a dim view of the term "official history," especially in places where it seems most tenacious; Japan is often taken to task. At one point during the hearings, Senator Ford warned that "the Smithsonian must understand that, as an institution supported with Federal funds, it is ultimately accountable to the American public, whose lives and history its exhibits reflect." Accountable to the American public, yes, in some way. But responsible, as Richard Kohn puts it, "for negotiat[ing] content with groups outside the museum with political agendas and no claim to scholarly knowledge, museum expertise, or a balanced perspective"?[43] That is a problem.

After 1994, the *Enola Gay* became the Smithsonian's most famous artifact, outrivaling even the ruby slippers and Kermit the Frog. Like the 1401, it is likely to remain in exactly the same place for many decades. But one can speculate about how long it will be sustained by such an attenuated

narrative. Time and again, the Smithsonian Council called for exhibits with a "non-celebratory attitude," and even after the council's dissolution by Small, those calls echo. It is worth repeating that Senator Barry Goldwater, NASM's patron saint, once said that he did not want the *Enola Gay* exhibited *at all*. During budget hearings on Capitol Hill in July 1970—just weeks after the last U.S. troops had been withdrawn from Cambodia—a congressman remarked that he would be offended by the airplane's display, and Goldwater concurred: "What we are interested in here are the truly historic aircraft. I wouldn't consider the one that dropped the bomb on Japan as belonging in that category."[44] A few years later, Michal McMahon asked, "Why *not* the *Enola Gay*?" and his question resonated with a Smithsonian secretary, Adams, and the NASM director he hired, Harwit.

America on the Move and the Udvar-Hazy Center are archetypes. The former presents its major artifacts in an elaborately constructed ambience purporting to mirror reality; one can stand in the Spencer Station, perhaps read some of the labels, and then take it in like a stage play, with sound and light and drama and *contrivance*. The latter contrives not at all, reducing the information to technological factoids that eschew explanation. Will it be better, if sometime in the future, the display of the *Enola Gay* takes on a few characteristics of *America on the Move*, in which an actual story is told, maybe even the story of what happened at ground zero? And, though not so pressing a need, parts of *America on the Move* might also have different stories, maybe even the 1401 in the Spencer back shop. Here, in a museum whose collections are strong in technology and whose staff is still strong in its history, technology is actually misrepresented. Just as the Udvar-Hazy airplanes are simply there, as if (so to speak) descended from heaven, the conveyances in *America on the Move* simply "begin to appear." Robert Casey was especially taken with an interactive video that intones, "Technology will continue to change transportation, and transportation will continue to change our lives." Shunted aside as nonstory is the question of "why we have the transportation we have."[45]

At the opening ceremony, Secretary of Transportation Norman Minetta said that *America on the Move* told the story of how transportation "has sculpted our lives." The missing story is how transportation systems and conveyances were themselves "sculpted" by the people who had their hands

on the levers, so to speak, of political power. The message the reviewer for the *Baltimore Sun* took away was of "Necessity as the Mother of Invention," a misunderstanding that no historian of technology would ever want to impart, certainly not in the context of transportation technology. The Interstate, the jetliner, these were *political* decisions. When automobiles were invented, when airplanes were invented a few years later, they were invented because they *could be*, and people simply had no conception of their "necessity." It was *necessity* that had to be invented. Steve Lubar, who imparted clarity to so many of NMAH's exhibits about technology in history, said that he believed "the focus on impact works better in a museum," and that may be true. But Smithsonian museums have been a vehicle for so many kinds of stories, and there are other stories yet to be told.

Those who control the past control the future and those who control the present control the past.

—GEORGE ORWELL, *1984*

EPILOGUE ▪ What *Is* the Story?

When the doors opened in 2004, it was apparent that the National Museum of the American Indian (NMAI) was different from any other museum on the Mall—not a history museum, not an art museum, though with attributes of both. But it did share something important with its neighbor just to the west, the National Air and Space Museum, and with NASM's Chantilly annex, the Udvar-Hazy Center. The *Washington Post*'s Bob Thompson, who had written about the Smithsonian so tellingly in the recent past, again got right to the point. Each museum was "beholden to a particular set of influential 'stakeholders' whose worldview frames its presentations. Each museum, as a result—despite the Smithsonian's historic commitment to the straightforward 'increase and diffusion of knowledge'—is open to the charge that the knowledge it is diffusing may be skewed."[1]

In 1994 NASM stakeholders, including a well-funded aerospace lobby, the Air Force Association, and a veterans organization, the American Legion, had stepped in and made certain that the story told with the

Enola Gay was the story *they* wanted, "and after that, period." Ever since, NASM's exhibits had been "framed" in accord with the "worldview" of its most influential outside constituencies. So it was, too, at NMAI. Director Richard West had a graduate degree in history, as well as a law degree, and he wanted people to know that he respected "anthropological, archaeological and historical approaches to the study of native peoples." But NMAI's foremost obligation, indeed its mission, was to "add the voices of native peoples themselves." Nobody doubted that those voices needed to be heard. From the Smithsonian's inception in the middle of the nineteenth century, Native Americans had been among its primary objects of study, but it treated them as "cultural curiosities," displaying their artifacts (often stolen) as part of "natural history," not "national history." Exhibits of times past, said West, were designed to personify Western civilization (so-called) "and Native Americans were outside of that, and often portrayed as quite subhuman."[2]

Historian Frederick Hoxie, a founding trustee of NMAI, elaborated on its stakeholders: "It's a very different situation," he said, when they are "members of a racial and cultural minority with a very disturbing history and a set of grievances against the United States, rather than being entwined with U.S. aspirations."[3] Having long been "confined to an undefined 'primitive' past" by the Smithsonian, even by well-intentioned ethnologists like John Ewers, Native Americans were entitled to a venue where they could "tell their own stories." But instead of "adding" these stories to the voices of anthropologists, archaeologists, ethnologists, and historians, at NMAI theirs typically became the *whole story*. Because of this, West and his museum were vulnerable to accusations of purveying "old pastoral romance" and providing "too little information." "It is not a matter of whose voice is heard," wrote the *New York Times*'s Edward Rothstein. "It is a matter of detail, qualification, nuance and context. It is a matter of scholarship."[4] The museum's response to Rothstein would have been, in so many words: what would you expect from a man with a doctorate in sociology whose title is "cultural critic at large"? In days past, this same man would have been studying Native Americans as "cultural curiosities."

The Smithsonian secretary who prepared the ground for the Indian Museum was Robert McCormick Adams, the same man who precipitated

the 1994 clash at the Air and Space Museum because he wanted stories that "went deeper" than the museum's stakeholders wanted. By the time the NMAI was completed, Adams was long gone, but he certainly had not lost interest in the Smithsonian. So when Bob Thompson phoned him in San Diego and suggested that the NMAI and NASM collections might be entirely different but that the two museums had much in common because they were "constituency driven"—dominated by stakeholders—"Adams let out a long laugh and said 'I hope you make that point.'"[5]

Because NMAI declined to be treated as a history museum—despite having immensely rich collections—it figures in this book only in passing.[6] With so many stories that *could* have been told in its exhibit halls, its stance may distress audiences wanting "information" conveyed in the way of museums where curators wrote with authority and designers added rich voicings. Still, there was no denying that in times past, Smithsonian exhibits and entire museums had often been framed in ways that now seem distressing. Recall George Brown Goode in the newly opened A&I of the 1880s and his plan for organizing everything around "the requirements or luxuries of man," or J. Elfreth Watkins and his aim of arranging artifacts so as to show a march of technology away from empiricism toward scientific principles, or George Maynard treating man the maker as distinct from man the handicrafter. Or recall the proposed armed forces museum that never got funded because of concerns that the United States would appear "warlike" or the long wait for a museum that could properly showcase the Wright *Flyer*, "the greatest mechanical relic in the world," largely because men in high places were averse to glamorizing such relics. Then, Washington power-brokers conceiving of both the Museum of History and Technology and the Air and Space Museum as weapons in the Cold War or, more recently, a president signing the authorization for the National Museum of African American History and Culture with "a lack of fanfare and no public statement" but doubtless that what he had done would "appeal to black voters."[7]

Recall the contested storylines: Samuel Langley and Orville Wright, Bell and Gray, even the Gillette Trac II and the American Floating Head. Or contests about professional status: *American Banking* and *Science in American Life*. Or the unabashed quid pro quo: the Smithsonian seek-

ing donations from "organizations that have received assistance from the institution" by way of public exposure, including Consolidated Coal and General Motors (this in 1925!). Or exhibits drenched in politics: the Nixon White House seeking to alleviate "the productivity crisis," Kenneth Behring standing with the chairman of the Joint Chiefs of Staff as *The Price of Freedom* opened while the Iraq war raged, or even the Udvar-Hazy keynote being sounded by Vice President Dick Cheney, speaking both in his role as a Smithsonian regent and as the key member of the president's war cabinet. Of course nothing so rocked the Smithsonian as the disputed narratives for the *Enola Gay*, and this was when it first became known that stakeholders with sufficient political power could claim ownership of "what is exhibited and how."[8]

■

FOR THE SMITHSONIAN INSTITUTION, we can understand that disagreements about "what is exhibited and how" are never going to be absent. In 2010, the National Portrait Gallery included a video called "Fire in My Belly" along with *Hide/Seek*, "said to be the country's first national exhibition devoted to gay and lesbian themes." There was a scene with ants and a crucifix, inevitably there was an outcry, and Secretary G. Wayne Clough "pulled" the video quickly—perhaps too quickly, and an outcry turned into a "crossfire."[9] Another crossfire was induced by the way the Museum of Natural History perhaps too quickly dismissed concerns about its relationship with a power-broker as divisive (some would say as dangerous) as David Koch.[10] Not everybody applauded when control of storytelling at the National Museum of the American Indian was openly ceded to its stakeholders or, rather, its most generous stakeholders. And, as I write, a major new Smithsonian presence is materializing. In 2016, thirteen years after its authorization, the National Museum of African American History and Culture (NMAAHC) is slated to open in a $500 million building designed by Tanzanian-born David Adjaye "to evoke the art of an ancient West African kingdom." When the Indian Museum opened in 2004, Rick West did not hesitate to call it "constituency driven," and because NMAAHC constituents are, like West's, members of a minority "with a

very disturbing history and a set of grievances against the United States," one might anticipate the same sort of driving force there.

Are the stories of constituents going to be heard? How could they not be? But the NMAAHC is led by Lonnie Bunch, whose credentials include a long stint at the Museum of American History, as a curator and then as associate director (Bunch was largely responsible for the presidential exhibit, *The Glorious Burden*) and who was named by the American Association of Museums as "one of the 100 most influential museum professionals of the twentieth century." Outsiders are justified in having high expectations for this new museum. Bunch's plans call for devoting one-third of the gallery space to arts and culture, including music and entertainment, and another third to what he calls *community*: sports, military history, and "the power of place"—set pieces such as a cell from Angola, the Louisiana State Penitentiary upon which Stephen King's *The Green Mile* is based, and a segment of Tulsa's Greenwood District, the "Negro Wall Street" that was virtually destroyed during the so-called race riot of 1921. And the other third? History, with the anchor being an exhibit on slavery.

Just as with Native Americans, there is a dark and contested past, but far from marginalizing "outside professionals" in creating the exhibits, as Rick West did, Bunch wants his museum "to reflect the best scholarship on black history, no matter who wrote it." A central role in the initial planning of the slavery exhibit was played by Richard Rabinowitz, an advisor to whom Roger Kennedy listened carefully at NMAH in the 1980s, and the senior curator for history is William S. Pretzer, a learned and forceful scholar who apprenticed at Kennedy's NMAH before spending twenty-one years at the Henry Ford Museum in Michigan. There, he was responsible for acquiring the Rosa Parks bus and raising a nation's consciousness about the civil rights movement's most compelling artifact.

Bunch says, "If my ancestors are smiling" when the museum opens, "I'll know we've done a good job," and he has been counting on the input of Rabinowitz and Pretzer to help make his African American ancestors smile, even though *his* ancestors are not *theirs*. Because of the celebrities bound to converge on NMAAHC and because of its evocation of immensely powerful places, Angola, Greenwood, and several more, this museum has the potential to become a magnet on the Mall with more dramatic pres-

ence than any other, even Air and Space. And if exhibits being previewed at the Museum of American History—such as *Slavery at Jefferson's Monti-cello: Paradox of Liberty*—are any indication, the NMAAHC will serve an educational role more provocative than any other Smithsonian museum: the watchword is "American history seen through the lens of the African American experience."

Surely NMAAHC will stir old controversies about identity politics, as will a newly refurbished Arts and Industries building, as it dawns on ev-eryone that the first museum building on the Mall is also going to be the last one available for occupancy. Beginning in the 1920s, Carl Mitman and Frank Taylor decried their "bootstrap" status in A&I, and the absence of the great Museum of Engineering and Industry they said the nation deserved. Eventually they got it. Now, in a new millennium, a gathering of "academ-ics, technologists, and think-tank executives, calling themselves Makers on the Mall," seeks a place for a museum that honors American ingenuity truly (NMAH, they believe, has become obsessed with "the detritus of popular culture"), and A&I looks perfect. But A&I may also look perfect to Latinos as the site for *their* museum, which will have maximum support because of the growing power of Latinos in national politics.

Identity politics will always be perilous. Where does it end? How to "say no to the next group, and the next group after that?" These words were those of Jesse Helms in 1994, denouncing plans for the African American Museum from the Senate floor, but they could as well have been Daniel Boorstin's from the NMHT director's office in 1969 or the words of a spokesman for Makers on the Mall in 2012: "If whites go to the original museum, African Americans [will] go to the African American Museum, Indians go to the Indian museum, Hispanics go to the Latin American museum . . . this is not *America*."[11]

That final remark evokes Kenneth Behring at his most unenlightened, with his notion of "a real *American* history museum." It also brings us back to a conclusion about the museum where most of the foregoing narrative took place. At the turn of the twenty-first century, American History's Spencer Crew and Ron Becker helped arrange for a show that was like no other in the history of the Smithsonian Institution. It was not an exhibit in any traditional sense; rather, the public was invited to watch

the refurbishment of the tattered 30-by-34-foot expanse of red, white, and blue wool and cotton that the Smithsonian had displayed, one way or another, since 1911: the Star-Spangled Banner. Work took place in an aseptic room visible through a long glass wall. The flag was laid flat, and a movable gantry resembling a truss bridge provided a working surface two inches above. The first task was to remove the 1.7 million stitches holding the flag to a linen backing that was causing its gradual disintegration. This was performance art of the first order. Wearing scrubs and using surgical tweezers and clippers, a team of conservators lying prone cut the stitches away and then decontaminated the flag with non-abrasive cosmetic sponges, realigned it, and sewed on a sheer lightweight backing. It took four years, and between 1998 and 2002 millions of visitors to NMAH were introduced to the techniques of textile preservation through this unique drama. Along with the gantry, *technology* was once again a prime attraction in a museum that once had that compelling word in its name but was now more inclined to spotlight Kermit, the ruby slippers, and the Bunker chairs from *All in the Family* than the inventions of Morse, Edison, and Bell.[12]

As for the Star-Spangled Banner, when *For Which It Stands* finally opened in 2008 after the makeover of the museum's central core, it was arguable whether the flag itself was augmented or diminished by the experience devised by Chermayeff & Geismar: a "darkened hallway, with the sound of rockets and bombs in the background." The hallway was *very* dark, almost like a theme-park funhouse. Before visitors could get inside, anywhere near the flag, however—reclining in its environmentally perfect enclosure—they would encounter the bold presence of a "40-foot by 19-foot abstract architectural representation of a waving flag created from 960 reflective tiles made of polycarbonate material."[13] It was an abstract architectural representation made of, well, plastic, a designer's (very expensive) flight of fancy, not to call it a gimmick. Did it upstage the Star-Spangled Banner? Because the door to the darkened hallway was all but hidden from view, some visitors actually believed that the abstract representation *was* the Star-Spangled Banner exhibit, perhaps the product of "new-think display theory." Even those who did find the original flag might well remember the reflective-polycarbonate-tile flag more vividly than the "real" thing, with the sound effects and the history lessons written on walls.

And what would visitors remember about the new central core of the museum itself, the atrium and translucent staircase that were integral to the Star-Spangled Banner exhibit—the makeover the Blue Ribbon Commission envisioned in place of the "claustrophobic" space where the pendulum swung? Maybe there was no new space anywhere in the Smithsonian—anywhere in Washington—that left one feeling more "hard pressed to tell the difference between museums [or] exhibits in department stores or airports . . . or theme parks."[14] It was bright and bleak at the same time. "They sure ruined that museum when they redid it," wrote an online critic, lamenting "the open space they created when they ripped everything out." No more would families and school groups rendezvous "at the pendulum" as they do "at the elephant" next door. Actually, the pendulum had become a national treasure in its own right. Here was an artifact that provided "a unifying experience across time and generation," the words of David Shayt, steadfast on its behalf till the very end. To objections that it was "not American and not historical," he responded that this was of no import compared to "adults and children watching together as a peg falls, looking across that circle at the people who watched it with you and applauding together."[15] There was no more need to dispense with the pendulum than there was to overshadow the Star-Spangled Banner with an artificial flight of fancy.

In 1952, at the Museum of Natural History, Clifford Evans and Betty Meggers were changing a few things in their exhibit of South American Indian artifacts, and while the display cases were empty they had the insides painted red. It never occurred to them that anyone would object, and they were surprised to get a call from the secretary, Alexander Wetmore, who said he was disturbed by "glaring colors" and advised them to reconsider. They did nothing, and one might imagine this episode as the first inch in a long slippery slope leading to exhibitry in which artifacts were simply one element of design, and then design just a constituent of something fanciful and dramatic but possibly empty of meaning, an abstract architectural representation of a waving flag, say.

A far-fetched scenario? Probably, but consider the publication fifty years after the red-paint episode of a book titled *The Manual of Museum*

Exhibitions. Here, one could read that "the criterion of success" for an exhibit was "whether it has achieved an affective experience, inducing a new attitude or interest, not whether visitors walk away from a museum having learned specific facts or having comprehended the basic principles of a scholarly discipline."[16] This sort of affective experience was *inherent* in an artifact like the Star-Spangled Banner, or the pendulum. Or the Wright *Flyer* or the *Enterprise*. Otherwise, it sometimes helped to impart something experiential to artifacts by means of "a new and special skill," as Harold Skramstad put it. Was this a skill that might supersede the skill of a curatorial contingent determined to impart an understanding of history, however modest this might be? That was one question deserving topmost attention in Smithsonian councils in a new millennium, and another question was whether the curators' understanding was to be accorded due respect if it departed from "commonly accepted viewpoints," commonly accepted by the most influential stakeholders, that is.

■

IN THE PREFACE, I MENTIONED the Museum of Jurassic Technology in California, a place, as Matt Roth puts it, where seemingly factual recitations veer off into "fantasy riffs." Here, one comes upon a complex and elegant scientific instrument atop a pedestal, all polished brass and clearly a "museum piece" but bearing no "factual" message. There is, however, an eyepiece pointed downward through which one is naturally tempted to look. And when one does look there is nothing to be seen, nothing to be learned, no facts or principles, just the floor. One may then perceive that there is no lesson to be learned *about the instrument itself,* but there *is* a lesson. The lesson is about what it means to have put something "on a pedestal" (or posed it against a dramatic backdrop, or designed it in to an "experience"). The lesson, the message, is that "*this* is worthy of attention."

Museum people are often warned about the danger of overestimating how much information people can be expected to absorb while "tramping through vast halls past countless objects," recalling a remark of Eugene Ferguson's when MHT was new. Nowadays, there is less need for people to do

any actual tramping, because exhibits have elaborate websites and because of the rapid advance of a "user-generated world." The authors of an article on navigating this new world write that "the traditional expertise of the history museum seems to be challenged at every turn. Web 2.0 invites ordinary people to become their own archivists, curators, historians, and designers as they organize images on Snapfish, identify artifacts through Flickr, post text on wikis, and create websites with WordPress and Weebly."[17]

Confronting this user-generated world—and confronting a warning from a pollster that Smithsonian name-recognition had slipped slightly and that a quarter of all respondents thought the institution to be "elitist"—Secretary Clough set forth into the world of "branding." The Smithsonian needed a campaign, he decided, "to help us change the way people see us, and to place more emphasis on what we do instead of on what we have." The London-based "brand experience" firm of Wolff Olins was paid more than a million dollars for research leading to a Smithsonian tagline (or strapline, the British expression), a word or phrase upon which an organization aims to stake its identity. In December 2011, Mary Ellen Muckerman, director of research at Wolff Olins, announced that the plan for the Smithsonian would be to call it *Seriously Amazing*.

Over the next few months, insiders reported that Seriously Amazing ran "a gauntlet of high-level, drawn-out reviews," and fared poorly, even in the face of reassurances from the Castle that it was intended only to reach "a particular demographic" of special interest to potential funders. This was "18-to-34," and reaching this group was integral to the planning for a multibillion-dollar capital campaign. In other words, the branding was not about museums and their stories; it was about money—and in September 2012, SeriouslyAmazing.com was given a full-bore launch as "the place to go for answers to our intriguing questions": a colorful question mark was to appear on billboards, in *People* and *Entertainment Weekly*, and via all manner of digital media. There were two problems. First, no serious attempt was made to inform the public at large that Seriously Amazing was not really for everybody, or to tell people who it really *was* for; at one point Secretary Clough defined the audience as "aware moms." Second, the questions about what "comes alive at the Smithsonian" were tailored for

an audience much younger than the target, and even then their "dumbing down" was, well, embarrassing. "How does an astrophysicist bake cookies?" "What was the hot hairstyle of the Founding Fathers?" "How is hip-hop like the microchip?"[18]

The "user-generated world" whose dimensions were outlined in 2011, the Smithsonian tagline launched in 2012—the former is likely to be ephemeral in its particulars, the latter in its totality. "If Harvard or MIT tried something like that," said Art Molella, "they'd never get another penny from the alumni." How seriously did anyone weigh the danger of seeming to trivialize *everything* about the Smithsonian? What could Seriously Amazing possibly mean with reference to *Hide/Seek* or the Hall of Human Origins? Or the Smithsonian's upcoming stories about Angola Penitentiary or Tulsa's Greenwood District? Or about slavery?

Heaven knows, the secretary (and the regents) had made mistakes in recent times, and getting involved with what the *Guardian* calls the "murky voodoo" of branding is of a different order than the mistakes in Lawrence Small's day. If the whole point is fundraising, then one must bear in mind that Secretary Clough had already proved himself masterful at the art at Georgia Tech. Moreover, he was quite aware that "if you try to message something, and you get the message wrong, you're going to harm the reputation of great institutions."[19]

The Smithsonian's "messaging" was breaking news as this book went to press, and one was reminded of a favorite expression of Roger Kennedy's, "the course to beat," by which he meant to remind anyone who complained about something that they ought to have something better in mind. What better, then? "The Nation's Attic" may be timeworn and may be ready for retirement. But is "the Increase and Diffusion of Knowledge"? Or, if not that, asked Ron Becker, how about a tagline based on "a simple and straightforward affirmation of a place with great artifacts and great stories, stories recounted and dramatized by men and women with special sorts of expertise"? That tagline might be "Here's the Story" or "We Tell Stories" or "What's the Story?" And how about taking that empty space where the pendulum once swung and erecting a marquee—maybe even made of high-tech polycarbonate—for the aphorism that appears at the beginning

of this epilogue, a remark by an Englishman who (like James Smithson) never came to America, who never saw the Smithsonian Institution, but certainly would have appreciated the dilemmas it has faced and faces still. The words are worth repeating over and over: "Those who control the past control the future and those who control the present control the past."

NOTES

ABBREVIATIONS

RU Record Unit
SIA Smithsonian Institution Archives, Washington, D.C.

PREFACE

1 On the way down to the Ripley Center, I am always mindful of its namesake
being an ornithologist and also of historian Rosalind Williams's remark about
"the defining characteristic of the subterranean environment [being] the ex-
clusion of nature—of biological diversity, of seasons, of plants, of the sun and
the stars" (*Notes on the Underground: An Essay on Technology, Society, and the
Imagination* [Cambridge, Mass., 1992], 20), but I am struck by its elegance
nonetheless, as I often was by Mr. Ripley himself.

2 The quote is from the preface to the exhibit catalog, *America's Smithsonian:
Celebrating 150 Years* (Washington, D.C., 1996), by the project director, J. Mi-
chael Carrigan. No author is credited for the 233 pages of historical informa-
tion following this preface, presented as if omniscient—this in keeping with
a Smithsonian convention for scripts that accompany exhibits. A label that

began, "Some historians believe . . ." or "On the other hand . . ." would not have been the Smithsonian way. "The average visitor does not enjoy looking at something and then reading that the 'experts' are not too certain about it," a senior Smithsonian curator observed in an after-dinner talk at Colonial Williamsburg.

3 Sandy Cohen, "Collectors Willing to Pay a Lot for a Piece of Hollywood History," *Washington Post*, 22 August 2010. Kermit's photo in the *America's Smithsonian* catalog is a full page, larger than a photo of Einstein. Daniel Boorstin first gained fame from a 1962 book titled *The Image*, in which he argued that a person could be famous for nothing more than being famous (the book was later subtitled *A Guide to Pseudo-Events in America*). "The celebrity is a person who is known for his well-knownness." The same held for an anthropomorphic frog, now perhaps the Smithsonian's best-known artifact. A Smithsonian curator refers to "objects from movies or television shows" as "the most democratic," presumably meaning most interesting to most people because most familiar. Margaret Weitekamp quoted in "Exploring Pop Culture Dimensions of Space Flight," *Washington Post*, 16 November 2010.

4 Ritterbush is quoted from the flyleaf of *Technology as Institutionally Related to Human Values* (Washington, D.C., 1974), and he also expressed a fear that museology would evolve into "a stygian process of concern to a few bottom-dwellers sifting through . . . for their private amusement" (*The Art of Organic Forms* [Washington, D.C., 1968], iv). Blitzer, who had been on the Yale faculty with Ripley, often expressed disdain for technology. Paradoxically, these men were central to one of Ripley's most valuable initiatives; his fellowship program brought promising historians of technology into Smithsonian precincts for many years. Ritterbush (1936–86) was a Rhodes Scholar, Blitzer (1928–99) a Harvard PhD in political science, but their careers had a tragic divergence. Ritterbush left the Smithsonian in 1971 and never had another important institutional tie. Blitzer became head of the National Humanities Center in North Carolina in 1983 and later returned to Washington to head the Woodrow Wilson Center for International Scholars, which he had co-founded in 1971. His *Washington Post* obituary (21 February 1999) called him "a fixture in Washington's unique amalgam of offices dealing with scholarship, public policy and politics." On Ritterbush and the presumption that he died of AIDS, see Thomas J. Schaeper and Kathleen Schaeper, *Cowboys into Gentlemen: Rhodes Scholars, Oxford, and the Creation of an American Elite* (New York, 1998), 269–70.

5 Or so it seemed to Tim Ingold, the reviewer of *Paths of Fire* (Princeton, N.J., 1996) in *Technology and Culture* 40 (1999): 130–32.

6 See, e.g., Peter Blute, "Revisionist History Has Few Defenders," *Technology Review*, August–September 1995, 51–52. Among historians, *revisionism* means

nothing more than asking questions of new information or new questions of old information.

7 Kenneth E. Behring, *Road to Purpose* (Blackhawk, Calif., 2004), 1. Behring acquired his $500 million fortune in various ways, notably from building an expansive gated community in California named Blackhawk.

8 James M. Goode, "The Arts and Industries Building," in Robert C. Post, ed., *1876: A Centennial Exhibition* (Washington, D.C., 1976), 208–13. Publication of *The Joseph Henry Papers* was completed in 2007 after forty years, and when this book went to press, A&I itself was getting a much-needed rehabilitation and was headed for a "re-purposing." It is coveted by groups whose concerns range widely.

9 Lynne Vincent Cheney, "1876, Its Artifacts and Attitudes, Returns to Life at the Smithsonian," *Smithsonian*, May 1976, 36–49. At the time, Cheney's husband, Dick, was President Gerald Ford's chief of staff.

10 In his masterful *Visual Shock: A History of Art Controversies in American Culture* (New York, 2006), 282–84, Michael Kammen tells how the museum "sowed and reaped a political whirlwind by offering a sharply revisionist look" at the doctrine of Manifest Destiny. It is largely because of Kammen's work that I feel comfortable with only passing mention of the many historical controversies involving the Smithsonian's art museums.

11 This was the conclusion reached by Carole Emberton in her review of *The Price of Freedom* for the *Journal of American History* 92 (2005): 163–66.

12 Frank Taylor to James W. Foster, Director, Maryland Historical Society, 17 July 1961, RU 623, Box 8, SIA.

13 One needs to see a file of these letters to appreciate the extent of their demands. "Will you please send me a list of passengers that came on the Mayflower in 1620. Name the boat & list that came on it in 1621 and also name of boat & list of passengers that came in 1623 . . . How many boats came between 1620 & 1700? Where did the boats start from?" (Mrs. J. Z. Spearman to S. B. [*sic*] Ripley, 7 April 1975, RU 276, Box 25, SIA). Such letters would typically come to the secretary, who would forward them to a subordinate with the notation "action." In an article titled "At the Edge of Science: Joseph Henry, 'Visionary Theorizers,' and the Smithsonian" (*Annals of Science* 41 [1984]: 445–61), Arthur Molella explains why and how Joseph Henry initially committed the Smithsonian to "a conscientious response to public inquiries."

14 The Getty Museum, which owns Man Ray's 1940 gelatin silver print of the Pony Express Museum, suggests that "the oddity of this monument to a brief moment in American history," located in the town of Arcadia, appealed to his "appreciation of the absurd." But nowhere at the Museum of Jurassic Technology is there even a hint that anything here should be regarded as absurd. See

Lawrence Weschler, *Mr. Wilson's Cabinet of Wonders: Pronged Ants, Horned Humans, Mice on Toast, and Other Marvels of Jurassic Technology* (New York, 1995), and Matthew W. Roth, "The Museum of Jurassic Technology," *Technology and Culture* 43 (2002): 102–9. For a taste of the museum's approach, see Tina Noel Marrin, ed., *Garden of Eden on Wheels: Selected Collections from Los Angeles Area Mobile Homes and Trailer Parks* (Los Angeles, 1996).

CHAPTER 1. A Chain of Events Linking Past to Present

1 An exception was the Conservation Biology Institute, known until 2010 as the National Zoo's Conservation and Research Center, which was threatened with closing and became the subject of a fierce dispute over the Smithsonian's priorities early in the secretarial regime of Lawrence Small.

2 At the National Museum of Natural History, controversy was inherent in an initial taxonomic scheme that addressed Native Americans as part of "natural" history, linked with wolves and bison rather than generals and politicians. Controversy persists in the Hall of Human Origins, which critics believe reflects the "climate science denial" of David Koch, who financed it and for whom it is named.

3 Mike Wallace, *Mickey Mouse History and Other Essays on American Memory* (Philadelphia, 1996), 262. The Smithsonian's mural was more honest in one regard. Robert Vogel, who was on the scene to watch Jackson at work, recalls that "Blaustein was portrayed just as he looked, 65 years, bald, and wearing rimless glasses, not exactly a prototypical oilfield roughneck!"

4 Heather Ewing, *The Lost World of James Smithson: Science, Revolution, and the Birth of the Smithsonian* (New York, 2007), 304.

5 For an informed address to a significant aspect of this debate, see Dana G. Dalrymple, "The Smithsonian Bequest and Nineteenth-Century Efforts to Increase and Diffuse Agricultural Knowledge in the United States," *Agricultural History Review* 57 (2009): 207–35. A classic analysis of what Smithson meant when he worded his last will and testament as he did is William L. Bird Jr., "A Suggestion Concerning James Smithson's Concept of 'Increase and Diffusion,'" *Technology and Culture* 24 (1983): 246–55. When Robert Adams delivered his invocation speech on the Mall in 1984, standing in front of the statue of Joseph Henry, he quoted from this article. "Larry" Bird has continued to write perceptively about the Smithsonian's history, as noted in later chapters. Heather Ewing calculated that the value of the 105,000 gold sovereigns ("exceeded only slightly" by the endowment of Harvard University) in current dollars would be $10.5 million in terms of purchasing power, a whopping $220 million in terms of per-capita share of the GDP (*Lost World*, 323, 330, 409).

6 The secretary's thoughts on diverse matters may be gleaned from Arthur P. Molella et al., eds., *A Scientist in American Life: Essays and Lectures of Joseph Henry* (Washington, D.C., 1980).

7 Henry to B. A. Gould, 30 January 1877, quoted in Wilcomb E. Washburn, "Joseph Henry's Conception of the Purpose of the Smithsonian Institution," in Whitfield Bell et al., *A Cabinet of Curiosities* (Charlottesville, Va., 1967), 144. Regarding Henry's concerns about how the Smithsonian would come to be defined, Nina Burleigh's *The Stranger and the Statesman* (New York, 2003), a book on the Smithson bequest, has as its subtitle *The Making of the World's Greatest Museum*. Newspaper stories about Secretary Lawrence Small and one of his most shocking transgressions—violating the Endangered Species Act—identified his position as "museum head," and when Small's predecessor, I. Michael Heyman, died in 2011, some of his obituary notices called him the "director of a museum complex."

8 William Stanton, *The Great United States Exploring Expedition of 1838–1842* (Berkeley and Los Angeles, 1975), 359; see also Curtis M. Hinsley Jr., *Savages and Scientists: The Smithsonian Institution and the Development of American Anthropology, 1846–1910* (Washington, D.C., 1981), 74–75. Thomas Coulson's *Joseph Henry: His Life and Work* (Princeton, N.J., 1950) was a workmanlike biography, but not until two hundred years after his birth was a biography published that drew heavily on Henry's papers: Albert E. Moyer's *Joseph Henry: The Rise of an American Scientist* (Washington, D.C., 1997). Moyer concentrates on the earlier period, however, and says little about Henry's feelings regarding a national museum.

9 Nathan Reingold and Mark Rothenberg, "The Exploring Expedition and the Smithsonian Institution," in *Magnificent Voyagers: The U.S. Exploring Expedition, 1838–1842*, ed. Herman J. Viola and Carolyn Margolis (Washington, D.C., 1985), 242–53, quotations on 250 and 252. Henry believed that the ideal "separation" would be for the government to buy the Castle to turn into a museum and that his institution might be enabled to move to "a building better adapted to its operations, and far less expensive in its maintenance" (Smithsonian Institution, *Annual Report, 1876* [Washington, D.C., 1877], 11–12).

10 The Washington City Canal was an "improved" stretch of Tiber Creek, which followed in the direction of what is now Constitution Avenue before turning south toward the Potomac. Serving both as storm drain and sewer, by the 1870s it was "notoriously stinky," and there was every inducement to get the cars unloaded quickly.

11 E. F. Rivinius and E. M. Youssef, *Spencer Baird of the Smithsonian* (Washington, D.C., 1992), 125. On the number and type of freight cars, about which there has always been confusion—some accounts have the total number in the eighties—

see Eugene S. Ferguson, "Technical Museums and International Exhibitions," *Technology and Culture* 6 (1965): 30–46, esp. 40.

12 Robert W. Rydell, *All the World's a Fair: Visions of Empire at American International Expositions, 1876–1916* (Chicago, 1984), 23.

13 James M. Goode, "The Arts and Industries Building," in *1876: A Centennial Exhibition*, ed. Robert C. Post (Washington, D.C., 1976), 206–13; Amy Donovan, "Change Presidents and Waltz," in *Every Four Years: The American Presidency*, ed. Robert C. Post (Washington, D.C., 1980), 142–49. "Columbia Protecting Science and Industry" was the creation of Casper Buberl (1834–99), best known for his 1,200-foot frieze on the Pension Building on F Street NW, since 1980 the National Building Museum.

14 My thanks to Helena Wright for sharing information about Goode's special agents, Barnet Phillips and Thomas Donaldson, as well as a copy of Donaldson's 6 January 1882 list of nearly one hundred items he was to find, wonderfully "broad-gauge and eclectic," as Wright puts it. On the graphic arts collection, see Wright, *Prints at the Smithsonian: The Origins of a National Collection* (Washington, D.C., 2006), and Wright, *The First Smithsonian Collection: The European Engravings of George Perkins Marsh and the Role of Prints in the National Museum* (Washington, D.C., 2015).

15 Steven D. Lavine, "Museum Practices," in *Exhibiting Cultures: The Poetics and Politics of Museum Display*, ed. Ivan Karp and Steven D. Lavine (Washington, D.C., 1990), 152.

16 And, in one of the small miracles that perhaps only the Smithsonian can work, the *John Bull* was still operable in 1981. A fond memory of mine is riding in an ancient railway coach, in a costume from Arena Stage, behind this even more ancient locomotive as it steamed along some disused tracks beside the Chesapeake and Ohio Canal, with curator and good friend Jack White at the throttle. See John H. White Jr., *The John Bull: 150 Years a Locomotive* (Washington, D.C., 1981).

17 Watkins, "Report on the Section on Transportation and Engineering in the U.S. National Museum, 1891," *USNM Report, 1891*, 163, quoted in Linda Eikmeyer Endersby, "Technology Belongs in the National Attic: The Cultural Brokering of Technology and the Fate of 'National' Objects in Museum Collections," paper delivered to the 2003 meeting of the Society for the History of Technology, Atlanta, Ga.

18 Robert C. Post, "From Pillar to Post: The Plight of the Patent Models," *IA: Journal of the Society for Industrial Archeology* 4 (1978): 58–60; "Patent Models: Symbols for an Era," in *American Enterprise: Nineteenth-Century Patent Models*, ed. Robert C. Post (New York, 1984), 8–13. *American Enterprise* is the

catalog for an exhibit I curated at the Cooper-Hewitt in New York, formally the Smithsonian's museum of design but often featuring exhibits that are primarily historical.

19 Matthew W. Roth, "Face Value: Objects of Industry and the Visitor Experience," *Public Historian* 22 (2000): 33–48, quotation on 35.

20 Otis T. Mason, *The Origins of Invention* (London, 1895), 200. Between 1861 and 1884, Mason (1838–1908) taught at Columbian College (now George Washington University). He worked at the National Museum for several years as a part-time "resident collaborator" before Baird appointed him as the Smithsonian's first curator of ethnology, and he would be far from the last person to work into an important position with the institution from a humble start.

21 Arthur P. Molella, "The Museum That Might Have Been: The Smithsonian's National Museum of Engineering and Industry," *Technology and Culture* 32 (1991): 237–63, quotation on 241.

22 Maynard, "History of the Division of Technology," RU 297, Box 7, SIA. Molella writes that Maynard (1838–1918) "introduced the Smithsonian to the modern age of electricity" ("Museum That Might Have Been," 247), and the Division of Electricity would assert a strong presence for another century, latterly under the forty-year curatorship of Bernard S. Finn (b. 1932).

23 Ewing tells how Bell believed that "Smithson's legacy had profoundly altered the direction and development of an entire country" and how he took personal responsibility for retrieving Smithson's coffin and bones from a cemetery in Genoa and bringing them to America, where they were reunited with their Italian marble sarcophagus in a crypt at the entrance to the Castle (*Lost World*, 336–42).

24 Biographical information on Vail is scarce, but there is an outline of his collaboration with Morse on the pioneering telegraph line from Washington to Baltimore in Robert C. Post, *Physics, Patents and Politics: A Biography of Charles Grafton Page* (New York, 1976), 67–68.

25 Russell Douglas Jones, "Engineering History: The Foundation of Industrial Museums in the United States" (PhD diss., Case Western Reserve University, 2001), chap. 1.

26 Tom D. Crouch, *Wings: A History of Aviation from Kites to the Space Age* (New York, 2003), 46.

27 The controversy over the aerodrome is recounted in every recent history of aeronautics but rarely with such relish as in Mark Sullivan's classic narrative, first published in 1927, *Our Times*, vol. 2, *America Finding Herself* (New York, 1971), 557–68.

28 The mistake, the absurdity, of judging "media of the senses" solely on the basis

of "the written word and Xerox copies of photographs," as critics are wont to do, is spotlighted in Martin Harwit, *An Exhibit Denied: Lobbying the History of the* Enola Gay (New York, 1996), esp. 214–15.

29 Of Mitman (1890–1958), Molella wrote in 1991 that he "was the most important figure" among "post–World War I engineer-curators" but also confessed that biographical material "has been difficult to find" ("Museum That Might Have Been," 248). Though significant progress has been made since then by Eric Nystrom, " 'Your Name Would Be Conspicuously Present': Curators, Companies, and the Contents of Exhibits at the Smithsonian," paper delivered to the 2006 annual meeting of the Organization of American Historians, Washington, D.C., information is still sketchy, especially on Mitman's early career as a mining engineer.

30 Michael J. Neufeld and Alex M. Spencer, eds., *Smithsonian National Air and Space Museum: An Autobiography* (Washington, D.C., 2010), 110–12. Having cost only $28,000, the building seemed like a fitting complement to the bottom-dollar A&I.

31 United States National Museum, *Annual Report, 1921,* 141, quoted in Molella, "Museum That Might Have Been," 250.

32 Porter quoted in Molella, "Museum That Might Have Been," 254. Porter (1858–1933) had once been employed by the ironworks that built the Union ironclad *Monitor* and was especially interested in the Swedish inventor John Ericsson.

33 C. D. Walcott to the Members of the Staff, 3 December 1925, RU 297, SIA. The largest of several A&I dioramas represented mining processes "from natural occurrence to finished product" (Nystrom, "Your Name").

34 "Notes on a National Museum of Engineering and Industries," 4 June 1941, RU 297, SIA. Mitman added that the 142,000 artifacts held by his department represented the "largest assemblage of original material on engineering and industrial progress in America."

35 A. Michal McMahon, "The Romance of Technological Progress: A Critical Review of the National Air and Space Museum," *Technology and Culture* 22 (1981): 281–96, quotation on 281. Among learned journals, *T&C* had pioneered with exhibit reviews in the 1960s; McMahon's was one of the most provocative. The *Enola Gay* was in pieces, and there were no current plans to display it. McMahon urged the people at NASM to "begin to ask new questions as they begin to move the museum into a new position that respects history and . . . avoids indoctrination and manipulation." The first question, more fateful than anyone could ever imagine, was "Why *not* the *Enola Gay*?"

1 On the origins of the Smithsonian's maritime collections, see Robert C. Post, "A Corner of the Nation's Attic," *Technology and Culture* 42 (2001): 519–22. Secretary Spencer F. Baird had headed the U.S. Fish Commission, which set up displays at international fisheries expositions, and in 1884 Joseph W. Collins, a veteran of the Gloucester cod fishery, became curator of the Smithsonian's Section of Naval Architecture. In 1936–37, Taylor collaborated with the Works Progress Administration in a project akin to the Historic American Building Survey (HABS) called the Historic American Merchant Marine Survey (HAMMS), to record drawings and information on the design and development of American watercraft.

2 Theodore T. Belote, *Descriptive Catalogue of the Washington Relics in the United States National Museum* (Washington, D.C., 1915).

3 Just as William L. Bird Jr. best analyzed what James Smithson had in mind with the wording of his last will and testament, he also wrote the most authoritative account of the exhibit of gowns, in a book on a different but related subject: *America's Doll House: The Miniature World of Faith Bradford* (New York, 2010), 25. His newest book, *Souvenir Nation* (New York, 2013), is the story of "association" items, "relics, keepsakes, and curios" that range from locks of presidential hair to a magnifying glass and chads from Broward County, Florida, in 2000.

4 All Taylor quotations in this chapter and the next one are from "Oral History Project: Interviews with Frank Taylor, Director General of Museums, 1968–1971," RU 9512, SIA; interviews by Miriam Freilicher and Pamela M. Henson, 1974, 1979–80, 1982.

5 Robert P. Multhauf Interviews, RU 9502, SIA; interviews by Miriam S. Freilicher and Pamela M. Henson, 1974.

6 Frank A. Taylor, *Catalog of the Mechanical Collections of the Division of Engineering United States National Museum* (Washington, D.C., 1939).

7 Inventories of what was on hand awaiting study were nothing if not haphazard. Early in my tenure as a Smithsonian employee, I was assigned once a week to its warehouses in Suitland, Md., as a roustabout, and at one point I had to help move a long row of surplus storage units to make way for a refrigeration compressor acquired from a defunct Baltimore brewery and slated for the *1876* exhibit. Though these were "quarter units," the smallest of the standard storage units, one of them was too heavy to move. Upon opening it, I found it to be jammed with specimens of flora and fauna from a Central American expedition in the 1920s. These looked to be properly tagged, but the registrar in the Museum of Natural History had no record of the quarter unit, and the contents were recorded as "found in collections," not unusual in the 1970s, or even at present.

8 Even though there seems to be a good deal of folklore adhering to Garber (1899–1992), there is no disputing that "he led the way in creating the finest collection of aeronautical artifacts in the world." His career, with special attention to his acquisition of the *Spirit of St. Louis*, is thoroughly addressed in Michael Neufeld and Alex M. Spencer, eds., *Smithsonian National Air and Space Museum: An Autobiography* (Washington, D.C., 2010), 112–68.

9 Bernard S. Finn and Arthur P. Molella, "History of Electricity at the Smithsonian," *IEEE Transactions on Education* E-27 (November 1984): 218–25.

10 Hendrik Willem Van Loon, *The Arts* (New York, 1937), 564. Shortcomings of "the antiquarian museum," such as Henry Ford's in Michigan, were starting to be recognized by the 1930s, as were the failings of simple chronologies. "A mere chronological treatment is not enough," I. N. Lipshitz remarked at the annual meeting of the ASME in New York in 1934. "For only when we study the history of engineering against the general historical and social background are we really able to understand it . . . and to explain it properly" ("The Study of Technical History," *Mechanical Engineering*, March 1935, 143–47). Pleas for "a great museum of industry" had echoed through the trade press since before World War I, e.g., "It is time for us to wake up. It is time for us to realize that here is a great means of industrial and technical education that we surely need. We should have a great national museum of industry" (*American Machinist* 39 [14 August 1913]: 287).

11 "The Met" was the second-most-visited museum in the United States, behind the American Museum of Natural History in New York and just ahead of the Smithsonian's Old and New National Museums in Washington.

12 Frank Taylor, "A National Museum of Science, Engineering and Industry," *Scientific Monthly*, November 1946, 359–65. This venerable periodical, founded in 1915 by the psychologist James McKeen Cattell, would be absorbed a few years later by *Science*, the journal of the American Association for the Advancement of Science, in which Taylor had also published a plea: "The Background of the Smithsonian's Museum of Engineering and Industries," *Science*, 9 August 1946, 130–32. With regard to the practical uses of the A&I collections, Taylor claimed (not very convincingly, as he himself must have realized) that they had been "consulted for solutions of problems and ideas on materials and processes to wage the war effectively."

13 Bird writes that "the First Ladies display had gone fallow since the death of Rose Gouverneur Hoes in 1933" and that Brown's first contact was with Eleanor Roosevelt (*America's Doll House*, 34).

14 Taylor had Kainen foremost in mind when he remarked, "I came to the conclusion that if you really wanted things reduced to the actual elemental facts, ask an artist or a poet." Kainen (1907–2001) had gone to work for the Smithsonian in

1942, just before Margaret Brown, and was probably unique among its curators in his leftist past, having published drawings of "stevedores, gaunt miners, and cloth-wrapped unemployed" in the *Daily Worker*. In an appreciation published after his death, the art critic Paul Richard recalled that Kainen was called before "the Smithsonian's loyalty board" during the McCarthy era and saved his job by presenting letters from J. Edgar Hoover commending him for his analysis of the inks in Nazi propaganda ("A Moving Life in Art," *Washington Post*, 20 March 2001). Kainen's own account, more nuanced, appears in "Oral History Interview with Jacob Kainen, 1982 Aug. 10–Sept. 22," Archives of American Art, Smithsonian Institution, www.aaa.si.edu/collections/interviews/oral-history -interview-jacob-kainen-12620. Evidence of Kainen's expertise in printmaking technology is evident in "Why [Thomas] Bewick Succeeded: A Note on the History of Wood Engraving," *United States National Museum Bulletin* 218 (1959): 185–201.

15 "Preliminary Report of Exhibition Subcommittee," October 1948, RU 623, Box I, SIA.

16 The NCFA would eventually find a home of its own after Carmichael got a chance to take over the old Patent Office building uptown on Judiciary Square, slated for demolition but saved by President Eisenhower in 1957. The collections of the NCFA (now the Smithsonian American Art Museum) were transferred there in the early 1960s, and the building was opened to the public in 1968.

17 The book was published under Rogers's married name: Grace Rogers Cooper, *The Invention of the Sewing Machine* (Washington, D.C., 1968); similarly, Margaret Brown's Smithsonian publications appeared under the name Margaret Brown Klapthor.

18 Philip Ritterbush, *The Art of Organic Forms* (Washington, D.C., 1968), vi. "Quick and deadly and no dumbbell" Ben Lawless told me. Lawless worked with Ritterbush on a film about biological imagery in modern art and sculpture, a topic suggesting how distant Ritterbush was from the concerns of ordinary curators in A&I.

19 Robert M. Vogel to the author, 26 June 2007. Vogel added an appreciative remark that fifty years before, in 1957, "Taylor had the daring (?) to hire a very young, very green young man to oversee the engineering collections." When Ben Lawless and Smithsonian filmmaker Karen Loveland produced a movie about the staging of the Philadelphia Centennial Exhibition, *Celebrating a Century*, a movie destined to win three Emmys, they cast Taylor and Vogel as engineers and architects, and I was cast as their assistant.

20 Roy Rosenzweig, "Marketing the Past: American Heritage and Popular History in the United States," in Susan Porter Benson et al., *Presenting the Past: Essays on History and the Public* (Philadelphia, 1986), 25.

21 Meggers, who later gained renown for her publications in Amazonian archae-
 ology, pre-Columbian transpacific contact, and cultural ecology, also had the
 dubious distinction of being kept with the title of "research associate" among
 the all-male curatorial staff of the Natural History Museum. That no such
 situation prevailed in A&I was owing directly to Taylor. By the time the new
 museum opened, there were nine women curators.

22 Anglim (1910–72) oversaw the A&I modernization program, creation and
 expansion of the Office of Exhibits, and planning for every MHT exhibit, as
 well as initial planning for the Air and Space Museum. Never, as Secretary
 Ripley put it, was there a more intense epoch "in the constantly evolving field
 of museum exhibitions" (quoted in "John Anglim, 61, Dies; Smithsonian Of-
 ficial," *Washington Star*, 24 May 1972).

23 Quoted in Marilyn Sara Cohen, "American Civilization in Three Dimensions:
 The Evolution of the Museum of History and Technology of the Smithsonian
 Institution" (PhD diss., George Washington University, 1980), 94.

24 Benjamin Lawless and Marilyn S. Cohen, "The Smithsonian Style," in *The
 Smithsonian Experience*, ed. Joe Goodwin and Judy Harkison (Washington,
 D.C., 1977), 52–59, quotation on 55.

25 Benjamin Lawless to the author, 28 September 2011.

26 Robert P. Multhauf, "The Museum of History and Technology: An Analysis,"
 6 February 1968, copy in author's collection.

27 On Lawless as a powerful influence on the tenor of MHT exhibits, see Peggy
 Thompson, *Museum People: Collectors and Keepers at the Smithsonian* (Engle-
 wood Cliffs, N.J., 1977), 265–71.

28 Gary Kulik, "Designing the Past: History-Museum Exhibitions from Peale to
 the Present," in *History Museums in the United States: A Critical Assessment*, ed.
 Warren Leon and Roy Rosenzweig (Chicago, 1989), 2–37, quotation on 38.

29 Barbara Melosh and Christina Simmons, "Exhibiting Women's History," in
 Benson et al., *Presenting the Past*, 203–21, quotation on 205.

30 For an analysis of the options that were considered and dismissed, see Marie
 Plassart, "Narrating 'America': The Birth of the Museum of History and Tech-
 nology in Washington, D.C., 1945–1967," *European Journal of American Stud-
 ies* (2007), http://ejas.revues.org/index1184.html. Plassart calls the Museum
 of Man project "a distant echo of George Brown Goode's writing of the late
 nineteenth century," an echo of his hope for a new museum genre, "the natural
 history of civilization, of man and his ideas and achievements" (paragraph 34).

31 Bird, *America's Doll House*, 44–45, referring to Carmichael's article "Needed:
 A New National Museum," in *Coronet* 38 (May 1955): 53–56. *Coronet*, owned by
 Esquire, was a "digest" with very brief articles. Altogether different was another
 article that appeared under Carmichael's authorship a few years later, nearly

fifty pages long: "Smithsonian Magnet on the Mall," *National Geographic* 117 (July 1960): 796–845.

CHAPTER 3. A Worthy Home for National Treasures

1 Marilyn Sara Cohen, "American Civilization in Three Dimensions: The Evolution of the Museum of History and Technology of the Smithsonian Institution" (PhD diss., George Washington University, 1980), 133.

2 In a different climate of opinion about "Victoriana," the A&I building would be listed on the National Register of Historic Places in 1971, just as planning was beginning for a renaissance five years later with *1876: A Centennial Exhibition.* Still, problems created when corners were cut during construction remained chronic, the leaky roof in particular. At least the wooden floor—rumored to have contributed to perpetual dampness and several deaths from pneumonia— had been replaced with ceramic tile.

3 In Michael Kammen's *Visual Shock: A History of Art Controversies in American Culture* (New York, 2006), Dondero (1883–1968) makes several appearances— "not so much as a star," Kammen writes with characteristic zest, "but as a gassy yet fiery comet that eventually burned itself out" (xxvi).

4 Dondero, quoted in William Hauptman, "The Suppression of Art in the McCarthy Decade," *Artforum*, October 1973, in Frances Stonor Saunders, *The Cultural Cold War* (New York, 1999), 253. Saunders refers to Dondero's "high-octane assault" on modernism, apropos for a Michigan politician. His papers in the Burton Historical Collection, Detroit Public Library, are a trove of Cold War diatribe ("Communism has infiltrated our Government, schools, labor organizations, churches, business, politics, veterans organizations and nearly every phase of American life," Dondero told a ladies' night gathering at the Roanoke Rotary Club) but shy on specifics about the inception of the museum, as is the Dondero correspondence in the Smithsonian's Archives of American Art.

5 Dondero, quoted in Deanna Cook, "Cold War Politics, Congressman George Dondero, and Jackson Pollock" (Master's thesis, Bowling Green State University, 1996).

6 This complication involving the Southwest Redevelopment Land Agency— which had contracted planning to a firm headed by William Zeckendorf, who developed the United Nations Complex—is addressed in detail in Cohen, "American Civilization in Three Dimensions," 148–61.

7 The firm had once boasted "the largest practice in the world" (Leland M. Roth, *McKim, Mead, and White, Architects* [New York, 1983], xix), but it was far into decline by the 1950s, as was well known to other firms that would have bid if

the deal had not already been sealed. Long before, McKim, Mead, and White had executed world-renowned commissions, including New York's Pennsylvania Station and the American Academy in Rome. But in the public mind, the firm remained most famous for the 1906 murder of senior partner Stanford White by millionaire Harry Thaw, who was jealous over White's affair with Thaw's wife, actress Evelyn Nesbit, and "the Trial of the Century" that followed.

8 Taylor's brochure included a full-page photo of a "historian of technology using reference collections," a man in a suit, seated comfortably amid antique type-writers and with an attendant in a white lab coat standing by to assist. When I started to work for the Division of Mechanical and Civil Engineering, I was honored to play this role with eminent scholars on several occasions.

9 The museum's ideological mission was nowhere more clearly spelled out than in a document entitled "Proposed Plan of the Smithsonian Institution for Enshrining the Original Star Spangled Banner," which noted, "At this period of our history when a rival ideology of the most sinister character threatens the Nation, the original Star Spangled Banner assumes supreme importance. It manifests the greatness of the United States of America, what it has been, and is determined to be in the future." Cited from RU 276, Box 87, SIA, in Joanne M. Gernstein London, "A Modest Show of Arms: Exhibiting the Armed Forces and the Smithsonian Institution, 1956–1976" (PhD diss., George Washington University, 2000), 141.

10 Anthony Nicholas Brady Garvan (1917–92) was a Yale PhD whose service in World War II both interrupted and fueled his academic pursuits, something that could be said of many of his Smithsonian colleagues in the 1960s, from Dillon Ripley on down. While assigned to the Research and Analysis Division of the Office of Strategic Service early in the war, Garvan wrote manuals for agents who were to be sent behind enemy lines. Between 1944 and 1946 he served with the navy in the Pacific.

11 Peter Welsh to John C. Ewers, 19 March 1963, RU 623, Box 7, SIA.

12 There had been the idea for the anthropologists, ethnologists, and historians to ally in a Museum of Man on the MHT site or, if not there, in expansive wings on the Museum of Natural History. After MHT won out, the anthropologists elected to stay put, confident that the wings would be added, as they were. But Watkins (1911–2001) cast his lot with Taylor (and his fellow ethnologist Ewers, now Taylor's second-in-command) and would become a founder of the Society for Historic Archaeology, chair of a new MHT Department of Cultural History, and one of the few curators ever promoted to the status of senior historian, with no duties other than research.

13 The 53-foot *Philadelphia*, one of fifteen lightly armed small craft with which Benedict Arnold fought twenty-nine British vessels off Valcour Island on Lake

Champlain in October 1776, was a remarkable survival indeed. But the overall modesty of the military history exhibit was due in no small part to the lack of interest by successive Smithsonian secretaries and others in the Castle, or, more to the point, their reluctance to play up arms and armaments. When it was getting difficult to allot space equitably, Ewers once suggested omitting the subject altogether, but military history eventually was addressed at MHT "in the context of national history" and later at the Air and Space Museum "under the rubric of history of technology" (Gernstein London, "Modest Show of Arms," quotation on 5).

14 One of my favorite tasks when I first went to work at the museum was setting these engines in motion at noon daily, using a compressed-air system, and then explaining their operation to interested onlookers.

15 The story of the 1401—the first artifact brought in the museum, in November 1961, long before it was finished—is told in Kurt R. Bell, "On the Shoulders of Giants: A Profile of John H. White, Jr.," *Railroad History* 204 (Spring–Summer 2011): 6–23. White adds that it was picked from a Southern Railway scrap line simply because it had recently been shopped and was in better shape than the others. At the time, nobody recalled the FDR association, nor realized that 1401 was the model number with which IBM had moved from tubes and magnetic drums to transistors and core memory.

16 Also making the first floor into a mecca was the rural post office that had been dismantled in Headsville, West Virginia, and reconstructed next to the front doors by Chuck Rowell, a genius at his craft who was also responsible for the Hart House, the *Everyday Life* reconstructions, and many first-floor "period" settings, such as an apothecary, an 1850 machine shop, and, later, a colonial tobacco warehouse, a marine underwriter's office, and a tattoo parlor. Anyone in theater arts would have recognized Rowell's creations as stage sets.

17 Peter Novick, *That Noble Dream: The "Objectivity Question" and the American Historical Profession* (New York, 1988), 512.

18 On the loyalty-oath controversy and the firebrand role of Multhauf's mentor, Ernst Kantorowicz, in opposition, see Bob Blauner, *Resisting McCarthyism: To Sign or Not Sign California's Loyalty Oath* (Stanford, Calif., 2009), esp. 74–77.

19 Multhauf was anything but volcanic, but all his life he remembered a "thermite" exhibit in the Hall of Science at the Century of Progress in Chicago in 1934, and once in a while he was overcome with an urge to throw out a pyrotechnic zinger. This remark, made while we were having a quiet conversation over coffee in 2001, was a perfect example. A thermite reaction is defined as "a burst of extremely high temperature focused on a very small area for a short period of time."

20 Lawless recalls that Keddy's "favorite remark when he spotted a curator lounging

against a rail on the A&I balcony was 'Look up there at your tax dollars hard at work.'"

21 Later, however, Rae did carry through an important research project in one of the museum's prime archival collections, held by the Division of Mechanical and Civil Engineering, and an automotive historian of commensurate stature, James Flink, prepared a plan for exhibiting motor vehicles in historical context, a plan that would materialize in spirit many years afterward with *America on the Move*.

22 Frank Taylor, "Curatorial Functions in the Science and Technology Sections of the Smithsonian's Museum of History and Technology," text for an address in St. Louis, copy in RU 224, Box 59, SIA.

23 Edwin A. Battison, "Eli Whitney and the Milling Machine," *Smithsonian Journal of History* 1 (Summer 1966): 9–34; Battison, "A New Look at the 'Whitney' Milling Machine," *Technology and Culture* 14 (1973): 592–98. Whitney took a sort of double-barreled hit from MHT: Robert Woodbury, an MIT professor who also worked at the museum in the 1950s, was the author of "The Legend of Eli Whitney and Interchangeable Parts," *Technology and Culture* 1 (1960): 235–53.

24 Robert C. Post, "A Life with Trains: An Interview with John H. White, Jr.," *Invention and Technology* 6 (Fall 1990): 34–40. The books by White on railroad locomotives and rolling stock would set a benchmark for comprehensive studies in the hardware of technology that has never been surpassed, while Ferguson's *Engineering and the Mind's Eye* (Cambridge, Mass., 1992) remains unsurpassed among studies at the intersection of technology and intellectual history. More importantly, it was a book whose insights would inspire curators and designers equally, even when it was getting difficult for them to agree on much else.

25 The clock, by Giuseppe Campani, was what inspired Bedini's first article for the *Bulletin*, in October 1953, and he was still pursuing his interest in Campani at the time of his death in 2007; of such passions are great museologists made.

26 In the 1980s, Bedini would write the *Technology and Culture* memorials for both men: "Derek J. De Solla Price (1922–1983)," *Technology and Culture* 25 (1984): 701–5; "Bern Dibner (1897–1988)," *Technology and Culture* 30 (1989): 189–93.

27 Quoted in Robert C. Post, "Memorial: Silvio A. Bedini (1917–2007)," *Technology and Culture* 47 (2008): 522–29; see also "Silvio A. Bedini (17 January 1917–14 November 2007)," *Proceedings of the American Philosophical Society* 156 (2012): 425–33.

28 Silvio A. Bedini, "The Compartmented Cylindrical Clepsydra," *Technology and Culture* 3 (1962): 115–41. Bedini received SHOT's Abbott Payson Usher Prize in 1962, as did Multhauf in 1965, Ferguson in 1969, and Otto Mayr in the 1970s.

All four became recipients of SHOT's Leonardo da Vinci Medal as well. When awarded his medal, Bedini titled his admirably modest remarks "The Hardware of History."

29 Eugene Ferguson to Brooke Hindle, 27 October 1977, RU 334, Box 6, SIA.

30 Bedini's passion for the "little men" of science and technology was best exemplified in his biography of the African American surveyor Benjamin Banneker and his *Thinkers and Tinkers*, a comprehensive survey of self-taught mathematical practitioners—navigators, surveyors, instrument makers. As time went on, he was increasingly absorbed with the history of surveying, a skill he had first learned in Connecticut with mud on his own boots. In *Celebrating a Century*, the movie Ben Lawless and Karen Loveland produced to accompany the *1876* exhibit, Bedini was cast as a surveyor in Philadelphia's Fairmount Park.

31 Needham quoted in Alex Roland, "Classics Revisited: Once More into the Stirrups: Lynn White Jr., *Medieval Technology and Social Change*," *Technology and Culture* 44 (2003): 574–85. Roland, a scholar a generation younger than White, and quite critical of his synthesis, could still term the book "brilliantly conceived and researched."

32 Brooke Hindle, foreword to John M. Staudenmaier SJ, *Technology's Storytellers: Reweaving the Human Fabric* (Cambridge, Mass., 1985), ix.

33 Lynn White Jr. to Melvin Kranzberg, 2 November 1983, Kranzberg Papers, Box 187, Archives Center, National Museum of American History.

34 "Address by the President of the United States," in *Dedication of the Museum of History and Technology of the Smithsonian Institution, January 22, 1964* (Washington, D.C., 1964), 20.

CHAPTER 4. Allies and Critics

1 Arthur P. Molella, "The Research Agenda," in *Clio in Museum Garb: The National Museum of American History, the Science Museum, and the History of Technology, Science Museum Papers in the History of Technology* 4 (1996): 40.

2 Kurt R. Bell, "On the Shoulders of a Giant: A Profile of John H. White, Jr.," *Railroad History* 204 (Spring–Summer 2011): 6–23, quotation on 13. White also won another prize, a "research day," every Thursday without fail, which he took great care to protect until the end of his Smithsonian tenure in the 1990s. Nobody doubted that he used it wisely.

3 "Wid" Washburn (1925–97) had taught at the College of William and Mary for three years before coming to the museum in 1958. After establishing himself in a new role, he spent much of his time at George Washington University, where he taught; eventually he was evicted from the museum and sent to an office in

the National Portrait Gallery. In a wonderfully candid reminiscence, Harold Skramstad writes that even though Washburn was "thrown out" of MHT, he soon realized that "he was out of sight and mind and could do what he wanted to do when he wanted to do it without much oversight by anybody." So it was for Washburn for more than thirty years (Skramstad to the author, 12 September 2012).

4 Cyril Stanley Smith (1903–92) was a veteran of the Manhattan Project who founded the Institute for the Study of Metals at the University of Chicago, collaborated closely with Mel Kranzberg as he was getting SHOT up and running, and brought a profound wisdom to bear on the relationship between art and technology, especially ancient technology. His breadth and imagination would later materialize in the form of a memorable exhibit at the museum.

5 A near contemporary of my own in the fellowship program was the eminent historian, cultural critic, and Leonardo da Vinci Medalist Susan Douglas. Barney Finn was advisor to both of us and, much to his credit, more active than any other curator in recruiting fellows, nearly all predocs for whom the experience was priceless. In "Robert Multhauf, 1919–2004," *Technology and Culture* 46 (2005): 265–73, Finn lists "historians of technology [who] flowed through our doors" in keeping with Multhauf's enthusiasm for the program and a remark of Derek Price's that "a Ph.D. who hasn't spent a year or half a year at the Smithsonian is no historian of technology."

6 Not everyone appreciated Ripley's dreams of a new Smithsonian whose system of values emulated that of a university, however, especially not Philip Bishop, the historian who was chair of the Department of Industries. Bishop said that he had quit academe and come to the museum with "a sense of mission," to collect artifacts for posterity that nobody else cared about saving. What would become clear after Bishop left, unfortunately, was that he may have loved collecting artifacts, but he cared not at all for paperwork. Decades later, Smithsonian people were still trying to identify things he had acquired and deposited in storage.

7 Albert Bush-Brown to Leonard Carmichael, 28 December 1959, RU 50, Box 83, SIA; Wolf von Eckhardt, "New Washington Museum Cries for a Spark of Life," *Washington Post*, 31 March 1963, both cited in Marilyn Sara Cohen, "American Civilization in Three Dimensions: The Evolution of the Museum of History and Technology of the Smithsonian Institution" (PhD diss., George Washington University, 1980), 245–46.

8 Ada Louise Huxtable, "The Museum of History and Technology of Smithsonian Opens Doors Today," *New York Times*, 23 January 1964. In his memorial for the *Times*, "Ada Louise Huxtable, Champion of Livable Architecture, Dies at 91" (7 January 2013), David W. Dunlap remarked that Huxtable had "invented a

new profession." But nobody, not even Huxtable, ever wrote of the building in more unflattering terms than Josiah Hatch, a young assistant to director Roger Kennedy, in an August 1980 memo assessing a plan by Washington architect George Hartman to improve the appearance in some small measure. It would be an impossibility, wrote Hatch, given "the dead block weight of the entrance lintel, the underwhelming blankness of the walls, and, on the other hand, the frippery of the shadow grids at the top of the façade and the nasty narrowness of the windows." Hatch, who had once gone to school in Rome, concluded that "the result is rather like what Mussolini did at the Circo Olympico and everywhere else he could."

9 Statement by the Secretary, *Annual Report of the Smithsonian Institution* (Washington, D.C., 1968), 3.

10 Leonard Carmichael to Frank Taylor, 6 October 1963, RU 334, Box 4, SIA.

11 Statement by the Secretary, *Annual Report* (1968), 4.

12 In "John C. Ewers and the Problem of Cultural History: Displaying American Indians at the Smithsonian in the Fifties," *Museum History Journal* 1 (January 2008): 51–74, William S. Walker explores the irony of Ewers having been on "the leading edge of an emerging hybrid discipline called ethnohistory that combined anthropology with history" while failing to translate this concern into his exhibits, which still "largely confined American Indians to an undefined 'primitive' past." In his important book *A Living Exhibition: The Smithsonian and the Transformation of the Universal Museum*, in the series Public History in Historical Perspective (Amherst, Mass., 2013), Walker examines a timeframe similar to mine but does so through an entirely different lens.

13 All were the work of L. C. Eichner, whose skills Multhauf celebrated in an elegant booklet, *Laurits Christian Eichner, Craftsman, 1894–1967* (Washington, D.C., 1971). Getting a commission to make a full-scale reproduction of one of Tycho's instruments was Eichner's lifelong ambition.

14 Welsh was the author of two recent and especially meaty monographs in the *Contributions from the Museum of History and Technology*: "United States Patents 1790–1870: New Uses for Old Ideas," 48 (1965): 110–52, and "Woodworking Tools, 1600–1900," 51 (1966): 179–227.

15 Statement by the Secretary, *Annual Report* (1968), 4.

16 Charles Blitzer, quoted in Bryce Nelson, "The Smithsonian: More Museums in Slums, More Slums in Museums?" *Science* 154 (December 1966): 1153.

17 Rodney D. Briggs, letter to the editor, *Washington Post*, 15 January 1967. A flood of letters and op-ed pieces such as William Hines's "The Preservation of Losersville" (*Washington Star*, 12 January 1967) exactly prefigured the corrosive rhetoric of the 1990s: "Is there anything the taxpayer can do to get such people

as Charles Blitzer . . . off the Federal Payroll?" asked a letter-writer in the 19 January 1967 *Star*. The idea of involving "sounds, smell, and touch" of course prefigured "immersive" exhibitry.

18 "Who Needs It?" *Washington Star*, 10 January 1967.

19 Blitzer had imagined looking over the "available slums" quickly and having one in hand "for fumigation" within weeks. Long afterward, the National Park Service would designate the Lower East Side Tenement Museum at 97 Orchard Street in New York as a National Historic Site. On the creation of this museum, see Daniel Scheuerman, "Stuffitude: Richard Rabinowitz and the Art of Exhibitry," *Humanities* 29 (2008), www.neh.gov/humanities/2008/julyaugust/feature/stuffitude.

20 Theodore Ropp, "Comments on the Hall of the Armed Forces of the United States," typescript, 20 January 1966, RU 276, Box 39, SIA. Ripley had asked Ropp to become an advisory editor for the *Smithsonian Journal of History*, joining a distinguished group of scholars that included Samuel Eliot Morison, Julian Boyd, and Lynn White Jr. For forty years the military history exhibit never advanced closer to the present than the Civil War, and then, with money provided by Kenneth Behring just as two grim and disheartening wars raged in the Middle East, it was brought right up to the present. Everything, including Vietnam and Operation Iraqi Freedom, was subsumed under the name *The Price of Freedom*, and partly because of this, reviews from academic regions were devastating.

21 W. James King, "The Development of Electrical Technology in the 19th Century, 2: The Telegraph and the Telephone," *Contributions from the Museum of History and Technology* 29 (1962): 273–332.

22 Grosvenor (1901–82) was in the process of taking the National Geographic Society's membership from 2.1 million to 5.5 million, as well as moving into television documentaries and supporting the research of Jane Goodall, Louis and Mary Leakey, and Jacques Cousteau. The society's new headquarters was dedicated by President Lyndon Johnson, just as MHT had been. Bart McDowell, "Melville Bell Grosvenor, a Decade of Innovation, a Lifetime of Service," *National Geographic*, August 1982, 270–78.

23 Joseph Marion Jones to Melville Bell Grosvenor, 27 January 1966; all quotations from correspondence about this episode are from copies of letters in the Kranzberg Papers, Record Group 266, Box 95, Archives Center, National Museum of American History. The Joneses and Grosvenor were eventually satisfied with Finn's article, published as "Alexander Graham Bell's Experiments with the Variable-Resistance Transmitter," *Smithsonian Journal of History* 1 (Winter 1966–67): 1–16, from which Gray was quite absent. Finn summarized a lifetime

of pondering the matter in "Bell and Gray: Just a Coincidence?" *Technology and Culture* 50 (2009): 193–210.

24 Finn was probably certain there was nothing to be gained by citing R. G. Collingwood's stricture that "the student of historical method will hardly find it worth his while . . . to go closely into the rules of evidence, as these are recognized in courts of law" (*The Idea of History* [London 1956], 268).

25 Multhauf and Boorstin, together with Eugene Ferguson and Brooke Hindle, had been at the heart of a 1965 conference at the Hagley Museum and Library in Delaware, a signal event in bringing specialists in the history of technology together with generalists in American history. See Robert C. Post, "*Technology in Early America*: A View from the 1990s," in *Early American Technology: Making and Doing Things from the Colonial Era to 1850*, ed. Judith A. McGaw (Chapel Hill, N.C., 1994), 16–39.

26 The "means" could simply be a story in which the beginning was obvious, either from what was displayed or from the silk-screened script, but there were ways to make certain that people followed the prescribed route, such as glass doors that would open only one way or carpeting with a slanted nap that made people feel like they were going to trip if they went the wrong way. (The danger of personal-injury litigation made the latter a short-lived experiment.)

27 Statement by the Secretary, *Annual Report* (1968), 4.

28 Daniel Boorstin, quoted in Kim Masters, "They Went Thataway; At the NMAA, Revising the Revisionism of 'The West as America,'" *Washington Post*, 2 June 1991. Boorstin's was not the only negative comment from a prominent historian; Columbia University's Simon Schama called the exhibit "a relentless sermon of condescension." Schama is quoted in Michael Kammen, *Visual Shock: A History of Art Controversies in American Culture* (New York, 2006), 283.

29 Michael Kimmelman, "Old West, New Twist at the Smithsonian," *New York Times*, 16 May 1991. For retrospectives, see Roger B. Stein, "Visualizing Conflict in 'The West as America,'" *Public Historian* 14 (1992): 85–91, and especially Kammen's layered analysis in *Visual Shock*, 282–84. On the third level, Kammen writes, the episode "set a precedent for [political] intimidation that would be well remembered."

CHAPTER 5. To Join in a Smithsonian Renaissance

1 J. R. Pole, "Daniel J. Boorstin," in *Pastmasters: Some Essays on American Historians*, ed. Marcus Cunliffe and Robin W. Winks (New York, 1969), 210–48, quotation on 234. A few years earlier, in *Historians against History* (Minneapolis, 1965), David W. Noble had put Boorstin in the company of Turner, Beard,

George Bancroft, Carl Becker, and Vernon Louis Parrington in order "to define the central tradition of American historical writing from 1830 to the present" (157–75).

2 Quoted in Herman Schaden, "Museum Director: Smithsonian Taps Boorstin," *Washington Evening Star*, 27 January 1969.

3 Noble, *Historians against History*, 169. Boorstin reprinted "The New Barbarians" in *The Decline of Radicalism* (New York, 1979), 121–35.

4 In *Cowboys into Gentlemen: Rhodes Scholars, Oxford, and the Creation of an American Elite* (New York, 1998), 339, Thomas J. Schaeper and Kathleen Schaeper write that "several of his classmates never forgave Boorstin." Boorstin also told the committee that his Harvard advisor in history, Granville Hicks, had been a communist, but this was old news, as Hicks had renounced communism in 1940 and twice testified before the committee himself. Boorstin's testimony appears in Eric Bentley, ed., *Thirty Years of Treason: Excerpts Before the House Committee on Un-American Activities, 1938–1968* (New York, 1971), 601–12.

5 Jon Weiner, "The Odyssey of Daniel Boorstin," *Nation*, 26 December 1987, 305. It was Lemisch who popularized the phrase "history from the bottom up," and when he was hired by Chicago, Boorstin would surely have appreciated the originality of his 1962 Yale PhD dissertation, "Jack Tarr vs. John Bull: The Role of New York Seamen in Precipitating the Revolution." Chicago did not renew Lemisch's contract, and he actually left the university before Boorstin did.

6 As a fellow Rhodes Scholar, Philip Ritterbush was likely present at the meeting with Boorstin, too, although his days as Ripley's confidant were numbered. In *Cowboys into Gentlemen*, the Schaepers write that "his abrasive, anti-bureaucratic temperament led him to resign in 1971 and become a free-lance consultant and writer." He was an occasional presence around the Castle and the archives and died in 1986.

7 Multhauf was anxious to disabuse Mel Kranzberg of the impression that he had been "kicked upstairs," emphasizing that Boorstin wanted "more action, and I'll be quite content with less," and also that his predecessor as director, Ewers, had likewise "moved from administration to research" (Multhauf to Kranzberg, 12 January 1969 and 25 January 1970, Kranzberg Papers, Box 155, Archives Center, National Museum of American History). The assumption is warranted, however, that both men had indeed been kicked upstairs. Previously, the only MHT curator who had ever been promoted to a "research" position was maritime historian Howard Chapelle; among the few afterward were railroad historian Jack White and ethnologist *cum* cultural historian Malcolm Watkins.

8 "Remarks of Daniel J. Boorstin upon Assuming the Directorship of The National Museum of History and Technology, September 30, 1969."

9 Statement of the Secretary, *Annual Report of the Smithsonian Institution* (Washington, D.C., 1968), 3–4.

10 Silvio Bedini to Ladd Hamilton, 10 and 15 July 1970, RU 334, Box 156, SIA. Hamilton was Boorstin's special assistant at the time. While this project was in process, Bedini finished much of the research for *The Life of Benjamin Banneker*, published by Scribner in 1972 and advertised as "the definitive biography of the first black man of science." Carroll Greene (1932–2007) emerged from obscurity years later to inaugurate the Acacia Collection of African Americana in Savannah, Georgia.

11 Statement of the Secretary, *Annual Report* (1968), 7.

12 S. Dillon Ripley, *The Sacred Grove: Essays on Museums* (New York, 1969), 107. Kinard (1937–89) held an MA from Hood Theological Seminary in Salisbury, N.C., and since 1964 had been a pastor at the John Wesley African Methodist Zion Church, where Medgar Evers's body had lain in state before his burial at Arlington National Cemetery.

13 In *The Memory Chalet* (New York, 2010), Tony Judt wrote that such an aversion can be founded in a concern about encouraging minorities "to study *themselves*—thereby simultaneously negating the goals of liberal education and reinforcing the sectarian and ghetto mentalities they purport to undermine." There is no reason not to believe that Boorstin felt the same way, but for voices of disagreement, see "Nomination of Daniel J. Boorstin of the District of Columbia to be Librarian of Congress," Hearings before the Committee on Rules and Administration, U.S. Senate, 94th Cong., 1st sess. (30 and 31 July 1975, 10 September 1975). As the National Museum of African American History and Culture moves toward an opening in 2016, there are bound to be concerns voiced about whether it simply amounts to a politically correct form of segregation.

14 Daniel Boorstin, *The Americans: The Democratic Experience* (New York, 1973), 640.

15 Richard Hofstadter, *The Progressive Historians* (New York, 1968), 457; Kenneth L. Kusmer, "American Social History: The Boorstin Experience," *Reviews in American History* 4 (1976): 471–82, quotes on 472 and 481. It is noteworthy how similar many of Boorstin's narratives were to those of "history from the bottom up" New Left historians.

16 Robert P. Multhauf to Daniel Boorstin, 16 September 1969, Multhauf Papers, RU 7469, SIA.

17 Exceptions for formal curatorial training were the Cooperstown Graduate

Program in upstate New York and the University of Delaware's program in American culture and decorative arts associated with the Winterthur Museum, in which several NMHT curators had studied. Another Delaware program was just taking wing under the leadership of Eugene Ferguson, linking museum training with graduate studies in the history of technology.

18 In his dissertation and in "The Georgetown Canal Incline," *Technology and Culture* 10 (1969): 549–60, Skramstad made exemplary use of a manuscript collection he himself had helped acquire and organize as a fellow in the Division of Mechanical and Civil Engineering, the papers of William Rich Hutton.

19 Kranzberg to Boorstin, 10 February 1969, 13 January 1970, 2 January and 25 October 1973, 13 July 1987, Kranzberg Papers, Box 65, Archives Center, National Museum of American History. Boorstin's draft had been afflicted with misunderstandings about division of labor, interchangeable parts, and Taylorism, among other things, which Kranzberg pointed up in detail. Boorstin's special assistant's request to "pay Mr. Kranzberg for expenses incurred while serving as a consultant to Dr. Boorstin" blurred the bounds between Boorstin's role as museum director and as an author whose writing projects were his own. Ladd Hamilton to Supply Division, 23 March 1971, RU 334, Box 149, SIA.

20 On these negotiations, see, Robert C. Post, "'A Very Special Relationship': SHOT and the Museum of History and Technology," *Technology and Culture* 42 (2001): 401–35, esp. the citations on pages 428 and 429 from the Multhauf Papers in the Smithsonian Institution Archives and the Kranzberg Papers in the Archives Center, NMAH.

21 Alan Howard Levy, *Government and the Arts: Debates over Federal Support of the Arts in America from George Washington to Jesse Helms* (Washington, D.C., 1997), 91, 96, 97.

22 Daniel J. Boorstin, Anne C. Golovin, and Rube Goldberg, *Do It the Hard Way: Rube Goldberg and Modern Times* (Washington, D.C., 1970). Goldberg died on 7 December 1970, a few days after the exhibit opened.

23 Boorstin had a stellar array of graduate students at Chicago but had gone on record a decade before as "not [being] in favor of encouraging woman students any more than they had been encouraged in the past," which was of course very little (quoted from a report of the AHA Committee in Graduate Education, in Peter Novick, *That Noble Dream: The "Objectivity Question" and the American Historical Profession* [Cambridge, 1988], 367). Boorstin would never before have encountered a professional staff with so many women as at NMHT, more than a dozen besides Golovin.

24 Peter Marzio, *The Art Crusade: An Analysis of American Drawing Manuals, 1820–1860* (Washington, D.C., 1976), viii.

25 In a long tradition of understated excellence, both with exhibits and with publi-

cations, is *G. A. 100: The Centenary of the Division of Graphic Arts* (Washington, D.C., 1986), coauthored by Harris (b. 1940) and Marzio's successor, Helena Wright (b. 1946), who arrived at the museum after fifteen years as archivist at what is now the American Textile History Museum. After retiring in 1997, Harris returned to her native England; in 2006, she received the American Printing History Association's Individual Laureate for distinguished achievement.

26 Marzio died at age sixty-seven in 2010. The *New York Times* obituary on 11 December was one of dozens that appeared all around the world.

27 Robert M. Vogel, "Assembling a New Hall of Civil Engineering," *Technology and Culture* 6 (1965): 60–61.

28 Daniel Boorstin, *The Americans: The National Experience* (New York, 1965), 106–14, with the story epitomized on p. 106: "American technology was a technology of the present, shaped by haste, by scarcity of craftsmanship, of capital, and of raw materials, and by a firm expectation of rapid change in the technology itself."

29 "The Dexter Prize," *Technology and Culture* 16 (1975): 422. It was in the second volume of his trilogy, *The Americans: The National Experience*, that Boorstin wrote about the history of technology and "a larger audience" (442), as quoted in the epigraph. Even a severe critic took approving note of Boorstin's emphasis on technology "as a major key to understanding the American past" (Kusmer, "American Social History: The Boorstin Experience," 477).

30 Harold Skramstad, "Daniel J. Boorstin, 1914–2004," *Technology and Culture* 45 (2004): 926.

31 Rowland Berthoff, "Consensus Pyrotechnics," *Reviews in American History* 2 (1974): 25.

32 "Story Line for Exhibit on Federal Science and Engineering," n.d., and press release, 3 April 1965, RU 276, Box 45, SIA.

33 And the museum was well known, too; in January 1969, there had been an inaugural ball for Nixon and another for Vice President Spiro Agnew. Boorstin denied writing speeches for Agnew, as was widely rumored, but they were friends, and Agnew was fond of quoting Boorstin, as when he decried "methods by which unqualified students are being swept into college on the wave of the new socialism" (in a speech at Des Moines on 13 April 1970) and then followed with an alarming remark of Boorstin's about "the armed demands of militants to admit persons to the university because of their race [or] their poverty."

34 Silvio Bedini to Harold Skramstad, 10 August 1971; George Schultz to Dillon Ripley, 17 March 1972; Daniel Boorstin to Grace Cooper, Anne Golovin, Peter Marzio, Scott Odell, Eugene Ostroff, and Richard Virgo, 3 October 1972, RU 334, SIA; Ben Lawless to the author, 24 February 1998.

35 The Boorstin regime provided a contracting bonanza for eminent historians

like William Goetzman and Edmund Morgan, as well as for younger men and women just starting out: $10,000 for Leila Smith "for a feasibility study/inventory of artifacts that relate to the Centennial." Skramstad authorized payment of $12,500 to Perry Duis "for a feasibility study on 1876 exhibit," but this was canceled in the Castle, and Duis was forever scornful of the NMHT exhibits.

36 According to the Milton Glaser Design Study Center and Archives, which featured this game on its Web site in February 2009, it "was a give-away" from the exhibit, so it seems likely that fifty cents was too much.

37 Jo Ann Lewis, "As a Show, It's Good, but It Could Be Better," (Washington, D.C.) *Sunday Star and News*, 14 January 1973.

38 George Basalla, "Museums and Technological Utopianism," in *Technological Innovation and the Decorative Arts*, ed. Ian M. G. Quinby and Polly Anne Earl (Charlottesville, Va., 1974), 355–73, quotation on 362.

39 Rodris Roth to Silvio Bedini, 31 May 1973, RU 334, Box 33, SIA. Shales's story appeared in the *Washington Post* for 1 June 1973, and he freelanced another for the *New York Post* on 6 June titled "How Shave Show Nicked a Museum." Roth (1931–2000), one of NMAH's several graduates of the Winterthur program, was among the museum's best and best-liked curators, sharing responsibility for the collections of domestic furnishings with Anne Golovin. Shortly before her death, Roth endowed a chair in the name of her mentor, Malcolm Watkins.

40 Joseph F. Cullman 3d to S. Dillon Ripley, 7 June 1973, RU 334, Box 33, SIA. That Ripley lived in a different world from his underlings is suggested by Cullman's aside that "we had a fabulous weekend with the Gardner Stouts at our place near Tupper Lake, and they both saw for the first time in fifty years a fine male spruce grouse." Gardner Stout was president of the Board of Trustees of the American Museum of Natural History, and Cullman knew that Ripley would appreciate the aside because he knew the Stouts and would share their excitement about the male spruce grouse sighting. After a day amid the wildlife of a New Jersey cove, Stout once exclaimed, "I feel so sorry for people who don't do this."

41 Malcolm Watkins to Silvio Bedini, 4 June 1973, RU 334, Box 33, SIA. Warnings of this sort are manifold in the museum correspondence, e.g., "the enthusiasms of company people tax our ability to control the content and the texts in a thoroughly responsible manner," this from Frank Taylor to Leonard Carmichael with regard to a Sperry Corp. exhibit in 1960 (RU 334, Box 112, SIA).

42 "Show me a man who claims to be objective," Henry Luce himself is said to have remarked, "and I'll show you a man with illusions" (*New York Times*, 1 March 1967).

43 My favorite example is the twenty-one-page memorandum on "Revamping of

Hall of Land Transportation along Lines of Social Impact," written for Boorstin by James Flink, a professor at the University of California, Irvine, and author of several authoritative histories of automobility. Department chairman Jack White responded politely in a memo expressing his own displeasure about the present design, with its "phoney gas station and plate-glass dividers." Indeed the design was subpar, and yet the exhibit remained essentially unchanged from the time Flink assessed its shortcomings in the early 1970s until the twenty-first century.

44 Benjamin Lawless, *The Color of Dust and Other Dirty Little Secrets from Our Nation's Attic* (Indianapolis, 2010), [2].

45 Daniel Boorstin, foreword to Claudia B. Kidwell and Margaret C. Chrisman, *Suiting Everyone: The Democratization of Clothing in America* (Washington, D.C., 1974). This well-written and well-designed catalog was enabled by another grant from Sears, Roebuck. *Suiting Everyone* engendered such enthusiasm that curator Kidwell and James Baughman proposed a Center for the History of Clothing that might well have taken hold if Boorstin had stayed on as director.

46 For *American Maritime Enterprise*, Karen Loveland produced a film about disasters at sea, artfully sequencing clips from Hollywood movies when authentic footage proved hard to come by. Rear-projected glimpses of moments from *The Poseidon Adventure* and similar features attracted crowds so large that they impeded the "flow" through the exhibit, to designer Makovenyi's distress, my own distress as the exhibit curator, and even more to the distress of fire marshals. The film had to be removed, superseded by movie posters set against a supergraphic of the *Morro Castle* burning off the New Jersey coast, dramatic but not show-stopping.

47 In an influential book, Edward P. Alexander tells how "Bauhaus-trained designers, intent upon obtaining maximum communication, began to study circulation carefully... [and] break displays down into small units to be viewed in definite sequence" (*Museums in Motion: An Introduction to the History and Functions of Museums* [Nashville, Tenn., 1979], 178, 179). Then designers might begin to skip over the "maximum communication" part (meaning communication by the artifacts on display) in favor of spotlighting their own ingenuity in creating their setting.

CHAPTER 6. A Special Kind of Insight

1 Robert P. Multhauf, "The Triumph of the Flag, or a Requiem for the MHT," revised draft, 16 April 2001, typescript in the author's possession.

2 Paul Forman, "Weimar Culture, Causality, and Quantum Theory: Adaptation

by German Physicists and Mathematicians to a Hostile Environment," *Historical Studies in the Physical Sciences* 3 (1971): 1–115. Forman (b. 1937) stayed at the museum until 2012, matching Finn's four-decade tenure on the curatorial staff.

3 The operation of cybernetic devices is based on the principle of feedback, "the property of being able to adjust future conduct by past performance." A simple example is the float valve in a toilet. Mayr's catalog, which perfectly exemplified Hindle's remark about a "special kind of insight," was published as *Feedback Mechanisms in the Historical Collections of the National Museum of History and Technology* (Washington, D.C., 1971). Mayr (b. 1930) returned once again to the Deutsches Museum, in 1983, as director, and told of his "transatlantic existence" in remarks upon receiving SHOT's Leonardo da Vinci Medal in Uppsala, Sweden, in 1992: "Scholarship and the Museum," *Technology and Culture* 34 (1993): 648–52.

4 Brooke Hindle to Harold Skramstad, 5 June 1974, RU 334, Box 39, SIA.

5 Statement by the Secretary, *Annual Report of the Smithsonian Institution* (Washington, D.C., 1968), 22–23. The "hoard" of "domestic, foreign and ancient gold coins," 6,125 of them valued at $5.5 million, required federal legislation to keep it "intact for the nation" (Adam Bernstein, "Elvira Clain-Stefanelli; Led Smithsonian Coin Collection," *Washington Post*, 4 October 2001). For their role in acquiring the Lilly Collection, as well as "their many other achievements and accomplishments in the numismatic world," Ripley presented the Stefanellis with the Smithsonian's Exceptional Service Gold Medal.

6 After moving on from Chicago in 1980, Skramstad would transform the Henry Ford Museum in Dearborn, Michigan; provide an editorial home for *Technology and Culture* after it left the Smithsonian; and eventually win plaudits from most of those at the Smithsonian who had regarded him as an upstart. In 1991 he received the National Endowment for the Humanities' Charles Frankel Prize (now the National Humanities Medal), whose other recipients have included Boorstin, John Hope Franklin, Doris Kearns Goodwin, David McCullough, and Bill Moyers.

7 In 1966, Ripley had invited Dupree to apply for the directorship, but he declined and now was comfortably settled at Brown University after a fraught departure from Berkeley much like Boorstin's from Chicago and Hindle's from NYU.

8 Brooke Hindle to Charles Blitzer, 27 November 1974, RU 334, Box 39, SIA. Hindle added that Bridenbaugh "was a very close personal friend of mine"— friend and mentor, he might have said, for Hindle wrote in the acknowledgments to his most notable book, *The Pursuit of Science in Revolutionary America, 1735–1789* (Chapel Hill, N.C., 1956), that Bridenbaugh had "provided constant inspiration and encouragement over a period of many years" (vii).

9 As Bedini later put it, such curators were "splendid experts in narrow subject

matter but without a feeling for history" (Bedini to Hindle, 24 March 1977, RU 334, Box 30, SIA). In the fall of 1973, I had accepted a job as an aide to the curators in the Division of Mechanical and Civil Engineering, Robert Vogel, Edwin Battison, and Otto Mayr. Then, when Hindle arrived, he took me into his own office with duties, in part, similar to what Skramstad's had been: when necessary, I was to bring to exhibits "a feeling for history."

10 Roger B. Merriman to Master of Balliol, 12 January 1934, quoted in Peter Novick, *That Noble Dream: The "Objectivity Question" and the American Historical Profession* (Cambridge, 1988), 173. Boorstin was born in Atlanta, which had the largest Jewish community in the South, but his father, a lawyer, elected to move his family to Oklahoma to escape an accelerating wave of Ku Klux Klan violence around the time Daniel was born.

11 Draft, Bedini to W. Liddon McPeters, President, the Security Bank, Corinth, Miss., 21 November 1973, RU 334, Box 38, SIA.

12 After Skramstad's departure, Hindle assigned me to the project, with the hope of lending credibility to the script and catalog (which I rewrote) but without ruffling any feathers. In 1996, a graduate student of Robert Friedel's at the University of Maryland, Tim Wolters, wrote a paper about the politics of the banking exhibit and especially *Chartered for Progress*, in which he depicted an attempt to endow a "deficient" text with a "veneer" of good prose.

13 For years, some of Washburn's colleagues had complained about his pretensions as "universal critic and conscience for the MHT" (Peter Welsh to Frank Taylor, 16 January 1964, RU 334, Box 3, SIA). Still, Washburn was a productive scholar, well known beyond Smithsonian precincts; he served as president of the American Studies Association just after William Goetzmann and Leo Marx, and he became active in the Society for the History of Discoveries, organizing a conference on the Vinland Map and editing the proceedings.

14 The Wilson Center had been co-founded in 1971 by Blitzer and Senator Daniel Patrick Moynihan, in part "to provide a link between the world of ideas and the world of policy." It was structurally part of the Smithsonian, and a link with the museum might have seemed natural, but Blitzer chose not to pursue it.

15 *The Frontiers of Knowledge: The Frank Nelson Doubleday Lectures at the National Museum of History and Technology, Smithsonian Institution, Washington, D.C.* (Garden City, N.Y., 1975) included a foreword by Hindle and essays from this series, initiated by Boorstin. Two more series followed that were initiated by Hindle, "Creativity and Collaboration" and "The Modern Explorers," the latter perhaps the most memorable, with contributions by Sir Edmund Hillary, Sir Fred Hoyle, Willard F. Libby, and Isaac Asimov.

16 Joanne M. Gernstein London, "A Modest Show of Arms: Exhibiting the Armed Forces and the Smithsonian Institution, 1945–1976" (PhD diss., George Wash-

ington University, 2000), 147. On the whole course of the board's activities, see Public Law 87–186, 87th Cong., 1 sess., HR 4659 (31 August 1961), and Gernstein London's chap. 4, "A War Museum by Any Other Name."

17 Silvio A. Bedini, "Smithsonian Institution Announcement for Eisenhower Institute," draft, March 1972, RU 334, SIA. The quiet tenor of this mission statement seemed essential at this particular time, in the context of renewed bombing of North Vietnam after a three-year hiatus, President Nixon's order to mine North Vietnamese ports, and all the domestic turmoil these moves precipitated.

18 Lundeberg (b. 1923) was a junior officer aboard the destroyer escort *Frederick C. Davis* when it was torpedoed and sunk by a German U-boat on 24 April 1945, two weeks before VE Day. More than half the 209 crewmen and officers were lost. After teaching at the U.S. Naval Academy for several years, he came to the Smithsonian in 1959 as a consultant and then a curator, becoming the leading authority on MHT's gunboat *Philadelphia*.

19 Pogue (1912–96) would complete the fourth and final volume of the biography, *George C. Marshall, Statesman, 1945–1959*, in 1987. His wartime service was as a master sergeant, and with his Clark University doctorate in European history at age twenty-four, he was sometimes called "the smartest enlisted man in the U.S. Army."

20 Seven of SHOT's first twenty annual meetings were hosted by the museum. Other professional societies meeting at NMHT in 1975 included the Agricultural History Society, the Costume Society of America, and the Society for Industrial Archeology.

21 "Planning Goals for the National Museum of History and Technology," 3 May 1974, RU 334, Box 39, SIA.

22 Nathan Reingold, always called "Nate," received his PhD in 1951 from the University of Pennsylvania, where one of his advisors, Richard Shryock, had also been Hindle's dissertation advisor. Learned and well connected, Reingold also had an appetite for the bureaucratic scrapping needed to bring about such a center. Although he had the support of Otto Mayr, in his proposal he made only a token bow toward technology, and it especially bothered Hindle that he never wrote a book, the key to advancement at any university. The prolific Bedini was quite conscious of this and foresaw the institute as a hideaway for the well educated but nonproductive (Brooke Hindle to Curators in the History of Science and Technology, 5 January 1977; Barney Finn, Paul Forman, and Otto Mayr to Hindle, 9 February 1977; Silvio Bedini to Hindle, 15 February 1977, 2 March 1977, 18 July 1977 [all in RU 334, Box 3, SIA]; Marc Rothenberg, "Nathan Reingold, 1927–2004," *Technology and Culture* 46 [2005]: 479–83).

23 Hindle to E. Jeffrey Stann, Smithsonian Office of Development, 12 March 1974, RU 334, Box 39, SIA.

24 J. Paul Austin, Coca-Cola CEO, to S. Dillon Ripley, 25 August 1977, RU 334, Box 2, SIA.

25 The fountain had been added when more than $500,000 remained from the building fund. Although Hindle always kept his dignity, he had to laugh aloud when Bob Tillotson, his assistant director for administration, told him that the fountain was "equipped to do everything but go into orbit but never does anything."

26 Hindle to Bedini and Tillotson, 26 January 1976, RU 334, Box 39, SIA. "Association items" were the sine qua non of the political history collections; ceramics were at the heart of the cultural history collections.

27 Hamarneh (b. 1925) took a degree in pharmacy at Syrian University in Damascus, then an MS at North Dakota State and a PhD in the history of pharmacy and science at Wisconsin, with a minor in medieval history. His research concerned "the encyclopedic al-Tasrīf, written in the late tenth century by Abū al-qāsim al-Zahrāw . . . probably the earliest independent work in Arabic Spain to embrace the whole of medical knowledge of the time." As esoteric as this might seem, it is worth recalling that the Section of Materia Medica was one of the very first established by George Brown Goode in 1881. Hamarneh traced its evolution in "History of the Division of Medical Sciences," *Contributions from the Museum of History and Technology* 240 (1966): 270–300.

28 "Jeff" Miller (1925–2005), with a law degree and a master's from the Winterthur program in decorative arts, was an authority on Meissen porcelain and English yellow-glazed earthenware. He would not have objected to being called a connoisseur rather than a historian, although he did coauthor a substantial treatise with an archaeologist, Lyle M. Stone, *Eighteenth-Century Ceramics From Fort Michilimackinac: A Study in Historical Archaeology*, published by the Smithsonian in 1970.

29 Hindle to Forman, 4 January 1978, Hindle to John Schlebecker, 11 March 1975, RU 334, Box 13 and Box 39, SIA.

30 Hindle to Susan Fay Cannon, 17 March 1978, RU 334, Box 14, SIA. By 1978, Cannon was dressing entirely in women's clothing, his deceased mother's actually, and told a *Washington Post* interviewer, "I feel I'm dressing as a clown when I wear men's clothes." Cannon's *Science in Culture: The Early Victorian Period* (New York, 1978) received the Pfizer Award "in recognition of an outstanding book dealing with the History of Science" in 1979, the same year he left the Smithsonian. He died in 1981 at age fifty-five, after undergoing a sex-change operation bound to be risky because of his poor health. In the October 1982

issue of *Psychology Today*, Aaron Latham and Andrea Grenadier recounted "The Ordeal of Walter/Susan Cannon."

31 Hindle to I. B. Cohen, 23 September 1977, RU 334, Box 14, SIA. Cannon's failure, the beginning of a slide toward a lonely and pathetic death five years later, resulted in the termination of plans for an exhibit about the U.S. Geological Survey, for which I had begun to develop the storyline.

32 Hindle to Dean B. Doner, 25 April 1977; to Richard Leopold, 5 August 1976; to Silvio Bedini, 17 March 1976; to Edward P. Alexander, 24 June 1976, all RU 334, SIA.

33 Hindle to Blitzer, "Interim Report on Your Request for an 'Action Manifesto,'" 1 July 1977, RU 334, Box 14, SIA.

34 These are my notes taken from remarks by the chair, Gordon N. Ray, the Yale biographer and bibliophile, at meetings of 29 April 1974 and 22 October 1975.

35 The "science curators" besides Finn were Cannon, Forman, Jon Eklund (Yale, curator of chemistry), Deborah Warner (Harvard, curator of astronomy), Audrey Davis (Johns Hopkins, curator of medicine and pharmacy), and Uta Merzbach (Harvard, curator of mathematics), with Mayr halfheartedly involved after he became department chair.

36 George Weiner to Frank Taylor, 6 April 1960, Taylor to James Bradley, assistant secretary for administration, 30 July 1964, RU 334, Box 114, SIA.

37 On Jackson's behalf, Charles E. Walker, chairman of the American Waterways Operators, raised hundreds of thousands of dollars from the owners and operators of towboats and barges. "Charlie" Walker was a giant of a man in a George Raft double-breasted suit, always with a cigar, and his manner seemed a little menacing to a pale and bookish "museum professional." I rarely saw anyone sit with him at a conference table who did not appear to be intimidated. One exception was Marzio.

38 Hindle to Charles Frankel, National Humanities Center, 31 January 1978, RU 334, Box 4, SIA.

39 Lawless to Hindle, 6 July 1977, Marzio to Hindle, 22 September 1976, RU 334, SIA.

40 Scheele (1928–95) would pull up a chair in a period room and sit for hours on end, just looking around and thinking about the smallest details that would make it just right. He started with the Smithsonian in 1959 and quickly outgrew the confines of philately, transforming his curatorial realm into "postal history"; he later led the museum into a consuming interest with popular culture.

41 Multhauf to Marzio, 22 November 1977, RG 334, Box 45, SIA.

42 Hindle to Multhauf, 30 July 1976, RG 334, Box 4, SIA. Seldom were Hindle's joys not tempered. He added that he was anxious to talk "about our history of

science personnel, for they constitute a problem area, solutions to which have not come to me."

43 *The World of Franklin and Jefferson*, the Eames Office show that toured Paris, Warsaw, London, and New York at the time of the Bicentennial, consisted chiefly of vibrant photoprints along with some forty thousand words.

44 Actually, Miner (b. 1931) bridled at being called a designer: "Charles Eames, there is a designer," he would say. He preferred "project manager," though this expression later took on a different meaning which seemed to exclude the creativity at which Miner excelled.

45 "Snoopy at the Smithsonian," *Wall Street Journal*, 25 October 1994. Recall that this is the exhibit whose "Victorian wonders" had been so admired by Lynne Cheney when she wrote about it in the May 1976 issue of *Smithsonian*. It was not just closing the exhibit to which the *WSJ* took exception; more so it was talk (actually, just talk) for replacing it with "the National African American Museum ... it really would be nice to know the rationale these advanced thinkers offer for demoting this country's contribution to the industrial revolution."

46 Klaus Maurice and Otto Mayr, eds., *The Clockwork Universe: German Clocks and Automata 1550–1650* (New York and Washington, D.C., 1980), ix.

CHAPTER 7. The Winged Gospel

1 *Great Inventions* (New York, 1934) was the final volume of the Smithsonian Scientific Series, which Abbot had helped create in 1929 as a commercial venture. Eventually there were a dozen books; Abbot wrote three of them. In the foreword to the final volume he confessed that the series had required more effort "than was anticipated," a sentiment to which many authors and editors could relate.

2 Abbot lived to the age of 101, and even in the early 1970s I would see him at work in the NMHT office designed to accommodate his private library.

3 Even in an atmosphere of fiscal hardship, Wetmore found the wherewithal to hire professional administrators. One suspects that he was determined not to lose time from his research; all the while he was secretary he made annual trips to Panama to collect avian specimens. His bibliography tops 700 entries, including descriptions of 189 species and subspecies "new to science." Later on, the Smithsonian's second ornithologist secretary coauthored a memorial: S. Dillon Ripley and James A. Steed, "Alexander Wetmore, June 18, 1886–December 7, 1978," *National Academy of Science, Biographical Memoirs* 56 (1987): 597–626; see also, Paul Oehser, "In Memoriam: Alexander Wetmore," *Auk* 97 (1980): 608–15.

4 The director, salaried by the Smithsonian, was William Duncan Strong, a for-
 mer student of A. L. Kroeber who had worked for the Smithsonian's Bureau
 of American Ethnology before joining the department of anthropology at
 Columbia University.

5 Abbot, *Great Inventions*, 229.

6 Charles G. Abbot, "The 1914 Tests of the Langley 'Aerodrome,'" *Smithsonian
 Miscellaneous Collections* 103 (24 October 1942), reprinted in *Annual Report
 of the Board of Regents of the Smithsonian Institution, 1942* (Washington, 1943),
 111–18, quotation on 118.

7 Joanne M. Gernstein London, "A Modest Show of Arms: Exhibiting the
 Armed Forces and the Smithsonian Institution, 1945–1976" (PhD diss., George
 Washington University, 2000), provides a masterful account of the protracted
 maneuvering behind the establishment of the National Air Museum (after 1966
 renamed Air and Space Museum) in a new building. The quotation is on p. 93.

8 U.S. House of Representatives, Committee on the Library, Report no. 2473,
 "Establishing a National Air Museum," 79 Cong., 2d sess. (9 July 1946).

9 Harold Miller (co-executor of Orville Wright's estate) to Senator Barry Gold-
 water, *Congressional Record*, 92 Cong., 1 sess., vol. 117, pt. 9 (26 April 1971).

10 Public Law 722, 79 Cong., 2d sess. (12 August 1946), 60 *Stat.* 955; quoted in
 Alex Roland, "Celebration or Education: The Goals of the U.S. National Air
 and Space Museum," *History and Technology* 10 (1993): 81.

11 This soon after World War II, many people were familiar with the custom of
 naming warplanes for wives or girlfriends. Actually, Tibbets (1915–2007) named
 the *Enola Gay* for his mother, Enola Gay Haggard before she was married. In
 2002, Tibbets told Studs Terkel that "my dad never supported me in my flying
 . . . When I told him I was going to leave college and go fly planes in the army
 air corps, my dad said, 'Well, I've sent you through school, bought you automo-
 biles, given you money to run around with the girls, but, from here on, you're
 on your own. If you want to kill yourself, go ahead, I don't give a damn.' Then
 Mom just quietly said, 'Paul if you want to go fly airplanes, you're going to be
 all right.' And that was that" (Tibbets, interview by Studs Terkel, 1 November
 2007, AVweb, www.avweb.com/news/profiles/).

12 People who work at the Air and Space Museum always refer to Silver Hill, but
 when I was involved in tidying up the storage on this site, in a part shared by
 the Museum of History and Technology, we always called it Suitland.

13 The first three volumes of *The Birds of Panamá* were published in 1965, 1968,
 and 1972; the fourth was completed by colleagues after Wetmore's death in
 1978. In recent years, historians have begun to put the work of Wetmore and
 others from the Smithsonian in the context of "imperialist science." Scott Blake
 from the University of Texas provided an up-to-date example of this approach

to the venerable NMAH Tuesday Colloquium on 24 July 2012: "The Nature of Tourism: Smithsonian Scientists in the American Tropics, 1912–1964."

14 Eugene S. Ferguson to Frank Taylor, 15 July 1959, RU 623, Box 2, SIA. As he had been asked to do, Ferguson was providing Taylor with a critical assessment of Grace Rogers Cooper's modernized Textile Hall. He noted "the distressing absence of crowds" even when nearby halls were congested and suggested that the problem stemmed from an attempt "to be a text book, with illustrations and objects supporting the text." This take on a new exhibit would have greatly interested a psychologist new to museums, namely Carmichael.

15 Grover Loening to Leonard Carmichael, 3 January 1953, RU 537, Box 1, SIA, cited in Gernstein London, "Modest Show of Arms," 203.

16 Carl Mitman to Alexander Wetmore, 12 October 1949, RU 50, Box 95, SIA.

17 "For the Air Age a National Museum," *Architectural Record*, September 1955, 164, 170. Carmichael believed that McKim, Mead, and White had done well for him at Tufts, but his continued partiality toward this firm was questionable. In a review of Mosette Broderick, *Triumvirate: McKim, Mead & White: Art, Architecture, Scandal, and Class in America's Gilded Age* (New York, 2010), Martin Filler writes that "McKim is the closest America had ever come to having a national architect, and his imprint on the city of Washington is still palpable." But even with its "glory years" long past, it "plodded on" for decades until it was absorbed by another firm while its last commission, the Museum of History and Technology, was still under construction ("Our Grand & Randy Great Architects," *New York Review of Books*, 26 May 2011, 20–22).

18 George Beveridge, "New Air Museum Location Outside S.W. Plan Asked," *Washington Star*, 17 December 1955. Recall that developers had once imagined that the Museum of History and Technology might serve as a magnet in another part of the "new southwest." The Independence Avenue site is where the Department of Energy's Forestall Building is now located.

19 Loening's remark was reported by Philip S. Hopkins in a memo to John Keddy, 4 April 1958, RU 50, Box 94, SIA. Loening (1888–1976) was reputed to have been the first recipient of a graduate degree in "aviation and aerodynamics," from Columbia University, and he had once managed the Wright brothers' factory in Dayton, Ohio.

20 Roland, "Celebration or Education," 83.

21 After his death in 1992, at age 93, the Silver Hill storage and restoration facility was named for Garber, thereby honoring him much more securely than if he had been director of the museum. Frank Taylor should have been remembered so well. For a time the Museum of American History had a Taylor Gallery next to the Constitution Avenue entrance, but the name went missing in the course of a major interior reconfiguration, and the former gallery is now a lunch room.

22 The firm's Web site describes the building thus: "External shapes consist of three ascending concentric rings of parabolic arches. The first layer of arches houses 20 small monastic chapels. An intermediate layer brings light into the nave of the church, and a bell tower with a lantern above the central altar crowns the chapel" (www.hok.com).

23 Obata was born in San Francisco, the son of Chiura Obata, a well-known illustrator, painter, and teacher. When Chiura was "interred" in Utah in 1942, the nineteen-year-old Gyo managed to get to St. Louis to continue the education he had begun at Berkeley.

24 Gernstein London, "Modest Show of Arms," 217.

25 Ibid., 222, 224.

26 S. Paul Johnston to Mr. Ripley, 8 May 1967, RU 537, Box 2, SIA.

27 Gernstein London, "Modest Show of Arms," 232; Roland, "Celebration or Education," 84. Gernstein London suggests that what most bothered Ripley about NASM people and the advisory board was their "lack of interest in the public concern," their inattention to noblesse oblige. That Ripley had come from a world where this was expected is evident from a profile published when he was thirty-six, fourteen years before he came to the Smithsonian (or, rather, returned, for he had been a curator briefly): Geoffrey T. Hellman, "Curator Getting Around," *New Yorker*, 26 August 1950. Ripley had been chief of the Office of Strategic Services' Branch of Secret Intelligence in Southeast Asia, and this profile includes an assessment by OSS high-chief Bill Donovan: Ripley, he said, had "contacts, experience, imagination, resourcefulness, energy, and tenacity." And humor—he never minded getting mistaken for Robert L. ("Believe It or Not") Ripley, though he did not want to be called Sidney—he was a direct descendant of Sidney Dillon, a principal (and much maligned) contractor for the Union Pacific Railroad, and later its president and chairman of the board.

28 S. Dillon Ripley to The President [Nixon], 22 August 1969, RU 99, Box 306, SIA.

29 William W. Warner to Dr. Ripley, 18 September 1969, RU 99, Box 306, SIA. Warner (1920–2008) was one of the first people Ripley brought into his administration in 1964, along with Blitzer and Ritterbush; he achieved his most lasting fame after he left the Smithsonian, with his book *Beautiful Swimmers*, a study of Atlantic blue crabs and their relation to Chesapeake Bay watermen. The book won the Pulitzer Prize for nonfiction in 1977, the second Pulitzer in five years for someone with Smithsonian ties (after Daniel Boorstin).

30 Glennan, a close friend of Kranzberg's, was on leave from the presidency of Case Institute. Kranzberg told the story of suggesting a NASA history program to Glennan when they happened to meet "while waiting in line at a supermarket checkout counter" in "Memorial: T. Keith Glennan (1905–1995)," *Technology*

and Culture 37 (1996): 659–62. Emme's Historical Advisory Committee had included Boorstin and Multhauf, SHOT stalwarts like John Rae and Thomas Hughes, and, as chair from 1966 to 1970, SHOT founder Kranzberg.

31 Charles Blitzer to Dillon Ripley, 17 February 1969, RU 104, Box 7, SIA.

32 Melvin Kranzberg to Robert Multhauf, 17 June 1970; Multhauf to S. Dillon Ripley, 2 July 1970; Frank Taylor to Multhauf, 18 August 1970, all RU 7467, Box 5, SIA; Burger and Taylor, quoted in Roland, "Celebration or Education," 85–86.

33 *Congressional Record*, 91 Cong., 2d sess., vol. 16, pt. 9 (26 April 1971).

34 Dian Post, Jack Warner, and Ed Lisee, eds., *CM for the General Contractor: A Guide Manual for Construction Management* (Washington, D.C., 1974), 27.

35 Asked to name a favorite project, Gyo mentioned "the most popular museum in the world . . . based on the idea of a mall of two levels, so people could go into the different exhibit areas, with the light and air from the north, which faces into the mall" (Cathy Sivak, "Interview with Gyo Obata, FAIA, Founding Partner of Global Architectural Firm HOK," 2 February 2006, Architecture Schools, http://architectureschools.com/resources/an-interview-with-gyo -obata-faia-founding-partner-of-global-architectural-firm-hok).

36 Gernstein London, "Modest Show of Arms," 259.

37 Melvin B. Zisfein (1926–95) was richly experienced in technical realms. His background included a BS and MS from MIT, then Lockheed, Bell Aircraft, Giannini Controls, and the Franklin Institute Research Laboratories. He was hired as the museum's deputy director in 1971 and sought, unsuccessfully, the directorship when Collins moved on in 1978. His situation was similar to Bedini's at NMHT: immensely qualified but "just not right" for the job. In 1982 he became director of the Army Discovery Center at the National Science Center in Fort Gordon, Georgia.

38 Gordon Ray to S. Dillon Ripley, 18 May 1977, RU 334, Box 43, SIA.

39 Hanle also helped launch *Air and Space / Smithsonian* magazine and, after leaving NASM, became executive director of the Maryland Science Center from 1987 to 1996, president of the Academy of Natural Sciences in Philadelphia until 2000, president of the Biotechnology Institute until 2011, and after that CEO of Climate Central, a nonprofit that analyzes and reports on climate science.

40 To follow this thread into the present, consider that the museum now has a collection relating to transportation security in post-9/11 America, which includes such mundane items as the plastic trays into which one deposits personal belongings before passing through a screening device and, of course, one of these devices as well.

41 I recall going to a Salvation Army store and buying an old suit of clothes to hang on a hook to enhance the ambience of this tattoo parlor. Since it was not

"real," the designer and her assistant Claudine Klose (and I) felt no guilt about putting our own names on a sign as the "artists": *Tattoos by Makovenyi, Klose, and Post*. Similar fictions pervaded *1876*, where Robert Vogel and I, according to a sign, were co-proprietors of a machine-tool firm.

42 In 2011, the director of the National Museum of African American History and Culture, Lonnie Bunch, was not embarrassed to accept an "indistinguishable replica" of the Parliament-Funkadelic Mothership. The original 1,200-pound spacecraft from the funk group's stage shows had been "trashed" nearly thirty years before.

43 Robert B. Gordon, "The 'Kelly' Converter," *Technology and Culture* 33 (1992): 769–79. Recall that when Silvio Bedini was writing for "true science" comics, his titles had included "Crazy Kelly: The Beginning of Modern Steelmaking."

CHAPTER 8. Celebration or Education?

1 Mayr was awarded the 1976 Abbott Payson Usher Prize for "Yankee Practice and Engineering Theory: Charles T. Porter and the Dynamics of the High-Speed Steam Engine," *Technology and Culture* 16 (1975): 570–602, in which he developed an intriguing theme, technological ventures pursued "mostly for an ancient but nonutilitarian motive, namely, intellectual curiosity, the innate urge to solve riddles." An earlier article, "Adam Smith and the Concept of Feedback Control: Economic Thought and Technology in 18th-Century Britain," *Technology and Culture* 12 (1971): 1–22, was a brilliant analysis of "the diffusion of ideas among separate areas of thought," never surpassed to this day.

2 Betty James, "District Profile: Working for the Waste Basket Didn't Suit Him," *Washington Star*, 14 June 1978. When I went to work for NMHT, with one-third of my time owed to Mayr, he imparted his own enthusiasm for ornamental turning lathes with elliptical and eccentric chucks that could be used for such intricate tasks as decorating gold watch-fobs, a hobby among British aristocrats. The museum had three such lathes, including an example of the most treasured, made by John Jacob Holtzapffel in London at the turn of the nineteenth century. Mayr enlisted my help in putting these on display, and in small but indelible measure this introduced me to the pleasures of staging exhibits, especially with mechanical artifacts having a measure of dramatic presence, or, as Mayr put it, "spiritual appeal" (*Philosophers and Machines* [New York, 1976], 4).

3 "National Museum of History and Technology: Background Report for the Smithsonian Council," October 1979, RU 334, Box 43, SIA.

4 Otto Mayr to Charles Blitzer, 6 October 1978, RU 334, Box 56, SIA. Most of the staff only grumbled about Mayr's imperious attitude, but for a few there was genuine hatred: "I have never felt you belonged here . . . your work is mainly

fit for the wastebasket," wrote Don Berkebile, a curator of transportation. Berkebile was never a placid man, and many years later when he was retired to a Pennsylvania farm, he was killed by a neighbor over a disputed property line.

5 For a short time Claudia Kidwell—who had come to the museum as a twenty-year-old student intern in 1961 and recently impressed everyone with *Suiting Everyone*—got to take a turn as acting director. Belatedly, Mayr would affirm Ripley's instincts about managerial potential when he was named director of the Deutsches Museum—the museum upon which MHT was directly patterned—and remained in Munich from 1983 to 1992. Among his accomplishments was the opening of an air museum in a former Luftwaffe aerodrome outside the village of Schleissheim. Along the way, he was awarded SHOT's Leonardo da Vinci Medal; in his acceptance speech in Uppsala, he revealed the goodwill too scarce in his Smithsonian days, and the good sense: "I knew that a good piece of scholarship can have a considerable life expectancy whereas the deeds of an administrator are forgotten at the moment of his departure" ("Otto Mayr: Scholarship and the Museum," *Technology and Culture* 34 [1993]: 648–52, quotation on 651).

6 Melvin Kranzberg to Charles Blitzer, 8 May 1978, Kranzberg Papers, Box 195, Archives Center, NMAH.

7 In 1981, after I inherited the editorship from Kranzberg, Skramstad floated the idea of such a move, but it did not actually materialize until 1996, when the editorship passed from me to John M. Staudenmaier SJ, a professor of the history of technology at the University of Detroit Mercy who often took classes to the museum on field trips.

8 Michael J. Lacey to Roger Kennedy, 20 August 1979. Lacey's letter (nine pages, single spaced) never made it into the archives, and to this day my leaked copy will elicit a gasp from any old-timer who had not seen it, especially since Lacey admitted that he had "never been privy to the inner life of the museum." But he seemed credible partly because the Wilson Center had become an elite address in the Castle. Under the direction of James H. Billington, it gained eminence with the creation of the *Wilson Quarterly* and several new programs including the Kennan Institute for Advanced Russian Studies. Billington would succeed Daniel Boorstin as Librarian of Congress in 1987; Charles Blitzer would succeed him at the Wilson Center.

9 In what Smithsonian curators wrote, it was almost never fair to peg them with a "public history" community whose compatibility with "norms of disinterested objectivity" was questionable (Peter Novick, *That Noble Dream: The "Objectivity Question" and the American Historical Profession* [Cambridge, 1988] 517). Nevertheless, Randolph Starn is not entirely amiss in observing that academic historians "outflanked the competition [and] from their newly won university

positions they relegated museum specialists, archivists, and other 'auxiliaries' or 'amateurs' to subaltern status" and that "these tribal divisions persist behind the smiling face of interdisciplinarity" ("A Historian's Brief Guide to New Museum Studies," *American Historical Review* 110 [2005]: 68–98, quotes on 69–70).

10 This was a remark by the chief historian of the National Park Service, Dwight T. Pitcaithley, when Kennedy became NPS director after leaving the Smithsonian. "Taking the Long Way from Euterpe to Clio," in *Becoming Historians*, ed. James R. Banner Jr. and John R. Gillis (Chicago, 2009), 54–75, quotation on 68.

11 Claudine Klose to Roger Kennedy, 3 August 1979, copy in author's files. The document was drafted by Mayr, together with Klose, who was his special assistant. Klose had come aboard as Bill Miner's *1876* assistant at age twenty-one, then worked with Nadya Makovenyi on *American Maritime Enterprise*, and for many years thereafter would be enlisted to expedite one program or exhibit project after another with exquisite skill.

12 Once, when Kennedy hurt Margaret Klapthor's feelings by announcing that I would be responsible for "extending" an exhibit concept of hers, a "smaller" concept that was apparently the best she could do, he took me by the arm and together we brought her a dozen red roses.

13 Michael S. Durham, "Keeper of the Attic," *Americana* 15 (November–December 1987): 43.

14 Kennedy would become almost an everyday media presence in the 1990s, with his NPR interviews with Diane Rehm, his TV series *Roger Kennedy's Rediscovering America*, and frequent C-SPAN appearances, which are archived at www.c-spanvideo.org/rogerkennedy.

15 The list of possibilities in William L. Bird Jr.'s book *Souvenir Nation* (New York, 2013) is beyond compare, except perhaps with Thomas Edison's "last breath" in the collection at the Henry Ford Museum.

16 Noble (1945–2010) had just published a book, *Forces of Production: A Social History of American Automation* (New York, 1984), in which he depicted technology "in the context of class conflict and formed by the irrational compulsions of an all embracing ideology of progress" (xiv) and seemed unwilling to believe that everyone at the museum was not united in "applause for industrial capitalism."

17 After Kennedy introduced Beschloss to his friend Jim Lehrer, he would appear on the McNeill-Lehrer News Hour dozens of times, and Kennedy and Beschloss would sometimes be teamed on C-SPAN to discuss the news of the day. Among Beschloss's honors are an Emmy in 2005 for the Discovery Channel's *Decisions That Shook the World*. He renewed association with the museum in the 1990s when a board of notables was established for fundraising.

18 Matthew Roth, "Face Value: Objects of Industry and the Visitor Experience,"

Public Historian 22 (2000): 33–48, quotation on 48. D. D. Hilke, a research psychologist hired to assess exhibit audiences, alerted Kennedy that "some curators seem to value scholarly opinion of an exhibit more than the reactions of visitors."

19 Stine also proved adept at discerning opportunities for "Placing Environmental History on Display," the title of his presidential address to the American Society for Environmental History, published in *Environmental History* 7 (2002): 566–88.

20 Marzio shared Boorstin's disregard for political correctness. I saw Silvio Bedini go ashen at a cocktail party in the Castle when Marzio remarked that Molella's hiring must have been a matter of filling the museum's "Wop quota."

21 Kennedy had a particular affection for the sponsorship of journals. At one point he was ready to back the operation of *Agricultural History* under Pete Daniel's editorship, and he was prepared to bid on *American Heritage* when it was put up for sale. He also fostered a start-up under the editorship of Gary Puckerein, *American Visions*, described as "the country's leading African American art and cultural magazine."

22 In a 9 July 1989 interview with Brian Lamb on C-SPAN *Booknotes*, Kennedy talked about his new book, *Orders from France: The Americans and the French in the Revolutionary World, 1780–1820* (New York, 1989), and about much else, including his friendship with Bundy, who began driving him to work after he was badly injured and during their commutes, Kennedy said, provided "the greatest course in American contemporary history imaginable" (http://booknotes.org/Watch/8270-1/Roger+Kennedy.aspx).

23 "Asst Sec for History and Art, National Museum of American History, Minority Strength Distribution Summary . . . Full Time Permanent and Trust Fund Employees," RU 334, Box 95, SIA. It was clear that a black man like Francis Gadsden would never get promoted out of the subprofessional ranks even though he knew the collections in agricultural history better than anyone and had a University of Chicago history degree while there were white curators in engineering and transportation who had never gone to college.

24 Like Boorstin and unlike Hindle, Kennedy did not suspend personal projects, and while he was director he completed several books. They drew mixed reviews, often depending on how taken a reviewer was with Kennedy's "cranky, insouciant voice" (Brendan Gill's words in his *New Yorker* review of *Architecture, Men, Women and Money in America, 1600–1860* [New York, 1985]).

25 Roger Kennedy to Richard Sheldon, 24 March 1981, with reference to proposals of 12 December 1980 and 13 March 1981, RU 223, Box 95, SIA.

26 In 1982, Kennedy enlisted Fleckner to create a central repository for material dispersed throughout the museum, as well as material from outside relating to

technology and material culture (among his early accessions were the papers of Melvin Kranzberg and the Society for the History of Technology). Over the next two decades, Fleckner distinguished himself as a leader in the archives profession, and his Archives Center would eventually have collections measuring 20,000 cubic feet. Fleckner tells of the center's establishment in "How Does Your Garden Grow? Building Sustainable Archives Programs," University of Illinois at Urbana-Champaign, University Library Colloquium, 19 May 2008, www.library.illinois.edu/committee/colloqm/speakers/fleckner.html.

27 Strictly speaking, there was one such exhibit before *Field to Factory*, a redo of the old Hall of Everyday Life in the American Past with attention to the people who actually lived in the period rooms instead of presenting them generically or, in one case, wrongly identified. A room that was thought to have come from the house of an artisan named Reuben Bliss and long called the "Bliss Parlor" was found to have come from the house of a merchant named Samuel Colton. The new exhibit, *After the Revolution*, reflected fine-grained research in the new social history, but its insights were embodied largely in labels aimed at appealing to "historians in the academy." The value of the research came through most vividly in a book by Barbara Clark Smith, *After the Revolution: The Smithsonian History of Everyday Life in the Eighteenth Century* (New York, 1985), one of whose pleasures is its citation of a research report by Edward F. Zimmer, "A Study of the Origins of the Connecticut Valley Parlor in the National Museum of American History, or Ignorance Is Bliss."

28 Lamb, *Booknotes* interview with Roger Kennedy.

29 Durham, "Keeper of the Attic," 45.

30 A journalist once quoted an offhand remark of mine about Kennedy being "the first director of this museum who didn't mumble." This was much to my chagrin, yet there was no denying that he was the first to have any real talent as a speechmaker, the first who would dream of referring to the things that might be stashed in an attic as being worthy because of their "symbolic incandescence" (quoted in Bill Bartol, "The Stuff of History," *Newsweek*, 24 April 1989, 80).

31 Copy of memo in the author's possession.

32 Kennedy had in mind the steam engine and *external* combustion (that is, the firebox external to the boiler and cylinders). *Internal* combustion, fueled by a hydrocarbon and with ignition inside the cylinders, was an invention of the latter nineteenth century.

33 Hindle, quoted in Hal Bowser, "Engines of Change," *American Heritage*, Fall 1986.

34 "Connie" Raitsky (1931–2009) had worked on the Eastman Kodak Pavilion at the 1964 New York World's Fair and then become a designer for the Metropolitan Museum of Art, resigning after a well-publicized dispute with the director,

Thomas Hoving. Raitsky freelanced for many years, including the work he did with Mayr on *The Clockwork Universe*, before joining the NMAH staff in 1985 to design *Engines of Change*.

35 Kennedy had worked hard to recruit Noble, and Noble spent two years planning an exhibit which (in the enigmatic expression of his memorialist in *Technology and Culture*), "didn't fly," although R2-D2 and his *Star Wars* companion C-3PO remain in the collections, along with a hammer once wielded by a Luddite machine-breaker. In a handwritten postscript to an 11 September 1984 letter to Kranzberg, Hindle wrote, "Noble has been told that he can quit or be fired" (Kranzberg Papers, Box 119, Archives Center, NMAH), but his departure remains unexplained because of nondisclosure pledges. The memorial is Thomas Misa, "David F. Noble, 22 July 1945 to 27 December 2010," *Technology and Culture* 52 (2011): 360–72.

36 John H. White Jr. to George Hilton, quoted in Kurt B. Bell, "On the Shoulders of Giants: A Profile of John H. White, Jr.," *Railroad History* 204 (2011): 18. In 1979 a museum team led by John Stine, the division of transportation's logistical mastermind, had also salvaged the power plant from the 1848 Great Lakes ore-boat *Indiana*, sunk in 131 feet of Lake Superior water for 120 years. This was the maritime equivalent of the *John Bull*, and Kennedy was excited about plans for exhibiting the two together. Ultimately, limited clearances inside the building prevented the display of all but one major component, but it was the most innovative component by far, the propeller (nearly all steam-powered vessels still had paddlewheels at mid-century). See Robert C. Post, "*Indiana* Salvage: Oldest American Marine Engine Recovered," *Society for Industrial Archeology Newsletter* 7 (September 1979): 1.

37 The GG1 designation is explained at www.spikesys.com/GG1/.

38 On Kennedy's plans for the windmills and the GG1, see Arthur P. Molella, "Tilting at Windmills," *Technology and Culture* 36 (1995): 1000–1006. Even more pleasing to Kennedy than the windmills would be the Frank Lloyd Wright house that was actually erected in the nonfunctioning fountain later on.

39 Kennedy to Melvin Kranzberg, 5 September 1980; Kennedy to Kranzberg, 7 January 1985; Kennedy to Kranzberg and Merritt Roe Smith, 8 January 1990, cited in Molella, "Tilting at Windmills," 1004. The initial commitment was shared with Noel Hinners, director of the Air and Space Museum. To help gain the favor of the editorial search committee over strong competition, Kennedy showed up unannounced at the Toronto hotel where interviews were under way in October 1980. In addition to committing staff and financial support, he made promises about the "ambience" that have entered the realm of folklore. Offices would be graced by art and artifacts from the museum collection (Currier and Ives prints, say, and patent models) and, to cap it off, he would see to there being

"fresh cut flowers" on the editor's desk every day. For years afterward, visitors would ask the managing editor, Joan Mentzer, where the flowers were.

40 Josiah Hatch to Roger Kennedy, 3 June 1980, RU 334, Box 57, SIA. Hatch's memo telling how the staff "reacts best to things concrete" and how resistant it would be to "counter-training" in the "history of ideas," was stamped CONFI-DENTIAL, but nobody expected that any such document would actually remain confidential.

41 One of Kennedy's first recruits was an Indiana University PhD, John Edward Hasse, who, as curator of American music and founder of Jazz Appreciation Month, as both a lecturer and a performer, would become an enduring Smith-sonian celebrity. As the Division of Music enjoyed special favor from Kennedy, Hasse would build the world's largest museum collection of jazz history, acquire the Duke Ellington Archive, and publish several books, most notably *Beyond Category: The Life and Genius of Duke Ellington* (New York, 1993). For more on Hasse, see Erica R. Hendry, "The Ambassador of Jazz," *Around the Mall: Scenes and Sightings from the Smithsonian Museums and Beyond*, 30, www .smithsonianmag.com/arts-culture/The-Smithsonians-Ambassador-of-Jazz .html.

42 Even though temporary, these exhibits would sometimes be accompanied by a pictorial catalog of lasting value, a prime example being Robert M. Vogel's *Building Brooklyn Bridge* (Washington, D.C., 1983).

43 John T. Schlebecker and Elsa M. Bruton, *The Changing American Farm, 1831–1981* (Washington, D.C., 1981), 19.

44 Peter N. Stearns, "Toward a Wider Vision: Trends in Social History," in *The Past before Us: Contemporary Historical Writing in the United States*, ed. Michael Kammen (Ithaca, N.Y., 1980), 205–30, quotation on 205.

45 Just before arriving, Kulik had coauthored *Rhode Island: An Inventory of His-toric Engineering and Industrial Sites* for the Historic American Engineering Record, and he had been hired to replace the curator of textile machinery, Grace Rogers Cooper. Forman had lately worked on an exhibit of particle accelerators. The two shared an intellectual bond through Hunter Dupree, a professor of Forman's at Berkeley in the 1960s and of Kulik's at Brown in the 1970s.

46 Forman's rejoinder implied that aside from its limited utility in a museum context, the very concept of the new social history was suspiciously "spongy," even in academe. To be sure, a watchword was "conflict" rather than consensus, but did not a "bottom up" perspective characterize the work of both Daniel Boorstin and his arch-enemy Jesse Lemisch? A lifelong adherent to the new social history has suggested that it went through three metamorphoses, and that in the early 1980s it would have been defined by its "love affair with British

Marxism." See Paul E. Johnson, "Looking Back at Social History," *Reviews in American History* 39 (2011): 379–99, quotation on 379. To my knowledge, only two NMAH curators ever called themselves Marxists, Kulik and David Noble.

47 David K. Allison, "The Information Revolution in Jefferson's America," 30 May 1996, http://americanhistory.si.edu/comphist/montic/allison.htm; "The Dibner Award," *Technology and Culture* 32 (1991): 571–72.

48 Rabinowitz, quoted in Daniel Scheuerman, "Stuffitude: Richard Rabinowitz and the Art of Exhibitry," *Humanities* 29 (July–August 2008), www.neh.gov/humanities/2008/julyaugust/feature/stuffitude.

49 While conceding that the new social history had helped "stretch both the range and depth of historical interpretation in our museums," Skramstad was contemptuous of the curatorial conceit "that the history museum's role is primarily to put an individual scholar's directly revealed truths, in words and pictures, up on a museum wall and call it an exhibit" (review of Warren Leon and Roy Rosenzweig, eds., *History Museums in the United States: A Critical Assessment* [Champaign, Ill., 1989] in *Technology and Culture* 32 [1991]: 651–53).

50 Kennedy quoted in Edward Tenner, "Pantheons of Nuts & Bolts," *Invention and Technology*, Winter 1989, 16–22, on 21.

51 As curator of *A Material World*, I need to emphasize that the contingency pertained only to the central location and never touched on *what* would be featured. It was simply not true that "half the displays" sought "to impress us on the unqualified virtue of synthetic polymers," especially DuPont's (Philip Burnham, "Consuming Interests," *Washington City Paper*, 10 November 1995). Nearly all of what was displayed was made of "natural" materials: wood, paper, leather, iron.

52 Both local daily papers skewered the exhibit. See Eric Gibson, "TechnoLove: Smithsonian Sets Computer on Pedestal," *Washington Times*, 10 May 1990, and Hank Burchard, "Information Overloaded," *Washington Post*, 11 May 1990.

53 Robert D. Friedel, "A Materials Showcase," in *A Material World: An Exhibition at the National Museum of American History* (Washington, D.C., 1988), 51. The dragster was staged with the *John Bull* just beyond, asking that they be contemplated together.

54 Tenner, "Pantheons of Nuts & Bolts," 21. Tenner was beginning work on one of the zestiest books ever written about technology in history, *Why Things Bite Back: Technology and the Revenge of Unintended Consequences* (New York, 1995).

55 In "Memorializing the Bomb," *Radical History Review* 34 (1986): 101–4, James Gilbert suggested that the exhibit was bland and uninformative because of the Smithsonian's sensitive position "on the axis between the White House and Congress." Goldberg, a well-regarded historian of modern science, responded that there had been no attempt, either by Smithsonian officials or anybody on

the outside, to interfere with his conceptualization of the exhibit. It would be a different story with another atomic bomb exhibit in the 1990s.

56 Roger B. Stein, "Visualizing Conflict in *The West as America*," *Public Historian* 14 (1992): 85–91, quotation on 91; Kim Masters, "They Went Thataway: At the NMAA, Revising the Revisionism of 'The West as America,'" *Washington Post*, 2 June 1991, online at http://pqasb.pqarchiver.com/washingtonpost/access/74688451.html. Accounts of the controversy also appeared in *Newsweek*, the *New York Times*, and the *Nation*.

57 Even a critic who reviewed the exhibit favorably, Robert Hughes, had to stop short at what he read in some of the essays in the catalog edited by curator William Truettner: "rectilinear frames," wrote one of the authors, "provide a dramatic demonstration of white power and control." Quoted in Hughes, *Culture of Complaint: The Fraying of America* (New York, 1993), 189. Hughes's book appeared just before the culture wars Armageddon, but he clearly understood the message: "We'll be back, get into line or we'll cut your funds off."

CHAPTER 9. A Crisis of Representation

1 This document is included in *The Enola Gay Debate*, one of several bound volumes of documents, articles, and proclamations made available by the Air Force Association.

2 Paul W. Tibbets Jr., "Our Job Was to Win," *American Legion*, November 1994, 70.

3 Harwit summarizes the internal discussions about the planning document in *An Exhibit Denied: Lobbying the History of the Enola Gay* (New York, 1996), 179–92. Among those who had serious reservations about using the bomb was General Arnold himself.

4 More recently, the buzzwords would be "civic engagement" and "shared authority," meaning a say in "what stories the museum showcases and how they are told" (Bill Adair, Benjamin Filene, and Laura Koloski, "How Do Staid Museums Navigate a User-Generated World?" *History News Network*, 12 December 2011, http://hnn.us/articles/how-do-staid-museums-navigate-user-generated-world).

5 A first iteration of the script, omitting photos and captions, is printed in Philip Nobile, ed., *Judgment at the Smithsonian* (New York, 1995), 1–127; the quoted passage (which the *New York Times* later singled out in a story titled "War of Words: What the Museum Couldn't Say") is on 103–4. Nobile includes a long essay, "The Struggle Over History," by Barton Bernstein, a member of the exhibit's ten-man advisory board, and an essay of his own titled "How the Smithsonian Was Forced to Stop Worrying and Love the Bomb." Although

Nobile later acquired a well-deserved reputation as a "semi-pro scold" (Thomas Oliphant, "The Smearing of [Doris Kearns] Goodwin," *Boston Globe*, 3 March 2002), this essay should not be devalued for that reason.

6 Paul Fussell, *Wartime: Understanding and Behavior in the Second World War* (New York, 1989), 138; Nobile, *Judgment at the Smithsonian*, 3. This remark, though it actually followed a paragraph about Japan's "naked aggression" and "extreme brutality" in China, reverberated alone as a "twisted lie" in dozens of accounts of the controversy and did unending damage to NASM despite being edited in all subsequent revisions.

7 Copy of authorization in author's possession.

8 One among many online bibliographies is Lehigh University's "The Enola Gay Controversy: How Do We Remember a War That We Won?" http://digital.lib .lehigh.edu/trial/enola/. Including Web sites and films, but not the countless articles in newspapers and popular periodicals, this list was running to more than five hundred entries by the time it was last updated in 2006.

9 Bernard S. Finn, "The New Technical Museums," *Museum News* 43 (1964): 22–26.

10 Richard H. Kohn, "History and the Culture Wars: The Case of the Smithsonian Institution's *Enola Gay* Exhibition," *Journal of American History* 82 (1995): 1036–63, quotations on 1044.

11 The other members of the board were Herman Wolk, Hallion's colleague at the Center for Air Force History; Edwin Bearss, chief historian of the National Park Service; Stanford's Barton Bernstein; Brookhaven National Laboratory's Victor Bond; Harvard's Akira Iriye; Edward Linenthal of the University of Wisconsin– Oshkosh; Richard Rhodes, author of *The Making of the Atomic Bomb*; Dartmouth's Martin Sherwin; and Stanley Goldberg, author of *Understanding Relativity* and by this time thoroughly experienced in the rough-and-tumble of Smithsonian history exhibits. (The committee's remarks about the script are from Goldberg's notes.) Bearss was even more experienced; Dillon Ripley had called on him to help assess criticism of the MHT military exhibit in the 1960s.

12 Tom Engelhardt, "Fifty Years Under a Cloud: The Uneasy Search for Our Atomic History," *Harper's*, January 1996, 71–76, quotation on 72. In a marvelous commentary she sent me in September 2012, Joanne Gernstein London had an even better take of this sort: "It was exciting to think we were going to create an exhibit as powerful (and as much a testament to American democracy) as 'A More Perfect Union.' The idea was a goner before it was ever proposed. I mean, it was the NASM, not the NMAH we were talking about."

13 John Leo, "The National Museums of PC," *U.S. News and World Report*, 10 October 1994; Jonathan Yardley, review of Heather MacDonald, *The Burden of Bad Ideas: How Modern Intellectuals Misshape Our Society* (Chicago, 2000),

in the *Washington Post*, 8 October 2000. Other remarks by Yardley about "the zealots of academe" are quoted in "How the Bomb Was Spun," in the *Washington City Paper*, 18 August 1995. *City Paper*, Washington's "alternative weekly," was one of NASM's few defenders.

14 Ben Lawless told me of his army division "resting in Czechoslovakia after chasing the Germans down there, when we were awakened one July morning by our captain, who announced in his usual cheery voice that we had been selected to be in on the second wave of the invasion of Japan. We went away from there pretty much sure we were all going to die."

15 These lists are reproduced in *The Enola Gay Debate*.

16 "The Smithsonian and the Bomb," *New York Times*, 5 September 1994. A measure of comic relief was supplied by newspapers that automatically substituted for the word "gay," such as the *Northwest Herald* in Crystal Lake, Illinois, whose 5 September 1994 story about a reunion of the 509th Composite Group in Chicago was headlined "Atomic Bombers Criticize Enola Homosexual Exhibit." There were also references to the "Enola Gray" (e.g., Louis L. Goldstein, "For the Truth About Bombs, Ask a Vet," [Easton, Md.] *Sunday Star*, 18 June 1995), with no way of telling whether this was a typo.

17 The fatuous numerical specificity resulted from negotiations in which the American Legion began by projecting a million casualties if there were an invasion; the number 63,000 came from historian Barton Bernstein of the advisory board; and the final break came when Harwit, on his own, reduced the number in the script from the 229,000 previously settled by negotiation.

18 Even though Adams had made known his plan to retire before the *Enola Gay* controversy reached white heat, he did have to admit that "this may be a good time to be leaving." Actually, it appeared that he was never comfortable in the job, almost from the beginning. What most disappointed the man that *Washingtonian* magazine had called "The Quiet Revolutionary" (22 August 1987) were the mixed results of his pledge to put the institution on the cutting edge of scholarship. Distinguished historians did come on board, but in general Adams set his sights unrealistically high. Like Ripley before him (and like Harwit), Adams had little regard for most military historians, though not all: he had been keen to land a military historian prominent in the Society for the History of Technology—soon to become its president—as director of NASM. But when Forrest Pogue retired as director of the Eisenhower Institute at NMAH, Adams simply allowed it to close up rather than authorizing a search for a replacement.

19 Jacqueline Prescott, "Michael Heyman: Airing the Nation's Attic," *Washington Post*, 20 September 1994.

20 *The Torch* played up "the biggest controversy ever at the Smithsonian [ending]

with the *biggest news conference*": sixty reporters, ten radio correspondents, and twenty-six television crews somehow managed to crowd into a smallish room in the S. Dillon Ripley Center, along with Heyman and fourteen regents.

21 J. Lynn Lunsford and George E. Hicks, "Interview—Paul W. Tibbets," *Dallas Morning News*, 5 February 1995; "Atom Bomb Plane *Enola Gay* Put on Display," Reuters, 20 September 1996.

22 Harwit first mentioned plans for "a major exhibition about the history of strategic bombing" in response to an accusation that the curators of an exhibit on the aviation designer Igor Sikorsky were influenced by the sponsor, United Technologies, the "parent" of Sikorsky Aircraft (Harwit, "Our Reputation Is Not for Rent," *Washington Post*, 23 December 1989). NASM was suspected of being influenced in this way routinely—recall Michal McMahon's remark in *Technology and Culture* about "a giant advertisement for the aerospace industry."

23 David Sanger, "Coloring History ~~Their~~ Our Way," *New York Times Magazine*, 2 July 1995; Arthur Hirsch, "Enola Gay Exhibit Opens—Without an Agenda," *Baltimore Sun*, 28 June 1995; Engelhardt, "Fifty Years under a Cloud," 76.

24 There was no room to show more than the forward fuselage (the "beer can") along with a potpourri of smaller components; hence, the exhibit was shorn not only of historical context but also of most of the aircraft itself. The fuselage would lack a proper *engineering* context until the entire plane could be reassembled for display at NASM's promised annex adjacent to Dulles Airport.

25 Johnson was a decorated Air Force veteran who had spent seven years as a prisoner of war in Hanoi and written a book about his ordeal, *Captive Warriors*. Besides the book intended to accompany the exhibit, there was to have been another from NASM. For more than a year in 1989 and 1990, the museum had hosted a series of symposia and lectures on strategic bombing, with a stellar array of participants and speakers ranging from Kurt Vonnegut and Freeman Dyson to Robert McNamara and Curtis LeMay, and Harwit repeatedly announced a forthcoming volume titled "The Legacy of Strategic Bombing" under the editorship of Tami Davis Biddle, a student of Paul Kennedy and Gaddis Smith at Yale who was a NASM fellow. Like *The Last Act*, it never appeared either.

26 As early as November 1994, Tibbets had met with Heyman and urged him to fire Harwit, along with Crouch and Neufeld, but the official Smithsonian position was always that Harwit resigned. Eugene L. Meyer, "Target: Smithsonian: The Man Who Dropped the Bomb on Hiroshima Wants the Exhibit Scuttled," *Washington Post*, 30 January 1995; William Schultz, "NASM Director Steps Down," *Torch*, June 1995.

27 Harwit, *Exhibit Denied*, viii, 429. Johnson was a quintessential Texas loose cannon. Several years later, he told President George W. Bush that the weapons of mass destruction not found in Iraq were actually in Syria and that he himself,

as an old fighter pilot, could "put two nukes on 'em and . . . we won't have to worry about Syria any more."

28 Neufeld would follow *The Rocket and the Reich* with *Von Braun: Dreamer of Space, Engineer of War* (New York, 2007), winner of multiple prizes, including the Leopold Prize from the Organization of American Historians, the Eugene M. Emme Award from the American Aeronautical Society, and the Smithsonian Institution Secretary's Research Prize. (Surely his time of troubles was forgotten in the Castle.) Neufeld also co-edited a book about NASM published by National Geographic. It includes a chapter he coauthored with Crouch, "The World's Most Popular Museum," in which they showed how well they had regained their equilibrium, not to say their wit and gumption, by including a segment about the *Enola Gay* controversy titled "The World's Most Unpopular Museum." See Neufeld and Alex M. Spencer, eds., *Smithsonian National Air and Space Museum: An Autobiography* (Washington, D.C., 2010).

29 Hallion quoted in "Outcry Wins Revision of Exhibit," *Washington Times*, 30 August 1994. The *Times*, founded as the city's "second paper" in 1982 by the Rev. Sun Myung Moon of the Unification Church to publish "socially and politically conservative views," printed the first newspaper story about the *Enola Gay* controversy, "Rewriting History," 28 March 1994, and—with its wealth of inside sources—seldom let it go for more than a day or two until after Heyman's exhibit opened in June 1995.

30 A reviewer of Harwit's book put this sense of his naïveté most succinctly when she wrote of his "failure to appreciate the tenacity and political savvy of his opponents" (Patricia Mooney-Melvin, review of *An Exhibit Denied* in *Journal of American History* 84 [1997]: 1159). Joanne Gernstein London relates a stunning instance of naïveté on Harwit's part: charged with writing the part of the script about the 509th, she was actually the *very first NASM staffer* to contact General Tibbets. Protocol! "The Director should have called the General," she writes, "not little ole me, and a girl to boot."

31 "Stanley Goldberg, 62, Physicist and Historian," *New York Times*, 17 October 1996. Goldberg's book was finished by political scientist Robert S. Norris as *Racing for the Bomb: General Leslie R. Groves, the Manhattan Project's Indispensable Man* (New York, 2003). When Norris gave generous credit to Goldberg's "many years of enthusiastic research," he was past caring. While he was still alive, however, Goldberg suffered shabby treatment at the hand of Heyman, who ordered NMAH director Spencer Crew to cancel Goldberg's talk about the *Enola Gay* controversy, slated for the museum's weekly colloquium on 7 March 1995. In a disingenuous memo to the NMAH staff, Crew wrote that the talk had generated too much "outside interest," and the conference room where the col-

loquium was held "could not accommodate the potential audience." Goldberg was promised a chance to participate in a Heyman-arranged symposium at the University of Michigan, "Presenting History: Museums in a Democratic Society." But he was never invited, even to a forum "far from political ground zero," and the symposium addressed few of the issues he told friends he would have sought to raise. Eugene L. Meyer, "Smithsonian Sifts Debris of Enola Gay Plan," *Washington Post*, 20 April 1995.

32 Donald S. Lopez quoted in Phil McCombs, "Staying the Course: At Air and Space, a Stout Salute to the Engen Legacy," *Washington Post*, 15 July 1999. Lopez, himself a combat ace who had been with the museum since 1972, was speaking as acting director while a search got under way for a replacement for Harwit's successor, Admiral Donald Engen, yet another ace. Engen had died in a glider accident at age seventy-five. McCombs wrote that when Engen "came on board, veterans and military groups felt that they were reclaiming a beloved institution from 'academics' such as former director Martin Harwit." Engen "instinctively understood Air and Space the way most Americans do," said Mike Fetters (who had been a spectacular failure as Harwit's public affairs officer), "as a patriotic Temple of Technology."

33 Neufeld and Spencer, *Smithsonian National Air and Space Museum*, 298.

34 Andrew Guilford, review of "The West as America: Reinterpreting Images of the Frontier, 1829–1920," *Journal of American History* 79 (1992): 199–206, quotation on 206.

35 Mike Wallace, *Mickey Mouse History and Other Essays on American Memory* (Philadelphia, 1996), 302.

36 Neil Harris, "Museums and Controversy: Some Introductory Reflections," *Journal of American History* 82 (1995): 1102–10, quotation on 1104. National museums always had this cachet: "When a man wants to write a book full of unassailable facts," wrote Anthony Trollope, "he always goes to the British Museum."

37 Peter Blute quoted in "*Enola Gay* Controversy Continues," *Organization of American Historians Newsletter*, February 1995. Blute later shifted his endeavors to a talk-radio program. In taking a ten-year perspective on the *Enola Gay* controversy, John Correll, now retired from the editorship of *Air Force* magazine, cast the entire narrative in terms of "Revisionism Gone Wrong," *Air Force*, April 2004, www.airforce-magazine.com/MagazineArchive/Pages/2004/April%202004/0404revision.aspx.

38 Heather MacDonald, "Revisionist Lust: The Smithsonian Today," original 1997 essay in the *New Criterion* reprinted in *Burden of Bad Ideas*, 117–43, quotation on 118. The word Gingrich used was mistakenly quoted in the newspapers as "ideologies."

39 Heyman quoted in Jacqueline Trescott, "Vietnam Exhibit Postponed," *Washington Post*, 24 February 1995.

40 Heyman quoted in Rowan Scarborough, "Smithsonian Chief to Alter Another Exhibit," *Washington Times*, 24 February 1995. As the *Enola Gay* saga seemed to be nearing a resolution, the *Times* relished Heyman's discovery of another stick with which to beat the errant curators.

41 John Heilbron, "Concluding Remarks," in *Museums of Modern Science*, ed. Svante Lindqvist (Canton, Mass., 2000), 189–92, quotation on 192.

42 Memo, Forman to Walter Cannon, Audrey Davis, Jon Eklund, Barney Finn, Uta Merzbach, and Deborah Warner, 29 July 1975, copy in author's files.

43 Bernard Finn, "Context and Controversy," in Lindqvist, *Museums of Modern Science*, 151–58, quotation on 156.

44 Barbara Charles, the original designer, had worked on many exhibits at the museum when Ben Lawless was there but clashed repeatedly with Michael Carrigan, Lawless's successor in a formal sense but nothing like him when it came to creative passion and his appreciation for that quality in others. Carrigan also clashed with Jeff Howard, who designed *A Material World*, but Howard was able to hang on.

45 Molella tells of his shock one evening when starting to lead a tour for distinguished visitors, including Nobel Prize winners, and hearing one of them call out, "Do you have *any* idea why scientists are angry about this exhibit?" (Robert C. Post and Arthur P. Molella, "The Call of Stories at the Smithsonian Institution: History of Technology and Science in Crisis," *ICON* 3 [1997]: 44–82, quotation on 57).

46 Christina Hoff Sommers, "The Flight from Science and Reason," *Wall Street Journal*, 10 July 1995. Sommers drew largely on a "damage report" by Harvard historian Gerald Holton, charging that the ACS had no inkling that American science was going to get depicted "as a series of moral debacles and environmental catastrophes."

47 Heyman quoted in Rowan Scarborough, "Clothing Makers Cite Bias in Exhibit," *Washington Times*, 27 September 1997.

48 In the notebooks could be found a copy of a letter warning Heyman to WITHOLD FURTHER FINANCIAL SUPPORT and another extolling "opportunities that 100 years of apparel manufacturing have allowed for the immigrant, the under-educated, the minority, etc." Making copies of this material available to the public was a novelty of the first order, but almost nobody picked up the notebooks or even noticed them.

49 The title of Jacqueline Trescott's *Washington Post* review (22 April 1998) was "In 'Sweatshops' Smithsonian Holds Back the Outrage," and the reviewer for *Technology and Culture* mentioned searching in vain for Emma Goldman and

"miss[ing] the Triangle fire unless you knew where to look for it" (Mary Alexander, "'Between a Rock and a Hard Place: A History of American Sweatshops, 1829–Present' at the National Museum of American History," *T&C* 40 [1999]: 861–65).

50 Henry to J. P. Lesley, 12 January 1877, and to B. A. Gould, 30 January 1877, quoted in Wilcomb E. Washburn, "Joseph Henry's Conception of the Purpose of the Smithsonian Institution," in *A Cabinet of Curiosities*, ed. Whitfield Bell et al. (Charlottesville, Va., 1967), 144, 145.

CHAPTER 10. Small's World

1 Paul Oehser's *Sons of Science: The Story of the Smithsonian Institution and Its Leaders* (New York, 1949), marking the Smithsonian's centennial, was long considered the institution's official history. And it remains useful for material on Baird and the inception of the National Museum, especially for the chapter titled "George Brown Goode, the Young Genius," 92–109. In *James Smithson and the Smithsonian Story* (New York, 1965), coauthored by Leonard Carmichael and J. C. Long (and dedicated to S. Dillon Ripley), Goode is inexplicably omitted.

2 At the Mall entrance, José de Rivera's mobile, *Infinity*, was installed in 1967. This was followed a year later by Alexander Calder's stabile, *Gwenfritz*, on the west side of the building and in 1969 by George Rickey's kinetic *Three Red Lines* on the east. See James M. Goode, *The Outdoor Sculpture of Washington, D.C.* (Washington, D.C., 1974), and, especially, "Measuring *Infinity*: José de Rivera's Smithsonian Sculpture on the National Mall," *Curator: The Museum Journal* 51 (April 2008): 179–85, by David Shayt, whose ironic detachment and lovely prose shine through in this, his last article. "*Infinity*'s stately rotation reflects one artist's personal, plastic experience with space, metal and time," wrote David, "but it was the museum itself that began to turn in 1980. The newly renamed National Museum of American History turned away from recognizing the exceptional category of 'technology' as an entity distinct from 'history,' shunning the notion of a logical progression of technological improvement over time and across the globe."

3 David Hackett Fischer, *Historian's Fallacies: Toward a Logic of Historical Thought* (New York, 1970), 4. I recall listening to Fischer give an informal talk to the curators in the mid-1980s, and realizing that some of these men and women had never before heard a rebuttal of "the Baconian fallacy," the supposition that fact stacked upon fact would eventually yield some "general truth."

4 Cary Carson, quoted in Fergus M. Bordewich, "Revising Colonial America," *Atlantic*, December 1988, 26–32, quotation on 31. Also see Richard Handler

and Eric Gable, *The New History in an Old Museum: Creating the Past at Colonial Williamsburg* (Durham, N.C., 1997), already a classic in the "scholarship focusing on museums as arenas for the significant convergence of political and cultural forces" (8).

5 I. Michael Heyman, "Do Curators Have Anything to Learn from Lawyers?" 1996 Hart Lecture, Georgetown Law Center, 20 March 1996. The last question spoke to an issue pertinent to the recruitment of curators trained as scholars and was summed up in a remark by Elie Wiesel about two different worlds of discourse. His own world, he said, "is that of words and verbal images, not of lenses and visual images" (quoted in Edward T. Linenthal, *Preserving Memory: The Struggle to Create America's Holocaust Museum* [New York, 1995], 126).

6 It was sometimes reported that Heyman had brought in much more at Berkeley, but the *New York Times* probably had it right: "donations more than tripled during his tenure [as chancellor], to $100 million from $31 million." These were paltry by Ivy League measure; more remarkable about Heyman's tenure was the increased number of nonwhite undergraduates during that same ten years, from 27 percent to 51. "Michael Heyman, Smithsonian Leader, Dies at 81," *New York Times*, 27 November 2011.

7 Beyond the special Bicentennial appropriation, fifteen individuals and firms were credited with "vital financial support" for *1876*, no amount exceeding four figures. When George Trescher, called by the *New York Times* "a master of fund-raising," was hired on behalf of *1876*, he told me that he found donors reluctant because of an assumption that "the Smithsonian can always count on Uncle Sam."

8 Selin (b. 1937) had been one of Robert McNamara's Defense Department Whiz Kids and became chairman of the Nuclear Regulatory Commission during the first Clinton administration. Darman (1943–2008) served in several Republican administrations, lastly as director of President George H. W. Bush's Office of Management and Budget. The profits of American Management Systems derived largely from consulting contracts with federal agencies; The Carlyle Group was one of the top three private equity firms worldwide. For a list of current board members, http://americanhistory.si.edu/about/board.

9 "Smithsonian Recognizes Donors of $1,000,000 or More During Fiscal Year 1999," *Smithsonian Today*, Winter–Spring 2000, 5.

10 Behring originally wanted his name to stand alone—"The Behring" it would have been, like The Freer, The Hirshhorn, or, indeed, The Smithsonian—but that would have taken an act of Congress. Worth repeating is Robert Hughes's remark in *Culture of Complaint: The Fraying of America* (New York, 1993), 177: "Museums have been sustained by some of the best and most disinterested people in America . . . and by some of the worst."

11 Kenneth E. Behring, *Road to Purpose* (Alexandria, Va., 2004), 90. While Behring's book has photos of him with presidents and kings, Heyman was the past master at striking a pose for publicity—happily astride a Harley Davidson motorcycle delivered by the governor of Wisconsin, for example. "Charm gets you everywhere," his Berkeley chief-of-staff remembered Heyman saying. But a historian on the Smithsonian Council recalls him "chatting with someone sitting next to him in a very loud voice" throughout a series of formal presentations.

12 According to an online description, "It's all stainless steel and plate glass standing on massive galleries of black, ruby, and pink Italian granite, lit by copper hued German skylights that make the gallery interiors glow" (www.discoversandiego .com/anderson/large/blackhawk1.htm, accessed July 2012).

13 Behring, *Road to Purpose*, 91–92. In his book, Behring sometimes refers to moves made for "tax purposes." He had just sold his football team and capital gains were substantial.

14 The elephant lost billing as the largest ever shot in 1974 and was now just "the biggest ever mounted."

15 Jacqueline Trescott, "Smithsonian Receives $20 Million Gift," *Washington Post*, 6 November 1997; Trescott, "The Give and Take of Museum Donations," *Washington Post*, 8 August 1998.

16 The Lemelson Foundation would contribute several more times, the total eventually topping $40 million. As Andrew Sullivan tells it in "The Past Isn't What It Used to Be: The Remaking of the Mixed-up National Museum of American History," *Weekly Standard*, 15 December 2008, Lemelson was no happier with what he saw in the museum than Behring was. Sullivan quotes him saying, "They just had the machines, not the people." Lemelson wanted exhibits that concentrated "particularly on the individual inventor . . . to inspire a new generation to enter this all-American profession."

17 Behring, *Road to Purpose*, 93.

18 Enid A. Haupt (1906–2005), the daughter of Moses Annenberg and sister of Walter Annenberg, "was the greatest patron American horticulture has ever known," said Gregory Long, president of the New York Botanical Garden. In Washington, she underwrote the Haupt Fountains on the Ellipse, as well as the four-acre Victorian garden planted atop the Ripley Center, a favorite site for Smithsonian ceremonies.

19 Barber Conable, quoted in Irvin Molotsky, "President of Fannie Mae Is to Lead Smithsonian," *New York Times*, 14 September 1999.

20 Thompson's "History for $ale," *Washington Post Magazine*, 20 January 2002, and Van Dyne's "Money Man," *Washingtonian*, March 2002, were both journalistic tours de force that appeared early in Small's third year as secretary, when

it was clear that he had "provoked his own civil war" (Joanna Neuman, "The Storm at the Smithsonian," *Los Angeles Times*, 2 June 2002). On the cover of the *Washington Post Magazine*, Thompson's article was headlined "Who Owns American History? The Smithsonian's War over Money and Control."

21 Howard Baker, quoted in "Regents Name Lawrence Small 11th Secretary of the Smithsonian," *Torch*, October 1999.

22 John Shepherd Reed, quoted in Philip Zweig, *Wriston: Walter Wriston, Citibank, and the Rise and Fall of American Financial Supremacy* (New York, 1995), 867, 868.

23 "Regents Name Lawrence Small 11th Secretary of the Smithsonian," *Torch*, October 1999. In its own press release, Small's former employer called him "a key participant in Fannie Mae's success in leading the nation to a record homeownership rate."

24 Zweig, *Wriston*, 283.

25 Ibid., 841. "People come to the Smithsonian for new knowledge," Beach told Diane Rehm on 5 July 2001, http://thedianerehmshow.org/shows/2001-07-05/milo-beach-freer-and-sackler-galleries. At issue with one of the directors who resigned, Alan Fern of the National Portrait Gallery, was a decision by Heyman about space allocation that Small upheld. Fern was reportedly called on the carpet by Small and "ordered not to talk publicly about the allocation dispute" (Jacqueline Trescott, "Portrait Gallery Chief Alan Fern to Retire," *Washington Post*, 4 February 2000). This was an early indication of Small's penchant for secrecy; a secret impossible to keep preceded his downfall.

26 Jacqueline Trescott, "Team Player," *Washington Post*, 25 January 2000.

27 Morton Kondracke, "Congress Should Encourage Reform at the Smithsonian," *Easton* [Maryland] *Star Democrat*, 8 August 2001. Kondracke understood that the "struggle [was] over who will control the Smithsonian—the secretary or 16 individual museum directors and their staffs, who have become accustomed to operating independent fiefs." The virtues of that system, with its aim of fostering scholarship, were appropriately upheld by a *Washington Post* correspondent who identified herself "as a historian and the daughter of Brooke Hindle, the last scholar/director of the National Museum of History and Technology" (Margaret Hindle Hazen, "At the Smithsonian, A Discouraging Direction," *Washington Post*, 2 February 2002).

28 Jacqueline Trescott, "Top Down Change at Museum," *Washington Post*, 12 February 2000. What was notable about Small's structure was that SBV would now be a separate entity with its own board of directors who would seek to enhance "profit centers" such as the IMAX theaters, six restaurants, fifteen gift shops, mail order and online shopping, a shopping-mall retailer, and, most importantly, cable television and Hollywood movie revenue.

29 The national zoo had been established in 1889 as the Department of Living Animals, in order to house a menagerie, mostly buffalo, encamped beside the Castle. Over the years, zoo personnel paid increasing attention to species facing extinction, but of course the public knows any zoo only for its exhibits.

30 Jacqueline Trescott, "History Museum Gets $80 Million," *Washington Post*, 19 September 2000. "A gift of this magnitude is unprecedented," said Small. "We are delighted to honor this great benefactor to the Smithsonian by establishing the Behring Center" (quoted in Linda St. Thomas in "Philanthropist Kenneth Behring Increases SI Gift to $100 Million," *Torch*, October 2000.) On the op-ed pages of the *Post*, Small would try to defend the Behring Center name as no different from the several other parts of the Smithsonian with the name of an individual at the front door.

31 Behring, quoted in Sullivan, "Past Isn't What It Used to Be."

32 "A Hurried Hail to the Chiefs," *Washington Post*, 9 June 2000.

33 Small the "process" man could not understand why the Kenneth E. Behring Family Hall of Mammals was still a long way from completion. But on-time and under budget with such projects was never a Smithsonian hallmark. That exhibit was not actually finished until the fall of 2003. With 25,000 square feet, it was three times the size of the old one, and it cost $10.3 million *besides* Behring's $20 million—$30.3 million total. Small never seemed interested in the Smithsonian's history, but he probably was aware that the total cost of the Museum of History and Technology was only $33.7 million, and that it had taken less than four years to build the Air and Space Museum from the ground up.

34 Jacqueline Trescott, "Hats Off to the Presidency," *Washington Post*, 15 November 2000.

35 Crew was a loyal soldier, telling an interviewer that he "had jumped on the idea" as soon as Small mentioned it but sounding as if he was reading a script sent over from the Castle when he affirmed his enthusiasm for "a return to an older kind of history," the kind the interviewer called "the history of dead white men" ("Presenting the Presidents: An Interview with Spencer Crew by Donald L. Miller," *American Heritage*, November 2000, 54–57, quotations on 55). This was not in accord with Crew's earlier pleas, oft repeated, for the need to "accustom visitors to encountering new ideas in museums" as a way of negating "the question of 'who owns history' " ("History in the Museum," *AHA Perspectives*, October 1996, 6–8, quotations on 8).

36 Alexis Doster, "Recollecting the Presidents: An Election Year Exhibition Proudly Hails the Chiefs," *Smithsonian*, November 2000.

37 One other promise to Behring was that his own architect, Doug Dahlin, who had designed Behring's home in California as well as the Blackhawk Museum,

could address an overall "modernization" of the museum's public spaces. Dahlin worked well with the staff despite the handicap of his association with Behring, but the contract for the makeover begun in 2006 went to the Chicago behemoth of Skidmore, Owings and Merrill, which utterly transformed the space where the pendulum once swung, by most estimates not for the better.

38 Quoted from Van Dyne, "Money Man."

39 Jacqueline Trescott, "Local Woman Gives Smithsonian $35 [sic] Million," *Washington Post*, 5 May 2001; Judy Wells, "EVE Speaker Worked for, Achieved Her Dreams," *Florida Times-Union*, 25 May 2003. As Catherine Brescia, Reynolds grew up in Jacksonville, Florida, and graduated from Vanderbilt University as an economics and business administration major. At first she went to work for Arthur Anderson, the accounting firm, then in 1988 she joined Whalen in a nonprofit aimed at making loans available to boys and girls "who didn't fit the usual grant and scholarship categories." Later it became EduCap, and Reynolds spun off a for-profit affiliate, Servus Financial Corporation, from which she netted a half billion dollars when it was sold to Wells Fargo Bank.

40 John C. Ewers to Wilcomb E. Washburn, 8 May 1958, RU 623, Box 3, SIA.

41 Jacqueline Trescott, "Smithsonian's Castle under Siege: Opposition Coalesces over Planned Science Program Cuts," *Washington Post*, 27 April 2001.

42 Memo, Lucy H. Spelman to staff, 5 April 2001. With a doctorate from the University of California, Davis, Spelman had been with the zoo for five years, most recently as chief veterinarian in the Department of Animal Health. As director, she was in charge of 324 employees and oversaw a budget of $26 million. At age thirty-seven, she had limited administrative experience, and her appointment foretold Small's practice of hand-picking young people, often women, for positions of high authority—people he could readily manipulate, so his foes claimed. Spelman would resign four years later in the wake of a devastating report from the National Academy of Sciences that the zoo had "problems at all levels" that "threaten[ed] the well-being of its 2,600 animals."

43 Loveland tells of Eames's role in founding the Exhibits Motion Picture Unit in 1969, and the closure of what was then called Smithsonian Production in 2002 by a secretary who "did not want to take the time to understand its purpose" in an unpublished memoir titled "Charles Eames—Film History at SI," which she had kindly shared with me.

44 "Gutted" was the word for the fellowship program that Peter Monaghan used in the *Chronicle of Higher Education*, 11 July 2003. Curator Jeffrey Stine reported that Small "told the Smithsonian research staff that if they valued the fellows so much they should either go out and raise the money themselves or allocate their discretionary research funds toward that cause." Actually, Small had his

own eye on these funds, which curators accumulated largely from speaking engagements.

45 Among the first letters of support were from the two daughters of S. Dillon Ripley, who had established the Research Center in 1974. Ripley was just recently deceased, and news of its impending closure broke three days before a memorial service on the Mall. "A little irony goes a long way," said NMAH historian Joyce Bedi.

46 Crew, quoted in Jacqueline Trescott, "American History Museum Director Quits," *Washington Post*, 20 September 2001. Jeffrey Stine told Trescott that Crew kept his own council about the controversy: "He never complained... but you could tell he was under pressure." In the top spot in Cincinnati, Crew found no respite from pressure, in this case fears and accusations that the Freedom Center was going to be "more a tourist theme park than an authentic place of history" (Frances X. Clines, "Slave 'Railroad' Buffs Question Museum Site," *New York Times*, 24 June 2002).

47 One of Small's first hires was James Morris, formerly with the American Enterprise Institute, as a speechwriter. In a 9 June 2001 letter to the *Post*, Morris wrote that "Americans will have reason to be grateful for the enduring consequence of Small's actions in a fundamentally strengthened and newly vital Smithsonian," and he scolded *Post* columnist Richard Cohen for presuming "to judge a man whose honesty and sense of purpose are on a plane far above his reach."

48 Patricia Nelson Limerick, "How Reporters Missed 'The Spirit of America,'" *Chronicle of Higher Education*, 24 May 2002. An example of this sort of reportage was John Balzar, "A Heritage for Sale," *Los Angeles Times*, 6 June 2001, which began, "There is simply no end of the fun that the filthy rich can have."

49 "Smithsonian Pluses and Minuses," *New York Times*, 7 February 2002. Small kept his thoughts to himself when Reynolds donated $100 million to the Kennedy Center for the Performing Arts, to launch the funding drive for a new educational center. With previous gifts to the Kennedy Center, Ford's Theater, the National Symphony, and the National Gallery of Art, Reynolds entered a philanthropic realm absent in Washington "since the days of Andrew and Paul Mellon." Jacqueline Trescott and Roxanne Roberts, "Record Gift for Kennedy Center," *Washington Post*, 2 December 2002.

50 Jacqueline Trescott, "Smithsonian Secretary Faces Federal Charge," *Washington Post*, 21 January 2004; Trescott, "Small Gets Two Years Probation: Smithsonian Secretary Bought Protected Artifacts," *Washington Post*, 24 January 2004. A year after he was sentenced, what Small said about reading for the blind and hammering nails got into a Hearst News Service story that appeared nationwide. Eric Rosenberg, "Just What Is 'Community Service'? Justice Balks at Letting

Museum Head Spend His Sentence Reading Up on Law He Broke," *Houston Chronicle*, 16 February 2005.

51 "Christián Samper to Direct Natural History," *Torch*, March 2003; see also Caroline Taylor, "Profile: Christián Samper, from Plant Dynamics to a Dynamic Museum," *Torch*, May 2005.

52 Maureen Dowd, "Tales from the Crypt," *New York Times*, 24 June 2001.

53 Estes Thompson, "Smithsonian Chief Pleads Guilty in Feather Case," *Washington Post*, 23 January 2004. This was an Associated Press story, well circulated. Jim Hobbins (b. 1943) can fairly be called the quintessential Smithsonian appartchik (of which there is no better definition than James H. Billington's in *Fire in the Minds of Men* [New York, 1999], 455: "a man not of grand plans, but of a hundred carefully executed details"). Before Small, Hobbins had served Heyman, Adams, and Ripley. But at the start, from 1967 until 1974, he had been a historian in the office where Nathan Reingold was editing the Joseph Henry Papers. By 2007 the very mention of a project like the Henry Papers evoked a Smithsonian world that was lost beyond recall.

54 When the Office of Federal Housing Enterprise Oversight and the Securities and Exchange Commission exposed the fraudulent accounting intended to enhance Fannie Mae's "executive bonus pool," Small was implicated, but the regulatory agencies took no action. See Katherine Day and Jacqueline Trescott, "Small Linked to Scandal at Fannie Mae," *Washington Post*, 26 May 2006. Later, Fannie Mae and Freddie Mac would be denounced from the political right as "mortgage scams" and "the root of the evil behind the financial collapse of 2007–2008" (David Bromwich, "The Republican Nightmare," *New York Review of Books*, 9 February 2012).

55 Keelin McDonnell, "A Blight in the Museum: Smallville," *New Republic Online*, 5 March 2007, www.newrepublic.com/article/blight-the-museum-smallville. "Visitors should be forgiven," wrote McDonnell, "for imagining that the museum is more concerned with the diffusion of merchandise than of knowledge."

56 Lawrence Small emails to James M. Hobbins and John Huerta, 25 January 2007, and to Hobbins, Huerta, and Yong Lee (Small's personal assistant), also 25 January 2007.

57 In 2011 Samper resigned as director of the Museum of Natural History to become CEO of the Wildlife Conservation Society, the organization that manages New York's zoos as well as 200 million acres of wild lands worldwide. In Smithsonian corridors, one heard "someday he'll be back" over and over.

58 Grassley, quoted in James V. Grimaldi and Jacqueline Trescott, "Museum Ousts Gary Beer for Excess Expenses," *Washington Post*, 2 August 2007.

59 Janice Kaplan, "Jim Hobbins: Quiet Support behind Four Successful Secretaries," *Torch*, September 2004; James Grimaldi, "Smithsonian Official Quits

after Records Destroyed," *Washington Post*, 8 August 2007. Through his lawyer, Hobbins contended that he destroyed only "transitional documents," and, years later, an article about his elegant home in Potomac, Maryland, mentioned only that "he retired in 2007 after a dispute over the proper procedure for handling transcripts of a regents' meeting" (Jura Koncius, "Living History," *WP* [Washington Post] *Magazine*, 30 September 2012, 20–27). Huerta resigned in 2008 "to pursue a new career in the arts by developing his creative talent."

60 Charles A. Bowsher, Stephen D. Potts, and A. W. "Pete" Smith Jr., *A Report to the Board of Regents of the Smithsonian Institution*, 18 June 2007.

61 Tom Ellington, "Smithsonian's Secret Mission: Small Issue?" *Washington Times*, 28 August 2001.

62 Charles Grassley, Chairman, Senate Committee on Finance, to Rob Portman, Director, Office of Management and Budget, 9 June 2006, online along with other documents pertinent to Small's "troubled performance record" at www .finance.senate.gov/newsroom/ranking/release/?id=6a76c433-5bf5-41a8-b01 b-e29ac2c7d8d3.

63 Berkley W. Duck III, *Twilight at Conner Prairie: The Creation, Betrayal, and Rescue of a Museum* (Lanham, Md., 2011).

64 The regents do convene several times a year in one of the Smithsonian's auditoriums, with the proceedings online at www.si.edu/Regents/.

CHAPTER 11. Timely and Relevant Themes and Methods of Presentation

1 Foner, the eminent De Witt Clinton Professor of History at Columbia, may soon have made Small and Burke (if not Darman) regret his presence. Toward the end of the meeting, he said that he had heard about controversies involving Reynolds and Behring but did not fully understand the issues and would like to see their contracts. To indications of general discomfort, Burke responded that this was not possible because they "were not public documents."

2 The exceptions who did have museum experience were Crew, of course, who remained a member even after moving to Cincinnati; acting NMAH director Marc Pachter (b. 1944), who had begun his career at the National Portrait Gallery in 1974 and then filled many curatorial and administrative posts including chair of the 150th anniversary celebration before becoming director of the Portrait Gallery in 2000; Diane Frankel, former director of the Institute of Museum Services in Washington; Ellsworth Brown, president of the Carnegie Museums of Pittsburgh; and Foner, who had curated exhibits at the Chicago History Museum and Virginia Historical Society, as well as consulting on presentations at Disneyland and Walt Disney World. In addition to Foner, other historians included Laurel Thatcher Ulrich, David Donald, and the ubiquitous Neil Harris

but nobody from the history of technology orbit, even though this was the staff's center of gravity and exhibits of technological devices still dominated more than half the exhibit space, and, by all reasonable expectations, always would.

3 *Report of the Blue Ribbon Commission on the National Museum of American History*, March 2002, http://americanhistory.si.edu/reports/brc/. The report was conveyed to the regents, to the museum's own board, to Lawrence Small and Sheila Burke, to Marc Pachter as acting director, and to the search committee to pass along to candidates for the directorship. Valuable as it was, the part about the architectural transformation would become "a can tied to the tail" of the incoming director, as curator Rayna Green put it. Green (b. 1942), who headed the museum's American Indian Program, had come to the Smithsonian as a predoctoral fellow in 1970, part of a first wave of young fellows who would attain eminence in the museum world, including Peter Marzio in Houston and Harold Skramstad in Dearborn.

4 Blake Gopnik, "Our Past, Cobwebs and All," *Washington Post*, 9 May 2002. "Where would you rather spend an afternoon," asked Gopnik, "in school or up under Grandmother's rafters?" "The galleries set up to teach and preach . . . are arguably less informative, and certainly less enticing, than the accumulated stuff of other exhibition halls." One could imagine Ben Lawless smiling.

5 Every director had been expected to solve the problem of incoherence, so glaring in comparison to Air and Space's straight corridors and clear sightlines. None had been able to do so, though there was some improvement. The exhibit of textiles and textile machinery, for one thing, was no longer staged on the far west end of the first floor as sort of a strange appendix to *Atom Smashers*, and Philately and Postal History, once sandwiched in a third-floor corner between Graphic Arts and Musical Instruments, now had a national museum of its own, in the old Central Post Office next to Union Station.

6 Bird was one curator who never forgot the maxim that a good exhibit demands a good catalog, and his were good. See, e.g., William L. Bird Jr., *Paint by Number: The How-to Craze That Swept the Nation* (New York, 2001).

7 *A Material World* covered the full chronological span, but this was in the process of being dismantled by Pachter, the acting director, whom it did not please.

8 Harold Skramstad, "The Exhibiting Dilemma: David Dernie's *Exhibition Design*," *Technology and Culture* 48 (2007): 603–11, quotation on 604. *America on the Move*'s vocabulary even included a "happening," a happy Ken Burns being driven up to the museum in a red 1903 Winton automobile similar to the one inside. The museum's Winton had made the first transcontinental road trip a century before, and Burns was debuting a PBS special, *Horatio's Drive*, in conjunction with the exhibit.

9 Another remark of Hayden White's, in *Metahistory* (Baltimore, Md., 1973), 192, seems especially apposite in the context of postmodern exhibit design: "Where alternate visions of reality are not entertained as genuine possibilities, the product of thought tends towards blandness and unearned self-confidence."

10 Don Phillips, "Did History End in 1926? One Wonders . . . ," *Trains*, March 2004, 14–15.

11 Robert H. Casey, "*America on the Move* at the National Museum of American History," *Technology and Culture* 45 (2004): 812–16, quotation on 814. This shop in Greenfield Village served notice that a "living-history" site had enormous educational advantages, no matter how rich the exhibit "vocabulary" of a museum like NMAH. Stepping aboard a car from the Chicago L that "almost felt like" it was jouncing along was an "experience," to be sure, but it was no match for an actual jouncing at Greenfield Village.

12 This was the bloodiest encounter involving American troops since Vietnam. The quoted phrase is from Scott Boehm's "Privatizing Public Memory: The Price of Patriotic Philanthropy and the Post 9/11 Politics of Display," *American Quarterly* (2006): 1147–66, on 1148. Boehm's critique might strike readers as intemperate, but its substance was mirrored in others cast in more moderate tones, e.g., Carole Emberton, "The Price of Freedom: Americans at War," *Journal of American History* 92 (2005).

13 In 2008 Pete Daniel, as president of the OAH, reported that a plan he helped devise, and several subsequent plans, had never gone forward because they "did not please Kenneth Behring." ("History with Boundaries: How Donors Shape Museum Exhibits," August 2008, www.oah.org/pubs/nl/2008aug/daniel.html.) In 2012, an exhibit called *American Stories* opened with the apparent purpose of fulfilling, finally, the promise of an introduction to the entire museum. But compared to what had once been envisioned, it was exceedingly modest, with mostly unremarkable specimens in glass cases, a design that would not have looked out of place in a modernized 1950s exhibit in A&I. A few people on the NMAH staff liked the traditional flavor and hoped it might signal the look of "American Enterprise," a planned exhibit on business enterprise for which the museum had received an initial $5 million from Mars, Inc., the makers of M&Ms.

14 Boehm, "Privatizing Public Memory," 1155. No attempt was made to call attention to anything being inauthentic, nothing like a label with *reproduction* or *replica* in parentheses, as had once been considered "good museum practice."

15 Bill Withuhn, "Artefacts at the Smithsonian: A New Long-Term Exhibition on the History of Transport Systems," in *Tackling Transport*, ed. Helmuth Trischler and Stefan Zeilinger (London, 2003), 167–72, quotation on 169. Suggestive of what an elaborate production *America on the Move* was, Withuhn reported

that he was one of *fifteen* curators and specialists directly involved in choosing artifacts and scripting; the initial MHT railroad and road vehicle exhibits were developed by a single curator, Jack White, with a helper or two.

16 Casey, *"America on the Move,"* 813, 812. Because *Jupiter* is indubitably a piece of the True Cross, the online version of *America on the Move* confused the issue even further by calling the entire Santa Cruz set piece, "not a part of the official Smithsonian Collection." The Brooke Hindle essay appeared in *Material Culture and the Study of American Life*, ed. Ian M. G. Quinby (New York, 1978), 5–20.

17 Lawrence Small, "Americans at War," *Smithsonian*, November 2004; Allison quoted in Boehm, "Privatizing Public Memory," 1149. Besides the name of the exhibit—assumed to be Behring's idea—the war in Iraq of course raised the most questions. In the *New York Times*, 19 March 2004, Donald Rumsfeld had written about "The Price of Freedom in Iraq." At the exhibit opening nine months later, Director of Homeland Security Tom Ridge and Joint Chiefs of Staff chairman General Richard Myers flanked Small and Behring on the podium. Thomas E. Ricks, in a generally favorable review of the exhibit, wrote that the curators "could have been more thoughtful than simply to repeat Pentagon rhetoric about how 'major combat operations took less than two months,' given that about 90 percent of U.S. soldiers' deaths in Iraq have occurred since then" ("On Wars," *Washington Post*, 10 November 2004).

18 Kenneth Behring got his name all over Natural History and American History, but as an individual "benefactor" (the term Small always used). Calling an exhibit "permanent" usually meant it was slated to stay up for at least ten years, but many lasted much longer than that. Though not dubbed a permanent exhibit, Marzio's *Henry R. Luce Hall of News Reporting* was still intact and open to the public in the late 1980s. When *On the Water* opened in 2009, the curator told a *Washington Post* reporter that it was replacing a "previous temporary maritime exhibit, which ran from 1978 to 2006." Overtired, perhaps, she also apologized for it being "very heavily into technology," when it was no more or less so than the new exhibit.

19 William L. Withuhn, "Only the Beginning," *Trains*, May 2004, 6.

20 Thompson, "The Wheel Thing," *Washington Post*, 23 November 2003. Anticipating the greatest vulnerability on the grounds of GM's alleged role in "destroying streetcar systems," one of the curators produced a refutation. Thompson seemed skeptical, even though the conspiracy theory was not tenable at all and the case could have been made more persuasively. See Robert C. Post, "Urban Railway Redivivus: Image and Ideology in Los Angeles, California," in *Suburbanizing the Masses: Public Transportation and Urban Development in Historical Perspective*, ed. Colin Divall and Winstan Bond (Aldershot, U.K., 2003), 187–209. One

suspects that the case was not made strongly for fear of seeming to curry favor from General Motors.

21 Small named Brent Glass (b. 1947) director in 2002. His previous job was at the Pennsylvania Historical and Museum Commission. (The other finalist for the job was Harold Skramstad.) To outsiders, Glass appeared to be unduly taken by his role as a "media presence" (an expression used in his Wikipedia entry), and many insiders were not surprised when he "retired" precipitously in 2011 in order "to promote history education."

22 Lubar quoted in Michael Lipske, "Full Steam Ahead for Exhibition of 'America on the Move,'" *Torch*, February 2003. Lubar had once been in the vanguard of the museum's small contingent of left-wingers and was savaged by the Manhattan Institute's Heather MacDonald for his fixation on "oppressive power relations." After beginning his NMAH exhibits career working with Brooke Hindle on *Engines of Change*, he was engaged for years afterward in nearly every exhibit that addressed technology in history, but in 2003 he departed for a professorship at Brown University.

23 There was an apparent misrepresentation in the picture book published along with the exhibit, Janet F. Davidson and Michael S. Sweeney, *On the Move: Transportation and the American Story* (Washington, D.C., 2003). A double-page photo of a vintage bus is accompanied by a block-letter quote from Rosa Parks about why she declined to give up her seat. In very small type, the bus is identified as an Indiana school bus, not, as one might assume, the Montgomery city bus in which Parks made history (which is at the Henry Ford Museum).

24 Otto Mayr believed that the controversy could have been deflected if the entire airplane had been exhibited inside the front entrance instead of just disconnected parts in "a limited nondescript space." Mayr, "The *Enola Gay* Fiasco: History, Politics, and the Museum," *Technology and Culture* 39 (1998): 462–73, quotation on 468.

25 Benjamin Forgey, "Lots of Air, and Plenty of Space," *Washington Post*, 16 December 2003.

26 Matthew L. Wald, "A Museum Increases Its Wingspan," *New York Times*, 16 November 2003.

27 Steven F. Udvar-Hazy quoted in Jacqueline Trescott, "The Gift That Got an Air Museum off the Ground," *Washington Post*, 8 October 1999; see also *Smithsonian Today* 1 (Fall 1999):1.

28 Ken Ringle, "Ready for Takeoff," *Washington Post*, 14 December 2003.

29 The 707 was restored by Boeing itself, a reliable NASM benefactor that also placed a glossy spread in a twenty-page Udvar-Hazy "advertorial" supplement in the *Washington Post Sunday Magazine* for 7 December 2003. Boeing mentioned "commercial aviation, space exploration, and unmanned flight" but not military

aviation. Joe Corn, who knew NASM from inside, notes that "aerospace probably generates a larger community of interest between those who interpret it and those who manufacture and use the artifacts than any other technological subject." "Tools, Technologies, and Contexts," in *History Museums in the United States: A Critical Assessment*, ed. Warren Leon and Roy Rosenzweig (Chicago, 1989), 244.

30 Lawrence M. Small, "A Century's Roar and Buzz," *Smithsonian*, December 2003, 20.

31 One can find answers to almost all the questions noted here in less than three pages of Anne Millbrooke's *Aviation History* (Englewood, Colo., 1999), 762–65.

32 Otto Mayr, "Museum Philosophy," copy of unpublished book-length manuscript in the author's possession, 4:4.

33 Edward Epstein, "Spreading Its Wings: The Smithsonian's Soaring Annex to the Air and Space Museum Shows Sweep of History, through War and Peace," *San Francisco Chronicle*, 15 February 2004.

34 Dailey quoted in Jacqueline Trescott, "Enola Gay Exhibit Won't Be Changed," *Washington Post*, 11 November 2003.

35 Even Tom Crouch's *Wings* (New York, 2003), 14, simply included the *Enola Gay* in the midst of a long list of NASM's well-known planes ("Wiley Post's *Winnie Mae*, Howard Hughes's classic H-1 racing aircraft, the B-29 *Enola Gay*, the Bell X-1"). Of the aircraft shown in a picture book about Udvar-Hazy, *America's Hangar* (Washington, D.C., 2003), about three-fourths were warplanes. It might be said that here in Chantilly is the war museum that was always shunned in Washington.

36 Maureen McConnell and Honee Hess, "A Controversy Timeline," *Journal of Museum Education* 23 (1998): 4–6. NASM's Roger Launius calls attention to the "Orwellian irony" of the beginning date, 1984, in his article "American Memory, Culture Wars, and the Challenge of Presenting Science and Technology in a National Museum," *Public Historian* 29 (2007): 13–30, quotation on 19.

37 Chuck Newbauer and Richard T. Cooper, "Senator's Way to Wealth Was Paved with Favors," *Los Angeles Times*, 17 December 2003; David Whitney, "Mr. Stevens Goes to Washington," *UCLA Magazine* 12 (Winter 2000): 26–31, quote on 26.

38 Peter Novick, *That Noble Dream: The "Objectivity Question" and the American Historical Profession* (Cambridge, 1988), 306. It was with the causes of World War I that the term *revisionism* became ingrained in historical discourse—in this case with a double meaning. As more documents became available during the 1920s and the war's complex causation more evident, historians revised earlier interpretations and also called for "a 'revision' of that clause in the Treaty of Versailles which declared Germany and her allies were solely responsible"

(Sidney B. Fay, *The Origins of the World War* [New York, reprint 1966], 1: xiii).

39 Heather MacDonald, "Revisionist Lust: The Smithsonian Today," *New Criterion*, May 1997, 17–31.

40 Peter Blute (R-Mass.), "Revisionist History Has Few Defenders," *Technology Review*, August–September 1995, 51–52. Under the heading of "The Atomic Age at 50," this issue of *Technology Review* included seventeen diverse essays, the authors including John Dower, Hugh Gusterson, Carl Kaysen, and Alex Roland.

41 Colin Divall and Andrew Scott, *Making Histories in Transport Museums* (London and New York, 2001), 99.

42 John Dower, "How a Genuine Democracy Should Celebrate Its Past," *Chronicle of Higher Education*, 16 June 1995.

43 Richard H. Kohn, "History and the Culture Wars: The Case of the Smithsonian Institution's *Enola Gay* Exhibition," *Journal of American History* 82 (1995): 1036–63, quotations on 1054.

44 House Subcommittee on Libraries and Memorials, *Smithsonian Institution: General Background—Policies and Goals from 1846 to Present*, 91 Cong., 2d sess., 21 July 1970, 185.

45 Casey, "*America on the Move*," 815.

EPILOGUE. What *Is* the Story?

1 Bob Thompson, "Where Myth and Museums Meet," *Washington Post*, 19 September 2004. NASM is situated in the Smithsonian bureaucracy as a "science" bureau, whereas NMAI is located with "history, art, and culture."

2 Rick West quoted in Thomas Hayden, "National Museum of the American Indian: By the People," *Smithsonian*, September 2004, 50–57, on 55.

3 Frederick Hoxie, quoted in Thompson, "Where Myth and Museums Meet."

4 Edward Rothstein, "Museum with an American Indian Voice," *New York Times*, 21 September 2004.

5 Bob Thompson to Robert C. Post, 21 September 2004, author's files.

6 In "National Museum of the American Indian," Hayden writes of 800,000 artifacts and 125,000 historical photographs in the NMAI collection "from a vast personal hoard assembled in the first half of the twentieth century by New York engineer and investment banker George Gustav Heye," a man who "was the very picture of Euro-American entitlement."

7 Lynette Clemetson, "[George W.] Bush Authorizes a Black History Museum," *New York Times*, 17 December 2003.

8 I repeat the phrase from a letter I received in February 1995, one of more than a

dozen in response to a facetious remark quoted in *U.S. News and World Report* about the American Legion's line-by-line review of the NASM script perhaps leading, at some other time, to a similar review by the Christian Coalition. My correspondent, Alan Thomas, wrote, "It would be all for the best if the Christian Coalition and the American Legion had the exclusive privilege of deciding what is exhibited and how."

9 The newspaper accounts were almost countless, but for a sampling just from the *Washington Post*, see Blake Gopnik, "National Portrait Gallery's 'Hide/Seek' Finds a Frame for Sexual Identity," 5 November 2010; Jacqueline Trescott, "Ant-Covered Jesus Video Removed from Smithsonian after Catholic League Complaint," 30 November 2010; Gopnik, "Reaction to National Portrait Gallery's Ants-and-Crucifix Controversy," 1 December 2010; Trescott, "Transformer Shows Banned Video, as Debate over Museum's Censorship Rages," 2 December 2010; Brett Zongker, "Gallery Vows Ongoing Protest against Smithsonian," 2 December 2010; Trescott, "Smithsonian Addresses Staff Fears, Fallout over Video Controversy," 10 December 2010; Phillip Kennecott, "Smithsonian Chief's Next Call Should Be to Step Down," 24 December 2010; Zongker, "Smithsonian Chief Defends Decision to Remove Video," 18 January 2011; and Trescott, "Smithsonian Regents Support Secretary's Censorship Decision," 31 January 2011. From a New York perspective, see Sheryl Gay Stohmberg and Kate Taylor, "Wounded in Crossfire of a Capitol Culture War," *New York Times*, 30 March 2011.

10 Already in 2010 there was the $15 million David H. Koch Hall of Human Origins, and Koch has pledged an additional $35 million for a redo of the dinosaur hall, always a prime attraction at Natural History. Koch might be described merely as a "prominent supporter of conservative causes" (Jacqueline Trescott, "Natural History Museum Gets $35 Million Gift," *Washington Post*, 4 May 2012), but this could be expressed in much less benign terms, e.g., "Polluter-Funded Smithsonian Exhibit Whitewashes Danger of Human-Caused Climate Change," *Climate Progress*, 1 April 2010, http://thinkprogress .org/climate/2010/04/01/205739/must-see-video-polluter-funded-smithsonian -exhibit-whitewashes-danger-of-human-caused-climate-change. On Koch more generally, see Jane Mayer, *Dark Money* (New York, 2016).

11 Rep. Jim Moran (R-Va.), quoted in Steven Pearlstein, "A Museum for American Ingenuity?" *Washington Post*, 29 February 2012. Ed Tenner counters that "a museum celebrating American ingenuity alone risks displaying the same kind of group identity that Pearlstein deplores—on behalf of the information technology tribe." Tenner suggests instead a Museum of American Manufacturing something like *1876*, but adds that there is really no hurry because the Lemelson Center for the Study of Invention and Innovation at NMAH already has "a

mandate for documenting and encouraging ingenuity." ("How to Celebrate American Industry on the National Mall," *Atlantic*, 22 February 2012, www .theatlantic.com/technology/archive/2012/02/how-to-celebrate-american -industry-on-the-national-mall/253306/).

12 Brent Glass, who followed Spencer Crew as director in 2002, loved pop-culture items—even items that seemed trivial among trivialities, like Jerry Seinfeld's puffy shirt and Kerry Bradshaw's laptop—especially the upbeat publicity, for the donor as well as the museum, that accompanied presentations.

13 Christine Miller Ford, "The American History Museum Reopens to Shine a New Light on America's Icons," *Torch*, December 2008.

14 Randolph Starn, "A Historian's Brief Guide to New Museum Studies," *American Historical Review* 110 (2005): 68–98, quotation on 91.

15 Along with a photo of the reflective-tile flag that also showed a circular patch in the floor where the pendulum once swung, the December 2008 issue of *The Torch* included an obituary for Shayt, mentioning his "eclectic interests" but not his noble effort to save the pendulum (Dawn Fallik, "Pendulum May Hang It Up," *Baltimore Sun*, 27 April 1998).

16 Barry Lord and Gail Dexter Lord, eds., *The Manual of Museum Exhibitions* (Walnut Creek, Calif., 2002), 17. Starn, "Historian's Brief Guide," quotes several authorities who decry "this devaluation of a museum's collections" as a source of meaning and value.

17 Bill Adair, Benjamin Filene, and Laura Koloski, "How Do Staid Museums Navigate a User-Generated World?" *History News Network*, 12 December 2011, http://hnn.us/articles/how-do-staid-museums-navigate-user-generated-world.

18 The tagline itself seemed even more embarrassing. Adding a new layer of triviality, a *Washington City Paper* blogger suggested that "Seriously Amazing" was a "perfect slogan for stoners," not what anyone would say "when admiring the first ladies' dresses" but rather "after smoking an eighth of Master Kush and listening to *In the Court of the Crimson King*" (Jonathan L. Fischer, "Seriously Amazing Dude," *Washington City Paper*, 19 December 2011, www.washingtoncitypaper .com/blogs/artsdesk/general/2011/12/19/seriously-amazing-dude/). And did anyone at Wolff Olins or in the Castle recall Disney's America, Michael Eisner's pet project, a theme park in suburban Virginia that aimed to evoke a history of the United States with the tagline "Serious Fun"? Or had anybody noticed that Fantasy Football would be rolling out "Serious Fun" on almost the same day in September 2012 as the Smithsonian rolled out "Seriously Amazing"? The Smithsonian official in charge of the branding campaign told reporters how proud she was of "the fun look and feel of these ads" and "the cool things [people] can learn." Pherabe Kolb, quoted in "What Is the Smithsonian: First Ad Campaign to Answer that question," *News Blaze*, http://newsblaze.com/

story/201292114320300001.wi/topstory.html; "Smithsonian Aims at Young in First-Ever Branding Campaign," *Chronicle of Philanthropy*, 21 September 2012, http://philanthropy.com/blogs/philanthropytoday/smithsonian-aims -at-young-in-first-ever-branding-campaign/54184.

19 G. Wayne Clough, quoted in Lonnae O'Neal Parker, "Smithsonian Launches Branding Campaign," *Washington Post*, 20 September 2012, http://articles .washingtonpost.com/2012-09-20/entertainment/35494288_1_largest-museum -and-research-smithsonian-institution-wayne-clough.

INDEX

Page numbers in *italics* indicate photographs.

educational background of, 43; exhibits
and, 97–98, 128–29, 179, 187; gender of,
296n21; Hindle and, 116; of NASM, 162,
163, 168; promoted to research positions,
306n7; reaction to Productivity exhibit
by, 109; recruitment of, 48–49, 51, 52,
126; relationship with designers, 33–34;
reputation of, 172; scholarship of, 53; of
science, 316n35; secretarial control of
exhibits and, 210–12; Small and, 231–32,
238–39; stakeholders and, 281; supervi-
sion of, 126, 127, 128; supervisory role of,
120; training for, 307–8n17
Curtiss, Glenn, 153

Dahlin, Doug, 341–42n37
Dailey, John R., 263, 266
Daniel, Pete, 180, 210, 259, 347n13
Darman, Richard, 225–26, 250–51
David H. Koch Hall of Human Origins,
 352n10
Davidson, Janet, 263
Deutsches Museum, Munich, xix, 14, 323n5
DeVorkin, David, 264–65
d'Harnoncourt, Anne, 228
Dibner, Bern, 50, 69, 123–24, 125
Dibner Award for Excellence in Exhibits in
 Technology and Culture, 189
Dibner Library for the History of Science
 and Technology, 123–24, 125
dioramas, 26–27, *136*
Discovery Communications, funding from,
 233
Discovery space shuttle, 260
Doctorow, E. L., 266
Do It the Hard Way (Rube Goldberg)
 exhibit, 101, 103, 177
Dondero, George, 39–41
Doubleday and Co., lecture series sponsored
 by, 121, 313n15
Douglas, Susan, 302n5
Dower, John, 269
Downing, Andrew Jackson, 4
Drovenikov, Igor, 132

Duck, Berkley W., III, 246
DuPont, funding from, 191, 225, 238, 258
Dupree, A. Hunter, 116, 117, 126, 215, 312n7
Dwight D. Eisenhower Institute for Histori-
 cal Research, 122–23

Eames, Charles, 32, 33, 107, 109, 131, 341n43
Eames, Ray, 131
Ehrlichman, John, 165
Eichner, L. C., 303n13
1876 exhibit, *144*; description of, xvi, 104–5,
 113; design of, 114, 131–32; financial sup-
 port for, 338n7
Einstein exhibit, 188
Eisenhower, Dwight, 35, 36, 41, *85*, 121
Eisenhower, Mamie, 35, 41, *85*
Electricity, Division of, 291n22
Electricity and Nuclear Energy, Division
 of, 116
Ellicott, Andrew, *136*
Emme, Eugene, 164, 165, 208
Engen, Donald, 261–62, 335n32
Engineering and Industries, Department of,
 15, 25, 26, 30
engineering museum, appeals for, 14–16, 23
Engines of Change exhibit, 185–86, 192,
 349n22
Englehardt, Tom, 207
Enola Gay: Arnold and, 155; disassembly and
 reconstruction of, 262, 292n35; display
 of, 12, 160, 198–99, 263–64, 266–67,
 270; fame of, 269–70; labeling of, 264,
 265; model of, *148*; Udvar-Hazy label,
 xii–xiv, 12, 206–7. *See also* "The Cross-
 roads" exhibit
Ethnogeographic Board, 152–53
Ethnology, Department of, 27, 30, 35
Evans, Clifford, 30, 31, 280
Everyday Life in the American Past exhibit,
 45
Ewers, John C., 28–29, 31, 36, 61–62, 92,
 139, 274
exhibit designers: emergence of profession,
 xi, 29–36; freelance firms, 117–18; pre-

Strong, William Duncan, 318n4
Suiting Everyone exhibit, 113–14, *145*, 323n5
Suitland (Silver Hill), 31, 156, 236, 237, 293n7

Taft, Helen, 20–21
Taylor, Frank, *147*; A&I and, 26; Air Museum and, 157; Anglim and, 31; appeal to Congress by, 39, 111–12; Boorstin and, 95; on completing exhibits successfully, 128; on designers, 33; on displays, 21; Division of Engineering and, 25; education and career of, 19–20, 22, 23, 151; Garvan and, 43; Lawless and, 32; material culture and, 22–23; MHT and, 36, 57, 62, *87*; Mitman and, 18; modernization program of, 26–29, 34–35; Multhauf and, 32, 46, 48, 115; NASM and, 163, 165; National Armed Forces Museum and, 121; opening of MHT and, 57; on publications, xviii; on social relevance, 63; Wetmore and, 152; *The World Is Yours* radio program and, 23–24
Taylor, Frederick Winslow, 109
Taylor, Joshua, 101
Technology and Culture (journal): debut of, 36; editors, 179; exhibit reviews in, 255, 292n35; funding for editorial offices for, 176, 186; influence of, 53
telegraph exhibit, controversy over, 11–12
telephone exhibit, controversy over, 65–72
Tenner, Ed, 352–53n11
Thompson, Bob: Adams and, 275; on *America on the Move* exhibit, 259; "History for $ale," 237, 339n20; W. Reynolds quoted by, 239; on stakeholders, 273; "The Wheel Thing," 348n20; "Where Myth and Museums Meet," 351n1
Thompson, Sylvanus P., 67
Tibbets, Paul, xiii, 155, 198–99, 206, 265
Tillotson, Bob, 108, 315n25
Tin Shed (Aircraft Building), 14, 16, 26, 31, *80*, 156
Townes, Charles, 249
Trans World Airlines (TWA) video, x, xi

Trescher, George, 338n7
Truman, Bess, 35
Truman, Harry S, 35, 153

Udvar-Hazy, Steven F., 226, 227, 262, 265. *See also* Steven F. Udvar-Hazy Center
United States National Museum, *77*; building for, 7; collections of, 7–8, 20; functions defined by Goode, 221–22; historical relics of, 20–21; opening of, xv; origins of, 5–7. *See also* Arts and Industries (A&I) Building
U.S. Constitution, two hundredth anniversary of, 193
U.S. Department of Transportation, 259

Vail, Alfred, 11–12
Vail, James, 12
van Loon, Hendrik Willem, 26
Vietnam War, 161, 165
The Vision of Man exhibit, 105–6
Vogel, Robert M., *147*; as curator, xviii, 103; education and career of, 49; *1876* exhibit and, 131; Multhauf on, 115; petroleum mural and, 288n3; Skramstad and, 59, 98
von Eckardt, Wolf, 60, 167

Wackerman, Dorothy, *142*
Walcott, Charles D., 12, 13, 14, 105
Walker, Charles E., 316n37
Walker, William S., 303n12
Wallace, Mike, 212
Warner, John, 237
Warner, William W., 320n29
Washburn, Wilcomb, 43, 44, 58, 98, 120–21, 301n3
Washington, George, 20, 183–84, 188
Washington City Canal, 289n10
Watkins, John Elfreth, 9, 10, 20, *79*, 112, 275
Watkins, Malcolm, *135*; on corporate support for exhibits, 112; as curator, 95, 110–11; *Everyday Life in the American Past* exhibit and, 45; Multhauf on, 115; *A Nation of Nations* exhibit and, 130–31